ANNA FELICITY FRIEDMAN

FOREWORD BY
JAMES ELKINS

THE
WORLD ATLAS
OF TATTOO

Thames & Hudson

CONTENTS

EUROPE

AFRICA AND THE MIDDLE EAST

ASIA

AUSTRALIA AND THE OCEANIC ISLANDS

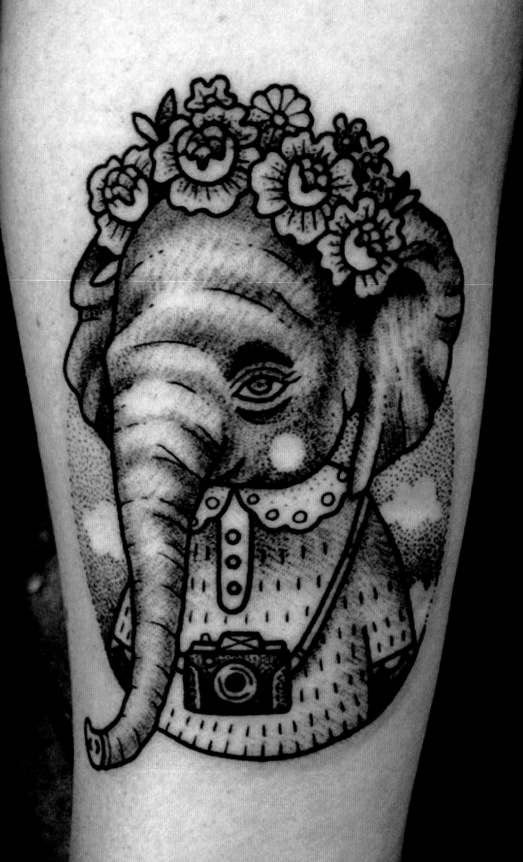

FOREWORD

BY JAMES ELKINS

Skin is a wonderful place to make marks, to write or draw, because it is always expressive. Your skin tells people if you're healthy, how old you are, whether you're embarrassed, nervous or sick. That's the language of skin. 'I'm getting older', it says, in a wrinkle, or, in a blush, 'I love you.' Paper is utterly inexpressive by comparison: it says nothing and its emptiness vexes writers. Skin, however, is always talking: expressing your moods, your health and showing you to the world. When a tattoo artist makes marks on the skin, he or she joins a conversation in progress. When you choose a tattoo, you reveal something about yourself that is already there, even if it's only a hope.

Consider the surfaces on which people make marks. Before history and language, people marked cave walls. The best cave paintings move with the surfaces of the walls: the bison's belly is placed exactly on a bulge in the rock, the ritual mark is hidden in a cleft. People also make marks on the skin of the world – tunnelling, bulldozing, dynamiting – to make its surface into something it is not. Sometimes we get it right: a curving mountain road follows the arcs and turns of a cliff, as if the road is listening to the mountain. People also draw pictures on the sky, when they imagine constellations. Like tattoos, sky charts respond to faint clues on a silent surface, finding figures and patterns where nature has not spelled things out.

Writing on a sheet of paper is different from writing on the skin because the skin is also writing its own story. Another difference between writing and tattooing is that the tattoo speaks in two directions: it speaks to people who see it, as well as to the person who wears it. A tattoo signals to people who see it, telling them about you, but it also writes back, telling you about yourself. It's easier to think about this in examples where the tattoo only speaks in one direction. In the movie *Memento* (2000), Leonard tattoos himself to remember his past. He is the only reader of his tattoos: they reveal things about him, but only to himself. In *The Exorcist* (1973), at one point Regan's torso breaks out in welts that read 'HELP ME'. Medically, this is an example of hysterical dermography – a kind of writing on

the skin from the inside, not seen by the patient and speaking only to the outside world. In James Joyce's novel *Finnegans Wake* (1939), there is a passage where the artist Shem the Penman is trying to write a letter. It's a crucial letter, but it's impossible to write because it's so long. Shem writes on every piece of paper he has and then he writes all over his apartment. Finally, when he's run out of surfaces, he turns to his own skin. He makes ink out of his own excrement and continues writing all over his body.

These are all partial examples of what tattoos do, like half-built buildings or half-finished sentences. A full tattoo is like a deep conversation: your tattoo tells me about you and it tells you about yourself. Most importantly, tattoos connect you to your family, town and culture. That is why a book like this is so important and why it's appropriate that it's an atlas. Even the most personal tattoo, which seems only to be about your own dreams and ideals, is also about your place in the world. Many tattoos in this book represent regional, tribal and national traditions. Some are well known, such as the Maori and Hawaiian tattoos. Some are new, at least to me; for example, Mo Naga's works, which express the values of Nagaland, a remote area near Burma. Yet, even the most personal tattoos, such as Susanne König's wonderful animals, are of their time and place. Anna Felicity Friedman is one of the world's most informed historians of tattoos, as well as an observer and collector of contemporary tattoos, and this book is an excellent reminder that nothing we do is wholly private. Even with an art as personal as tattooing, we live, always, in the public world, in culture and in history.

There are beautiful examples in this book of those convoluted, wordless conversations. Tattooing is intimate, heartfelt and all the things people say, but it is also astonishingly complex: a tattoo is one of the most eloquent and intricate ways to speak without words.

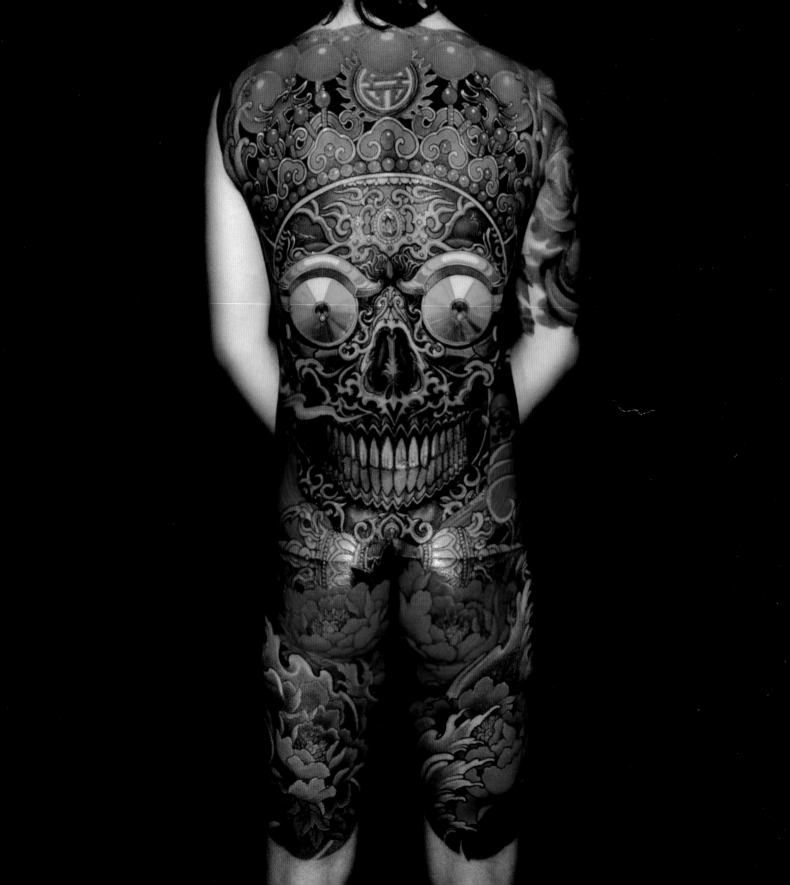

INTRODUCTION

Today tattooing exists in nearly every country on the skins of a phenomenal array of people. Perhaps at no other time in history has this art form been so prevalent, both in terms of its geographical reach and the sheer number of people who wear tattoos. Since the mid-1990s, an astounding range of new tattoo genres has arisen alongside revitalizations, reinventions and continuations of indigenous traditions. The result is a global tattoo culture rich in historical roots and rife with contemporary innovation. *The World Atlas of Tattoo* celebrates this diversity and highlights a microcosm of current practice in its 100 artists chosen from the four corners of the world.

The word 'tattoo' itself – which has come to globally represent the art form and cultural practice that inserts pigment under the skin to leave a permanent image – has a global history. Its root can be traced to mid-18th-century interactions between Polynesians who used the term *tatau* and explorers, such as Louis Antoine de Bougainville and James Cook. 'Tattoo' and its equivalents in other European languages, such as *tatouage*, *tatuaggi* and *tätowierung* have largely replaced myriad regional terms, such as the 17th-century French *piquage*, the early modern English 'pricking', the Kurdish *deq*, the Baka *tele*, the Thai *sak yant* and the Japanese *horimono*.

With tens of thousands of contemporary tattooers spread throughout the globe practising these diverse forms of tattooing – several thousand of whom can be considered exceptionally skilled – how is it possible to pick 100 artists to profile? Instead of trying to determine the 'best' or 'top' 100 tattooers (an impossible task), this book showcases the incredible range of people working today. It strives to achieve a balance of geographical location, genre, gender and ethnicity. From a curatorial perspective, 100 artists cannot even come close to representing one per country, much less one per state, province, island or major city. Difficult choices had to be made. For cities like New York, to which dozens of impeccably credentialled and brilliantly talented artists flock, can only one representative even be chosen? In some instances, there are no artists to profile in a given place. Many artists continuing indigenous tattoo traditions are inaccessible (due to geography, language barriers or secrecy) and are therefore difficult to profile. Other artists, such as those tattooing in countries like Iran who face serious prosecution for practising their vocation, would be putting themselves at significant risk with international exposure. With few exceptions (mainly in the Middle East, Africa and certain parts of the Pacific), the artists featured in this book could have been replaced with countless other artists to reflect the diversity of style and practice around the globe.

To pare down the several thousand excellent tattooers under consideration for *The World Atlas of Tattoo*, some parameters for inclusion had to be set. The book focuses on artists who emerged from the mid-1990s through to the present day – in parallel with the current global explosion in tattooing. Therefore, most of the artists featured are rarely older than fifty, with a few notable exceptions. For example, Whang-Od (see p.372), who, although ninety-four years old, has experienced a resurgence of interest in her work over the past decade; Pius (see p.238) captures a story that highlights the struggle to maintain tattooing in the face of colonialism and globalization. Certainly many tattooers whose careers launched prior to the mid-1990s are also still significant today; many are mentioned in the chapter introductions. What resulted from this selection process is a mix of relatively new rising stars together with those who have been working professionally for several decades.

One of the striking aspects of *The World Atlas of Tattoo* is the representation of female artists. Had this book been created in the late 1980s, there would have been perhaps two or three included. However, more than a quarter of the artists profiled here today are women – a testament to the hard fights many have waged in order to break into a business that has been traditionally male dominated. Some women, such as Jill 'Horiyuki' Bonny (see p.80) or Sarah Johnson (see p.98), doubly break boundaries by working in tattoo genres (Japanese and macabre black and grey) that are almost exclusively the domain of men. New genres are also well represented in the pages of this book,

2 Sun-like motif rendered in dotwork by Sanya Youalli (see p.112) **3** Modern Polynesian blackwork by Aisea Toetu'u (see p.336) **4** Traditional Fulani marks by Tirga Poli (see p.226)

from the radically experimental work of Caro Wilson (see p.178) to the whimsical art-brut style of Nuno Costah (see p.152). Other artists are noteworthy for producing unlikely work in remote places – for example, Pierre Bong's Japanese work in Suriname (see p.126) or Dmitry Babakhin's Marquesan and other Pacific Islander work in Russia's St Petersburg (see p.198).

Some artists continue their culture's traditional tattooing, working from unbroken traditions that have remained consistent, only occasionally updating motifs as client demand dictates. Thus, in Africa, Poli Somalomo (see p.222), Tirga Poli (see p.226) and Sam Ije (see p.230) continue to inscribe the bodies of their community members. In Jerusalem the Razzouk Family (see p.244) tattoo Christian pilgrims as they have for centuries, while expanding their business to include other forms of tattooing. In Samoa the Sulu'ape Family (see p.360) offer *pe'a* and *malu* as they have for generations and as their ancestors did before them.

Perhaps the most poignant element of the current global tattoo explosion is the reclaiming of tattooing as an important part of indigenous cultural heritage. Artists such as Keone Nunes (see p.332), Durga (see p.366), Julia Mage'au Gray (see p.328) and Elle Festin (see p.68) are carefully working from archived images and investigating historical practice to create tattoos faithful to what was inscribed in times past. Another way in which tattoo traditions are being reclaimed is by the reinvention of indigeneous practice (often reflecting a blend of cultural influences) rather than reconstruction. In Mexico we see two very different approaches to reclaiming pre-Hispanic tattooing, by Pedro Alvarez (see p.108) with his neo-Aztec movement and Sanya Youalli (see p.112) and her contemporary blackwork. Elsewhere, in New Zealand Steve Ma Ching (see p.354) combines Samoan and Maori tattoos.

Another exciting 'neo' tradition creates culture-oriented tattooing in the absence of historical evidence. For example, Tatu Lu in Australia (see p.326) renders stunning neo-Aboriginal creations whereas Colin Dale in Denmark (see p.192) has pioneered neo-Nordic tattooing and also brought neo-Celtic work to new heights. These artists craft designs that pay homage to particular cultures by mining images from other art forms.

The arrangement of artists geographically also posed several conundrums. The chapter divisions of the book reflect the inadequacy of standard continental or regional umbrellas to

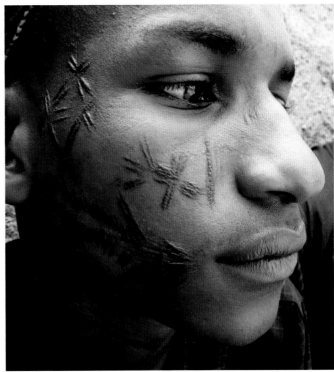

group global tattooing into homogeneous units. Instead of the typical 'North America', the United States and Canada share a chapter without Central America. More tattooing is going on in the United States in terms of numbers than anywhere else in the world and the tattoo history of Canada parallels that of its southern neighbour, albeit at a significantly reduced rate. Both countries experienced the extinction of indigenous Amerindian tattoo traditions, with only limited traces of precolonial traditional tattooing surviving to the 20th century on the bodies of Arctic people.

The chapter on Latin America combines Central and South America to reflect the unfortunate legacy of colonialism that decimated indigenous populations and caused their tattooing to become almost extinct. The colonial legacy also established conservative attitudes towards the body that reflected the influence of Catholic missionaries and resulted in societal taboos against tattooing. These are only now being regionally overcome in the 21st century as youth culture – aided by exposure to global tattoo culture – embraces a less restrictive model of the body. Native North American indigenous traditions might have more appropriately been discussed together with those in Central and South America because they overlap significantly; however, since the trajectories of contemporary

'Western' tattooing diverged significantly from the 16th century, a generalized 'Americas' chapter did not make sense.

The Middle East (what might from a historical perspective be termed Asia Minor) is paired with Africa. Indigenous tattoo motifs and motivations have remained remarkably consistent across North Africa and the Middle East, as well as into parts of sub-Saharan Africa. As in Latin America, Africa and the Middle East only recently joined the 'Western'-derived contemporary tattooing movement, with a limited number of artists in major urban areas.

With respect to the Oceanic Islands and Australia on the eastern edge of Asia, the South East Asian islands of the Philippines and Indonesia also get separated from their usual continental affiliation. These island groups share numerous similarities with the Pacific Islands because tattooing spread during the Neolithic period from mainland Asia (probably south China) eastwards and southwards through island hopping. Australia's relatively recent tattoo history makes it complicated to place in a geographical division. Conceptually, it fits more appropriately with the United States and Canada or Europe because its history parallels the 20th-century histories of those regions. However, because of the overwhelming geographical proximity to the Oceanic Islands, combined with its history of

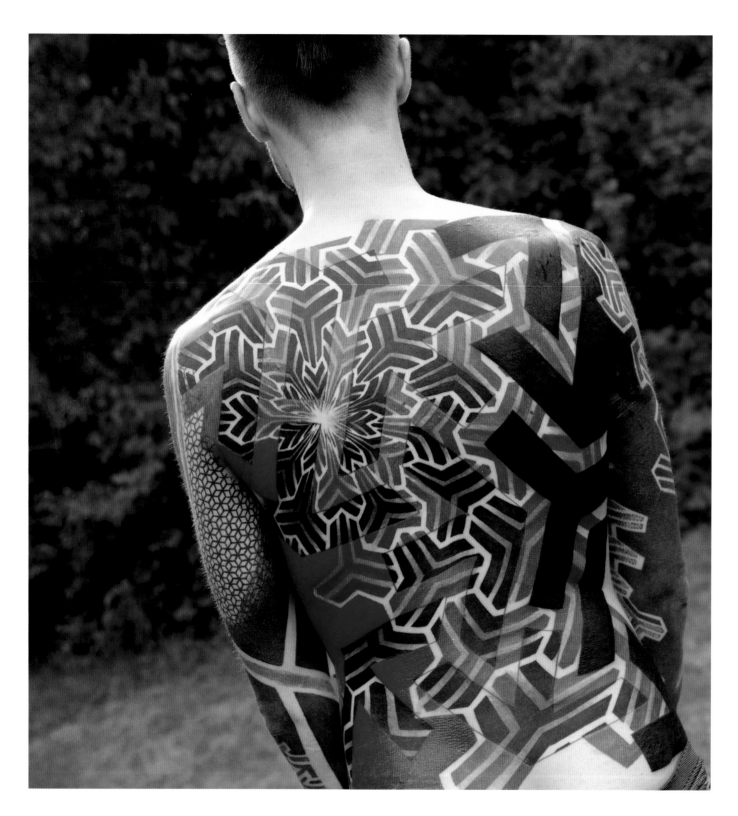

5 Geometric mandala exploding by Little Swastika (see p.170)
6 Vibrant pirate ship by James Kern (see p.50)

5

6

European colonialism in the 18th and 19th centuries, it makes sense to include them together.

What remains of Asia results in perhaps the most diverse chapter of the book. East, South East, South and Central Asia all have distinct tattoo traditions (the latter now extinct) that are hard to connect. With the added layer of Western-influenced global contemporary tattooing, what emerges in Asia can only be described as a thrilling mix of contemporary innovation with survivals of longstanding indigenous practice (some, such as Japanese *horimono*, with surprisingly recent roots). Of all the regions, Europe most easily defines itself geographically, in keeping with the usual continental divisions. Although the majority of tattooing taking place in Europe today belongs to the global contemporary tradition, the continent had a rich history of now extinct indigenous practice about which only fragmentary knowledge remains. As various ruling empires expanded, contracted, assimilated and collapsed, tattooing ebbed and flowed, and changed dramatically on European bodies.

As much as *The World Atlas of Tattoo* celebrates the great diversity of tattooing today, a sombre side emerges from the chapter introductions and the stories of individual artists. Prior to the Age of Discovery in the 15th century, when Europeans began to explore the globe on missions to expand empire and conquer new populations, tattooing had been customary across an enormous swathe of the world. These traditions frequently resulted in nearly all members of a particular population being tattooed (or at least all members of one gender) with often extensive and elaborate patterns and motifs. Yet within a few centuries, hundreds if not thousands of these tattoo traditions evaporated (along with other forms of body modification and adornment) as indigenous populations were killed, displaced, made to change their ways or feel inferior and otherwise pressured to cease tattooing. Particularly damaging was the widespread imposition of a brand of intolerant Christianity that stipulated that the body should not be marked (and ignored the fact that Christian populations have a long history of tattooing).

The only positive aspect of the devastation of indigenous tattoo traditions is the fact that colonial interlopers often documented the traditions they encountered. Despite preserving a tiny fraction of this disrupted cultural heritage, European colonialism was generally disastrous for most non-Western tattoo traditions. Had colonialism not happened,

this book would have had far more options to profile indigenous tattooers throughout the Americas, Middle East, Africa and South and South East Asia and would have had harder choices to make in the Pacific Islands. The revitalization and reconstruction movements active in so many places around the globe offer great hope for reinstating tattooing as an integral cultural and artistic practice in places where it once existed widely.

Nevertheless, an incredible diversity of experience emerges from the images of people and their tattoos in this world atlas. One can browse these pages as one would a book of maps – imagining the places behind the images and planning voyages to go and see them. Channel the narrator in Ray Bradbury's *Illustrated Man* (1951) and use these tattoos as windows to global experience. Sit back and (armchair) travel through the astonishingly varied designs inscribed by talented and dedicated tattoo artists on the skins of a colossal range of the world's citizens. **AFF**

UNITED STATES
AND
CANADA

NEW YORK CHICAGO WILMINGTON NEWPORT MANKATO FESTUS
PORTLAND CINCINATTI RICHMOND ATLANTA AUSTIN COLUMBIA
STANTON FOUNTAIN VALLEY LOS ANGELES SAN FRANCISCO
SALMON ARM GUELPH MONTREAL KELOWNA TORONTO

AMANDA WACHOB DUKE RILEY STEPHANIE TAMEZ NICK COLELLA BJ BETTS DANA MELISSA DIXON
MEGAN HOOGLAND JESSICA WEICHERS JAMES KERN KORE FLATMO MARINA INOUE MIYA BAILEY
NICK BAXTER SHANNON PURVIS BARRON ELLE FESTIN JOSE LOPEZ ZULU JILL 'HORIYUKI' BONNY
ROXX DION KASZAS RIKI-KAY MIDDLETON SAFWAN MIKEL SARAH JOHNSON

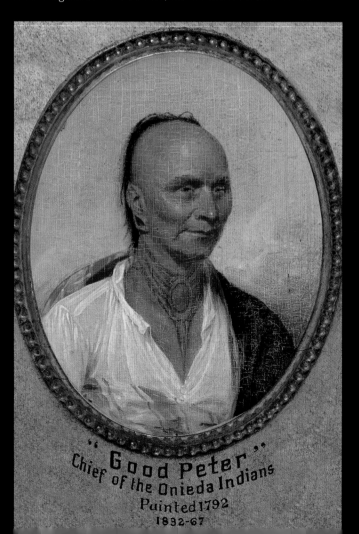

"Good Peter"
Chief of the Onieda Indians
Painted 1792
1832-67

The histories of tattooing in the United States and Canada have largely paralleled one another. Beginning long before either country existed, indigenous Native American groups throughout North America widely participated in permanently inscribing their skins. As Europeans began to explore and colonize the continent, many of them also became tattooed. Some of the designs inscribed on the new residents of and visitors to North America reflected their adoption into local indigenous communities, others could be considered souvenirs of cross-cultural experience, whereas others still followed exisiting European traditions of marking names, honouring memories of people and places, and visually asserting group or religious identity.

Unfortunately, most Native American tattoo traditions were extinct or severely limited by the time of the American Revolution in 1776, apart from some isolated practice that persisted along the north-west coast of the continent and Arctic shores, where European-heritage populations had limited influence until the 20th century. 'Western' traditions, on the other hand, continued. Itinerant artists, often working on battlefields, gradually gave way to professional tattooers who began to set up shops. At first this was largely concentrated in port cities, but it had spread practically everywhere by the dawn of the 21st century. The trajectories of non-indigenous tattooing in the United States and Canada followed relatively similar paths, although artists in the former pioneered important innovations that Canadian artists adopted later.

In addition to common tattoo themes, such as names and crosses, various folk art motifs persisted throughout tattooing's history in the United States and Canada. In the mid- to late 19th century, Japanese art began to influence the North American vocabulary of tattoo images, with overtly Asian-influenced designs rising and falling in popularity over the following decades. The tattoo renaissance of the late 1960s and early 1970s resulted in the incorporation of many other visual influences mined from a range of cultures and subcultures, including 'hippie' counterculture, fine art, prisons and non-Western societies. By the 1980s new and distinctly American genres of tattooing had emerged. By the first decade of the 21st century, tattooing in the United States and Canada reflected an immense range of styles, with tens of thousands of artists working professionally.

Native American Tattooing

Throughout North America – from coast to coast, north to south and across all environments – numerous Native American groups had tattooed for thousands of years before Europeans arrived on the continent. Most of the documentation for Native American tattoo traditions comes from accounts and images provided by those of European heritage who encountered

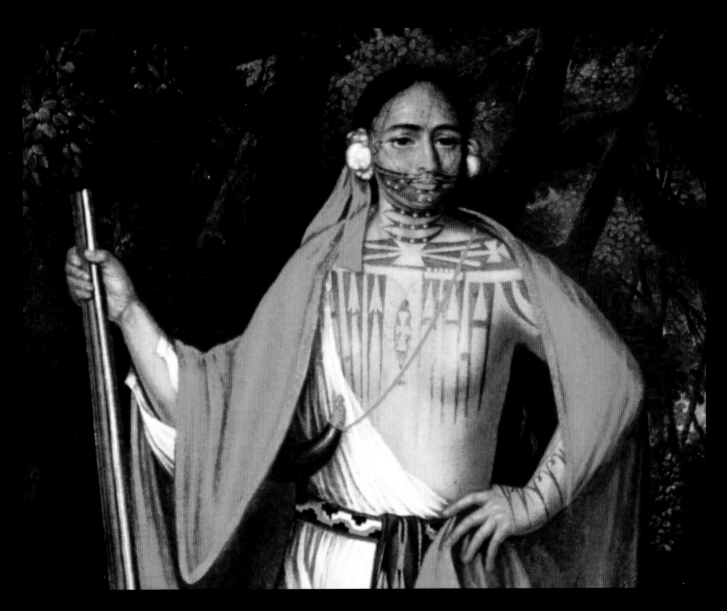

them (see images 2 and 3). Since such documents are subject to the vagaries of memory and artistic talent, some of these reports may have been exaggerated, downplayed or garbled. Archaeological specimens, such as effigy pots and incising tools, also provide insight into what these tattoos may have looked like, as well as how they might have been technologically applied and what they might have meant. What clearly emerges from these colonial texts, however, is the astounding diversity of Native American tattoo practice in terms of who got tattooed, what the tattoos looked like, and how and why they had been inscribed.

Although many of these observational accounts provide limited information – for example, some merely note that Native Americans were 'pricked' or 'marked' or even 'most hideously painted' – many other authors carefully reported what they saw, detailing both tattoo designs and technique. Among the first post-contact descriptions, Thomas Hariot, who was travelling in Virginia around 1585–86, observed that women had 'their legs, hands, breasts and faces cunningly embroidered with divers workes, as beasts, serpents, artificially wrought into the flesh with black spots'; John White provided corroborating illustrations of some of these tattoos. Father

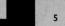

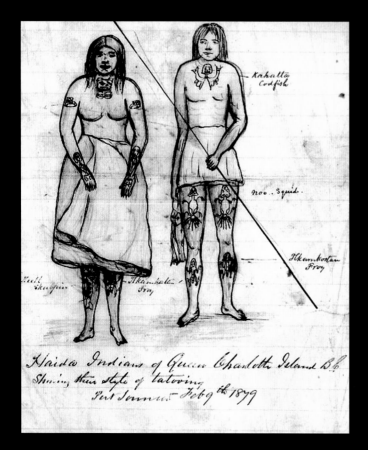

Haida Indians of Queen Charlotte Island B.C. Showing their style of tatooing Port Simmons Feb 9th 1879

Gabriel Sagard, one of many French Jesuit missionaries during the 17th century who wrote extensive accounts, recorded that the Hurons had their 'body and face engraved with figures of serpents, lizards, squirrels and other animals . . . pricked into the surface of the flesh in the same manner as the crosses' of European pilgrims.

Native American tattoos varied in their meaning: they marked rites of passage, signalled aspects of group or individual identity, offered healing medicine or protection, commemorated bravery and enhanced beauty, among other things. James Swan (see image 4) described what his late 19th-century informants related about the Haida tattooing they wore: 'Every mark has its meaning; those on the hands and arms of the women indicate the family name, whether they belong to the bear, beaver, wolf or eagle totems, or any of the family of fishes.' Frederick Beechey wrote in the mid-19th century that the

tattooing of Californians served 'both to ornament the person and to distinguish one clan from another'. Reverend John Heckwelder remarked in 1742 that the body of one particularly heavily tattooed Munsee/Lenape: 'represented scenes of the various action and engagements he had been in; in short, the whole of his history was there deposited'.

Early European-Heritage Tattooing
Numerous travellers and settlers of European heritage, particularly the French, were tattooed in what later became the United States and Canada from the late 1600s through to the end of the 1700s. Immigrants and explorers occasionally received marks that represented their cultural adoption into Native American groups. Perhaps most famous among these were the children of the Talon family, who travelled with one of the La Salle expeditions in the 1680s and had their faces extensively tattooed in keeping with Hasinai and Karankawa traditions. Feodor Ivanovich Tolstoy (the cousin of Russian writer Leo Tolstoy) was one of the last Europeans to receive non-Western tattoo marks in North America. He received a Tlingit thunderbird across his chest in 1805 after being abandoned on the Pacific Northwest coast due to his poor behaviour as a member of Russian explorer Adam von Krusenstern's expedition.

Inspired by the Native American tattoos they saw, other 17th- and 18th-century visitors obtained Western-style tattoos that reflected traditions from back home in Europe. Christian marks of faith were particularly common. Monsieur Dièreville, a surgeon who spent a year travelling in Acadia in 1699 and viewed tattoos on French fur traders, related that their chosen motifs included 'all types of images, crosses, the name of Jesus, flowers'. Swedish explorer Pehr Kalm noted in 1749 that French fur traders he encountered had 'in fun followed the example of the natives' and that the tattoos they inscribed were 'made up of stripes, or they represent the sun, our Crucified Saviour or something else which their fancy may dictate'.

By 1776 tattoos were popular enough, especially among seafaring men, to serve as marks of identity on early passport-like papers known as Seamen's Protection Certificates. These documents reveal an incredible variety of tattoo motifs, many of which are similar to those still inscribed today, such as initials, nautical imagery and religious symbols. A half-century later, writing in *White-Jacket or The World in a Man-of-War*, a young Herman

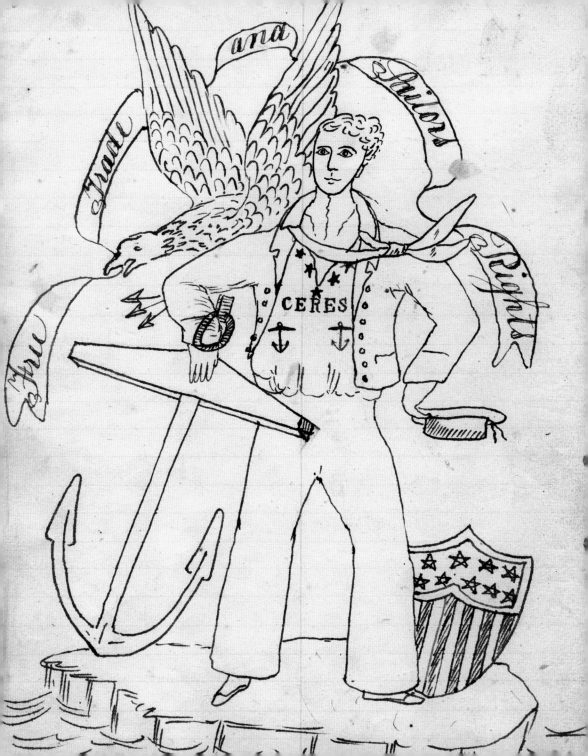

6 8

7 9

6 Circus performer Annie Howard, late 19th century
7 Charles Longfellow in Japan, c. 1885–93 **8** Sailor Jerry flash, mid-20th century **9** Milton Zeis flash, mid-20th century

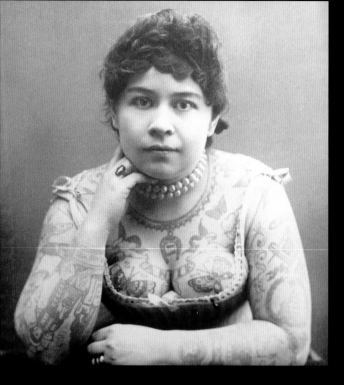

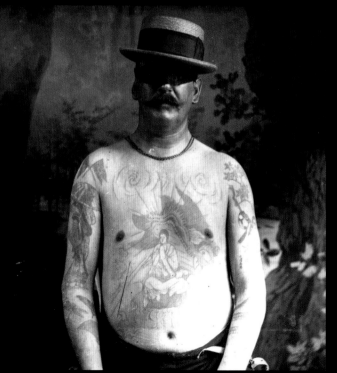

Melville, who saw tattoos on the bodies of his fellow whaleship sailors in the 1840s, described similar designs rendered by the two shipboard tattooers who 'would prick you to order a palm tree, an anchor, a crucifix, a lady, a lion, an eagle or anything else you might want'. During the Civil War, itinerant tattooers crossed battle lines to inscribe soldiers with marks of patriotism and faith.

In keeping with the transculturite tradition on American soil, when people of European heritage started travelling in the Pacific Islands, many of them received the traditional marks of those cultures. By the mid-19th century, some of these men, such as James O'Connell, became circus performers who toured around the United States and Canada showing off their exotic tattoos to captivated audiences. Others, such as Horace Holden, published books recounting their harrowing tales, which further familiarized the 19th-century American public with tattooing. By the middle of the 19th century, as tourism became a viable practice for increasing numbers of North Americans, tattooing had expanded further. William Sands, a traveller on board the steam ship *Cuba* from San Francisco to New York in 1850–51, described in his diary how he obtained not one, but two tattoos from the resident shipboard artist during his journey. The designs he chose – oak leaves and acorns on his arm and a 'small shield' on his foot – may have represented his political interests.

After Commodore Matthew Perry played a leading role in opening up Japan to the West in the 1850s, tourists began to travel there and obtain small souvenir tattoos, as well as more extensive work. Examples of these include the large pieces on prominent US citizens Charles Longfellow, son of poet Henry Wadsworth Longfellow (see image 7) and Charles Goddard Weld in the 1870s and 1880s. Women also got tattooed both abroad and on home soil with designs such as their lovers' initials or beauty marks. Although a fictional tale, Elizabeth Stoddard's novel *The Morgesons*, published in 1862, features a character who has her lover's initials tattooed in a bracelet design.

Professional Tattooing Emerges

In the late 19th century, tattooing shifted from transactions by itinerant, shipboard and home-based artists to new professional practitioners working in shops, mainly in urban areas. The earliest shops, including Martin Hildebrandt's atelier and Samuel O'Reilly's Bowery studio, appeared in New York in the 1870s. These

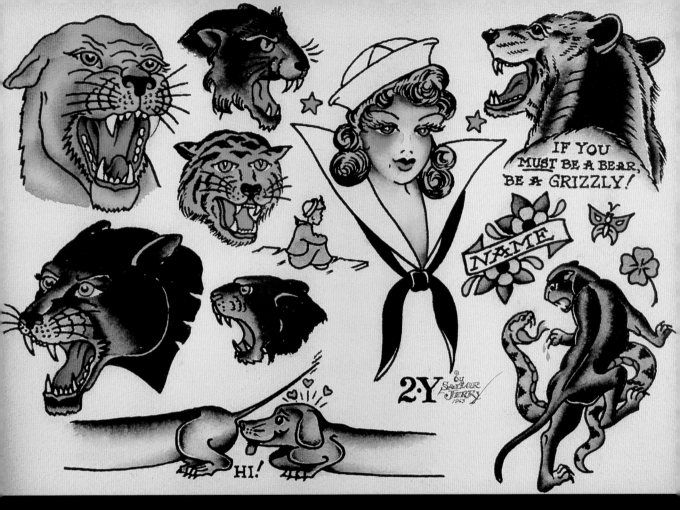

early professional tattooers continued to hand-tattoo, however, the painstaking and time-consuming nature of the process prompted artists to explore ways to mechanize it. In 1891 O'Reilly filed his patent for an electric tattoo machine and the beginnings of an expansion in both clientele and tattoo aesthetics ensued. This new technology allowed ever greater numbers of people to get quick, small inscriptions on their skin.

Other innovations, such as stencils, enabled those with limited artistic ability to enter the business of tattooing. The machine also allowed for faster colouring and shading of large areas; the 'traditional' tattoo style of a heavy black outline filled with smooth blocks of colour and chiaroscuro-like shading subsequently emerged as the primary aesthetic. However, hand-tattooing coexisted simultaneously with machine tattooing

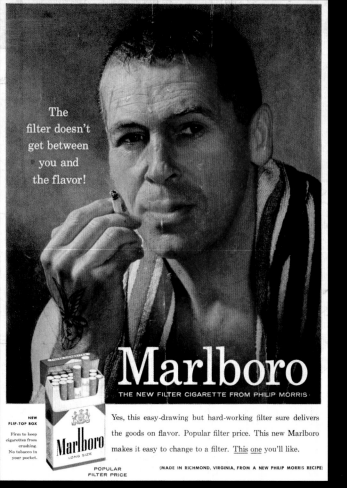

"ICARUS
DESCENDING"
a design for
the chest
DONE IN TWO
SITTINGS
per
sitting

itinerant tradition, famously eschewed tattoo machines because
hand-tattooing equipment provided a more portable kit.

Perhaps due to Canada's much smaller population, which
resulted in reduced demand for tattoos, the professionalization
of tattooing in Canada lagged slightly behind that of the United
States. Whereas the first storefront tattoo shops had appeared
in US cities by the 1870s, Canada's oldest shop opened several
decades after that. Most early Canadian artists worked by hand;
machine technology does not seem to have reached the
Canadian tattoo community until 1916, when Fred Baldwin
started using one in his Montreal studio.

The circus influenced the spread of tattooing throughout
the late 19th and into the 20th century, especially in areas away
from the coasts where tattooing was less common. Tattooed
attractions illustrated the possibilities of tattooing and also
promoted the art to popular audiences who were inspired to
get their own, albeit smaller, marks. Initially, these attractions
were dominated by tattooed men, such as Barnum's Captain
Costentenus, but by the end of the 19th century tattooed
women became a major draw, in part for the titillation of being
able to see the female body on display in skimpy (for the time)
clothing. Many of these tattooed attractions spun wild tales of
their tattoo acquisition in exotic places, but the reality was that
most had been tattooed by American tattooers on home soil.

Unfortunately, around the turn of the 20th century, because
of publicity surrounding derogatory academic treatment of
tattooing by scientific-racist criminology writers, the more elite
population who had been drawn to fine art tattoos dwindled.
The period from 1900 to 1960 marks a low point in tattoo
history with little diversity of clients or designs, although certain
artists produced masterful works within a limited aesthetic
vocabulary. Although tattooing acquired an unsavoury reputation,
from the turn of the 20th century tattoo shops proliferated and
spread across the continent, largely concentrated close to
potential clients in urban areas (skid rows and red-light districts
in particular), near military bases and by amusement parks.

Old School Style

In the early to mid-20th century, tattooing in the United States
and Canada became defined by what is known today as old
school style: bold motifs, rendered with a limited colour palette
of black outlines and shading with accents of red, green, yellow

blue and brown. The iconography skewed towards folk art motifs that reflected tattoo wearers' occupations, Christianity, romantic partners, patriotism and personal history. Supply companies emerged to satisfy the needs of the growing ranks of tattooers and one particularly savvy businessman, Milton Zeis, from Rockford, Illinois offered a correspondence course complete with flash sheets that helped to promote this old school style as the standard during this time. However, exceptions always existed, and artists such as Milwaukee's Amund Dietzel, who started tattooing around 1907, continued to work in a more delicate fine art hand with a lingering Japanese influence from the tattoos once fashionable among late 19th-century elites.

In the United States, New York, with its ports and Coney Island, emerged as a primary centre for tattooing. Chicago's South State Street also served as a launching point or stop on the apprenticeship circuit for many emerging artists, who often worked on recruits from the nearby Great Lakes naval training station. The Pike in Long Beach, California similarly became an important locus of tattoo activity. The vast navy base in Norfolk, Virginia, attracted many prominent tattooers to that part of the country. Smaller urban areas, such as St Louis, Detroit and Philadelphia also boasted important tattooers. On the Canadian side of the border, Montreal in particular became a central hub for tattooing followed by Halifax, Toronto and Vancouver. Artists readily moved to greener pastures. Bert

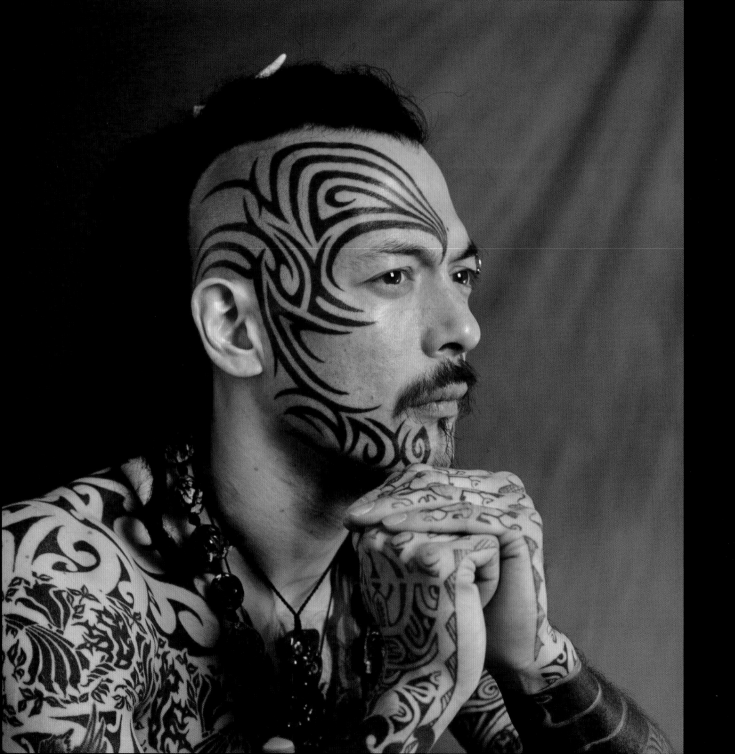

Grimm is only one example of the many tattoo artists who constantly shifted location. Born in Portland, he started tattooing in Chicago, moving on to Honolulu, Salt Lake City, Las Vegas, Seattle, St Louis and various other places, before eventually settling for many years in Long Beach.

Despite lingering stigmas surrounding tattooing, its popularity surged, particularly around World War I and II. The Marlboro Man advertising campaign that launched in 1955 captured the prevailing notion that tattoos were signifiers of potent masculinity; Marlboro Men ranged from cowboys and sailors to socialites and businessmen, with each sporting a military-style hand 'tattoo'. (Evidence does indicate that women also received small tattoos throughout this period.) The reputation of tattooing was damaged further when hepatitis scares in the 1960s resulted in the imposition of age limits for tattoo acquisition and even outright bans. New York City prohibited all tattooing in 1961 and the entire state of Massachusetts followed suit in 1962. A combination of the desire to 'clean up' Chicago's South State Street skid row by demolishing it and the raising in 1963 to twenty-one (from eighteen) of the Illinois age minimum for tattooing caused Tatts Thomas to relocate to Milwaukee to work with Amund Dietzel. Milwaukee later banned tattooing in 1966.

The Tattoo Renaissance

Tattooers in the United States played a pivotal role in fundamental changes to the aesthetics of Western tattooing. In the late 1960s, a handful of artists with formal art school training began working and corresponding, mainly in southern California, with established tattooers interested in pushing the boundaries of the art form. Although traditional folk art-inspired tattooing has persisted, the dramatic new tattoo styles and techniques that came out of the tattoo renaissance spread across the United States to Europe and then gradually beyond, forming the foundations for the great diversity of global tattooing today.

A reignited interest in Japanese tattooing united many of the artists of the tattoo renaissance. Prominent among the old-timers, Sailor Jerry Collins, working from Honolulu, corresponded with and apprenticed a number of budding tattooers, introducing them to Japanese designs and his own expertise with traditional Americana. Foremost among those influenced by Collins was Ed Hardy, who took this Japanese inspiration and used it to explode notions of what American tattoos could be by

experimenting with scale and shading in pioneering ways. Many other artists in the United States and Canada also began to experiment with Japanese-derived visual ideas in novel ways.

US tattoo artists also started to incorporate a variety of nontraditional influences into their work: images from popular culture, delicate line work more typically seen in etchings and non-Western cultures beyond Japan. For example, Cliff Raven's flash deviated significantly from standard designs on the walls at Chicago Tattoo; they were drawn from the mythologies of various cultures and his art school training. Conceptual art influenced tattooing further and opened up the minds of potential, art-minded clients to the possiblities of what could be inscribed on the body. Spider Webb combined tattooing and performance

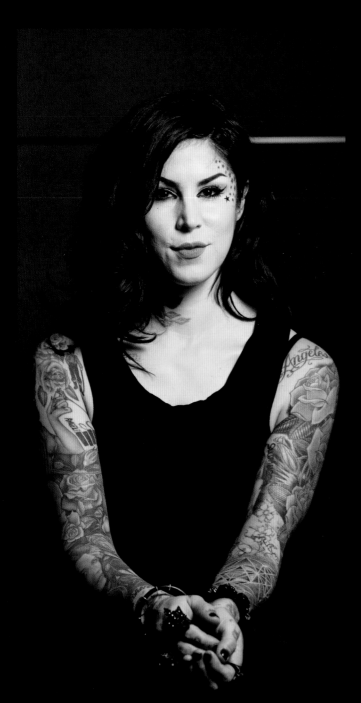

art, creating lively happenings in New York that further dissolved the boundaries between tattooing and the fine art world.

Not only did the tattoo renaissance introduce new visual inspiration, it also radically changed how and where tattoos were placed on the body. Whereas traditional American folk tattoos consisted of small pieces arranged into patchwork on the body, renaissance artists designed tattoos to cover large swathes of skin, to preserve ample areas of negative space or to highlight the curves of the body. In addition to a broadening of tattooing's aesthetic vocabulary, tattoo clients started to change in the 1960s and 1970s. The 1960s counterculture movement created activist-minded young adults who wanted to permanently memorialize their radical and transgressive nature via tattoos. Women, in particular, began to get tattooed in greater numbers, spurred on by artists such as Lyle Tuttle, who tattooed female celebrities and actively promoted the art form to new audiences via media appearances.

From Subculture to Mainstream

From the renaissance experiments, two new tattoo movements emerged that can be connected intimately to the US tattoo experience. Stark tribal blackwork began to be refined by artists, such as Los Angeles-based Leo Zulueta, who was inspired by an interest in non-Western tattooing from places such as Polynesia and Borneo, as well as historical Native American tattooing. This type of tattoo work took hold on the West Coast and was popularized by the book *Modern Primitives* published in 1988.

Black and grey tattooing, characterized by a 'single needle' aesthetic that started with hand-tattooing in Chicano barrios in California, Texas and nearby states, was refined through tattooing with improvised electric machines in prisons. By the mid-1970s, these delicate drawings, rendered in tiny lines and chiaroscuro, formed the basis for a codified genre. Several artists interested in this style – including some from the Chicano community and some from those who had tattooed in prison – began offering it in southern California, in particular Goodtime Charlie, Jack Rudy and Freddy Negrete. Women working in a variety of genres, among them Kate Hellenbrand, Jamie Summers, Vyvyn Lazonga and Suzanne Fauser, began to match the men in the business with the quality of their work.

As the possibilities for what you could get tattooed on your body expanded, so too did the clientele. Tattooing extended

to middle-class populations, college students and other groups that had not generally been tattooed before. From the late 1970s and through the 1980s, musicians embraced tattoos, especially those in the genres of heavy metal and punk. Motorcycle enthusiasts and bikers became particular adopters of heavy and visible tattooing, which added to the public perception in the late 20th century of tattoos as marks of a socially transgressive nature. Tattooing gained even more of a counterculture edge that appealed to youths wanting to rebel.

By the 1990s, the edgy, subcultural, countercultural allure of tattooing resulted in its co-option into high fashion and eventually onto the bodies of an even wider array of US and Canadian bodies. Tattooing became hip because of this boundary-pushing perception, especially among college students, and generic, small-scale versions of groundbreaking tattoo renaissance forms became common, such as tribal armbands and decorative lower back 'tramp stamps'. Sports stars, especially those in basketball, started getting extensively inked and brought even greater visibility and acceptance to the art form, even if some of the specific tattooed characters, such as 'bad boy' Dennis Rodman, continued to perpetuate an outlaw, anti-establishment spirit.

21st-Century Tattooing

Tattooing in the United States and Canada today astounds with its diversity of practitioners, clients and styles. The two countries boast thousands of tattoo shops, and with most shops employing multiple tattoo artists, the numbers of artists reach into the tens of thousands. Nearly one in four adult North Americans has a tattoo, and, in 2010, 38 per cent of eighteen to twenty-nine year olds had been inked. The rise of easily obtainable, inexpensive tattoo equipment has caused amateur tattooing to proliferate; this has sparked criticism from the whole industry and rekindled sanitation concerns that recall the problems of the 1960s, as well as aesthetic debates about what constitutes a quality tattoo.

In the 2000s, two new developments promoted tattooing to ever wider populations. Reality television realized that tattooing, with its edgy reputation and colourful cast of characters, could draw large audiences. Although ostensibly about shock value, shows such as *Miami Ink* and *LA Ink* instead communicated the message that tattooing was a viable means of personal expression and helped further broaden the demographics of who got tattooed (see image 15). Hip hop and urban street culture also

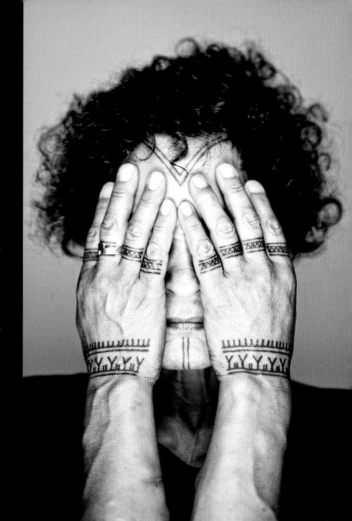

embraced tattooing, especially on highly visible parts of the body, such as necks, hands and even faces, and popularized tattooing among wider Hispanic and African American populations who had not previously been represented in the tattoo community as artists or clients.

As tattooing in the 21st century continues to grow, clients have an ever-increasing number of niche genres to choose from. The beginnings of a revitalization of indigenous Native American tattoos marks an exciting development in tattooing in the United States and Canada (see image 16). However, it remains to be seen whether tattooing's popularity in North America will continue to increase, plateau or be subject to the same ebbs and flows of popularity that marked the 20th century.

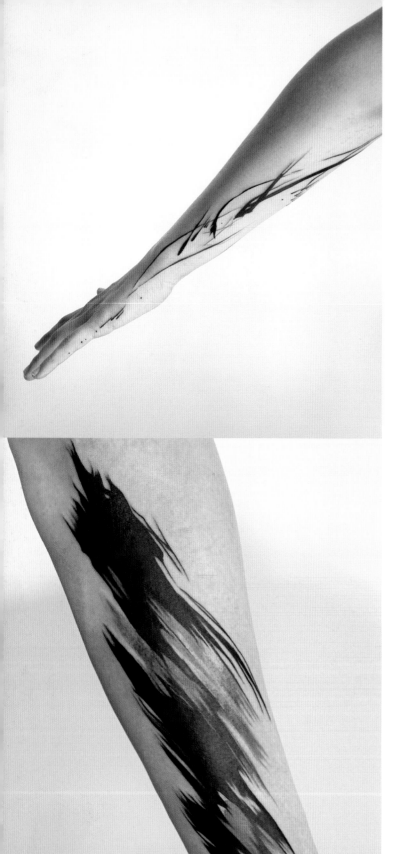

AMANDA WACHOB

Amanda Wachob loves to experiment. Her flowing tattoos – reminiscent of bold brushstrokes punctuated by paint-like splatters – situate Wachob among the industry's avant-garde. Despite the conceptual nature of her work, Wachob remains entranced by tattoo traditions. 'What isn't special about tattooing?', asks Wachob, rhetorically. 'I still feel so excited about it after doing it for over a decade. There's nothing like the smell of a tattoo shop.'

After finishing photography studies at SUNY Purchase, Westchester in 1998, New York-born Wachob began tattooing in the same way as many others do: inking an almost endless stream of $40 kanji. The tide changed when she worked two hours north of New York City, in the Hudson River Valley town of Kingston. An adventurous local English professor came in asking for an abstract design, and Wachob's now signature style took root. 'I feel there are so many untapped possibilities in

1 Monochromatic lines resembling calligraphy or brushstrokes 2 Painterly brushwork
3 Brushstroke gesture

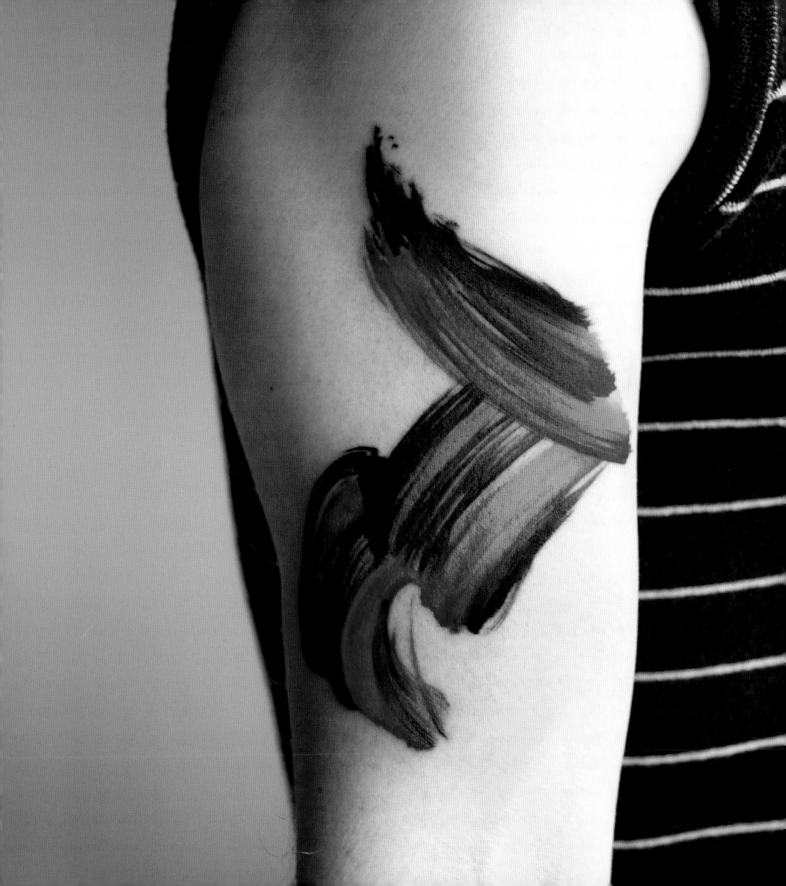

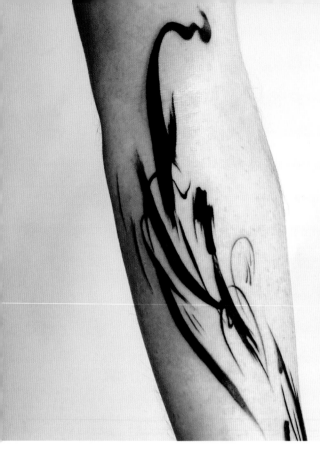
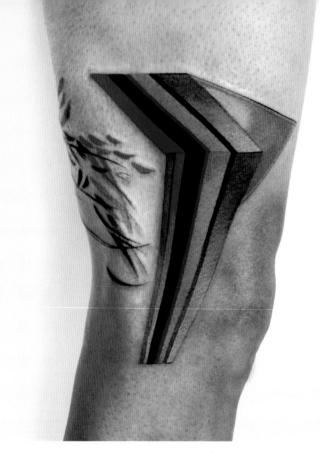

4 Monochromatic lines that mimic calligraphy or brushstrokes **5** Geometric prism-like design **6** Swirls simulating an ink spill **7** Bright colour blocks evoking mid-20th century abstraction

tattooing, I'm really excited to explore it as an art form and as a medium in ways that haven't been looked at before,' says Wachob, who splits time between a Brooklyn studio and a Manhattan shop. 'I'm excited about expanding the possibilities of the medium.'

Those possibilities have drawn the attention of tattoo enthusiasts and museum curators alike. Over the past few years, Wachob has been included in the Museum of Art and Design 'NYC Makers' exhibition, as well as group showings in Canada, Denmark and Switzerland. She has also taken residencies – three youth-driven art projects at the Metropolitan Museum in New York and a six-week stint at the New Museum on the Bowery. There, Wachob produced a series of works through data mapping the time of each individual tattoo in concert with the voltage of her machines. 'The idea was to take all the numbers out of the equipment from the tattoo and colour code it,' said Wachob. 'I wondered, essentially, if it was possible to turn the process into a visual representation.'

The technical elements of tattooing inspire Wachob's wider artistic approach and her desire to broaden the spectrum of tattooing influenced her decision to open a private studio. 'The studio is great because if I'm not tattooing a client, I'm tattooing a piece of leather or a piece of canvas. I started a series where I'm tattooing lemons,' she says. 'I have my light set up so I can take real photographs. I can open up the dialogue about the possibilities of tattooing.' As Wachob developed conceptual ideas about tattooing, the private studio made logistical sense but she still interacts with the trade's core. 'At Fun City, it's pranks and jokes and camaraderie,' Wachob says of her current shop, where she works one day a week. 'Everyone's pretty heavy into traditional stuff there. That's always fun to be around . . . I'm equal part highbrow and equal part lowbrow'. Although she operates mostly outside the industry, Wachob can be seen as continuing its technical traditions. She is pushing tattooing's artistic progression, while never forgetting her pure love of it. **NS**

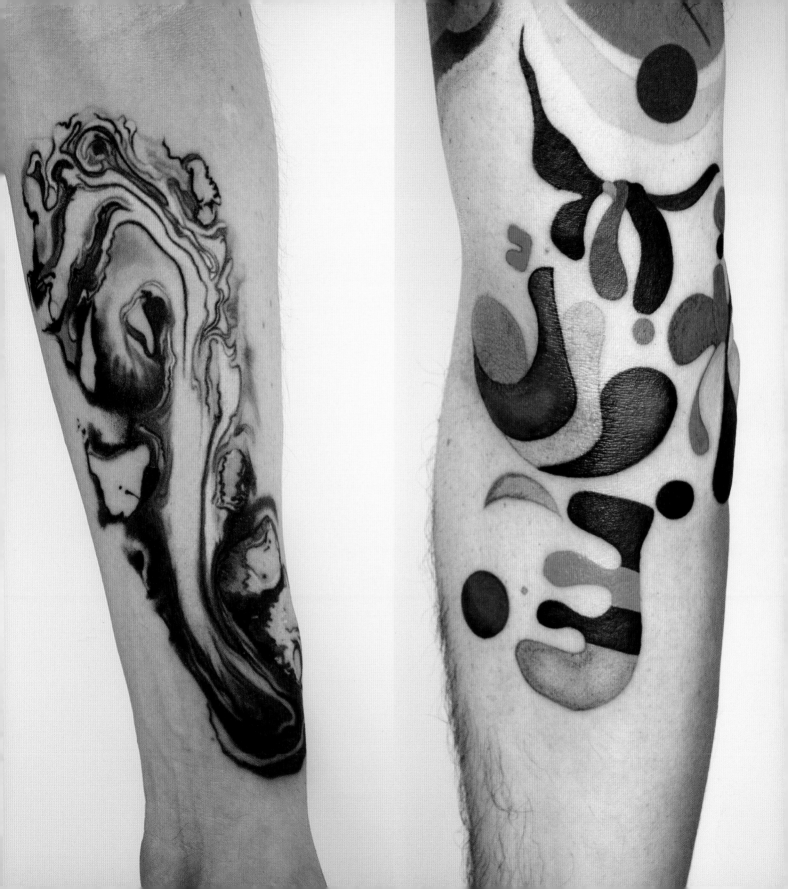

DUKE RILEY

Duke Riley's stark black representational tattooing conjures antique woodcuts or engravings, but with a quirky, folk art twist. His bold lines and use of geometric patterns to create texture and shading form striking graphic images that appear to jump off the skin. Iconographically, he works with classic images from the Euro-American folk tattoo tradition, as well as elements taken from old maps, martime art and natural history prints.

The art school-trained Riley belongs to a growing subset of tattooers for whom crafting skin inscriptions is only one of many forms of making art. After experimenting with hand-poked tattoos and home-made machines as a teenager, he began formally tattooing in 1993 in Providence, Rhode Island. In 2001 he opened Brooklyn's East River Tattoo, where he gathered artists working in similar styles and with equivalently eclectic interests, such as taxidermy, rare books and other esoterica.

Riley regularly revisits his nautical roots growing up on the New England coast. His non-tattooing activities – ranging from performance art and sculpture to printmaking – evoke his passion for the maritime world. He explains: 'At some point during the late 1990s, after tattooing for several years, I started trying to reach beyond the aesthetic influences of my traditional tattoo artist predecessors and began to look more at things that were of influence to them, such as early maritime folk art, scrimshaw and 19th-century engravings. This fell more in line with my own fine art practice and now I find the two inform each other.'

His passion for the sea shows in the ship motifs that are central to his tattoos; animals and elements from nature also predominate. Riley is philosophical about tattooing: 'I'm interested in the dichotomy of tattooing. It is both revered and feared for its perceived permanence. It is an eternal and decisive action on the part of the recipient. Yet in the context of history and art, it is extremely fleeting, something that dies with its mortal canvas.' AFF

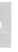

1 Badger and fox fighting 2 Lighthouse island carried away by birds 3 Vignette with octopus at sea 4 Flying bird

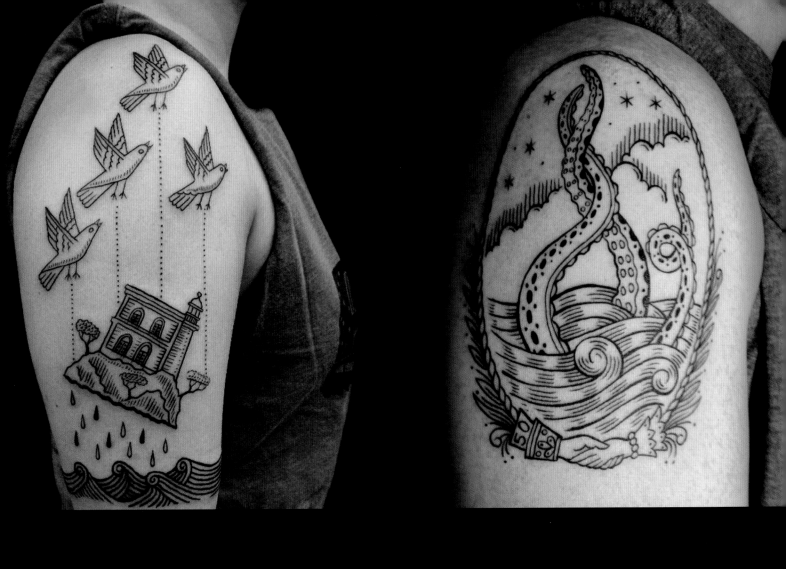

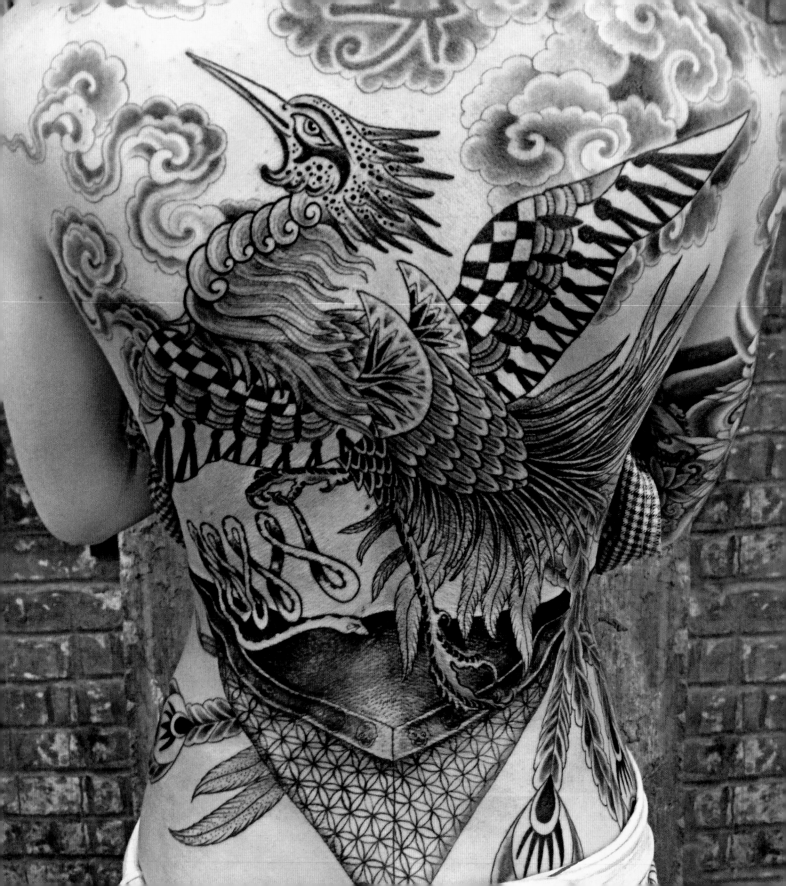

STYLE CONTEMPORARY **INFLUENCES** NON-WESTERN CULTURES, GRAPHIC DESIGN, ILLUSTRATION, FOLK ART **LOCATION** NEW YORK, USA

STEPHANIE TAMEZ

Born in San Antonio, Texas, Stephanie Tamez started tattooing at the age of thirty. A childhood friend introduced her to Filip Leu during a trip to Europe. Leu inked her first tattoo and invited Tamez to join the Amsterdam Tattoo Convention. The experience solidified her interest in tattooing and opened up a world of potential in what she describes as 'the greatest art school I could have ever gone to'. Tamez had recently moved to San Francisco, leaving her birth state and a previous career in graphic design behind. There, Leu linked her with locals Bill and Junii Salmon, who provided a technical basis for Tamez's new occupation.

Tamez plunged head first into tattooing, but her design sensibilities remained strong. After apprenticing at the Salmons' Diamond Club, Tamez initially built her reputation on an uncanny ability to reproduce traditional font types. Drawing inspiration from a broad range of material, Tamez's tattooing relies on a deft balance of risk and reward – pushing the

1 Egyptian-inspired phoenix rising from a Tibetan-patterned pedestal 2 Phoenix sleeve blending Japanese and contemporary illustration-like aesthetics

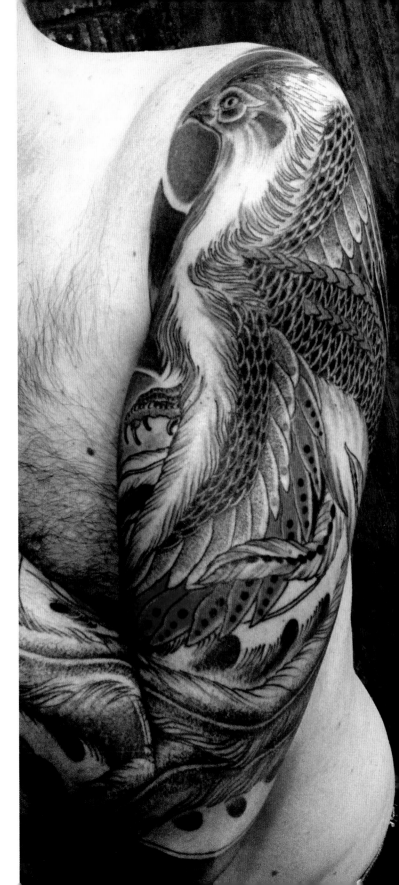

conventional arrangements of tried and true tattoo tropes. 'My sources and interests aren't always from tattooing. I don't gravitate to those typical poses. I try and find another little weird thing that hasn't been done before,' says Tamez. 'I get bored very easily. There are so many tattooers out there doing perfect clean work, it is all cool and all wonderful. I'm looking to do something my way. It is just my aesthetic.'

After ten years in San Francisco, Tamez moved to New York, working first at the esteemed New York Adorned before moving, in 2012, to Scott Campbell's Brooklyn-based Saved. In Kings County, her work has evolved. 'I've mostly eliminated text,' she explains. 'I'm mostly doing big things, like back pieces.' Tamez's creative energy hits full force when she can 'meld different cultures and styles as a jumping-off point'. An Egyptian-inspired phoenix back piece exhibits her capacity to blend. The tattoo fuses elements of Tibetan design (achieved in the detailing of the pedestal) – tying into a pre-existing

sleeve by Yoni Zilber – with the client's desire for a Bennu (ancient Egyptian deity linked with the sun and creation). Tamez's composition realizes something familiar, true to her own 'weird' style. In some pieces, her approach employs striking contrast in background and line weight, while in others she fills chest pieces with soft shading. The glory of her work stems from its diversity, each tattoo starting with a standard and progressing to an imaginative, original idea.

Despite her boundary pushing, Tamez remains reverential to the rules of tattooing. As well as blending styles in her work, Tamez has found a way to bring the design and tattoo worlds together: she teaches a foundation course at New York's School of Visual Arts. 'There are no machines,' she states. 'It is about the compositions of tattoos. Most think of the class as a design challenge.' The explanation of her college class describes Tamez's tattoo philosophy: 'Let yourself go within the structural rules, if you stay true it will show.' Self-expression, too, follows suit. NS

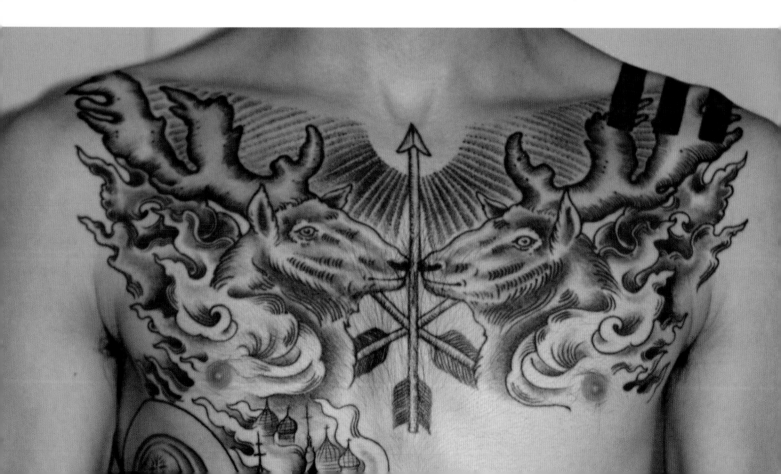

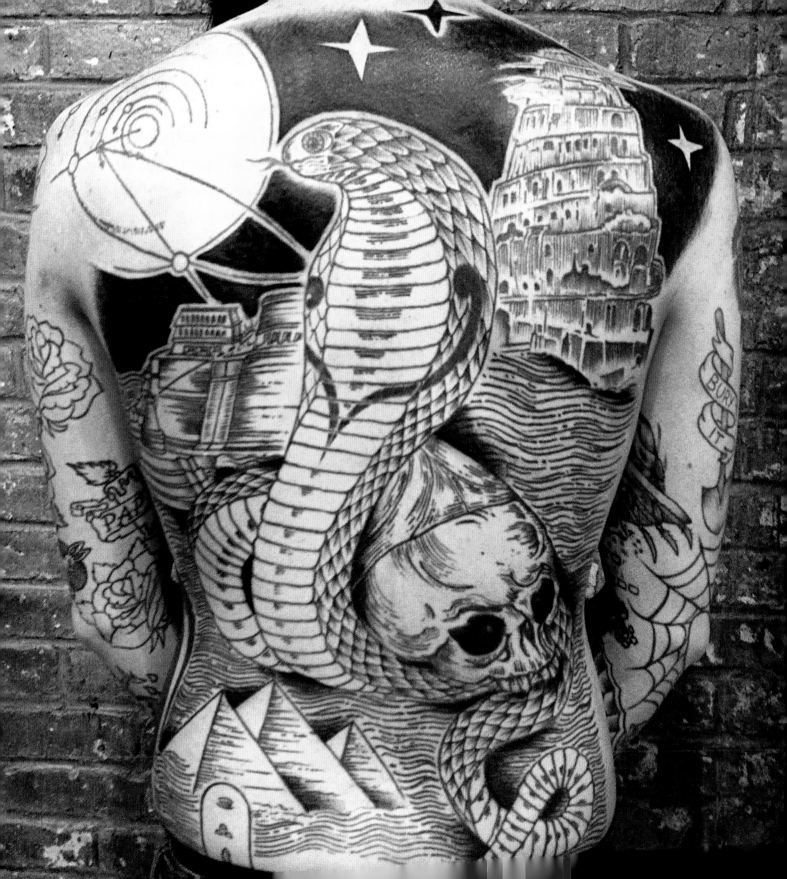

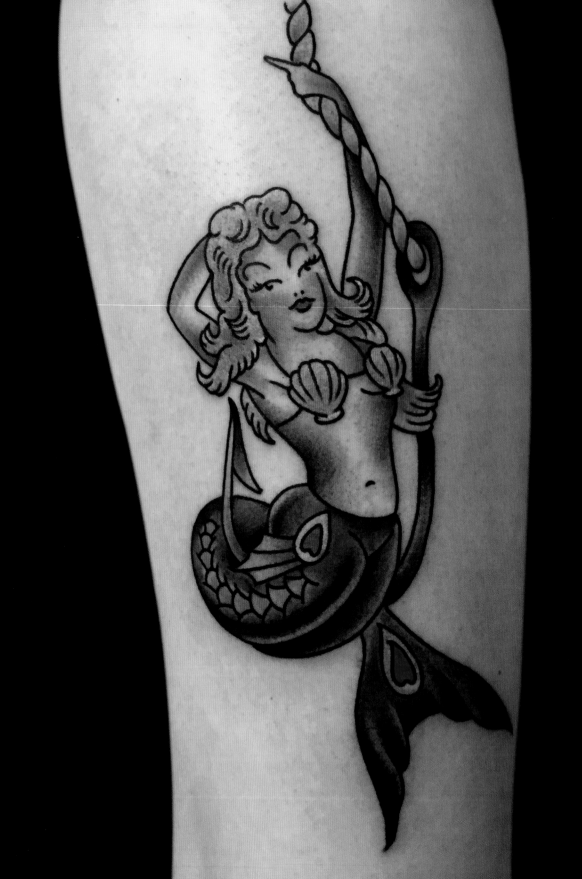

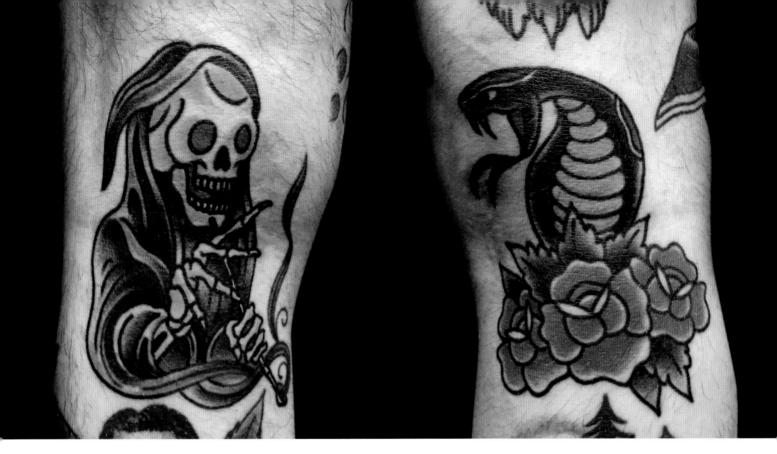

STYLE OLD SCHOOL **INFLUENCES** CHICAGO HISTORY,
TRADITIONAL AMERICAN TATTOOING **LOCATION**
CHICAGO, ILLINOIS, USA

NICK COLELLA

Nick Colella channels the ghosts of tattooing's past, particularly those from Chicago's history. This partly stems from the tattooing he was exposed to early in his career at Chicago's oldest tattoo shop, where 'they had forty sheets of Cliff Raven flash on the wall . . . people came in and picked images off those sheets. That originally piqued my interest in the older-looking stuff.' This experience not only gave Colella a deep appreciation of the old school aesthetic, but cemented a personal connection to the history of tattooing that most artists working in the genre today lack.

Born and raised in Chicago, Colella was drawn to tattooing as a teenager when he saw it on the skins of the punk musicians he admired and wanted to share in that rebellion; he drily notes: 'I wanted to be tough, I didn't want people to talk to me, I wanted to be left alone. Obviously that has completely backfired today.' In 1994 Colella found an informal mentor in Wayne Borucki at Chicago Tattoo, who showed him the

1 Mermaid dangling from fish hook 2 Grim reaper
3 Cobra emerging from roses

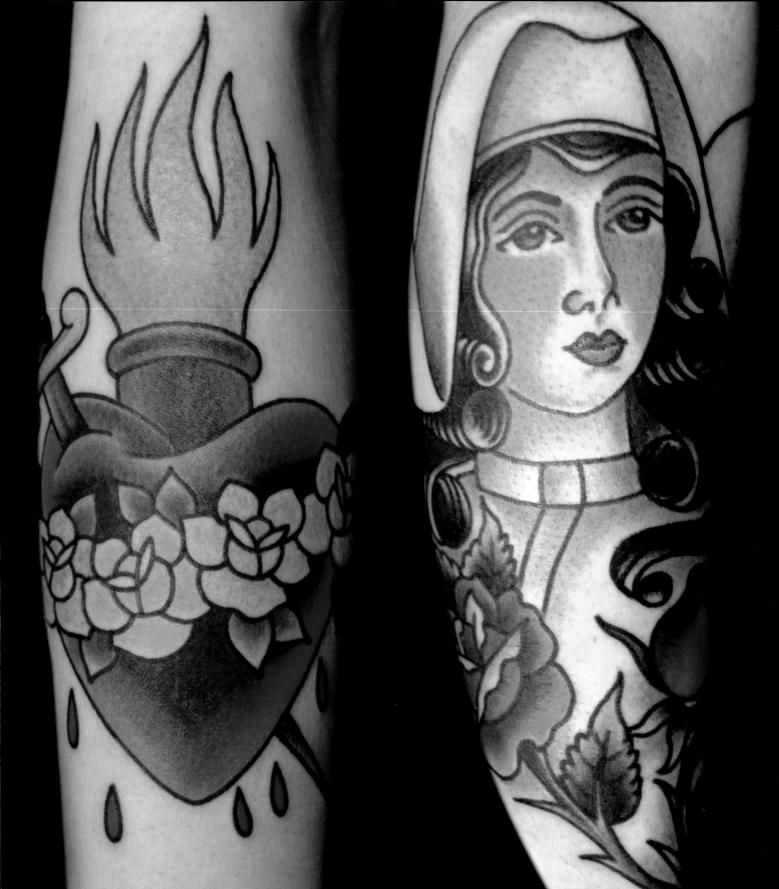

4 Sacred heart with flowers instead of thorns
5 Rose of No Man's Land 6 Flying eagle

rudiments of the tattoo business such as making needles and generally 'how a tattoo shop works'. Colella remained at Chicago Tattoo for nearly two decades, honing his skills, before branching out with his own shop in 2013, Great Lakes Tattoo, that he owns with his wife Sarah. The artists he brought on to work in the shop, some of whom he had worked with for fifteen years, 'all had the same idea of what we wanted in a tattoo shop and how to present it to people'.

With respect to Great Lakes, Colella saw a gap in the tattoo scene in his city: 'Chicago needed a tattooing institution that it didn't have at the time, it needed a place where the history of tattooing in Chicago was displayed and openly embraced.' In contrast to many of his peers who started tattooing in the mid-1990s, Colella never tired of the street shop format, enjoying the mix of customers that trickle through the door. When he opened Great Lakes, he preserved this tradition and walk-ins are always welcome. The shop also serves as a hub for

tattoo history – many of its walls are lined with historic artefacts and a gallery space on the lower level hosts special exhibitions. When asked to describe his most prized tattoo artefact, two came to mind: a Tatts Thomas personal machine used in the late 1940s and Cliff Raven's late 1960s travel photo album of the West Coast and Hawaii, where he visited artists such as Sailor Jerry, Ed Hardy, Zeke Owen and Don Nolan.

Colella is renowned for his traditional American designs that feature bold line work, blocks of vivid colour and heavy shading. Yet he humbly asserts that he is 'a regular journeyman tattooer' who inscribes designs on a wide range of clients, 'from the hip tattoo collector to the guy who cleaned my gutters yesterday – the whole gamut'. When asked to describe his tattoo philosophy, Colella replies: 'Everybody deserves a good tattoo, I'm just there to provide that service for them. I'm not there to stroke my own ego – I try to do right by customers and my peers and the guys who came before me.' AFF

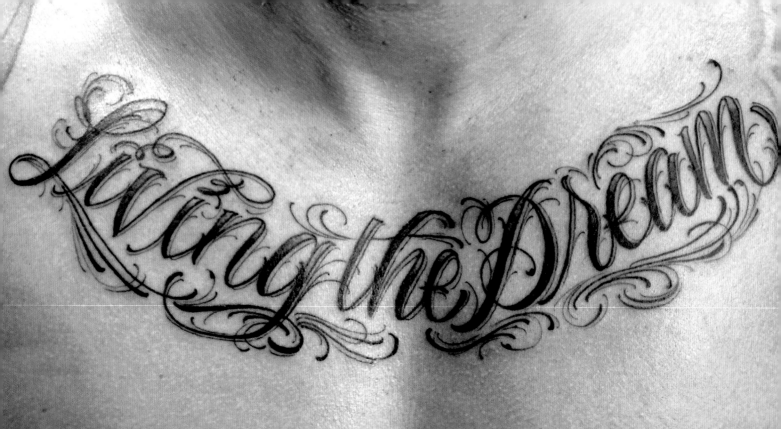

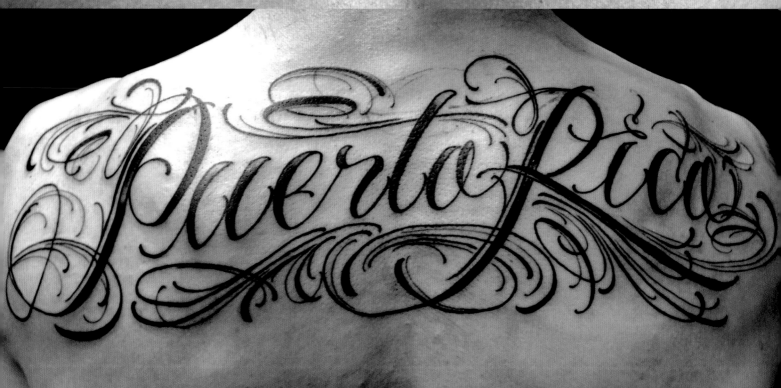

BJ BETTS

Lettering, in some form, has been a common component of
Western tattooing for centuries. BJ Betts, a Delaware-based
tattooer, has dedicated his career to exploring the potential
of text-based designs. Through his tattooing and the publication
of industry standard guidebooks first produced in 2004, the
pioneering Betts has propelled a small compositional element
into its own certified tattoo niche.

Betts' interest in fonts started in high school, where he
became fascinated by typography. His classmate, Andy Cruz,
who later established the renowned House Industries typeface
foundry, allowed Betts the opportunity to incorporate its
theoretical underpinnings into his tattooing. 'The starting point
for me is drawing a rough sketch on the skin – considering the
arch and curve of the body – with a Sharpie and building layers
until I'm happy with the direction,' Betts explains, describing his
process. 'If I'm happy, I can start tattooing on the skin. Otherwise,
I'll make a tracing of the area and tighten it up for a stencil. For
those that are more ornate, I like to take a little more time and
go the stencil method.'

In tattooing the word 'locals' across a client's shoulders,
for example, Betts chose a bold, shadowed font that accentuates
the powerful force of the sentiment. By contrast, he employs
a softer script for a collar piece that reads 'living the dream'.
Tone and intent define Betts' text tattoos as he visualizes
words through their shape and letter weight. 'I generally
make the word with the font. If someone wants, say, his or
her surname, depending on the name you want something
stronger,' Betts says. 'You have to think about the feeling
behind the words.'

Betts has influenced not only his immediate peers. His
approach transcends the tattoo world and has inspired a
generation of graphic designers to re-evaluate the power
of hand-drawn lettering. NS

1 'Living the Dream' 2 'Puerto Rico' 3 'Willis'
4 'Respect' 5 'Locals'

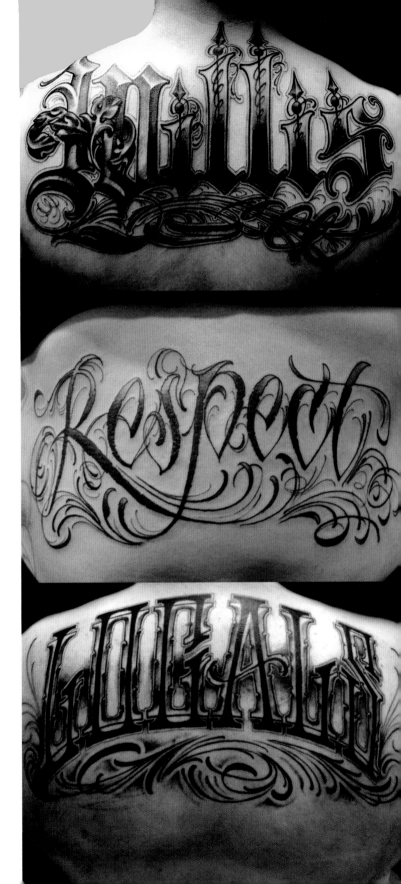

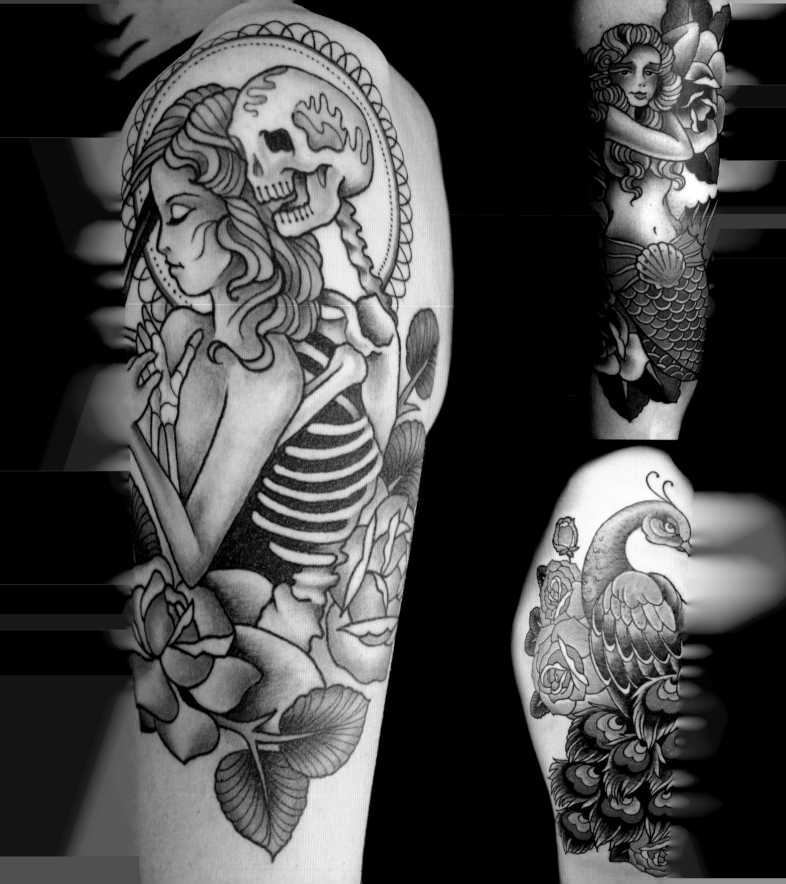

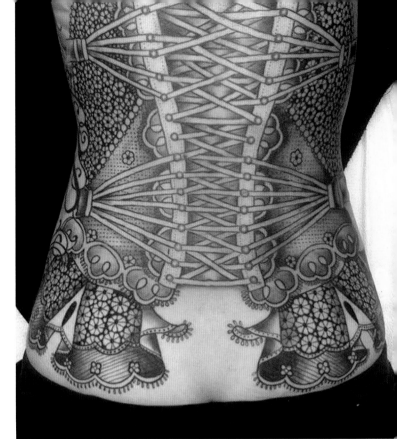

DANA MELISSA DIXON

Dana Melissa Dixon's love for old school American tattoos is rooted in her appreciation of the simplicity and clarity of traditional designs, as well as the style's significance in the history of tattooing in the United States. Dixon and her husband, Aaron Dor Dixon, co-own the Old World Tattoo Parlour on the Oregon Coast Highway, although they lived and worked previously in Texas, Florida and Montana.

Dixon's interest in tattooing orginated in her participation in body modification rituals in the Pacific Northwest during the 1990s. She explains: '[I] spent years exploring different mediums before I found which ones work best for me and my skill set.' She finally fell in love with the artistic expressiveness of tattooing, as well as its ritual and performance aspects. Her neo-traditional work is inspired by early American tattooists, including Jerry Collins, Paul Rogers, Amund Dietzel and Bert Grimm, and she says: 'I have a sense of duty to keep their work alive.'

When working on a design for a client, she first spends time researching references before starting to draw; she then likes to 'study it on paper multiple times to help with composition'. This intensive process has helped her to infuse her personal style into classic American tattoo imagery; she also works in blackwork and lace, as well as designs with Japanese and Pacific Northwest influences. Dixon's careful preparation is evident in the sharpness, simplicity and limited colour palette of her old school tattoos. Her lacework designs reflect a vintage influence, with combinations of delicate scrolling lines and finely crafted geometric shapes incorporated into corsets, lace cuffs or even Dixon's own tattooed lace-up boots. Dixon's work combines a strong respect for tattoo work of the past together with her own thoughtful sensibility. AKO

1 Woman embraced by death 2 Red-haired mermaid
3 Peacock with roses 4 Corset design with delicate
lacework 5 Americana-inspired back piece rendered
in black only

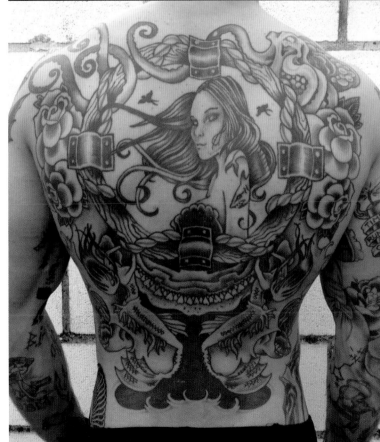

1 Portrait of a woman in the armed services
2 American flag in black and grey 3 Dynamic elk in the
woods 4 Psychedelic face and skull 5 Van Gogh's *Starry
Night* interpreted via tattoo

MEGAN HOOGLAND

Megan Hoogland has mastered two styles that are not usually
seen together in a portfolio: black and grey realism and
contemporary colour work. Her use of black and intricate shading
techniques achieves a hyperrealism and photograph-like quality,
whereas her black outlines, bright colours, elaborate blending
and shading gradations create cartoonish, illustrated fantasy
pieces. She has taken the few commonalities shared by these
divergent styles – mainly using black and delicate shading for

effect and depth – and made them synergetic. She says: 'It's all
about contrast and proportions, the dark and the light. I never
tattoo without black any more.' Her new school tattoos have
a powerful three-dimensional element and her use of black ink
helps to increase longevity. Conversely, her black and grey
designs have expanded in subject matter to include the unreal,
such as an elk with massive, biomechanical-like antlers.

A master at both portraits and Elvgren-style pin-up girls,
Hoogland adds her own twist to both subgenres: 'I've managed
to find what I consider my style in black and grey realism. Before
tattooing I never considered myself a true artist because I could
only duplicate images, but now it's what I specialize in through
tattooing. It's still a creative process, it's just different to illustrating.'
With twenty years of experience, Hoogland is one of the top
US female tattoo artists. On preferences for pieces, she says:
'I want to [do] even more large-scale pieces, for the simple reason
that larger looks better and flows with the body better.' KBJ

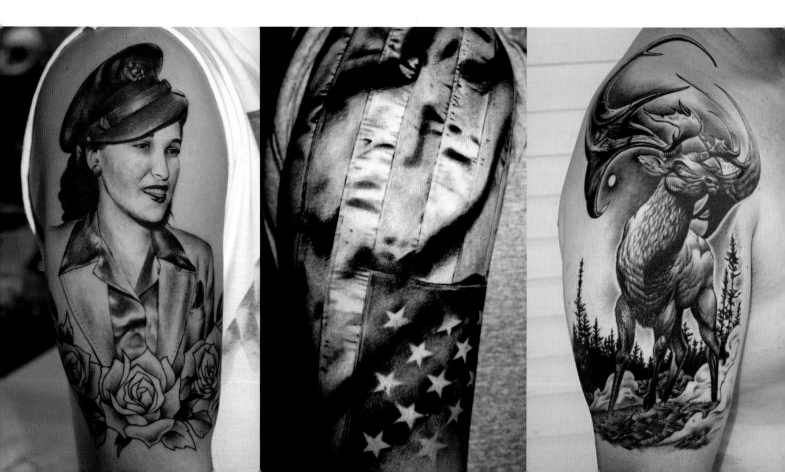

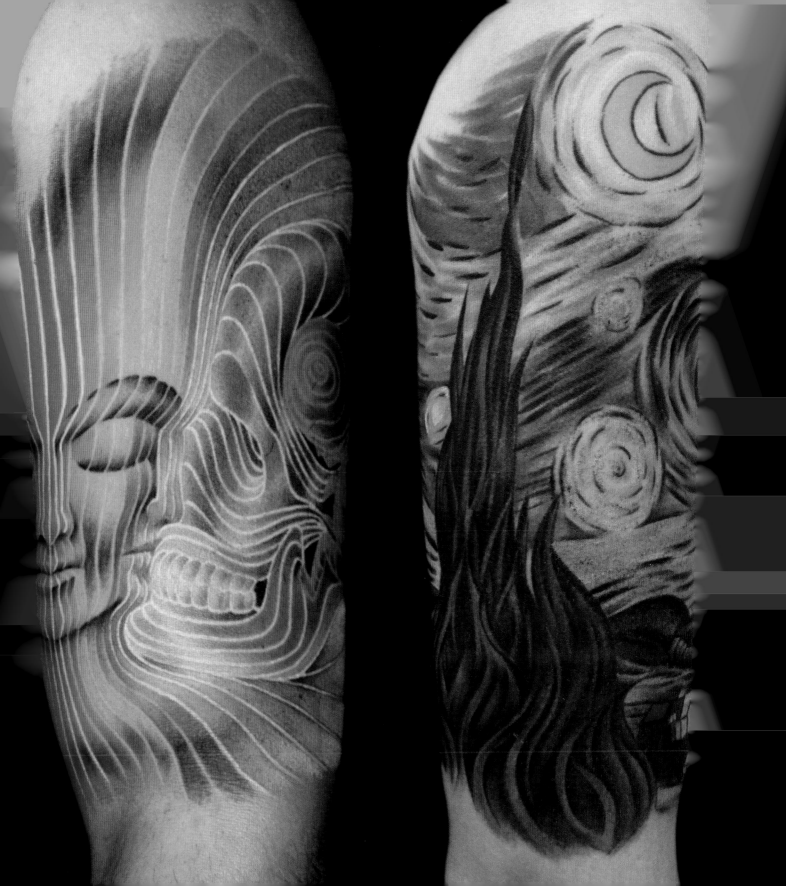

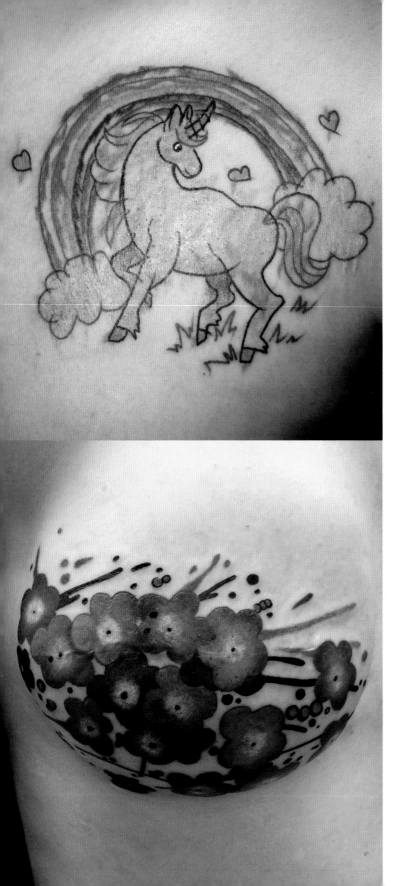

STYLE CONTEMPORARY INFLUENCES NATURE, FLOWERS, CHILDREN'S BOOK ILLUSTRATIONS LOCATION FESTUS, MISSOURI, USA

JESSICA WEICHERS

Jessica Weichers renders richly colourful work that expresses femininity with a sense of playfulness. Like many of the female artists who began to change the gender balance in contemporary tattooing, she faced typical hurdles and notes: 'no one would put a machine in my hand because I was a woman'. She began tattooing in 2004 after a short apprenticeship in St Louis and informally learned from the artists who tattooed her own body; she cites Kelly Gormley as a particular influence. In 2014 Weichers opened her own shop, Seed of Life, in Festus. She says that after a decade in the business 'I enjoy the feeling of a small town these days . . . the forest, my gardens, the quiet lifestyle are much more conducive to the stressful life a tattooer can have.'

Besides strong floral work, Weichers has a talent for quirky drawings, which blend an art brut aesthetic with a style that is reminiscent of children's book illustrations. 'Why do you need to get a tattoo [with] deep meaning? That was always a question that was going around in my mind. So for fun I decided to do child-like drawings for a convention . . . I called them "whims" because people seem to get them on a whim, and they also had a whimsical feeling about them.' Of her floral work, she says: 'I fully embrace it because it's a style that a lot of male artists cannot pick up . . . just like there are many styles I cannot pick up.' Her joy in being a tattooer shines through in her designs: 'The tattoos I have received over the years have helped make me more comfortable with myself . . . I just want to be able to give that feeling back to my clients because I know how happy it makes me feel.' **AFF**

1 Unicorn and rainbow 'whim' tattoo 2 Floral mastectomy scar cover-up tattoo 3 Flowers reminiscent of textile patterns 4 Pocket watch with stylized flowers

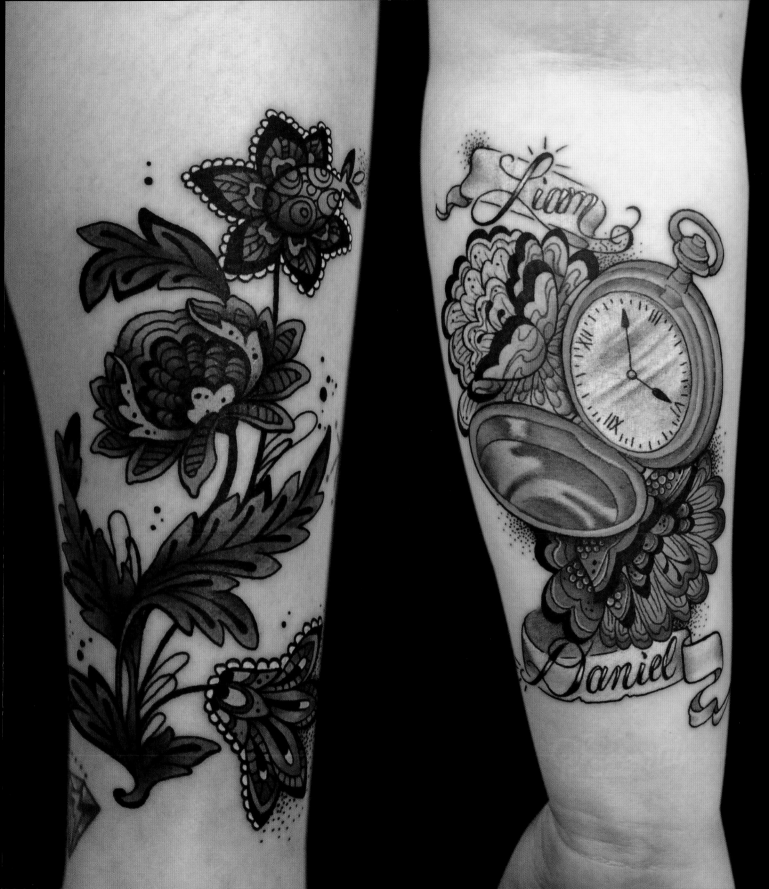

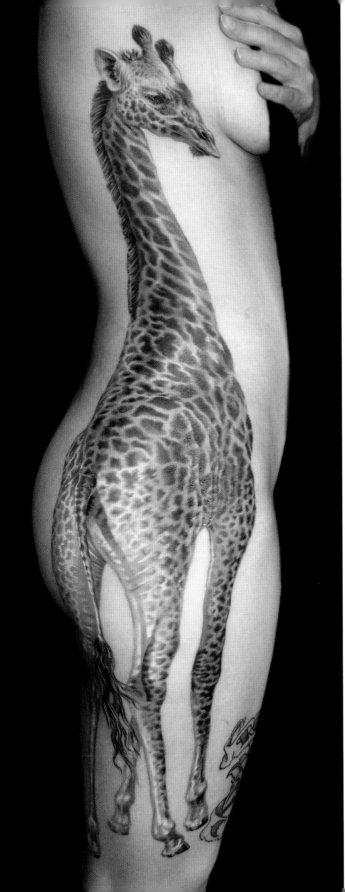

JAMES KERN

James Kern's unique brand of realism creates otherworldly compositions that hum with vibrant colour and transform skin into rich canvases that impress with their attention to detail and complexity. Born in St Louis, Kern went to several art schools in the early 1990s and finally settled in Chicago, where he learned to tattoo on his own. He worked for several years as the resident tattooer in a hair salon in the days when only a handful of shops operated in the city. Guy Aitchison's pioneering work inspired Kern in his early years and motivated him 'to think about how art fits on the body and that tattoos didn't have to look "traditional". Kern settled into the business, taking over an existing shop, No Hope No Fear, in 1999 with his twin brother and fellow tattooer Tim, and found his niche in realism. In 2004 he relocated to Portland.

Kern has specialized in cover work. He wrote a book on the subject and gives seminars at tattoo conventions. Kern relishes

1 Burning city at the end of the world 2 Giraffe

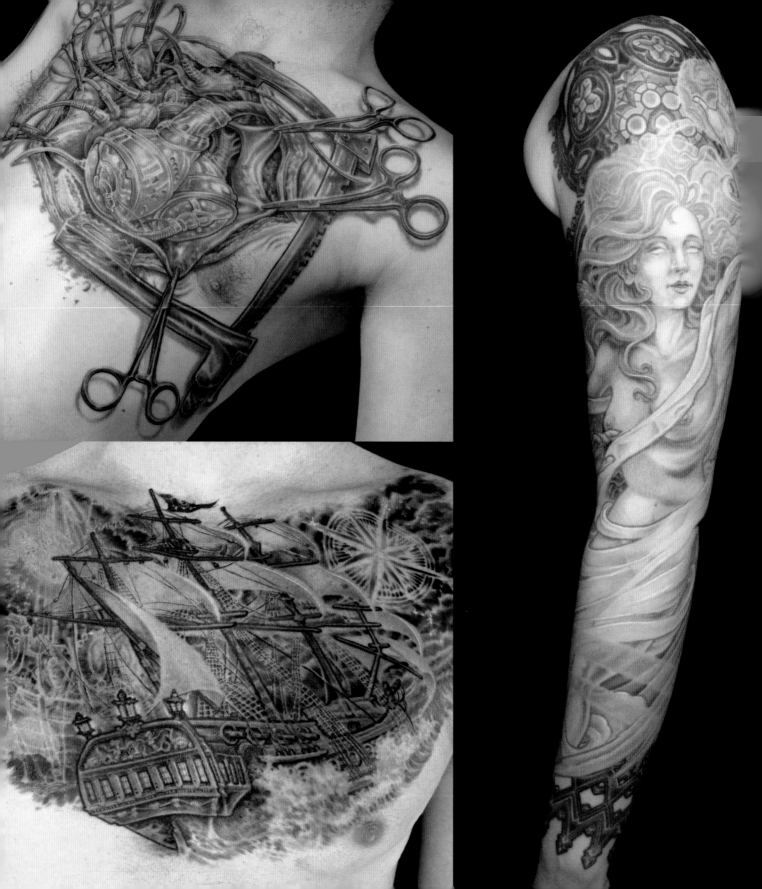

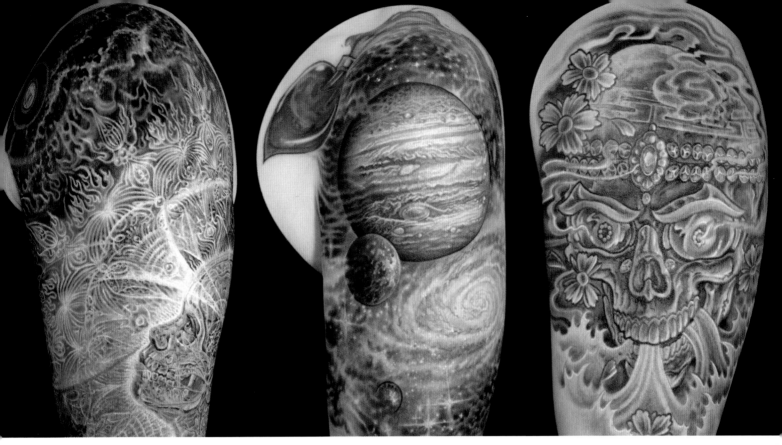

3 Open-(biomechanical) heart surgery
4 Ship sailing at dusk 5 Elegant nude
6 Rendition of Alex Grey's *Wonder*
7 Planets and galaxies 8 Bejewelled skull

the challenge, but also appreciates the psychological side of morphing something problematic into something glorious. 'You will never have a happier client than someone who no longer has a tattoo that they hate. It destroys their self-esteem. I love the transformation physically and spiritually.'

Compared to most artists who work in realism, the motifs Kern tattoos often diverge from the usual mix of portraits, biomechanical imagery, animals and flowers (although he certainly does those, too) to quirkier subject matter or elements seemingly taken out of old master paintings but updated to contemporary times. He does not simply duplicate existing images but instead creates signature artworks: 'I like the realistic style – but not necessarily doing a realistic image. I want to fool the eye – but not copy a photo.' Kern's interest in psychedelic and visionary art by people such as Alex Grey comes through overtly in some of his works and more subtly in others, particularly with respect to his colour palette.

Beyond a successful career, tattooing surprised Kern with a welcome addition to his life. While working on an elaborate back piece for a female client, he fell in love and they recently got married. His thoughts on that particular backpiece – a depiction of a burning city at the end of the world – reveal much about Kern's tattoo philosophy of always trying to achieve the best possible tattoo while constantly striving for ever greater artistic heights. 'The piece was challenging in the amount of detail required and really pushed me to refine my technique. It has to have a lot of detail to look like a city and not a model. So I had to up my game.' Ultimately, Kern balances his clients' desires with his own signature style, recognizing the obligation inherent in being a tattoo artist: 'I don't try to push anyone in a direction that isn't what they want – but I like the creative freedom to express their ideas. I feel that it's crucial to do the absolute best you can, because there's a huge responsibility in marking someone for life.' AFF

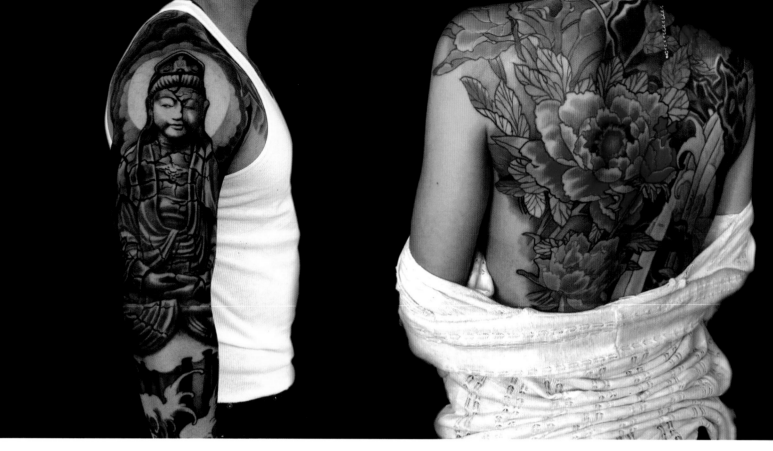

STYLE REALISM, JAPANESE, BLACK AND GREY
INFLUENCES JAPANESE ART, PHOTOGRAPHY,
WATERCOLOURS **LOCATION** CINCINNATI, OHIO, USA

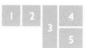

1 Serene buddha 2 Japanese peonies with waterfall
3 Tiger amid waves and waterfalls 4 Ancient sculpture
showered in rose petals 5 Skeletons in moonlight

KORE FLATMO

Kore Flatmo sees tattooing as folk art: always decorative, at times utilitarian, but never purely aesthetic or to be sold as fine art for profit. He says: 'No matter how refined the finished tattoo looks to me, at the end of the day it is still folk art. The artwork born of the physical and aesthetic rules of tattooing, that is to say large and simple, with strength and hopefully elegance, is my goal.' For Flatmo tattooing represents the art of a culture and the modern sense of tribe. On the future of tattoo art, he adds: 'I see an emphasis moving to promotion and celebrity (tattoos meant to be seen by the masses), rather than the personal and the private (tattoos meant primarily for the individual's experience).'

With three decades of tattoo experience behind him, Flatmo's portfolio demonstrates this with an impressive mastery of black and grey realism and neo-Japanese tattoos. In his spare time, Flatmo works on watercolour painting, charcoal drawing and custom etching work, and he translates the skills and techniques necessary for these mediums across to his tattoo work.

His portrait tattoos have an elegant, sophisticated level of shading and a great sense of depth; the faces look three-dimensional but, most importantly, the character of the person comes through. This renders the photographic quality emotive as much as realistic. His bright and colourful neo-Japanese pieces feature elements such as big bold flowers, fierce exotic tigers or koi dragons. All have touchable textures and shading so gradual they look painted rather than tattooed. His black and grey tattoos, featuring skeletons, tall ships and gods, have a luxurious smoky shading and great use of black for depth that makes them appear like charcoal illustrations on the flesh. **KBJ**

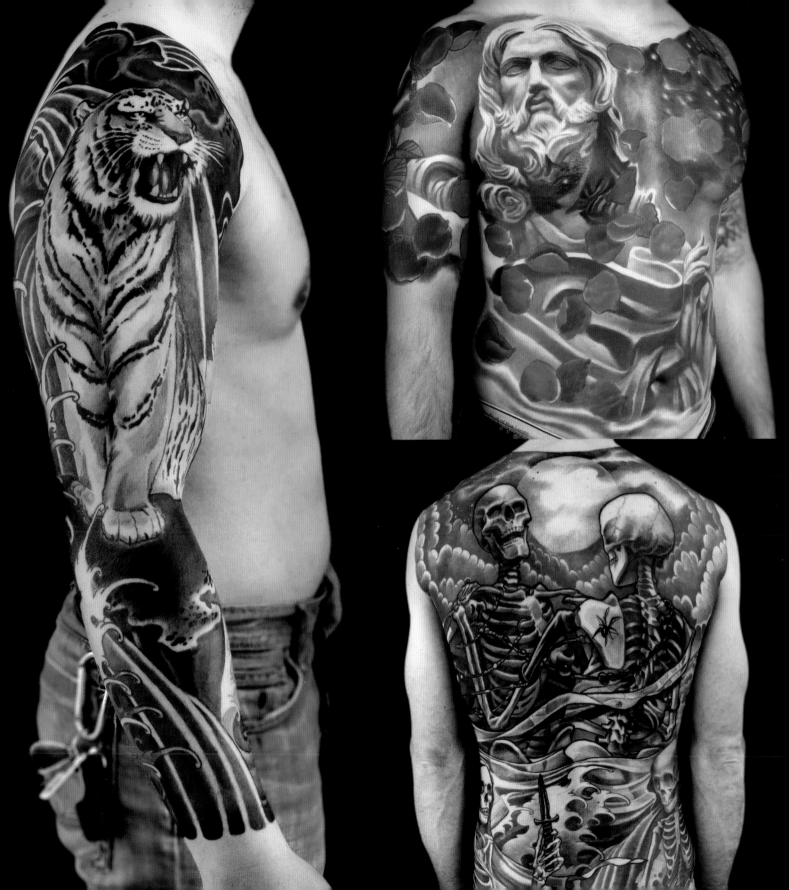

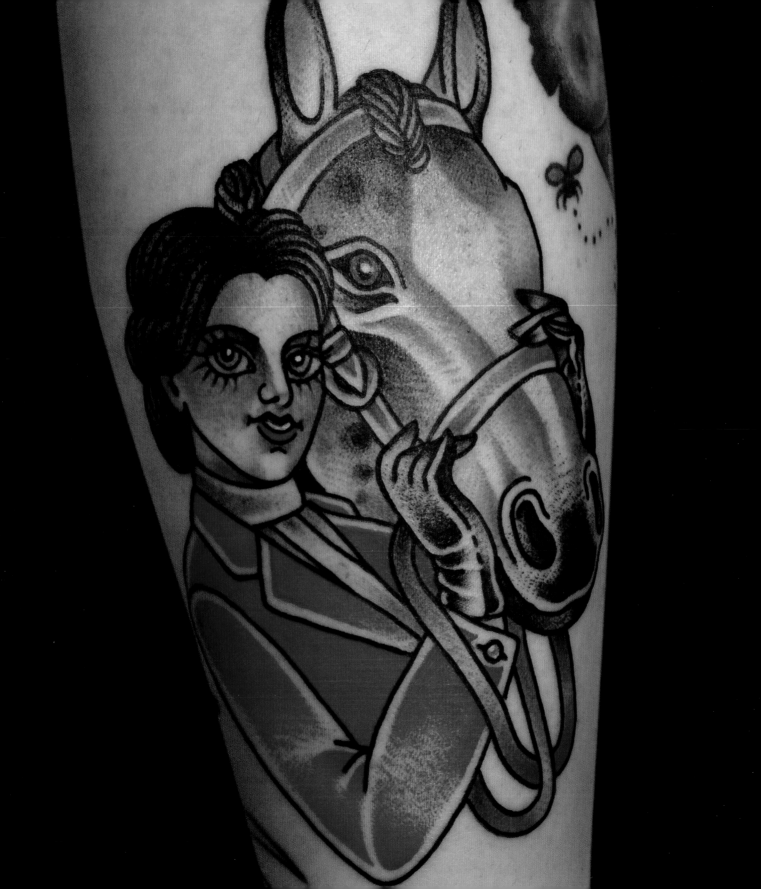

STYLE OLD SCHOOL **INFLUENCES** ANTIQUES,
PRE-WORLD WAR II TATTOO FLASH
LOCATION RICHMOND, VIRGINIA, USA

1 Equestrienne with stallion 2 Mysterious woman with
jewelry and tiger-head hat 3 Pin-up girl in Japanese
bondage 4 Friendly witch with cat

MARINA INOUE

Marina Inoue grew up in New York City's punk and hardcore
scene, which exposed her to many tattoos, and she knew early
on that she 'wanted to get a lot of them'. Having achieved that,
she now covers others in old school and traditional American
tattoos. Inoue's work closely mirrors an old school flash style,
with a limited colour palette, strong outlines and flattened shapes.
Yet her delicate, intricately drawn images deviate somewhat from
this traditional aesthetic. She grew up surrounded by her mother's
antique collection and notes that, 'Americana has always been
something that I find aesthetically pleasing'. Despite her connection
to old school flash, she draws from a variety of non-tattoo vintage
images that allow her to 'get a more unique design'. Her tattoos
often pay homage to pre-World War II, old school imagery –
daggers, animals and electric-infused lettering. To this style, Inoue
adds modern details – women with soulful eyes and elaborate
swirling hair, accented with hats, flowers and feathers. Inoue
launched her career at Flyrite Tattoo in Brooklyn, where she
apprenticed with Elio Espana, who she credits as a major influence:
'Without Elio and those guys [at Flyrite], I wouldn't be anywhere
close to where I am now. I spent a lot of time at the shop drawing,
painting, cleaning, doing whatever the tattooers needed me to
do.' Inoue's climb from shop girl to artist has not dimmed her
appreciation for the traditional path she took. She relies heavily
on the influences of her tattoo elders and stresses the need for
artists to earn their craft through hard work and humility. AKO

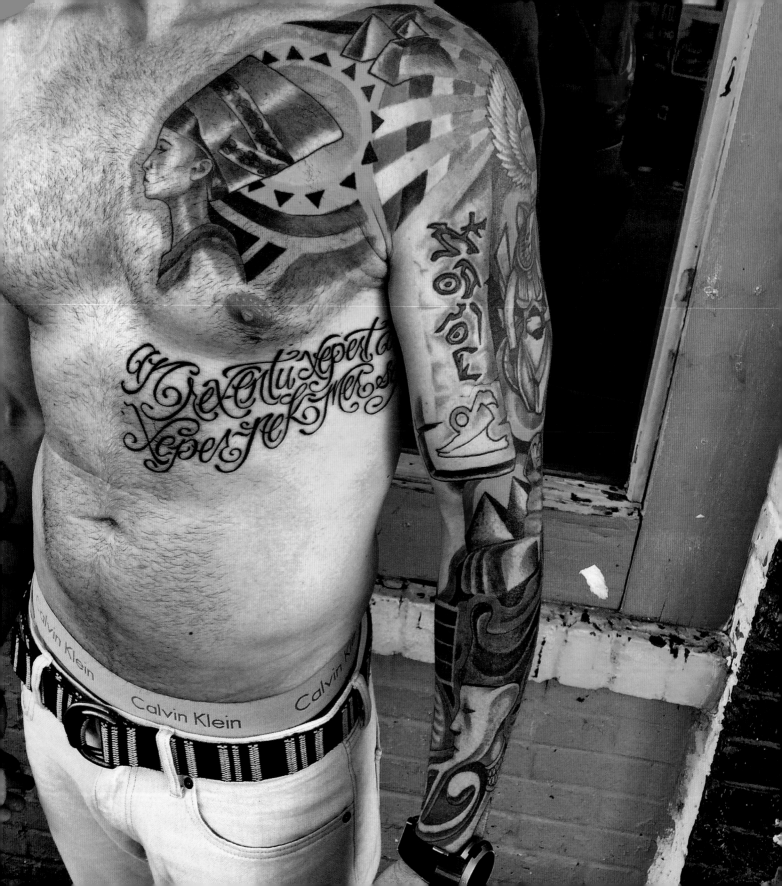

STYLE CONTEMPORARY **INFLUENCES** COMIC BOOKS, CUBISM, POPULAR CULTURE, JAPANESE ART
LOCATION ATLANTA, GEORGIA, USA

1 Egyptian-themed chest piece and sleeve
2 Homie the Clown portrait 3 Floral composition

MIYA BAILEY

During the past two decades, Atlanta-based Miya Bailey has pursued his tattoo work with a singular mission – to challenge preconceptions of urban art and elevate the stature of African Americans working in the industry. His style blends elements of graffiti, fine art and classic psychedelic themes through colourful graphic pops interspersed with flowing negative spaces. Bailey's style is continually evolving; he has carved a firm niche for himself and ushered in a distinct tattoo typology through his tattoo shop franchise, City of Ink. 'The term "urban" typically means Hispanic, Latino or black. It remains a base descriptor for people of colour, which I don't like,' explains Bailey. 'A lot of hipsters are urban, but those artists are not in the "urban" category.'

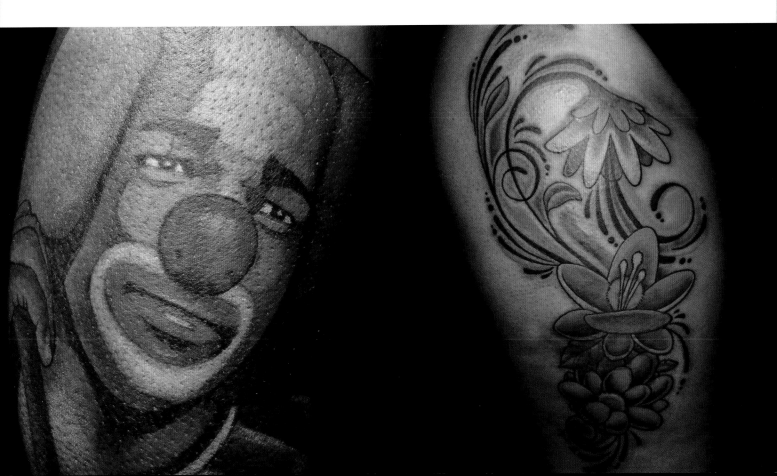

4 Lotus flower 5 Daddy-O portrait 6 Pan-African half sleeve

Bailey's influences range from comic books to the architect of Funkadelic music visuals, artist Pedro Bell. Most important, however, is the spectre of Picasso. 'I started to incorporate a lot of shapes in my work after travelling to Paris and studying the work of Picasso at the Louvre', states Bailey. 'I began to understand how to use circles and shapes to produce something complex, but still familiar.'

His varied output reflects diverse patronage. However, when Bailey arrived in Atlanta from Asheville, North Carolina in 1993, he was frustrated with the limitations of the flash deemed appropriate to his clients (which, in the early 1990s, was dominated by appropriations of hip hop label logos). He apprenticed under Julia Alphonso, owner of Westside Tattoo, and it was in her shop that Bailey's desire to elevate tattooing in the African American community took root. On Wednesdays, he exclusively took custom work and, slowly but surely, Bailey's vision of contemporary urban tattooing began to define popular form in Atlanta.

A half-sleeve of pan-African motifs demonstrates Bailey's skill at combining diverse elements in a single composition. The negative space, forming the word 'truth', provides contrast against evocative design details – pyramid and spear – and sets apart the central section, an African continent-shaped mask. Another black ink composition mixes a figurative fishing scene with Japanese-inspired waves and Bailey's trademark blank-space tribal banding. 'I started the negative space in the 1990s, and it is continually requested,' Bailey says. 'I want things to look like two designs in one, so a person not into tattoos can look at it and appreciate the pattern. I've learned that, especially in the black community, everything is about rhythm.' This notion has filtered into Bailey's technique, as he famously cracked the code of applying colour ink to black skin. He calls his method 'relaxed tattooing', which reduces trauma and the risk of scar tissue. As such, colour sings in Bailey's tattoos allowing for bold articulations of Japanese peonies and even realistic portraits of popular culture icons.

In his quest to redefine urban tattooing, Bailey produced (together with director Artemus Jenkins) the film documentary *Colour Outside the Lines* (2012). The film investigates the culture and history of black tattooers in the United States and is a valuable document of a period when minority practitioners existed largely in the margins of the industry. NS

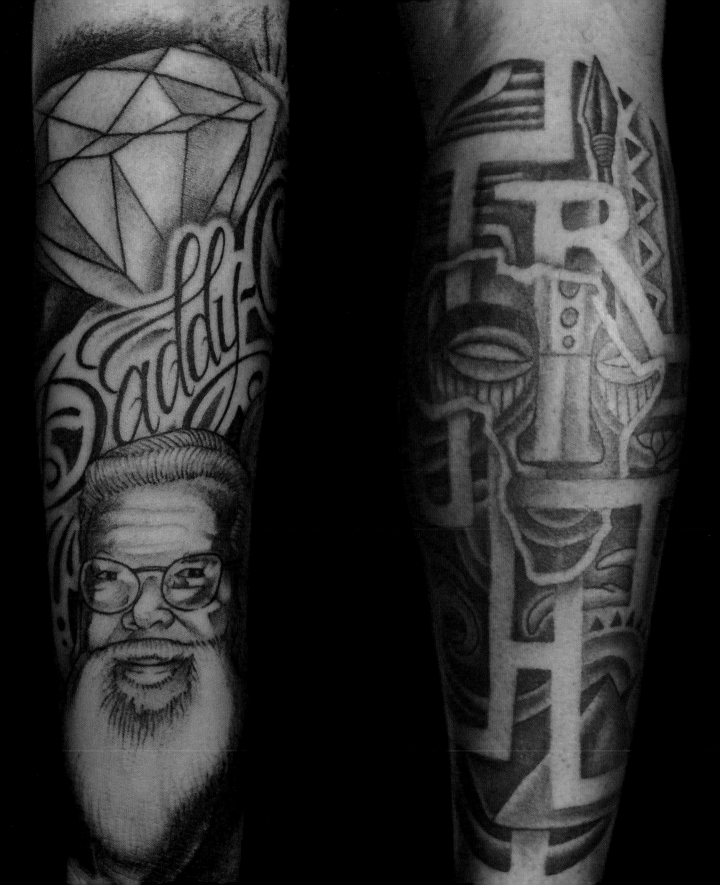

STYLE REALISM INFLUENCES BIOMECHANICAL
ART, SURREALISM, ILLUSTRATION, STILL LIFE
LOCATION AUSTIN, TEXAS, USA

NICK BAXTER

A Renaissance man for the 21st century, Nick Baxter wears multiple hats: painter, tattoo artist, philosopher, photographer, writer and teacher. Like his life, his tattoo work – seamless and at times hypnotic – melds several styles and blurs the distinctions between inanimate canvas and animate flesh. Having completed an art school education, including training in the basics of still life painting in the classical *trompe l'œil* style, Baxter began tattooing in 2000. Since then he has developed and refined his skills in other mediums, such as painting, mixed media collage and photography.

With bright colours, sweeping fluidity and various touch-inducing textures, he achieves a wonderful synchronicity between body and artwork. His harmonious blend of fine art and technical tattooing skill makes the bio-organic and biomechanical come alive with the flesh. He notes: 'I think my tattooing style could best be described as colour surrealism, blending elements of convincing realism with illustrative and painterly illusions. I employ the use of layers and a subtle colour palette reminiscent of my other art medium of oil painting in order to achieve a wide array of effects.'

The sentiment at the heart of his every artwork reveals a devout passion for issues of mental health and well-being. Baxter is 'inspired by a sincere concern for the human condition and a deep appreciation of the natural world, with the aim to question familiar assumptions and pierce the surface appearances of what we often take for granted; to create a space in which emotional certainties waver and taste loses its bearings, so that deeper truth may be uncovered'. On his website, he expresses the necessity that every person should help communicate information related to the improvement of mind-body wellness, in a way that is philosophical rather than pharmaceutical. This integrated view of the person perfectly matches his holistic approach when teaching aspiring artists and tattooists. KBJ

1 Back piece with biomechanical skeletal armour
2 Insects feast on succulent fruits in a Florida tribute sleeve 3 Forest-fire sleeve showing rebirth by way of destruction

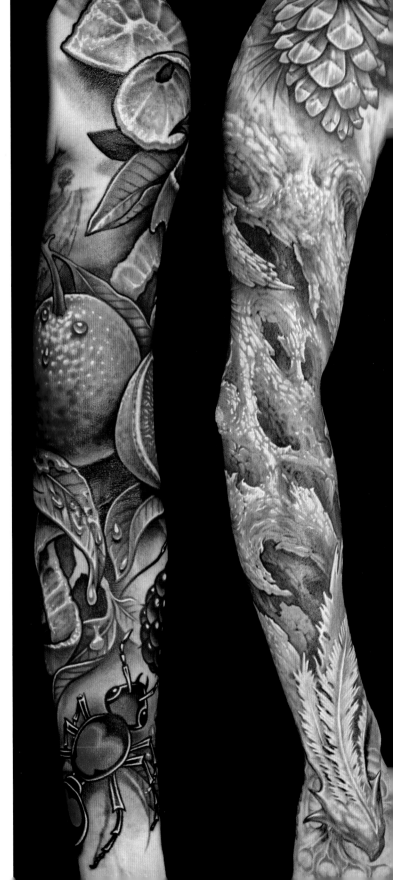

SHANNON PURVIS BARRON

STYLE CONTEMPORARY, OLD SCHOOL
INFLUENCES SAILOR JERRY, AUDUBON NATURE AND BIRD
PRINTS **LOCATION** COLUMBIA, SOUTH CAROLINA, USA

Shannon Purvis Barron's bold tattoos vacillate between traditional motifs and more complex creations that weave popular culture and nature into custom designs. Inspired by classic American tattoo design and the artwork of early American artists/naturalists, Barron references Sailor Jerry and John James Audubon as particular influences.

When working with traditional motifs, she remains true to that aesthetic: her pin-up girls and geishas look as if they have come from a sheet of early 20th-century flash. At the other end of her artistic spectrum, quirky client requests, such as a capybara (guinea pig-like mammal) or poignant ones, such as a portrait of a pet dog, get surrounded by floral motifs. Nature figures prominently in her work – a coral snake, for example, slithers along a customer's body. On occasions her two tattoo styles are united. In one design, a coffee mug is embellished with a cat that features the bold line work and textual banner ('Death Before Decaf') of a traditional tattoo, but adds elements from nature in some cat's tails alongside it.

1 Virgin and Child 2 Mockingbird with floral branches
3 Capybara with ornate foliage

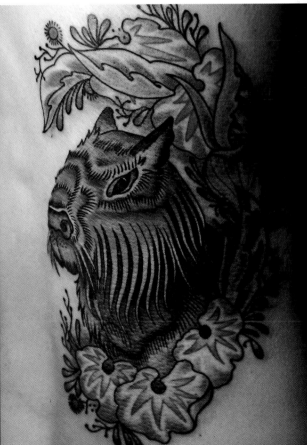

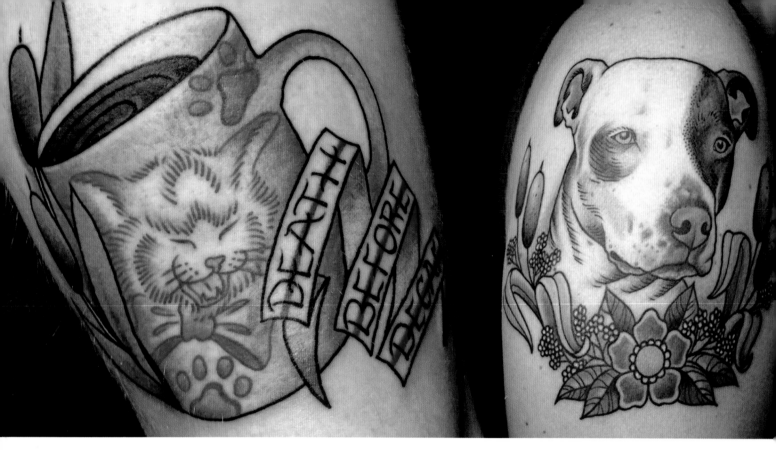

4 'Death Before Decaf' coffee theme 5 Pet portrait with floral embellishment 6 Pin-up girl in sailor suit

Barron, who comes from a small town in South Carolina, developed an early interest in art. As tattooing was illegal in South Carolina (the state was the second to last in the United States to legalize tattooing in 2004; Oklahoma was last in 2006), Barron did not have much exposure to the art form until later. She had to travel to Asheville, North Carolina to get her first tattoo at the age of seventeen. She initially worked as a body piercer in Columbia, where she bought the shop, Body Rites, she worked in. After tattooing became legal, she converted it into a tattoo shop and changed the name to Indigo Rose Tattoo in 2012. Rather than following the traditional apprentice route, Barron 'dove in head first and learned off of those artists who joined me in opening the shop'. She tries to balance life and work, and continues to paint as well.

At college Barron began studying biology, but eventually switched to painting. She started buying tattoo magazines and in her art classes based 'every project I did off a tattoo design'. However, South Carolina's conservatism affected her studies

and her desire to become a tattoo artist was 'not entirely well received and a little brushed to the side'. When she pursued an independent study about tattooing, a professor instead 'suggested that my class be structured around why people were adorning themselves with artwork in general'.

Barron's tattoo work transcends the merely decorative: she is also an active member of the P.ink/Personal Ink project whose 'mission is to pair [breast] cancer survivors with mastectomy scars and tattoo artists in hopes of facilitating further healing and survivors' reclamation of their bodies'. She works closely with these clients to craft their tattoos, especially as 'this is the first tattoo experience for many survivors'. She explains that her work for the project, which provides tattoos at no cost, has made her step 'outside my comfort zone . . . [and] push myself in ways and directions that I would not have before'. The delicate flowers and other motifs from nature she often tattoos over scars testify to the art form's power to transform and beautify. **AFF**

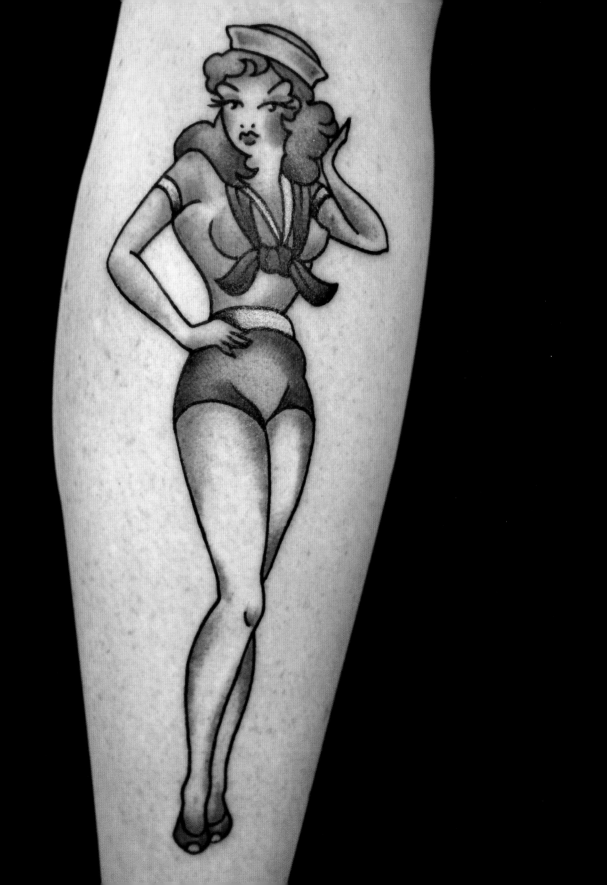

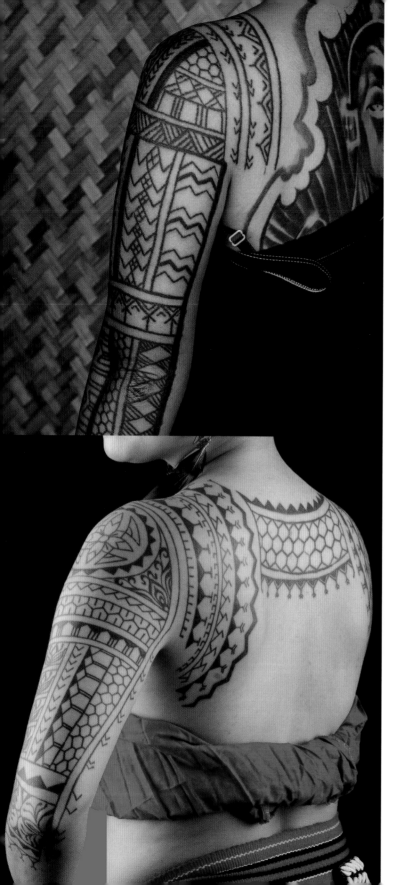

STYLE BLACKWORK **INFLUENCES** INDIGENOUS ART, RITUAL PRACTICE, PHILIPPINE TRIBAL CULTURE **LOCATION** STANTON, CALIFORNIA, USA

ELLE FESTIN

Elle Festin is largely responsible for the global resurgence of neo-tribal tattoo art inspired by indigenous Philippine sources. Born on the island of Mindoro, Festin and his family migrated to California twenty-five years ago, although his ties to his ancestral homeland have remained strong. Festin invested large sums of money to acquire old and rare reference material, including books, photographs and objects of Philippine tribal culture, to help inform his tattoo designs. An amateur anthropologist of sorts, he also conducts field research back home with the last generation of tribal tattoo bearers and artists.

In the late 1990s, Festin and several friends founded the Mark of the Four Waves Tribe (*Tatak Ng Apat Na Alon*). A global community of hundreds of men and women of Filipino heritage, the Four Waves have sought to revive the tattooing traditions of the many tribal peoples – including Ibaloi, Kalinga, Bontok, Ifugao, Manobo, Gaddang, Visayan – who call the

1 Neo-Kalinga hand-poked sleeve 2 Hand-poked chest and machined shoulder tattoos inspired by historic Ibaloi and neo-tribal designs 3 Body tattooing inspired by Kalinga tattoo iconography

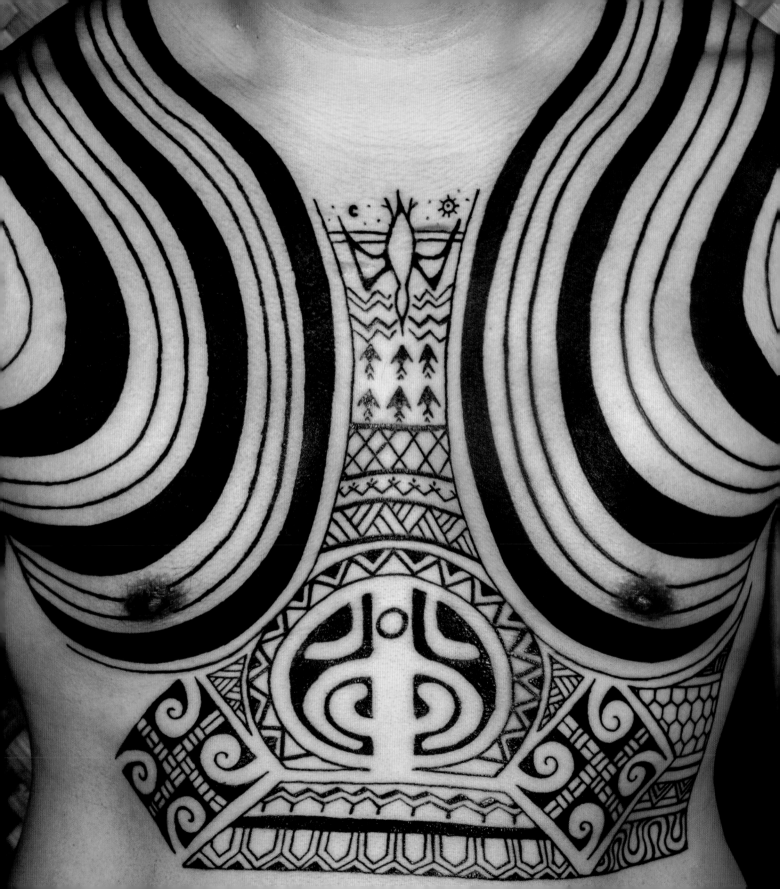

Philippine Islands home. Members of Four Waves work closely with selected tattoo artists and historians to develop their customized genealogical tattoo designs. The bold and beautiful blackwork patterns they create form autobiographical statements and tell tales of family history and personal accomplishment. Festin notes: 'Whether it is a family, cultural or personal story, we want to help our clients document it through the meaningful tattoos we create together.'

An accomplished tattoo artist and designer, Festin typically employs traditional tools and techniques to produce his lasting designs. He feels that the handcrafted tattoos he conceives pay homage to the indigenous peoples who practised tattooing, especially tribal designs achieved by hand-poking or hand-tapping. Festin says of his art: 'Each tap or poke is like a whisper from another time or place. We want to pay our deepest respect to those tribal artists who came before us, and that is why we give it proper ceremony and ritual when using these kinds of

implements. Otherwise the practice of tattooing will be like an empty vessel, hollow and without meaning, and I will never let that happen now that the Philippine tattoo revival is under way.'

Festin and his wife, Zel, also an accomplished tattoo artist, travelled to Kalinga province in the northern Philippines to meet the Kalinga master tattoo artist Whang-Od (see p.372), and the last generation of tattooed warriors. This trip had a deeply spiritual effect on Festin and, at Whang-Od's invitation, he hand-poked her. He says: 'It was an incredibly inspirational experience and now, more than ever, I feel deep down in my heart that I should continue this tattoo revival for her and the many others who are seeking their culture and roots. I want to expose tribal tattooing's great depth and beauty, because the tribal pieces we create are not flash art you see on other shops' walls. Rather, we create art that has an energy and life of its own and our clients are drawn to it because there are so many levels of meaning embodied within it.' LK

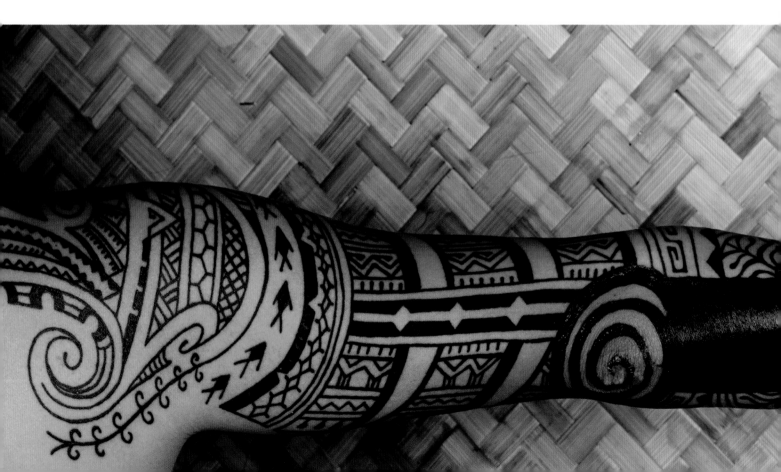

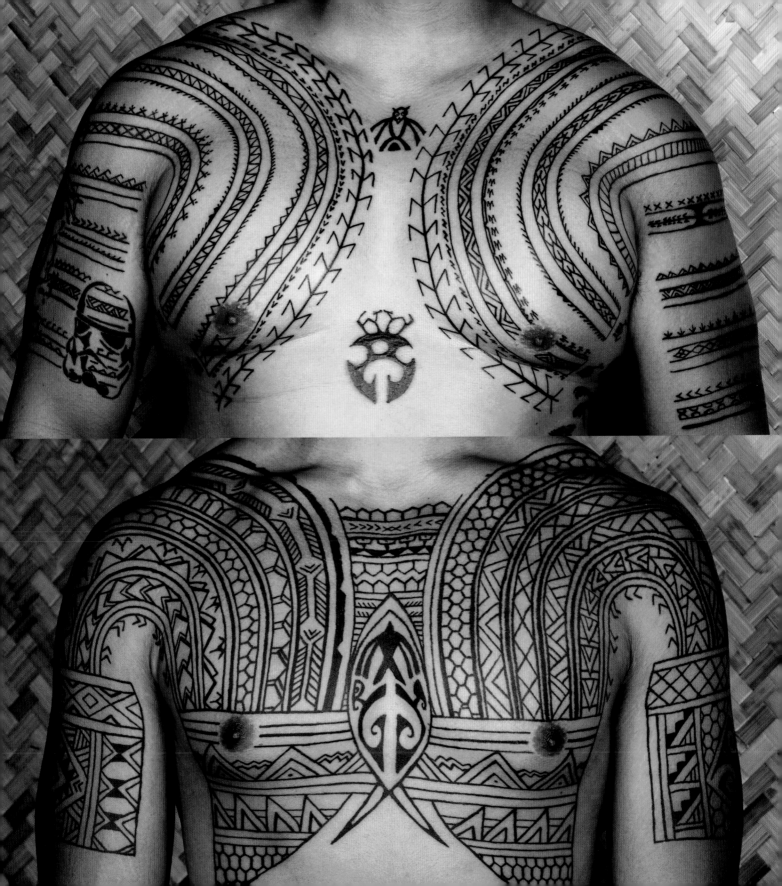

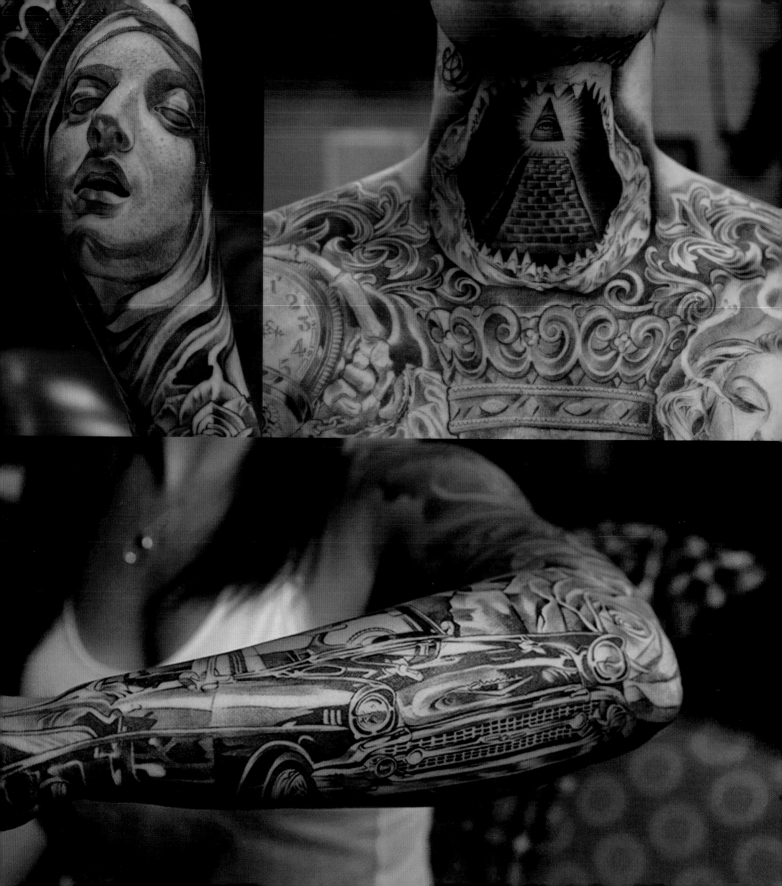

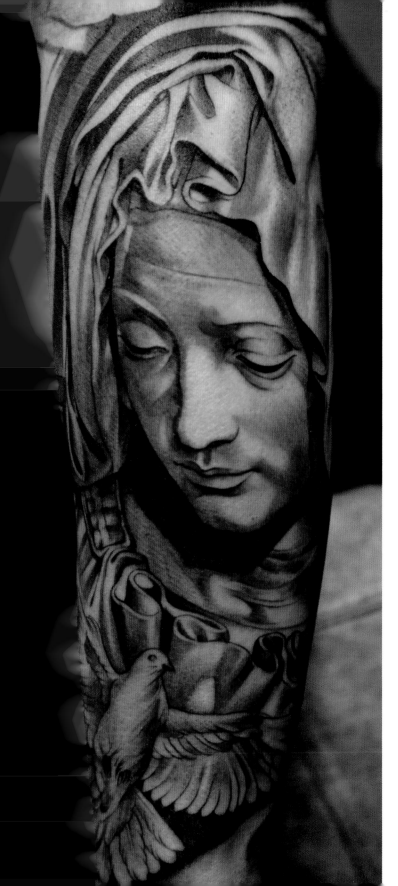

JOSE LOPEZ

From his home in California's Orange County, Mexican-born artist Jose Lopez is leading a global reinvention of traditional black and grey tattooing. 'At this stage, black and grey tattooing is very important. At one point, Japanese traditional was globally the most popular style, but now black and grey is on par,' he says. 'Basically, you can turn anything black and grey. That is strengthening the style. I wanted to establish myself as one of the people that helped make that happen.'

Lopez's path has been forged out of his dedication and personal resolve. In 1993, on Halloween night, a bullet struck the then fifteen-year-old Lopez. He had been in the United States for only four years and, against all odds, did not allow the American dream to elude him. 'I've always had an interest in art, but started doing a little more art in high school to get through the classes. After my accident, I had nothing else to do so I started tattooing,' Lopez recalls.

1 Classical female face 2 Masonic pyramid inside shark's mouth with foliate border 3 Low-rider forearm 4 Madonna with dove

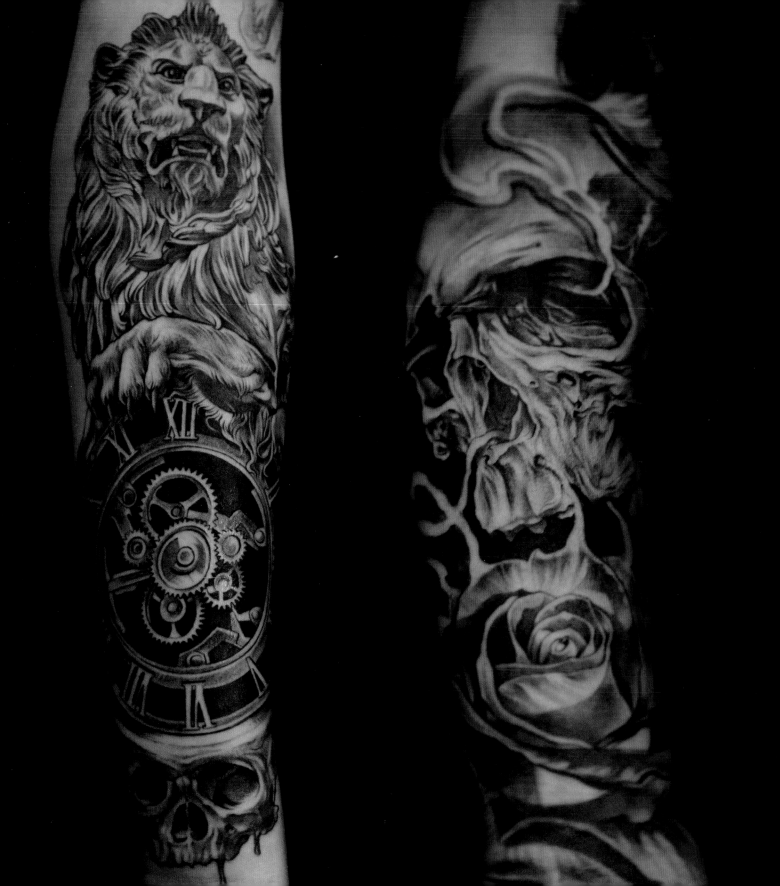

At first he simply copied things that caught his eye. Jesús Helguera, the famed Mexican calendar artist, was an influence. So were the stars of tattoo media. 'I would also get tattoo magazines, and I would see so many artists doing great stuff. I didn't know anyone's name or where they came from, but they caught my attention.' While he was becoming aware of tattoo culture, he was reluctant to get started. 'I was very shy, very afraid to ask for a helping hand.'

Eventually, Lopez found the courage to get an apprenticeship. 'I got my first job at a shop called Sick Dogs,' he reports, where Frank Sardelli 'taught me how to make needles' and 'the old school, traditional way of tattooing'. Studying the generation before him, Lopez became enthralled with black and grey. Locals Jack Rudy and Chuey Quintanar changed his perspective on tattooing, and he also looked up to New York's Paul Booth. 'I was never into the type of thing that he did, but I loved the grey tones,' Lopez says of Booth. 'It made me do black and grey.'

Beginning originally in southern California, Lopez developed an international following and started to travel outside the United States. As he began to experience the world, his version of black and grey evolved. 'In California, we were only exposed to certain things. Now we are travelling around the globe, and we're curious about the cultures to which we are exposed,' Lopez states. 'In Rome we see Renaissance painting and sculpture. We like religious tattoos, but now we are looking at thousands of statues of saints and hundreds of variations of the Virgin Mary. We see all types of different designs that we now apply to our work. As time goes on, as we become more cultured in art, the compositions get a lot better.'

In 2014 Lopez opened a London branch of his Lowrider Tattoo in Bethnal Green. The shop gives Chicano black and grey a home in Europe, as well as allowing Lopez space to further push the style's multicultural reach. NS

STYLE CONTEMPORARY **INFLUENCES** INDIGENOUS ART, SPIRITUALITY **LOCATION** LOS ANGELES, CALIFORNIA / AUSTIN, TEXAS, USA

ZULU

Known as the 'godfather of spiritual tattooing', Zulu treats each client as a potential moment of discovery. His studios (in Austin, Texas and Los Angeles, California) are spa-like enterprises that serve to soothe anxieties and allow for relaxed dialogue. 'I bring tattoos out of people,' says Zulu. 'I've never tattooed a stranger. By the time I tattoo you, we know each other.'

Growing up in the small city of Terre Haute in Indiana, Zulu stumbled upon an auspicious introduction to body marking. 'I was fortunate enough to live next to a foreign exchange family from Kenya, and they had body modifications – scarification,' he recalls. 'I remember asking, "Why do you do that?" Nobody in my family had markings. I come from a very Christianized family. And here was this family that rejoiced in it. . . . and they explained that it had meaning. It made me not (at age nine) want to go get one, but very curious about it.'

1 Buddha head with nautilus and lotus 2 Tattooed version of Caravaggio's *Saint Francis of Assisi in Ecstasy* 3 Fire goddess seated on a lotus

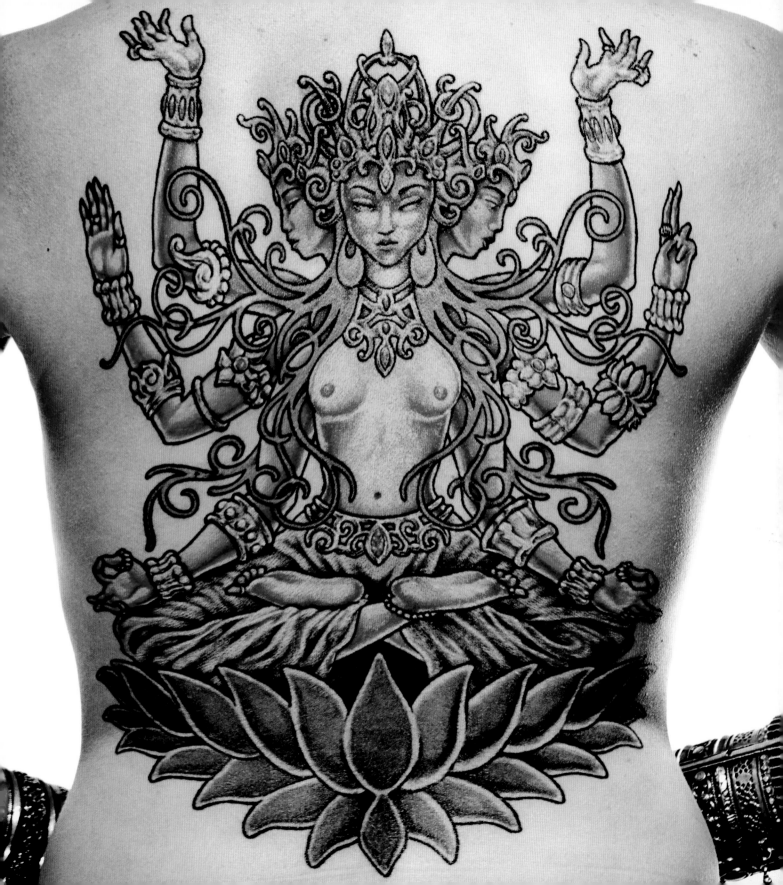

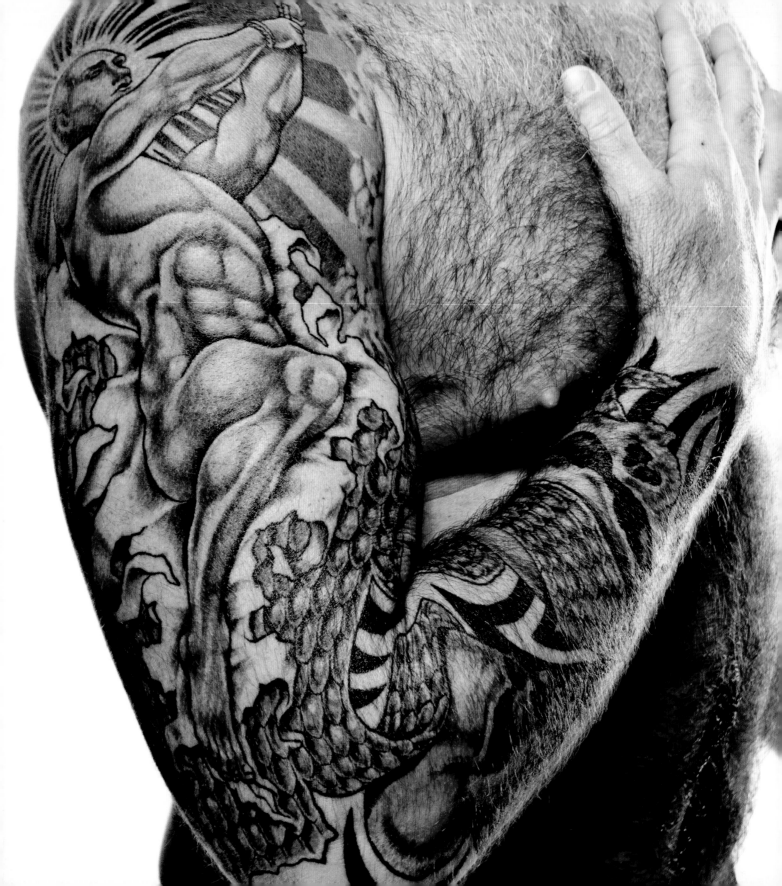

4 Sleeve inspired by the theme of transformation
5 Maori-inspired arm piece integrating bold colour
6 Realistic King Tut

Zulu began noticing tattoos and was soon drawing designs for friends who were frustrated by the lack of spiritually driven iconography at local shops. He started tattooing in earnest in 1990 and although he faced few creative hurdles – thanks to training in graphic design and commercial illustration – he did experience barriers, as an African American, in gaining a foothold in the industry. 'I most definitely consider myself an outsider. I couldn't apprentice, it was almost impossible due to my race,' Zulu explains. 'I've had to pull weapons on people to get them out of my shop. People have threatened my life. There are moments when the police have had to get involved. I was most definitely an outsider, and I was certainly made to feel as if I was one.'

Despite the challenges, Zulu has found allies. He travelled to Polynesia with modern tribal master Leo Zulueta, an experience that connected his childhood intrigue with the potential of tattoos to serve as a meaningful 'catalyst towards an ideal'. Describing his consultation process, Zulu says: 'I first ask why you want this tattoo. [I] then ask what you want it to represent, if anything. I want to know if it is meant to be representational, or just purely ornamental.'

Although primarily known for his tribal work, Zulu estimates that about half of his clients come in seeking something else. 'I think [with] a lot of people . . . there's something they need to see within themselves and sometimes the only way to attain it is to see it, so they mark themselves,' he says. He tattoos both in black and colour, and produces images of deities representing all religions as well as photorealistic portraits.

'The thing about tattoo culture is that it is still very lowbrow,' comments Zulu. 'I want to bring it up to a fine art.' This ambition, coupled with his outsider status, propels Zulu's conception of tattooing as a healing force. In breaking down industry barriers, Zulu is a brilliant force for change and his perseverance makes tattooing, and its experience, all the more inclusive. NS

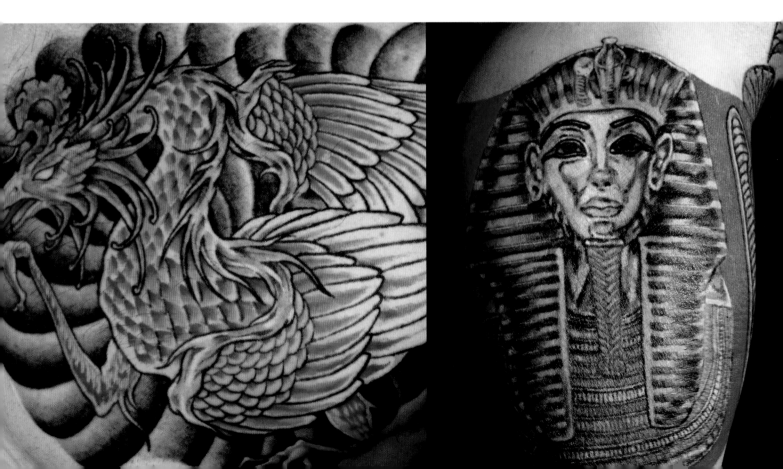

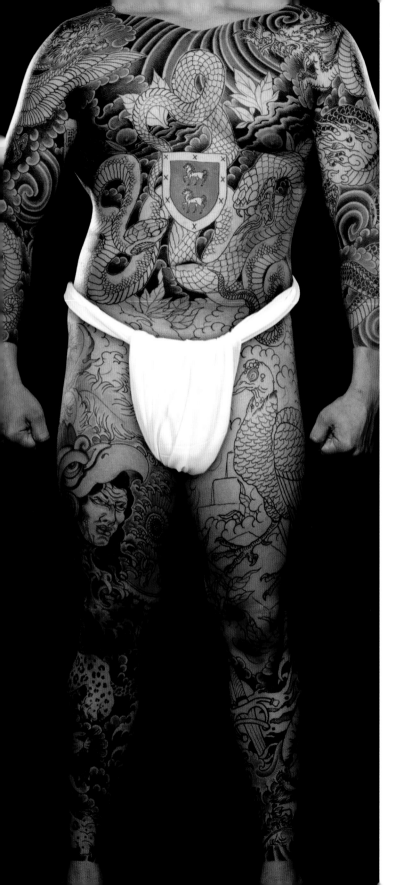

STYLE JAPANESE **INFLUENCES** JAPANESE AND AMERICAN TATTOOING **LOCATION** SAN FRANCISCO, CALIFORNIA, USA

JILL 'HORIYUKI' BONNY

Few women have risen to the upper echelons of the male-dominated genre of traditional Japanese tattooing. Jill 'Horiyuki' Bonny represents a bright shining female star in this sea of men. She brilliantly executes classic Japanese tattoo compositions, as well as pieces with a signature style informed by traditional American-style tattooing. Of her style, she says: 'I have always found my tastes to be somewhat conservative in relation to the subjects of the tattoos I prefer to do, and find a satisfaction in the steadiness of paying homage to the celebrated archetypes of Japanese tattooing. I have always enjoyed the pursuit of American-style tattooing, yet I continue to aspire to the high art of the Japanese tattoo.'

1 Bodysuit in progress with entwined cobras and other elements from Japanese tattooing 2 Tiger perched on rocks with peonies and cherry blossoms

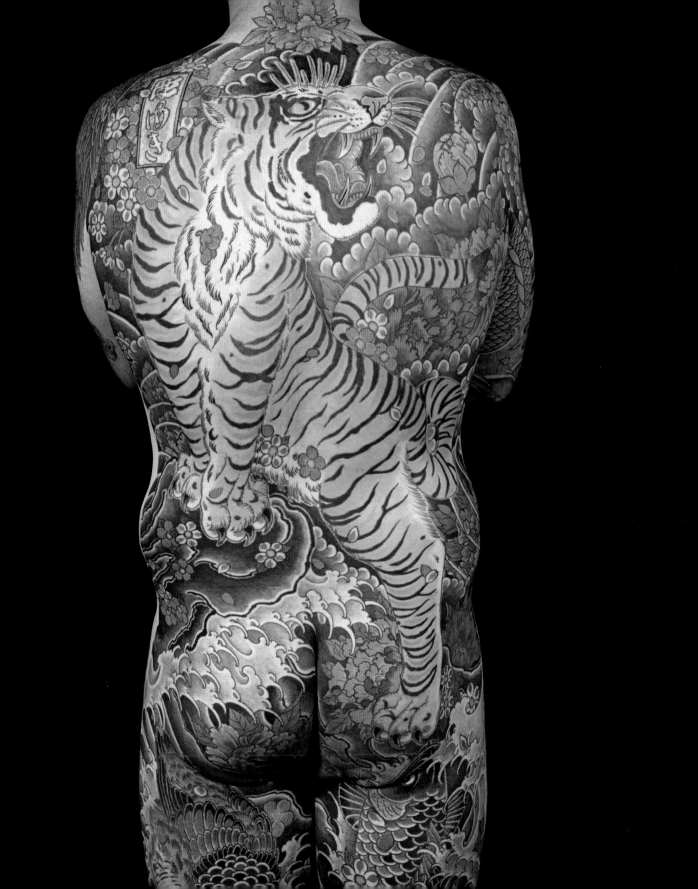

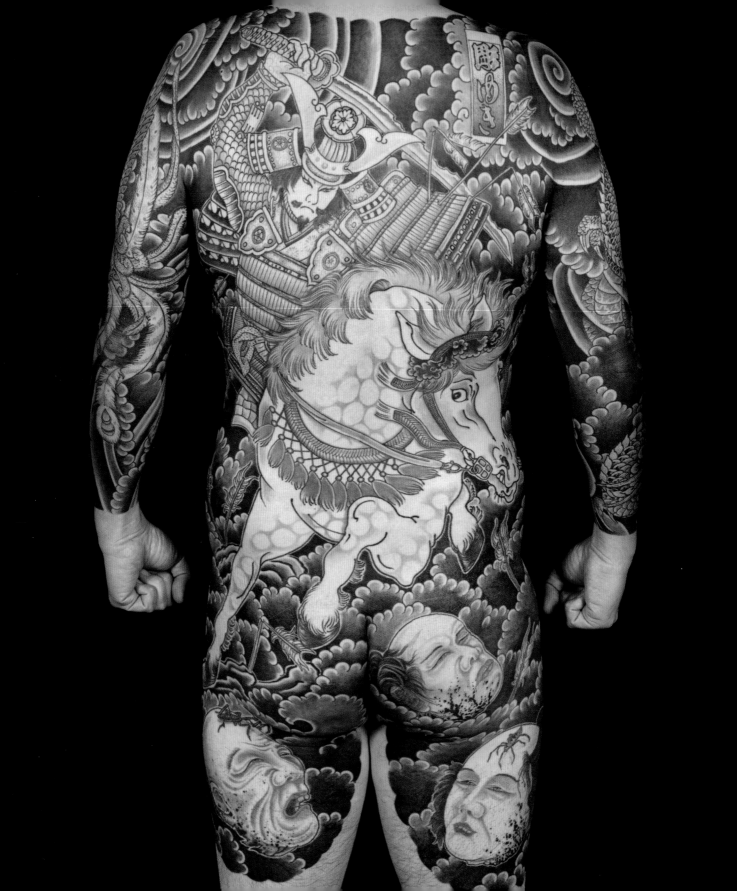

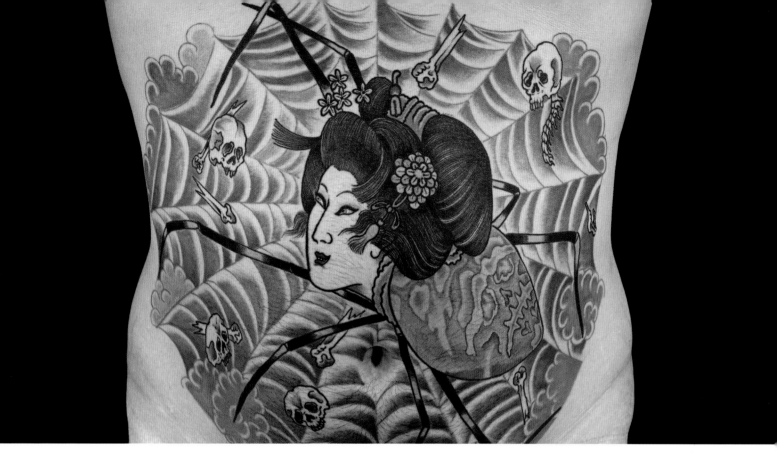

3 Oda Nobunaga astride a horse with *namakubi*
below 4 *Jorogumo* transformed with woman's head

Art school-trained at the Cooper Union in New York, Bonny has been tattooing for nineteen years. She spent from 2002 to 2014 at the San Jose studio, State of Grace, which specializes in the Japanese genre, and recently branched out on her own. She received the title 'Horiyuki' from the venerable Horiyoshi III of Yokohama in 2006, which acknowledges her status in the Japanese tattoo community and the calibre of her artistry. Bonny has written books and articles, and lectured on tattooing; she also pursues painting and printmaking. Bonny inscribes both enormous and modest pieces; her tattoos reflect traditional bold Japanese images of warriors, mythological characters, dragons, snakes, tigers, peonies and cherry blossoms set against backdrops of waves, wind and clouds. Although clients go to her for her Japanese work, she notes the collaborative aspects of custom work: 'It is my clients that continue to inspire me with the projects and ideas they bring to me, encouraging me to push my boundaries, artistically, on a daily basis.'

Certain pieces stand out that reflect a less straightforward translation of traditional Japanese tattooing. A black and grey bodysuit features a Japanese warrior – Oda Nobunaga, the first great unifier of Japan – riding a horse whose bridle and spot pattern are derivative of Kuniyoshi. The horse's pose is inspired by a Western 19th-century illustration, whereas the *namakubi* (severed heads) reference Horiyoshi III. A smaller piece renders the mythical character of the *Jorogumo*, a spider that can transform itself into a woman: the spider's head is in a traditional Japanese style, looking rather like a geisha, while the web and surrounding skeletal remnants evoke traditional, old school style and the spider's body shows a more painterly style. Bonny's thoughtful approach to tattooing is reflected in her tattoo philosophy: 'The challenge is in meshing the intellectual with the visual – or using study and research to inform design. The thesis I am cultivating in my Japanese-style tattooing is in acknowledging Japanese tattoo art and history to inform and shape my vision.' KBJ

STYLE BLACKWORK **INFLUENCES** RITUAL PRACTICE, SPIRITUALISM, INDIGENOUS ART, ARCHITECTURE
LOCATION SAN FRANCISCO, CALIFORNIA, USA

ROXX

Roxx's versatile blackwork style ranges from large geometric shapes and curvilinear lines to delicate dotwork. She brings a precise, graphic design aesthetic to her work and seamlessly blends a combination of organic and hard-edged motifs into masterpieces that cover substantial stretches of her clients' skin. At times her work defines the underlying anatomy of the human body, whereas at others her designs disrupt the flow of the body, making the skin and anatomy merely a support for something more visually powerful.

Roxx explains that much of her artistic inspiration is spiritual: 'It is of a spiritual nature to communicate with the source of things. I feel like a conduit for energy. I tune into a combination of that person, myself and a higher consciousness. It feels super powerful because I'm connecting to a consciousness that is bigger than myself.' In this role as conduit, Roxx channels a variety of cultural and aesthetic influences. Design-wise, her tattoos evoke different Pacific cultures from Micronesia

1 Sleeves with swirling bands reminscent of patterns from architecture, textiles and Oceanic art
2 Symmetrical forearm tattoos evoking Pacific Islander tattooing, sacred mandalas and architectural ornament

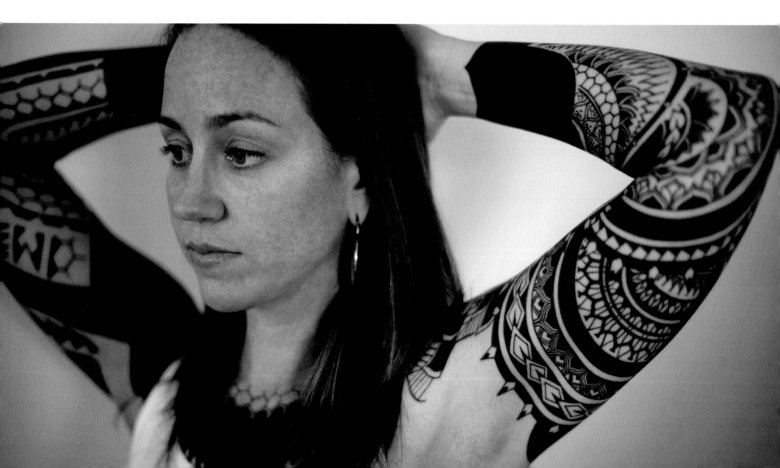

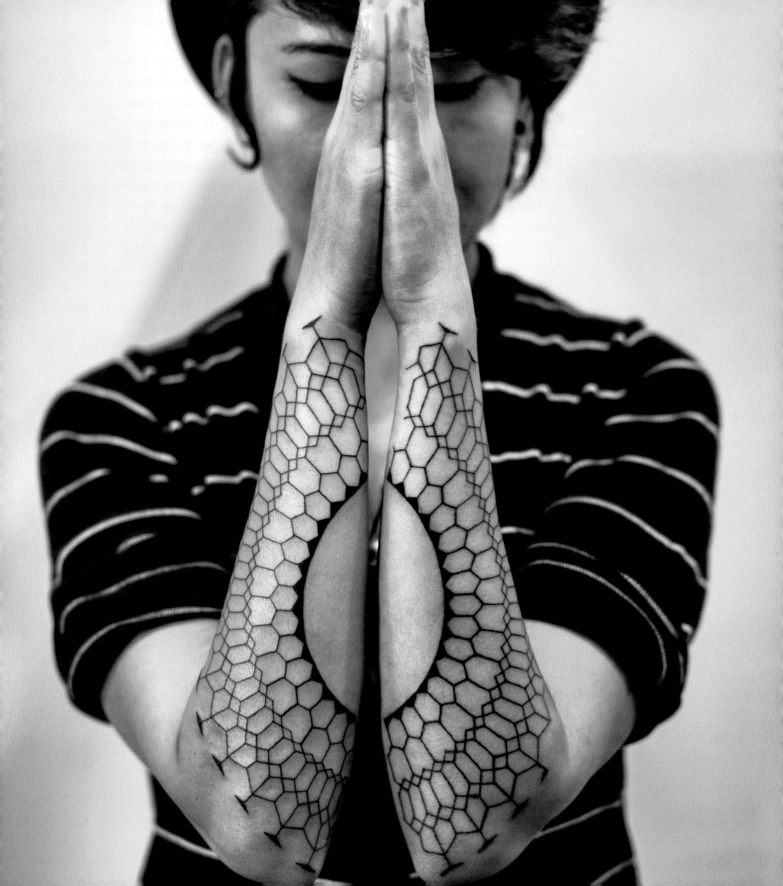

3 Back piece evoking Micronesian tattoos and
accentuating the spine and ribs underneath
4 Shoulder tattoos that split a sacred mandala
design into separate halves

5 Sleeve design with extensive solid areas of black
and architectural flourishes

(especially Pohnpeian), Polynesia (Marquesan, Samoan), the
Philippines (Kalinga) and elsewhere (Borneo). They also bring
to mind patterns from ritual images, such as mandalas, and
the architectural decoration seen in churches and mosques.

With their meandering lines and mix of cultural influences,
her designs seem to reflect her personal wanderings. Two
decades ago she started tattooing by hand-poking small designs
on her fellow punk rockers in London. As she developed skills
and gathered funds for equipment, she moved on to work in
shops in Edinburgh and Amsterdam, as well as guest spots
around the world. She eventually settled in San Francisco,
a city that particularly suits her style with its deep blackwork
roots, which originated on the West Coast during the tattoo
renaissance of the 1960s and 1970s. There she opened 2Spirit
Tattoo and created a mecca for high-quality work in this genre.

Booked months in advance, she draws clients – many of
whom work in art and design – from throughout the world
who want to wear her award-winning creations. Roxx's
clients dedicate large parts of their bodies to her art and
trust her to produce consummate work. She says of her
clients: 'They get that I really want to please them and give
them something special, and I'm grateful to be allowed to
work freely.' These blackwork tattoos require a commitment
to preserving large swathes of negative space in order to
emphasize the aesthetics of the design. Pieces frequently
require multiple, lengthy tattoo sessions to complete. Roxx
has realized that artistic autonomy is vital to creating her
powerful designs and admits: 'I find that working under art
direction for the client results in soulless work, and I can't
work that way any more.' Her clients trust her independent
vision and allow her 'free rein with their bodies'. The images
of her clients clearly reveal that Roxx has a particular talent
for using these bold, black shapes to draw inner power from
the soul to the surface. **AFF**

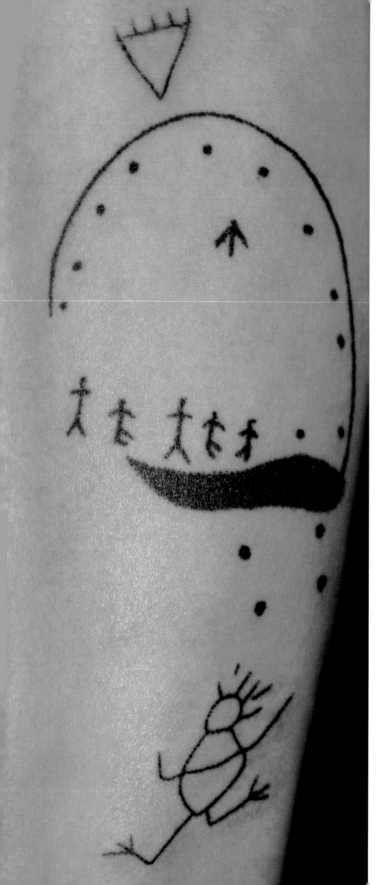

STYLE INDIGENOUS, BLACKWORK
INFLUENCES PICTOGRAPHS, POLYNESIAN TATTOOS
LOCATION SALMON ARM, BRITISH COLUMBIA, CANADA

DION KASZAS

Nlaka'pamux tattoo artist Dion Kaszas is responsible for the rebirth of his ancestral tattoo traditions. In the 19th century, guardian tattoos were a common form of indigenous North American spirituality that embodied protective spirits, but these cultural traditions were lost. Among the Nlaka'pamux people of Canada, tattoos were related to initiation rites performed in the rugged mountains of British Columbia, where spiritual beings communicated with their human counterparts through dreams and visions. Rock art sites throughout these remote regions depict scenes from these spirit quests and portray motifs that were once used as guardian tattoo symbols.

Kaszas, who has learned the traditional hand-poking and skin-stitching techniques of his ancestors, seeks to revive Nlaka'pamux tattooing traditions to enable local indigenous young people to become more anchored to their cultural and spiritual heritage. He also leads groups into the wilderness to visit sacred locations where they can experience these spirit places and begin dreaming again. He says: 'I have found healing in my tattooing, for as I become more knowledgeable and more connected to my ancestors' way of life, I now know that the Nlaka'pamux tattoo revival will help heal our people.'

Kaszas regards himself as a warrior dedicated to the process of decolonization through promoting the Nlaka'pamux study of ancestral tattooing. Long ago, Nlaka'pamux elders were compelled by missionaries, the government and non-indigenous settlers to discard their tattooing traditions. Kaszas is a deeply spiritual man, who recalls when he applied his first skin-stitched tattoo, a design inked on his own leg: 'When I sat down to skin-stitch and began moving through the process, I felt as if I was connected to something that was beyond this plane of existence; a place connected to my ancestors in a way that I never felt possible.' LK

1 Hand-poked pictograph 2 Hand-poked hummingbird
3 Hand-poked tattoo with Polynesian design 4 Machined tattoo inspired by Native American iconography

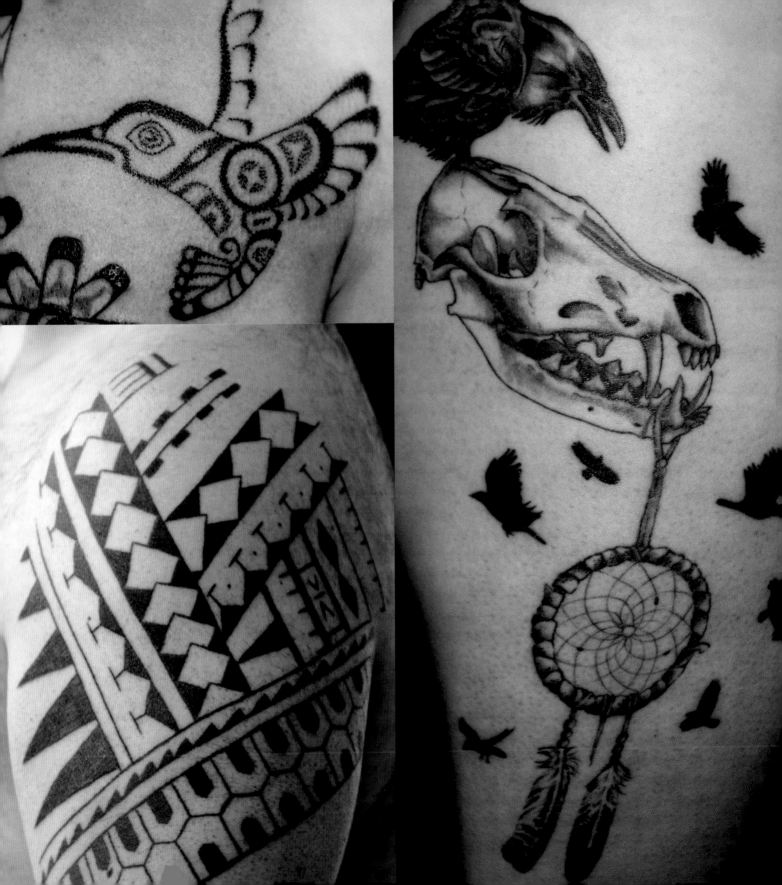

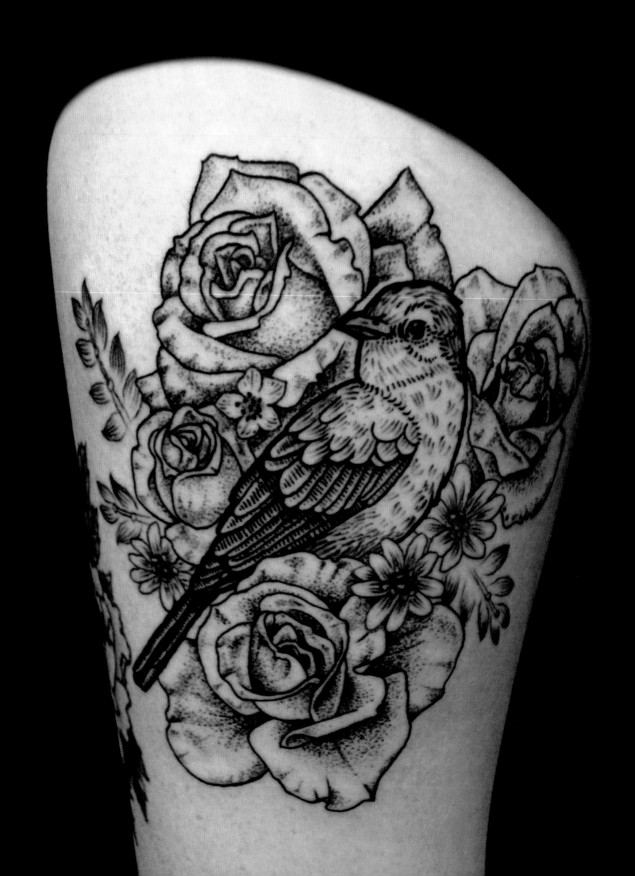

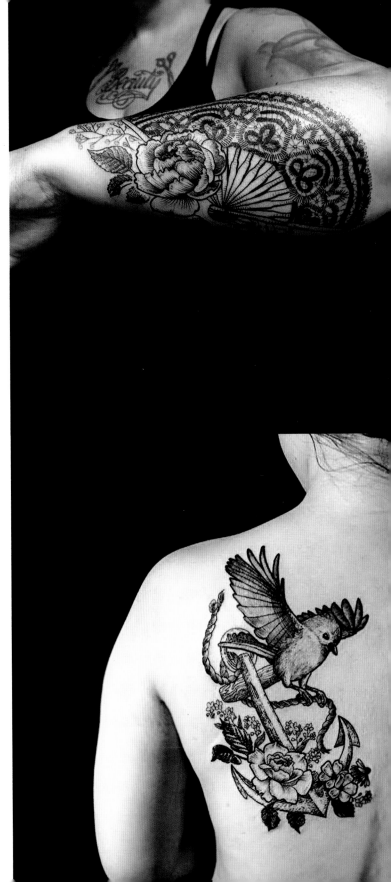

STYLE CONTEMPORARY, BLACKWORK **INFLUENCES** ENGRAVINGS, DECORATIVE ART, RENAISSANCE AND VICTORIAN ART **LOCATION** GUELPH, ONTARIO, CANADA

RIKI-KAY MIDDLETON

Riki-Kay Middleton's tattoo style, with its intricate line work and fine shading, resembles an illustrated Victorian children's storybook on the skin. Many of her designs call to mind the popular illustrations of Sir John Tenniel, such as those that appeared in Lewis Carroll's *Alice's Adventures in Wonderland* (1865). Others, particularly her tattoos of animals or people, recall the etchings of German painter Albrecht Dürer. Regardless of their subject matter, all the tattoos in Middleton's portfolio are executed in a precise, delicate, elegant fashion and have a touch of the whimsical about them.

Middleton is a self-taught artist and insomniac, who consequently spent most of her days and nights drawing. On the evolution of her tattoo style, she comments: 'I remember the day I discovered this huge vintage book about Albrecht Dürer. The moment I saw his work it just felt right. Right away I started emulating his techniques but with a pen rather than woodcuts, and eventually developed my own style.' The blend of drawing based on pointillism and etching in her tattooing perfectly matches her personal aesthetics: she loves to be surrounded by flowers, feathers, lace and religious iconography.

As Middleton's unique drawing style developed, she began showing her art in galleries and in magazines. It was at a gallery show that a tattoo artist she held in high regard approached her about doing an apprenticeship. The tattoo world was not unknown to her – she had friends in the industry and had visited tattoo shops – but she felt that world was unattainable until the apprenticeship came along. Learning the art of tattoo has greatly enhanced her drawing technique, especially in terms of contrast, outlines and the importance of dark and light. **KBJ**

1 Sparrow sitting among roses 2 Ornate fan with peony 3 Bird perched atop anchor wreathed in flowers

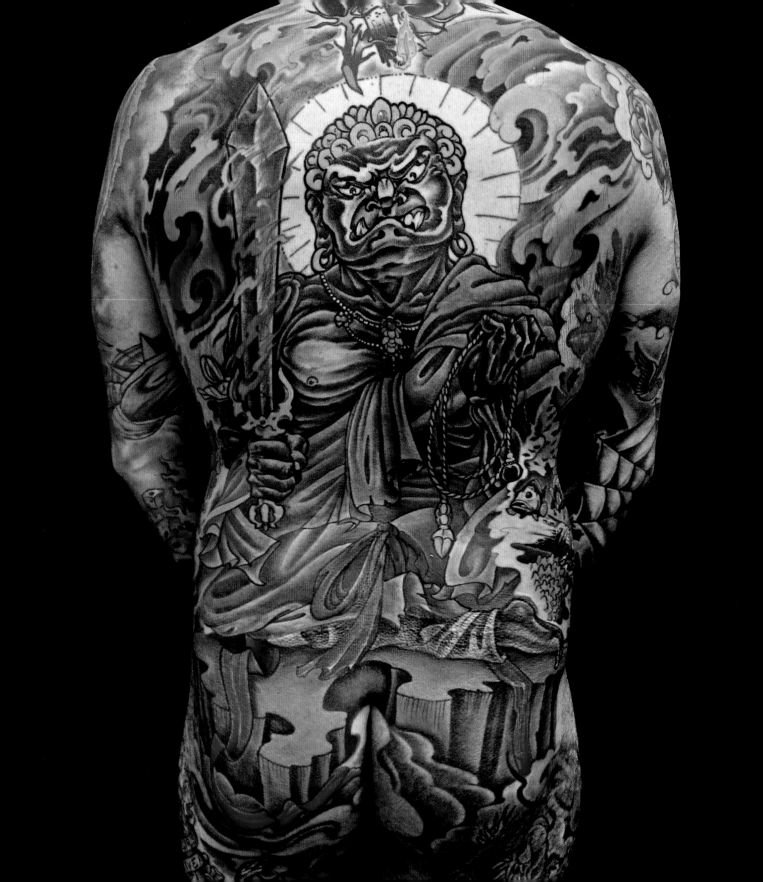

STYLE CONTEMPORARY **INFLUENCES** JAPANESE TATTOOING, ILLUSTRATION **LOCATION** MONTREAL, QUEBEC, CANADA

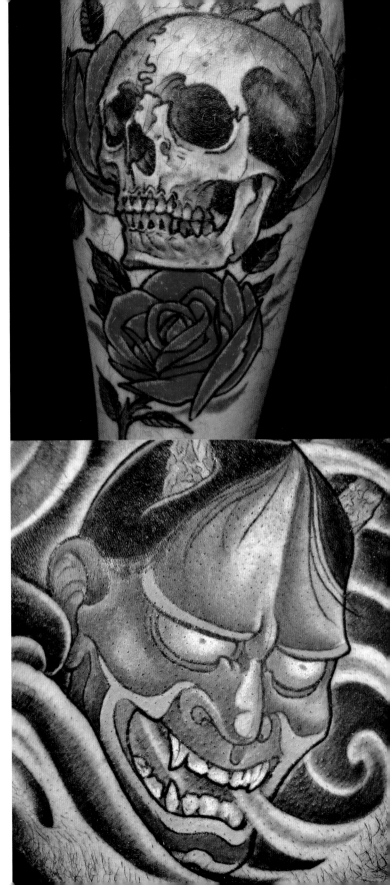

SAFWAN

Safwan's work is a vibrant, colourful and intricate fusion of neo-Japanese and neo-traditional styles. Every tattoo he creates exhibits a deep respect for the core traditions of both styles, while at the same time skilfully innovating new forms. He explains: 'I start with the "rules" that traditional Japanese and Western styles provide, and I try to bring it my own twist. I'm also strongly influenced by contemporary illustration.' His rich and bold colour palette, precise black lines and juxtaposition of airy and heavy elements, such as flowers delicately falling around a warrior skull, create a lasting visual impression. Safwan is a versatile tattooer: whether you want a big, loud and proud statement tattoo or one that is a delicate, graceful whisper, he can execute it with the utmost skill and flair.

Born in Cairo and raised in Montreal, Safwan's introduction to the tattoo world was through a sketch pad: as a child he loved to draw, and he later designed and drew personalized

1 Japanese Buddhist deity Fudo 2 Skull with roses
3 Japanese *oni* with wind

|5| |7|
|4|6|

4 Japanese dragon-koi hybrid 5 Kabuto helmet worn
by an unmasked skull 6 Chickadees on cherry tree
branches 7 Japanese warrior and dragon

tattoo pieces for friends, long before he started actually tattooing. He studied anthropology at university, which cultivated his growing interest in tattoos. His studies provided him with continued inspiration, as well as the tools to study the ethnography of tattooing. He explains: 'I basically graduated in anthropology studies knowing that I was to be a tattooer. When I discovered tattooing and got passionate about it, I knew that it was to be my path and that there was no turning back.' In 1994 he began tattooing, and in 1997 he opened Imago Tattoo Studio, the first 'custom only' shop in Montreal.

He prefers the label 'tattooer' rather than tattoo 'artist' and believes that the 'sound and customer-pleasing tattoo is more important than an artsy creation. Doing a solid piece that will age gracefully is more rewarding than an artist ego boost'. For Safwan, tattooing is a privilege and he always tries his best to honour his client, as well as the traditions of his trade. He considers himself a craftsman and a service-provider in regards to the act of tattooing. For him it is one that also concerns the tattoo machine itself. He builds tattoo machines from raw materials for tattooers he admires and respects: 'It's a passion as much as a discipline that helps to keep me sharp on a technical level. It's a great way to exchange on technique with other tattooers and keep the art of handcrafted tattoo machines healthy for future generations.' He strives to be a true 'renaissance man' of tattooing.

Safwan was particularly inspired by fellow tattooer Dustin 'Bones' Kroetsch, who died tragically in 2013. Safwan describes him as 'one of the unsung heroes of Canadian tattooing' and adds: 'He was one of the best, most confident and wisest advisers I've had in the tattoo world.' In addition to his colleagues at the Imago Tattoo Studio, there is also a small crew of tattooers he has travelled and exchanged ideas with for over a dozen years, who Safwan considers truly instrumental in his tattoo evolution. **KBJ**

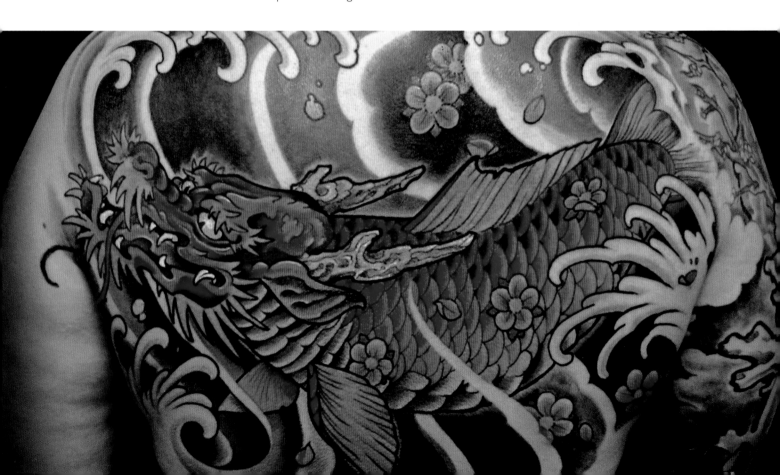

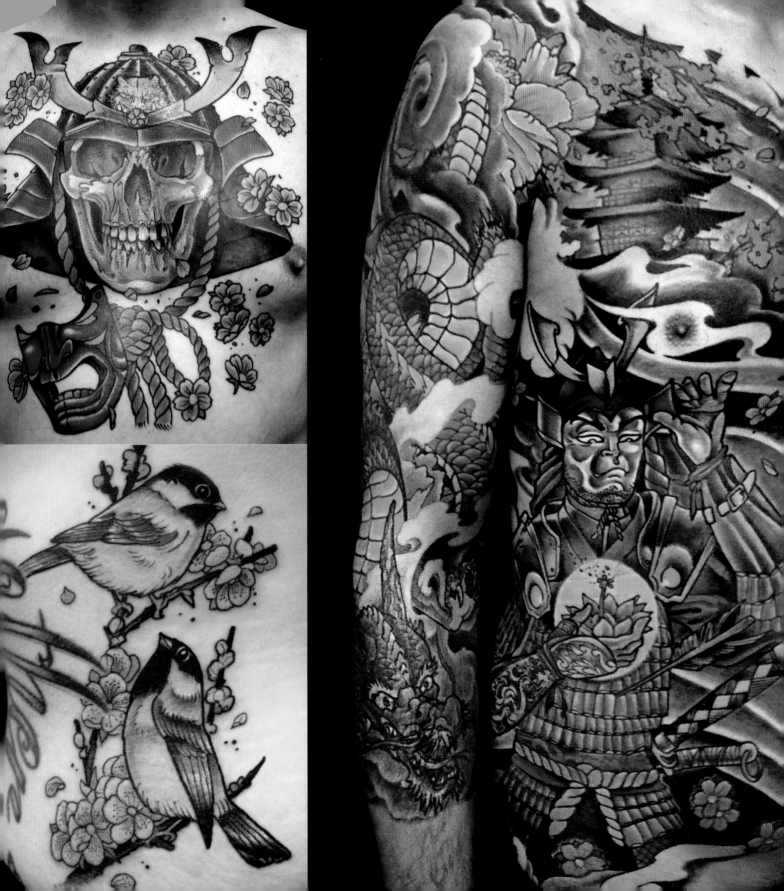

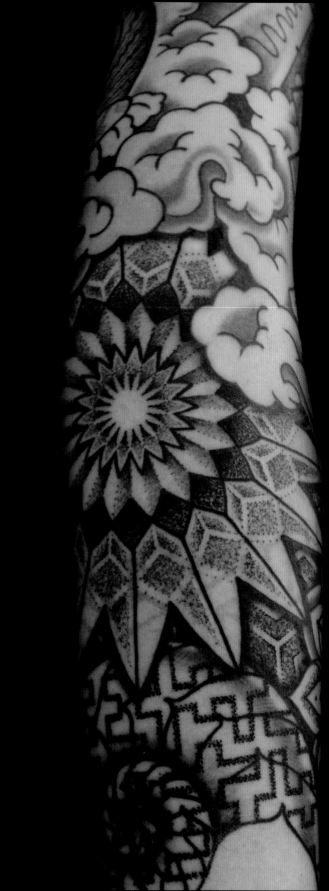

MIKEL

All things sacred, profound and spiritual inspire Canadian tattoo artist Mikel. Although he has worked across many different styles, over the last eight years his tattoos have largely focused on indigenous imagery, from that of the native North American Haida to the sacred geometric shapes, symbols and patterns of Buddhism and Hinduism. Browse his online portfolio and you will encounter spiritual elements from both East and West: tattoos with Buddhas, mudras, hamsas, mandalas and yantras, together with Haida-styled birds, bears, turtles and fish, and others with Polynesian blackwork patterns.

Mikel began his tattoo career in 1997 in Vancouver. He was drawn to tattooing because of its permanence. For him, it was a response to feeling disenfranchised and unsettled by the dominant attitude that everything in middle-class suburban Canadian society is disposable. All of Mikel's tattoos are executed with a precision, intricacy and confidence that is suited to their significance and spiritual weight. He often mixes line work with dotwork to achieve a layered effect. In every piece, his sense of awe and respect for the corporeal and spiritual elements of life shines through. He explains: 'To me, tattooing is magical. There is something about it. I really believe that the desire to decorate ourselves is in our DNA.'

His passion for the sacred also extends to the ceremony and ritual that surrounds the application and healing of a tattoo. He is a Reiki master and he incorporates hands-on-healing techniques into his tattoo practice to reduce stress and promote healing. Using these techniques contributes to a truly holistic experience and deepens the relationship of mind, body, spirit for both the artist and the client. He adds, 'I really love the sacredness that the whole process can have, or not have, depending on the client and their desires. It's a symbiotic relationship, really an amazing one.' KBJ

1 Geometric dotwork arm with nautilus and waves
2 Haida motif chest piece 3 Dotwork swirl with snowflake-like motifs 4 Patterned bird with mandala 5 Buddha design with lotus mandala

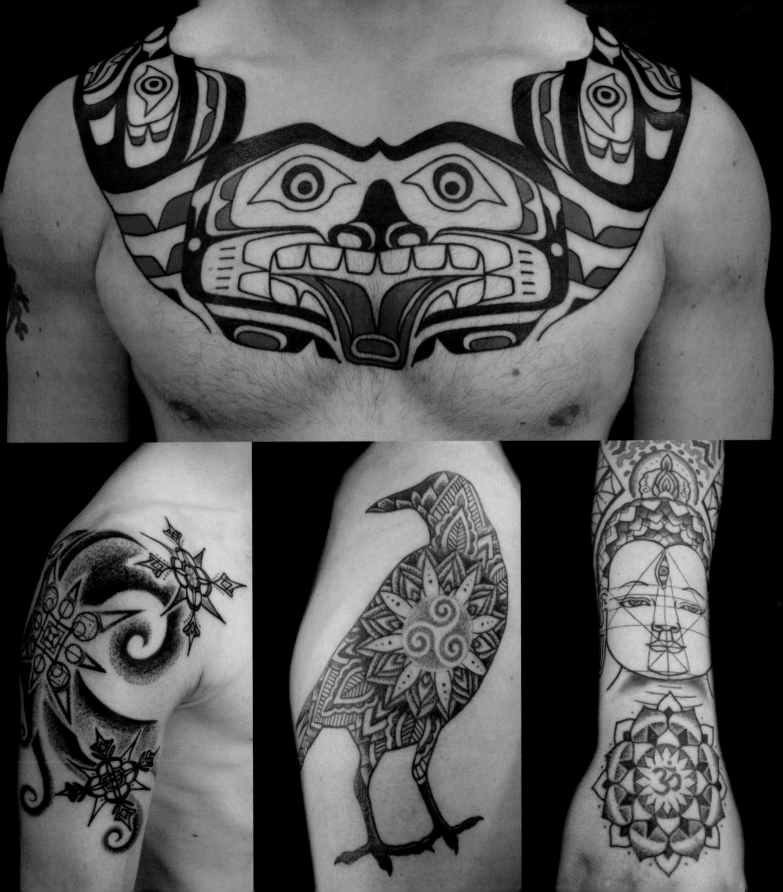

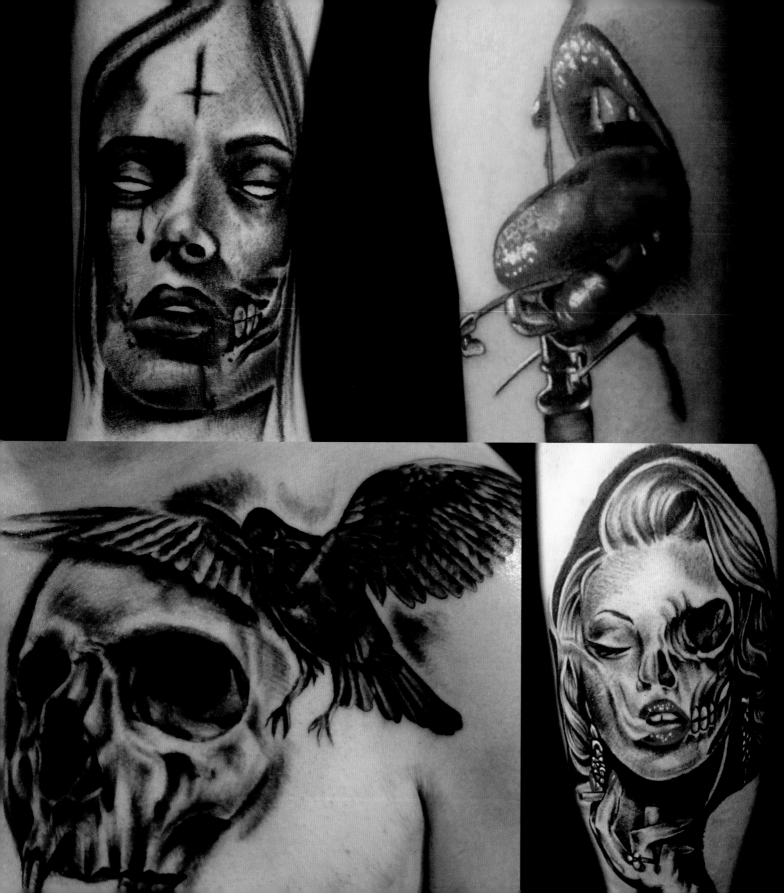

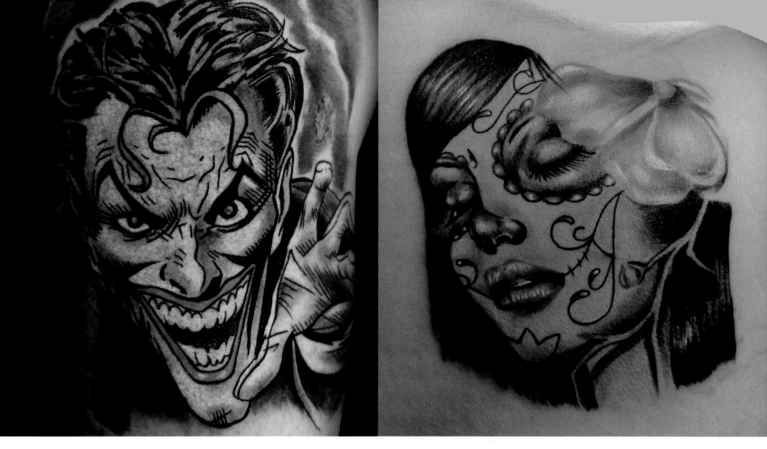

STYLE CONTEMPORARY, BLACK AND GREY, REALISM
INFLUENCES ILLUSTRATION, HORROR, BIOMECHANICAL
LOCATION TORONTO, ONTARIO, CANADA

1 Dead female face with demonic cross 2 Safety-pin
tongue piercing 3 Skull with raven in flight 4 Zombie
Marilyn Monroe, smoking 5 The Joker from *Batman*
6 Pin-up portrait with *calavera* make-up

SARAH JOHNSON

Sarah Johnson revels in the dark and macabre. All her tattoo work, including black and grey or colour, exhibits an adoration for mystery, the sinister and all things gory and ghoulish. A strong sense of darkness always dominates the shadows and lines of her creations – whether a flying blackbird, a grotesque zombie, a lovely lady surrounded by flower petals or a painted Day of the Dead woman's face. She explains: 'I'm inspired by countless things, old and new, but always gravitate towards the world of

shock and horror for the most creative fun. Within that realm you can play with such a diverse fantasy of carnage and beauty.' A touch of evil lurks in the lips, smiles and eyes that she inscribes, and which she renders with such beauty and grace. Her tattoos evoke classic fairy tales: under the bright, shiny and pretty surface lies something putrid or horrifying that just might try to eat you.

Johnson does not limit herself to horror tattoos or to any one style; rather she seeks to explore new ideas, expand her skills and try everything. She started her career creating designs for other tattoo artists to ink, which opened her mind to the opportunities that lay before her with a tattoo machine. For Johnson this is what being an artist is all about. She says: 'It's all about trying new things, even if considered a fail. I don't see that as a discouraging quality of the profession. Now repetitiveness, on the other hand, that is always a struggle. I continue to look for what's next, what future custom design I will create that not only exceeds what the client is looking for but also develops my personal vision.' KBJ

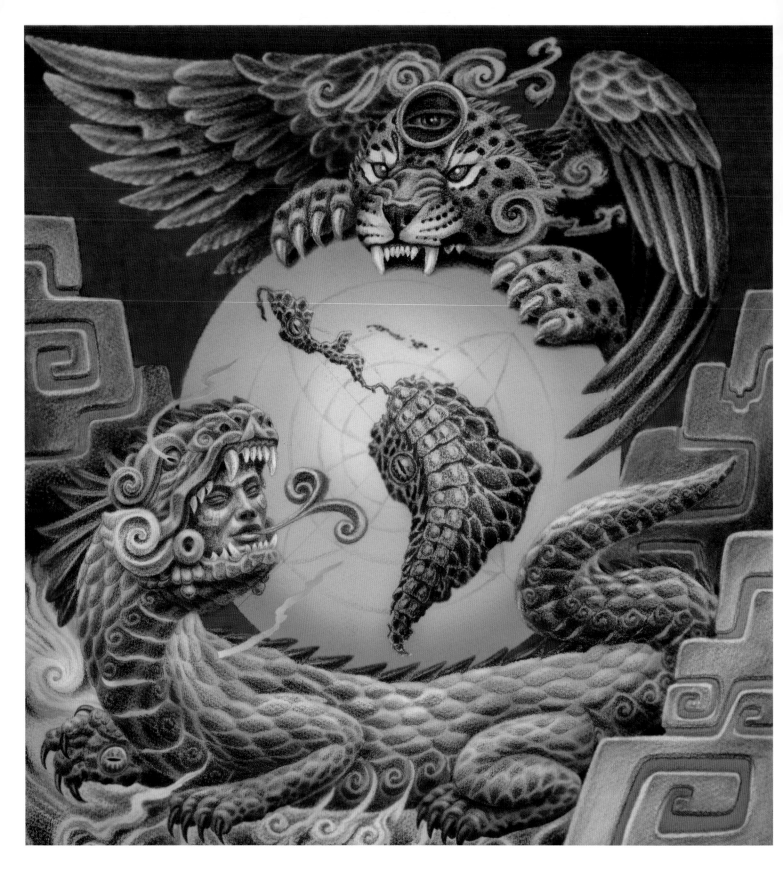

LATIN
AMERICA

MEXICO CITY PALENQUE GUADALAJARA CONCEPCIÓN
RIO DE JANEIRO BUENOS AIRES BOGOTÁ PARAMARIBO

PEDRO ALVAREZ SANYA YOUALLI STOMPER DANIEL CAMPOS
HENRIQUE MATTOS NAZARENO TUBARO MIGUEL DARK PIERRE BONG

2 Moche mummy from El Brujo, 450–500 CE **3** Nazca anthropomorphic vessel with tattooed arms, 180 BCE–500 CE **4** Moche effigy pot with possible facial tattoos, 100–800 CE

4

2 3

Before European colonial powers set foot on the shores of what would become Latin America, Central and South America possessed vibrant body art cultures, many of which included significant tattooing. The oldest known specimen of tattooed skin anywhere in the world dates from c. 6000 BCE and was found on the upper lip of a mummy from the Chinchorro culture in present-day Chile. This moustache-like tattoo is thought to have been part of a cosmetic tradition and may have been a purely decorative addition to the body. Tattooed human remains exist in several cultures in Latin America and other archaeological evidence, including effigy pots and sculptures, reflects a multitude of motifs and patterns placed on the body. However, ancient cultures in the Americas practised a wide variety of body

adornment techniques – tattooing, body painting and a henna-like staining, as well as piercing and scarification – that complicates determining which archaeological artefacts represent tattooing in the absence of additional documentation. After the European influx started in the late 15th century, more specific documentation of tattooing emerges. Unfortunately, the rapid changes in indigenous cultures brought on by colonization (particularly the widespread death of local populations due to violence, imported disease and the intolerance of Catholic missionaries to 'heathen' cultural practices) decimated traditional tattooing. Only in recent decades has tattooing started to re-emerge on a widespread scale in Latin America. A handful of indigenous traditions, mainly in remote jungle areas, has survived to the present day.

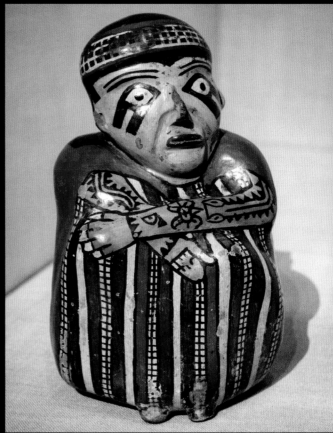

In major urban areas and artistic enclaves, global tattoo culture has blossomed, with artists working in as broad an array of styles as anywhere else in the world.

Pre-Hispanic Tattoos

Numerous archaeological artefacts from the pre-Hispanic period provide tantalizing evidence of tattooing. In South America, mummified human remains from a variety of cultures definitively preserve what ancient tattoos looked like in this part of the world. In addition to the Chinchorro culture, tattooed mummies have been found in other Andean cultures, including the Moche, Chimu and Chiribaya. The context in which some of these archaeological specimens were found helps to reveal their meaning and function, but in many cases the reason behind the tattoo acquisition remains cryptic.

The mummified body of a high-status, 1,600-year-old Moche woman, possibly a priestess, found at El Brujo, features extensive elaborate tattoos (see image 2). The designs on her hands and arms combine geometric motifs with stylized spiders and mythical animals. Tattoos on a female Chiribaya mummy from c. 1000 CE feature a combination of therapeutic and ornamental motifs with simple overlapping circles on the woman's neck and upper back; more elaborate motifs on her hands and arms reflect nature and the animal kingdom.

A wealth of possible tattoo evidence exists in South American art. Pottery provides myriad examples of human figures with painted or incised lines. The difficulty, however, is in determining which represent tattoos and which body painting (or scarification). Moche effigy vessels produced between 100 and 800 CE often represent specific portraits of known historical figures and may show tattoos among the many decorated faces, arms and legs (see image 4). Nazca figurines dating from 180 BCE to 500 CE also feature possible tattoo patterns on various parts of the body (see image 3).

In Central America, a mummy dating from 250 CE features extensive arm tattoos; although known as the 'Toltec mummy', its age clearly predates that culture. Among the Maya, who spanned the pre- and post-contact eras, sculptural figures and human images on temple walls and pottery show marks varying from small dots on the face to elaborate geometric designs twining around the body. Other Meso-American cultures also produced sculptural figures with body decoration that may

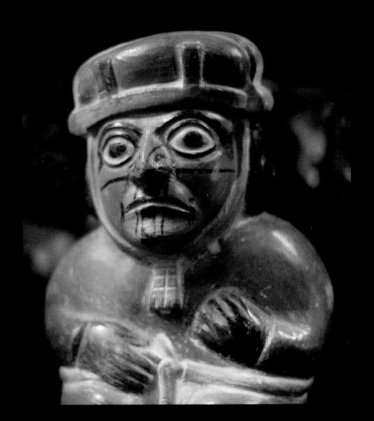

constitute evidence of tattooing. In the Huastec culture, the interpretation can be helped by an image in the post-Hispanic, 16th-century Florentine Codex, which illustrates a man with geometric marks on his ribcage and slashes on his face. Olmec figures, such as the famous 'El Señor de las Limas', feature elaborate incised marks, which perhaps suggests that tattooing could have taken place in Central America as early as 1,000 BCE.

Tattooing seems to have been most significant among Maya in the Yucatán region of Mexico, where it proliferated during the 8th to 10th centuries. Numerous accounts from colonial encounters specifically mention permanent pigmented marks on both men and women in various Mayan societies throughout Central America, supporting the belief that some body patterns on artefacts represent tattooing. For example, in the mid-16th century, Spanish bishop Diego de Landa noted

5 Tupinambá warrior from Claude d'Abbeville, 1614 **6** Contemporary Matis, Brazil
7 Contemporary Matsés, Peru/Brazil

5 7 6

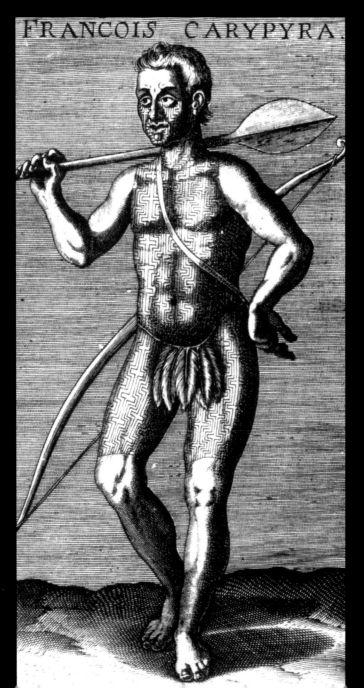

FRANCOIS CARYPYRA

that the more tattoos Mayan men had on their bodies, 'the more brave and valiant are they considered, as tattooing is accompanied with great suffering, and is done in this way. The professional workers first painted the part which they washed with colour, and afterwards they delicately cut in the paintings, and so with the blood and colouring matter the marks remained in the body'.

Post-contact Tattoos

European travel accounts and early histories of Central America, South America and the Caribbean contain numerous mentions of tattooing as distinct from body painting. These accounts use terms such as 'carved' (often referring to a technique where the skin was slashed and then pigment applied), pierced, embroidered or pricked, to describe a process that placed pigment into the skin rather than on top of it. Gonzalo Fernández de Oviedo y Valdés, an early 16th-century historian of the region, described tattoos on people across a broad geographical area. According to him, the Taino in Haiti 'imprinted' *zemi* (demon-like) images 'held and perpetuated in a black colour for so long as they live, piercing the flesh and the skin, and fixing in it the cursed figure'. He also documented tattoo traditions in Nicaragua.

Besides the Maya other Meso-American groups, such as the Otomi, clearly tattooed; 16th-century ethnographer Bernardino de Sahagún noted: 'their breasts and arms were painted like embroidery of a very fine blue . . . cut in with a small blade'. The Opata tattooed their infants with black-spotted arches around the eyes and added more tattoos as children aged. Manuel de Arellano, an artist based in Mexico City around the turn of the 18th century, captured facial decorations on an indigenous 'Chichimec' (a Nahuatl term for nomadic people) in one of his paintings that have been interpreted as tattoos. Aztec tattooing remains more hypothetical. Although according to explorers' accounts and artefactual evidence this group clearly engaged in body painting, whether this was permanent is unclear.

Tattooing appears to have persisted in Central America into the early 20th century. A. T. Sinclair reported in 1909 that many Mexicans told him that 'the wild Indians' still tattooed, but noted that 'the Indians with whom the whites generally come in contact have given up the practice'. Sadly, no extant indigenous

tattoo traditions exist in Central America today. Several contemporary artists in the region are starting to work with motifs drawn from visual documents, but their tattoos mine the richness of the historic past rather than recreate it.

In South America, although many traditions died out early, others have persisted to the present day. Among those that disappeared, Tupinambá warriors in Brazil were tattooed with net-like patterns of protective armour (see image 5) whereas girls from the same society were heavily tattooed throughout a lengthy coming-of-age process. Their neighbouring rivals, the Munduruku, similarly had heavily tattooed warriors. People of mixed European and indigenous heritage also bore tattoos there; travel accounts from the period c. 1570 to 1600 describe many tattooed *mamelucos* – the offspring of Portuguese colonists and native Amerindian women in Brazil – who served as cultural intermediaries.

Numerous 16th-century Spanish colonial sources document South American tattoos. Historiographer Antonio de Herrera y Tordesillas mentions that in parts of Colombia and Ecuador men and women 'engraved' their faces and arms, in addition to distinctive body painting. Along the coast of Ecuador in 1525 Bartolomé Ruiz viewed 'men and women [who] carved their

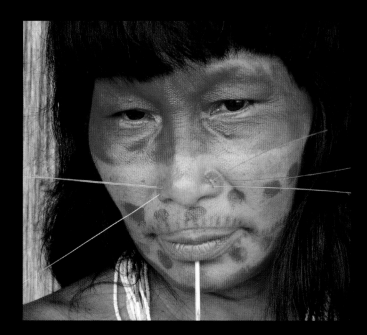

faces like the Moors' (Spanish explorers often made comparisons between Latin American and Berber/Bedouin tattooing). Historian Gonzalo Fernández de Oviedo mentioned tattoos in Venezuela. In the mid-18th century, Bohemian Jesuit missionary Father Florian Paucke recorded the extensive tattoos of the Mocoví in Paraguay as stippled dots in geometric patterns.

Contemporary Indigenous Tattooing
Indigenous tattooing survives among a handful of South American groups. Some of these survivals, such as those of the Marubo and Matsés (see image 7), exist only on the bodies of elderly people and no one still actively tattoos; the Matis still tattoo today (see image 6). There has been a small movement towards the revitalization of traditional tattooing among the Ikpeng people in Brazil. A fascinating documentary produced by Vincent Carelli and Virginia Valadão's Video in the Villages project features the Ikpeng as they relearned a coming-of-age ritual involving facial tattooing. Only youths and very old women wear tattoos in the film, which demonstrates that a generation or two of tattooing had been lost after this group were influenced by European contact in the mid-20th century. The video shows society members collecting soot on the

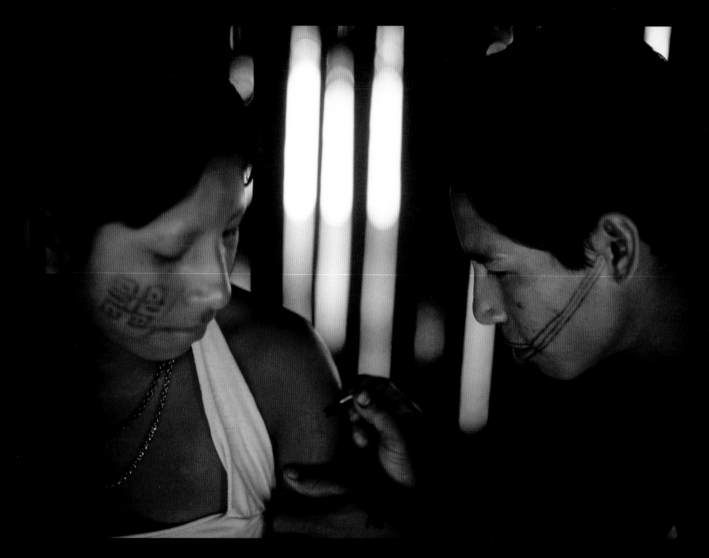

bottom of a cooking pot to use as pigment for ink and then pricking it into the cheeks of pre-teen boys during the ceremony.

The Kayabi, who live near the Ikpeng in Brazil's Parque Indígena do Xingu, may have the most active indigenous tradition (see image 8). Kayabi tattooing uses a tool made from two thorns and cotton thread as a pricking implement. Some of the most powerful Kayabi designs are glyphs related to naming ceremonies (historically they were also names of victims that warriors had killed). Despite having endured European contact since the mid-19th century, a core group of community elders still bear tattoos today and ample documentation of Kayabi designs by visiting Europeans exists from the 19th and early 20th centuries; tattooing only lapsed for a few decades. One remaining tattoo master, Yxyt, began to reintroduce tattooing

in the early 21st century. Even though he died in 2003, he inspired a new generation of Kayabi to continue to revive the practice. Cousins Jemy and Kurapi now lead the movement.

Modern Latin American Tattooing

A predominantly conservative attitude towards the body has dominated much of Latin American culture in the post-colonial era due to the heavy influence of Catholicism and the intolerance of missionaries towards indigenous practices. Tattooing has therefore occupied an uneasy place in Latin American culture. It is unclear as to exactly when Western-influenced tattoos started being inscribed in Latin America, but exposure clearly would have come through tattooed sailors arriving in the many ports, as well as residents of prison

8

9 | 10

8 Tattooer Kurapi of the Kayabi revival, 2000s **9** Mexican prison tattoos from Francisco Martínez-Baca, 1899 **10** Contemporary El Salvador gang tattoos

colonies (who sometimes escaped) in places such as French Guiana. By 1899 Mexican anthropologist Francisco Martínez-Baca had documented a wide selection of Western-influenced motifs on prisoners in Puebla and discussed the tattooing of Mexican soldiers (see image 9). Many designs reflected the Catholic faith, as well as eroticism, decoration and anti-sociality. In 1909 Sinclair noted that in Cuba: 'the Nañigo, a cut-throat secret society . . . all had a certain tattoo device on the biceps of their arms' and that 'there is considerable tattooing now among the lower classes in parts of Mexico'.

With the dawn of globalization in the late 20th century and the spread of tattooing via international conventions and the internet, tattooing has developed a strong niche presence in Latin America. Black and grey tattooing, born in the barrios

of the United States, spilled over the border from Southern California and Texas into Mexico and down into South America. As in the United States, gang subcultures rapidly embraced this style of tattooing as a form of rebelliousness and a way of marking group identity by covering their faces and bodies with extensive, bold tattooing (see image 10). Subcultural communities in major cities, including Buenos Aires, São Paolo and Rio de Janeiro, have fostered an appreciation for global tattoo styles, such as blackwork and traditional Americana. Beach areas, where tourists want to enhance their swimsuit-attired bodies or mark souvenirs of their travels on to readily visible skin, have spread tattooing to ever wider Latin American audiences. Tattoo conventions and magazines have followed, and a vibrant contemporary community has been formed. **AFF**

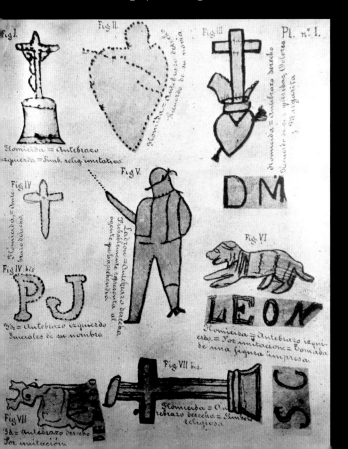

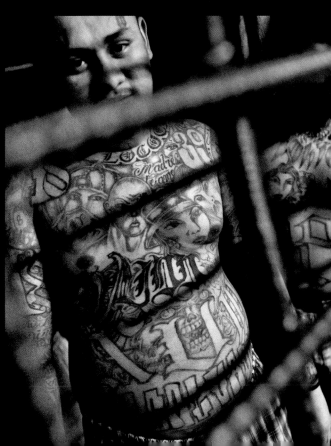

STYLE CONTEMPORARY INFLUENCES PRE-HISPANIC ART, MEXICAN MURALISTS, H. R. GIGER, 1970S AND 1980S ALBUM COVERS, COMICS LOCATION MEXICO CITY, MEXICO

PEDRO ALVAREZ

Paying homage to pre-Hispanic culture, Pedro Alvarez takes historical images and merges them with contemporary motifs. He infuses his tattoos with vibrant colours that explode with energy. Alvarez achieves an incredible dimensionality in his works – the images in the tattoos leap off the skin, evoking the sculptures and reliefs that inspired them. As one of the founders of the neo-Aztec tattoo movement, he has become a canonical figure in the celebration of Mexican culture through reinterpreting ancient motifs as contemporary masterpieces.

He grew up in Mexico City in the 1970s and 1980s, when tattooing was regarded as negative, and faced obstacles to becoming a tattoo artist. Drawn to the art form at a young age, he obtained and inscribed his first tattoos when he was only twelve. He recalls: 'It was a time when tattoos were frowned upon in Mexico and although they were never officially banned, the police treated us as if it had been. It was a common practice

1, 4 Mictlantecuhtli – an Aztec god of the dead
2 Pre-Hispanic feathered serpent deity Quetzalcoatl
3 The three stages of existence: youth, old age and death

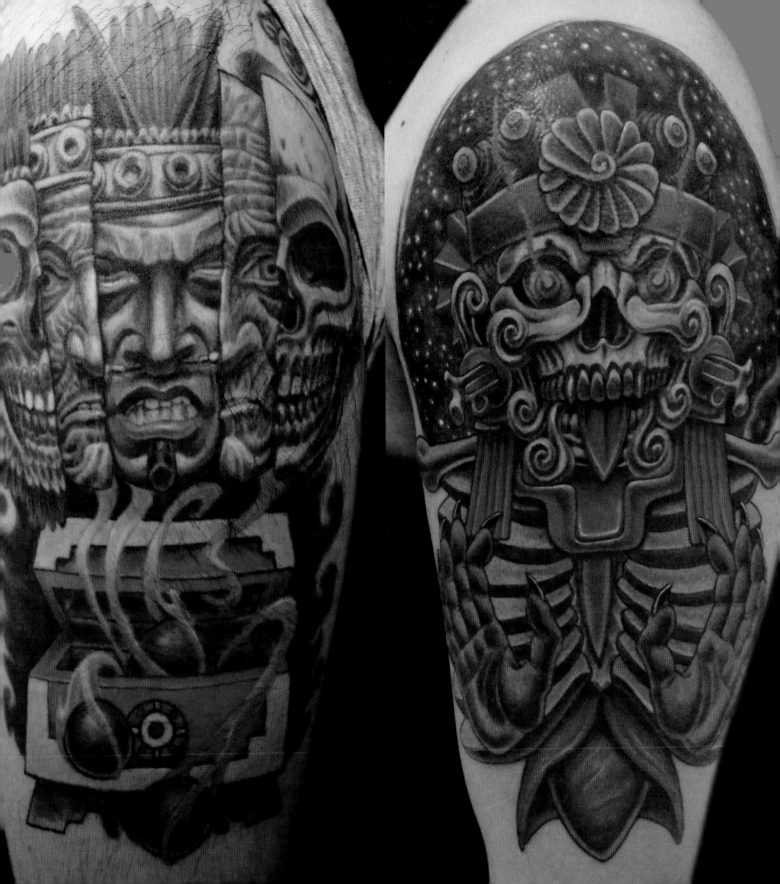

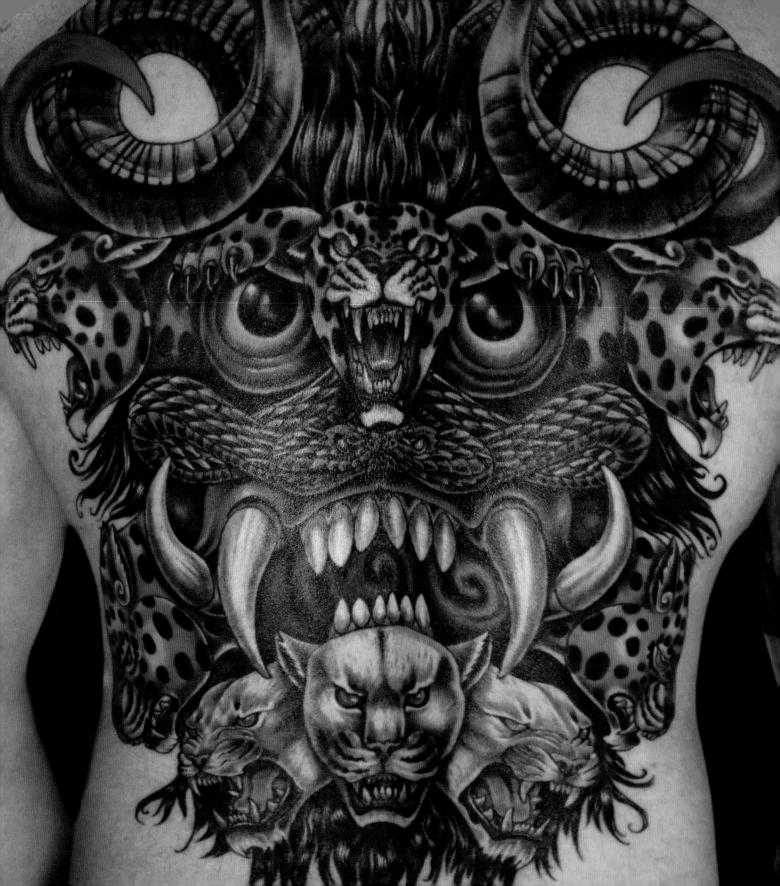

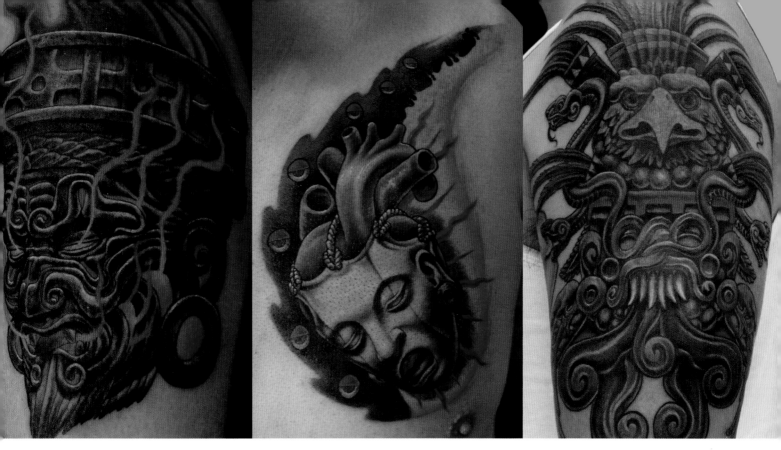

5 The devil of Teloloapan 6 Aztec deity Xiuhtecuhtli, the lord of fire 7 Aztec deity Xipe Totec merged with a human heart 8 Aztec rain deity Tlaloc with bird headdress

to stop us in the streets for simply having visible tattoos. At that time I never imagined I would become a professional tattoo artist, there were no tattoo studios in Mexico, and I virtually didn't charge for them.' He traded tattoos for supplies and meals and 'devoted myself for years to do illustration, scenery backdrops and murals to make money while still tattooing as much as I could'. The year 1994 marked the first that he could 'live 100 per cent [from] tattooing' since few tattoo clients existed in Mexico before then. He now works out of a private studio, by appointment only.

Alvarez relates his technique to traditional tattooing; he uses well-defined black borders that contain each colour: 'I prefer this style because it is similar to that made by the ancient pre-Hispanic *tlacuilos* (painters).' He cites Filip Leu, Shige, Jeff Gogue, Stéphane Chaudesaigues, Sailor Jerry and Ed Hardy as tattooers that he admires. From a design standpoint, he enjoys the challenge of tattoos 'integrated to the human body, tattoos with motion or adapted to the shape of different parts of the body. There is a recurrent subject in Aztec or Mexican art, in particular, which places faces of mythical animals or skulls on joints like elbows, knees or shoulders'. He incorporates contemporary elements, as well as art from other cultures, in his work: 'In terms of artists I like those of the Mexican muralist movement, especially [David] Siqueiros and Jorge González Camarena. I have also been influenced by H. R. Giger's art and rock album covers from the 1970s and 1980s and comic books. I like the art of Hinduism and Buddhism.'

Alvarez acknowledges that his neo-Aztec imagery goes beyond Aztec culture to a wider mix of pre-Hispanic societies. He explains why he dedicates time to research ancient Mexican culture: 'I am aware that . . . no one can know exactly what was the philosophy and cosmology of the ancient Mexica or Maya So I try to build a new current version inspired by what we know about the past, but adapted to our times.' AFF

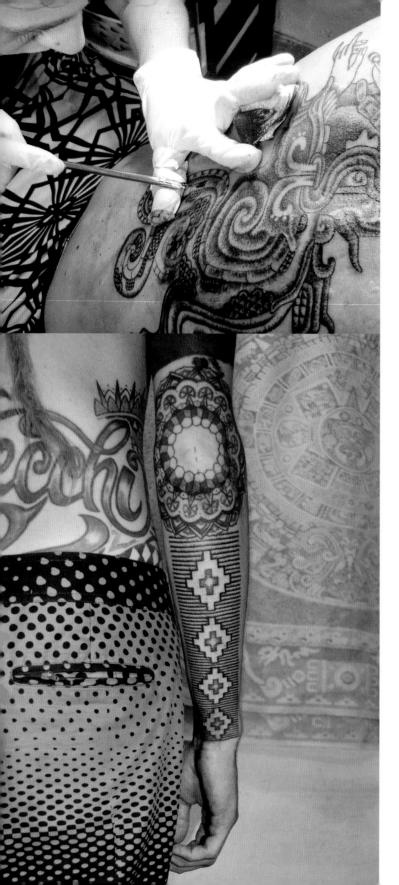

STYLE BLACKWORK **INFLUENCES** ANCIENT MEXICAN CULTURE, SACRED GEOMETRY **LOCATION** PALENQUE, CHIAPAS, MEXICO

SANYA YOUALLI

Born in Slovenia in 1979, Sanya Youalli has become an unexpected face of the revival of indigenous Mexican tattoo traditions. Her contemporary dotwork pieces, inspired by a range of ancient Mexican cultures, including Olmec, Mayan, Toltec, Aztec, Totonac and Zapotec, are painstakingly rendered with hand tools in sessions infused with ritual practice. Her passion for reviving lost traditions started after she studied pre-Hispanic culture and learned that tattooing in Mexico had disappeared over a century ago; she then 'received the calling of reviving lost tattoo ancient techniques'. In a global fusion, she weaves elements, such as Mayan glyphs and calendrical symbolism, with forms derived from nature and sacred geometry-like mandalas.

Youalli's approach to tattooing reflects a deep spirituality and sense of calling. Referencing a statement made by the last Aztec ruler Cuauhtémoc in 1521, she believes that 'reviving this

1 Youalli working by hand 2 Lower arm incorporating mandala and textile-like pattern 3 Pre-Hispanic character with geometric background

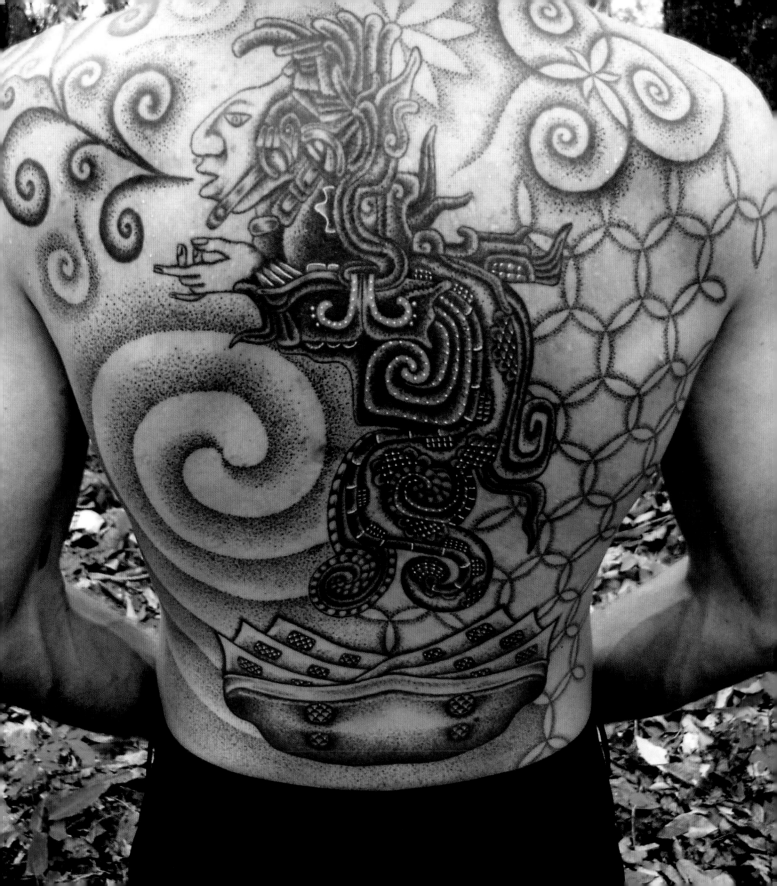

4 Collar referencing archaeological patterns
5 Geometric collar evoking nets or baskets 6 Mandala-inspired design bridging the two halves of the body
7 Mandala-inspired design highlighting body meridian

lost knowledge is part of a prophecy, which is fulfilled by the return of the ancestral ways and the identity expression of the people and their connection to the spiritual realm in the modern society as a metaphor of grandfather sun showing his face again.' Youalli considers 'the body as a temple of the soul and the skin as the canvas'. As such, she works with her clients to create custom pieces that act 'like feng shui on the body' to 'protect, heal or mark important events in our life'. One particularly memorable piece for her involved tattooing over an extensively scarred back where the tattooing served as both therapy and adornment. Other pieces carefully delineate or emphasize the natural divisions of the body.

Her artistic journey began with performing at fire shows and in theatres and this early improvisatory nature clearly informed her tattoo path. In 2002 'destiny', as she describes it, brought her to Mexico where she met body piercer Samuel Olman and became interested in tattooing. She began tattooing with

a machine, but shortly after starting she received a bamboo tool from a friend that inspired her to craft handmade steel tattoo tools. Intuitively, she began to use these new implements to render pre-Hispanic-style designs via a *tebori*-like technique. She later created tools from bamboo, wood and stone, and developed a hand-poking technique to achieve a dot style.

Tattoo sessions with Youalli involve 'ancestral elements like the burning of copal [a sacred tree resin] and traditional healing music during the whole ceremony'. That she considers her tattoo sessions ceremonies illustrates the reverence she has for the process and connecting to historical roots. However, as a modern innovator, if a design calls for it, she does not hesitate to use technology, such as computer design programs to assist in the artistic process. She currently lives and works in Palenque, Chiapas where she enjoys working in a 'in jungle atmosphere surrounded by nature' with the mystical Mayan archaeological site nearby for inspiration. **AFF**

STOMPER

Genaro David Gallegos – better known in his native Guadalajara in Mexico as Stomper – translates the compositional rules of graffiti art into a personal, stylized form of tattoo realism. He says of his style: 'I approach realism in portraits with the belief that I can always try to put in some of my style and merge techniques.' His colour tattooing incorporates a rich, painterly influence, while Stomper's black and grey work connects his story to that of his American heroes, Jack Rudy and Paul Booth.

Born in 1978, Stomper grew up in the impoverished barrio of San Andres in Guadalajara. Drawing offered an escape, and in 1992 he became engaged in the nascent local graffiti scene. 'I think graffiti was what led me to art and thanks to that I had a better idea about the combination of colours and techniques,' says Stomper. His chosen subject of demon faces emerged because he did not want to depict only 'the neighbourhood streets, or the kind of life which occurred in Mexico'.

In 1994 a graffiti writer friend, Kruel, introduced Stomper to tattooing through a home-made machine. 'At first I did not take much notice, but eventually I realized that there was another world and I slowly went deeper,' Gallegos explains. The opportunity of an apprenticeship in Puerta Vallarta strengthened his interest and paved the way for his true career. 'It was 1997,' he recalls. 'I learned about welding needles, serving customers, shading techniques, applying more colour in skin, hygiene and using professional machines.'

Despite international recognition for his shop, Stomper Tattoo, he remains confident that 'humility is the key to getting ahead', and is dedicated to 'raising awareness about the talent in Guadalajara'. His style connects directly to global trends, which makes Stomper perfectly positioned to push Mexico's tattoo culture forward. NS

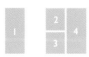

1 Glamorous female face 2 Classic vintage pin-up
3 *Shishi* sculpture 4 Female portrait with autumn leaves

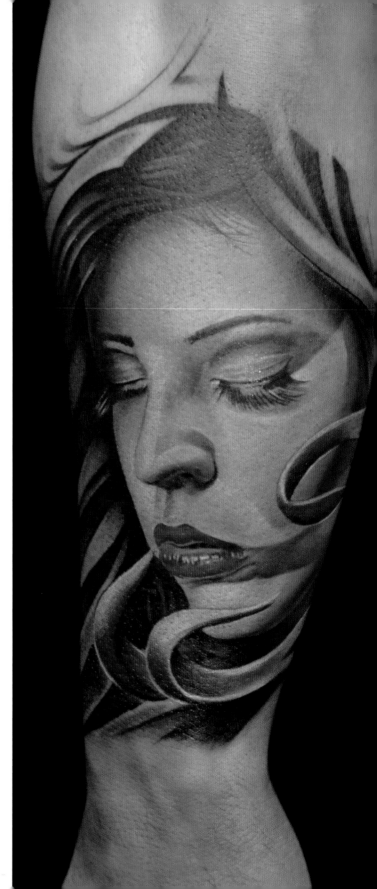

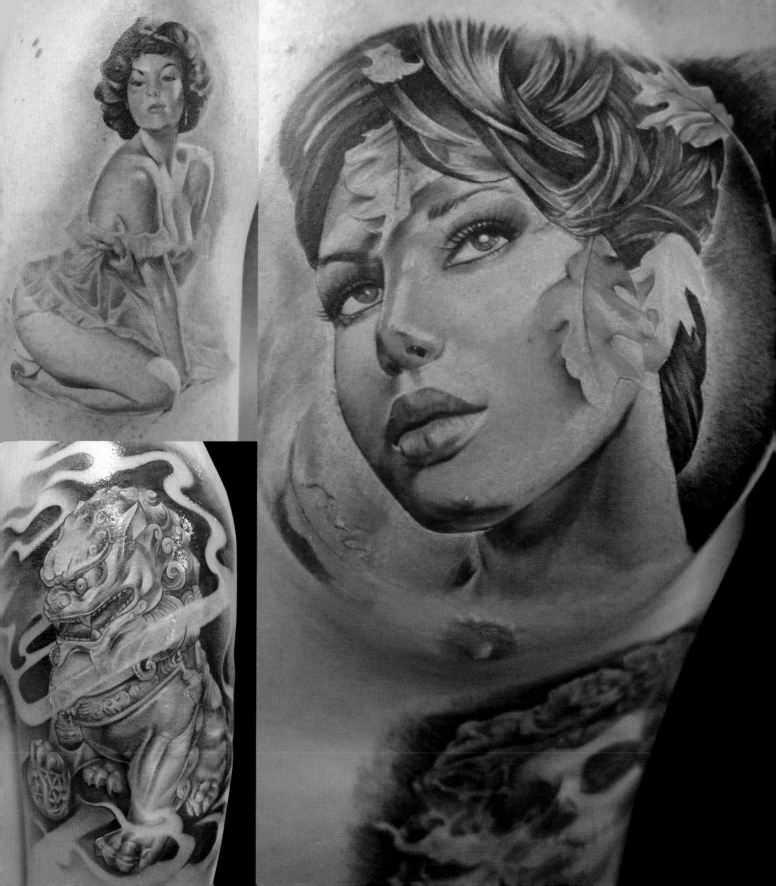

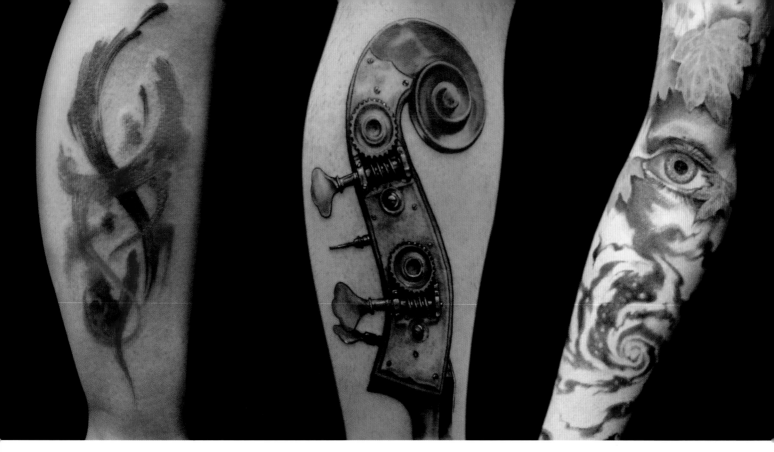

DANIEL CAMPOS

Daniel Campos' tattoos reflect his varied history in the art world: black and grey, realism, colour work, including the new watercolour style, even the occasional blackwork piece. Born in 1974 in Concepción, Chile's second-largest city, Campos began tattooing in 1997 while at art school. First he learned from a travelling tattooer who passed through town, and then he received tips from Italo Sepulveda with whom he opened a shop in 2007 and who served as a mentor to him. He pondered a move to the capital, but decided against the 'constant exodus of talent in search of better opportunities in Santiago'. In 2009 he opened his own shop, 13Agujas Tatuajes & Gabinete de Arte. After an earthquake partially destroyed his studio in 2010, Campos rebuilt it and currently employs two other artists and an apprentice.

Campos is also a printmaker and performance artist who uses tattooing as part of his live work; he has also worked in design for print media and as a creative consultant for 'everything from stage design for TV and theatre to commercial illustration'. This versatility clearly manifests in the range of tattoos he produces. Campos' philosophy makes his clients' needs, rather than his signature style, paramount: 'I strive to provide the best possible experience and make the person feel secure and relaxed . . . I will refuse to start tattooing and look for alternatives and different approaches until I see that look of enthusiasm and anticipation that tells me that I have been able to connect and fulfil the expectations of the client.' AFF

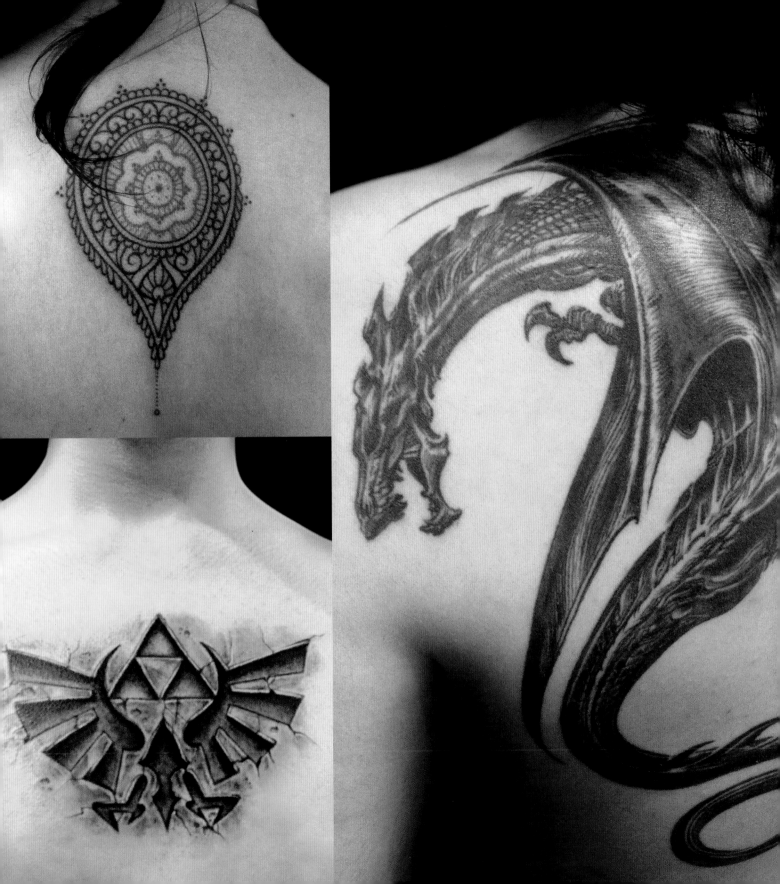

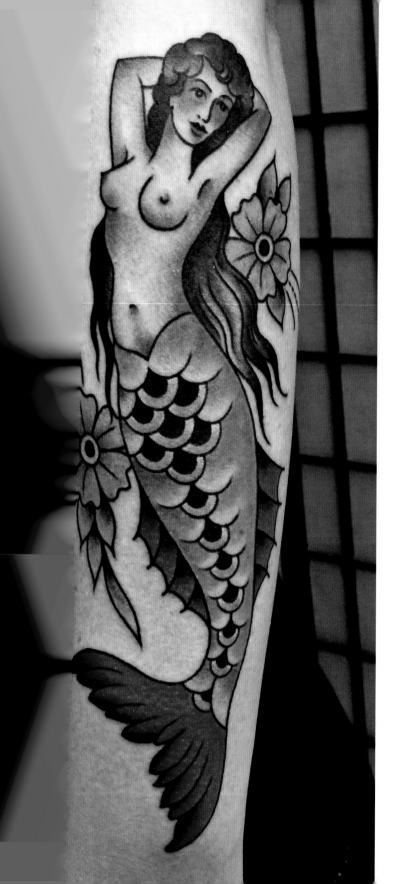

STYLE OLD SCHOOL, CONTEMPORARY
INFLUENCES TRADITIONAL AMERICAN TATTOOS,
ILLUSTRATION **LOCATION** RIO DE JANEIRO, BRAZIL

HENRIQUE MATTOS

Through his tattoos, Henrique Mattos extends and evolves the work of the classic masters of traditional American tattooing: Cap Coleman, Paul Rogers and Sailor Jerry, to name only a few. His anchors, beautiful ladies, roses and tigers have the majesty, character and deep nostalgia of old school style, but he reinterprets and revives them through a broader palette and with subtle shading and transitioning between colours. Mattos truly celebrates the past using present-day inks, techniques and objects. His bold black lines, beautiful bright saturated colours and delicate shading come together in diverse designs featuring perfume bottles, ornate gold filigrees and frames, Sugarloaf Mountain, teacups and even fine art paintings by the Belgian surrealist, René Magritte.

Traditional tattooing has a double significance for Mattos: he loves the iconic imagery, but also the lifestyle of the traditional artist who wanders the world. He writes: 'I really like the bohemian [life]; it fits my personality.' Mattos is a self-taught artist who has made tattooing his life; he has pursued no other career. From the beginning, he was strongly influenced by innovators of the traditional style, particularly Lango in San Francisco and Marcos Ribeiro in London, both natives of Rio. Meeting these artists in the mid-1990s changed his life and cemented his passion: 'I became . . . really inspired by them, I tried to follow in their steps, which means not only being an outlaw tattooist but [being] interested in art and culture, and always pushing ourselves to a higher level. Basically, that's what I'm still trying to do today. Their generation and mine changed tattooing in Brazil: it's not an underground kind of living any more.' KBJ

1 Classic mermaid with flowers 2 Tropical scene merged with traditional anchor 3 Montage of René Magritte images 4 Portrait of an elegant lady with cat 5 Traditional tiger with roses

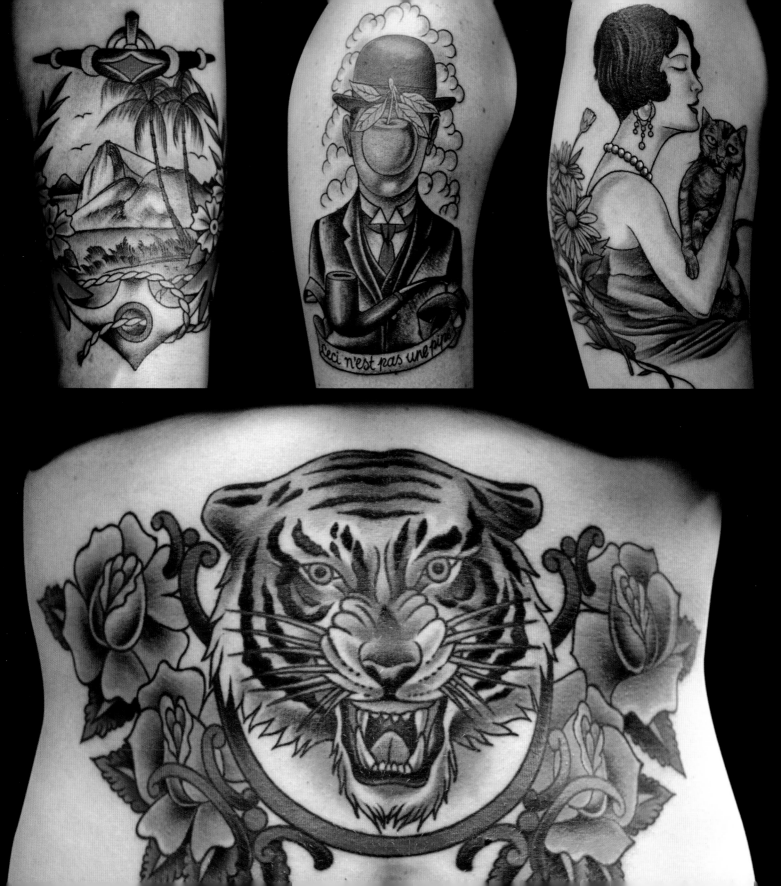

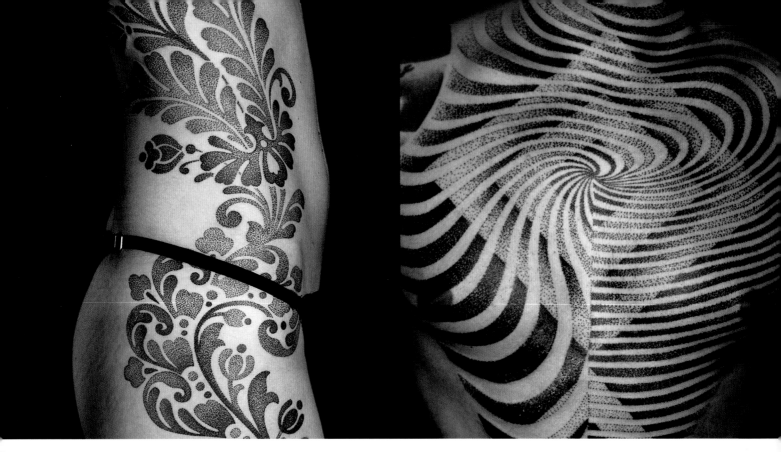

1 Foliate design rendered in dotwork 2 Geometric shapes that highlight regions of the body 3 Sleeve with designs evoking sacred geometry and indigenous tattooing

NAZARENO TUBARO

Nazareno Tubaro crafts impeccable contemporary blackwork tattoos. Born in Bahia Blanca, he began tattooing in 1994, before the art form had gained a contemporary footing in South America. He studied art at IUNA (Instituto Universitario Nacional de las Artes). Tubaro cites Ivan Szazi as his biggest mentor; although Szazi works in a different style (Japanese), he taught him about scale, technique, design and how to run a studio. Tubaro has travelled widely and the anthropological material he has seen in many of the world's museums has influenced him. In Borneo, he got a hand-tapped tattoo that he cites as a significant moment.

Tubaro's early work focused on blackwork, contemporary 'tribal' designs in particular; in 2007 he added dotwork to his repertoire. Many of his tattoos incorporate geometric designs that reflect a mix of mathematics and indigenous non-Western designs; the hard edges of the lines and angles contrast with more graceful, curvilinear forms. His influences range from South Asian mandalas and floral designs to indigenous art, including pre-Hispanic and Oceanic. In contrast to dotwork that has a feminine, gently flowing feel to it, Tubaro's version is more hard-edged. The emphasis shifts to the edges of the forms he inscribes with the dots acting as shading, which is reminiscent of the interplay between lines and shading in old school Western tattooing. He describes his philosophy as relating to 'simplicity (minimalism), an open mind, travelling' and that one should 'work only with black and . . . the flow of the body'. AFF

STYLE REALISM, BLACK AND GREY

INFLUENCES BIOMECHANICAL ART, SURREALISM, HORROR

LOCATION BOGOTÁ, COLOMBIA

1 Animal skull with rose and smoke 2 Rabbit clutching skull with roses 3 Biomechanical face with demon lurking above 4 Jungle scene with leopard, snake, parrot and flowers

MIGUEL DARK

Among many notable artists on the burgeoning tattoo scene in Colombia's Bogotá, Miguel Bautista (known as Miguel Dark) stands out for his blend of realism and biomechanical imagery infused with an elegant creepiness. Born in 1977, Dark began his path to becoming a tattoo artist when he was sixteen. He learned to tattoo while working in two Bogotá shops, and at the second one, Store Tattoo, he met Julio Díaz and Joaquin Forero, who he says, 'helped me develop as an artist'. He then began to focus on his passion for black and grey, realism and biomechanical.

Dark's tattoos expertly capture the dark ethos of the artists who inspired him, such as Paul Booth, Robert Hernandez, Tommy Lee Wendtner and Victor Portugal (see p.204). Some of his works reflect classic biomechanical scenes inspired by H. R. Giger. His

work often blends horror with surreal or unlikely elements, as in one piece in which a sinister, yet still somehow cuddly, rabbit clutches a skull. The rabbit's red eye visually connects to roses that are beginning to melt into blood. Other pieces show a more abstract, atmospheric style – for example, an arm piece of an animal skull with a rose shrouded in smoke that frames the central motif with blackwork-like geometric swirls.

Dark works at Acid Ink with a group of talented artists whose philosophy has always been 'to create new designs and not to copy or reproduce the tattoos . . . in magazines or on the internet'. He notes that Colombia's tattoo scene rivals those elsewhere, with 'many artists and shops that generate a level of competiton among ourselves so that we have nothing to envy in the tattoo scenes of other countries of the world'. Dark tries to steer his clients 'towards good design taking into account the ideas they bring, always wanting to make original designs'. This interplay between client and artist shines through Dark's tattoos. AFF

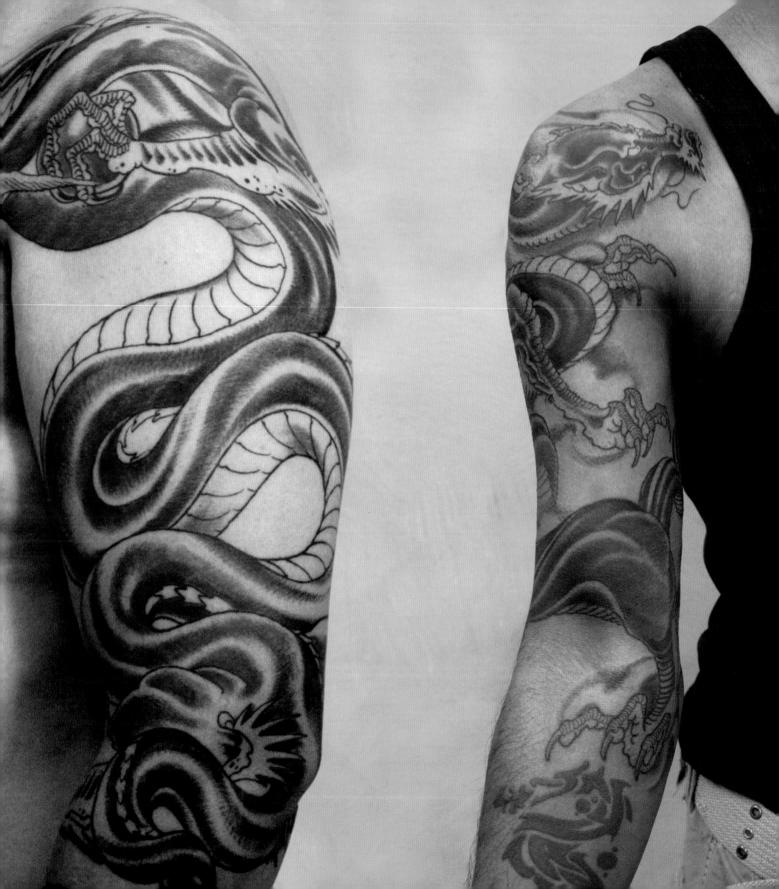

PIERRE BONG

Suriname, a tiny country on the north-eastern edge of South America, might seem an unlikely place to find elegant Japanese-influenced tattooing. Yet Pierre Bong, who was born there in 1975, has carved a unique niche for himself, creating limited-palette custom works in black and grey, with occasional touches of colour, such as burgundy red. In the 1990s, Suriname had no electrified tattoo shops. Bong explains: 'My neighbourhood buddies (who knew I could draw) used to ask me to do drawings on them, to be tattooed elsewhere (by needle and thread). That's how my "tattoo journey" kind of started.'

Bong then became interested in learning how to tattoo by machine. He began to purchase equipment from mail order supplier Spaulding and Rogers, and taught himself the art form. Reading tattoo magazines, such as *Outlaw Biker Tattoo Revue* and *International Tattoo Art*, introduced him to work by the Leu family, who became an enormous influence for him. He enthuses: 'They just command respect, they have such a positive vibe about them.' Bong currently tattoos out of his home and studio by appointment. Besides tattooing, he continues to build custom machines and enjoys painting dream-like canvases that meld tropical colours and Surinamese mythology, flora and fauna with tattoo aesthetics.

Bong sums up the particular appeal of Japanese tattooing for him: 'The way [Japanese artists] play with the width of the lines, how the lines live, the subtle gradations in black, the way the backgrounds play an equal part as the subject in the total tattoo . . . the total composition on the human canvas.' Joking that 'bigger is better', he elaborates by adding: 'Usually when I have to do a small tattoo, I feel like I cramp up, I have to remind myself to relax while doing the tattoo, whereas I am naturally at ease when doing a large piece. And I experience that as freedom.' AFF

1–2 Dragons entwined around arms
3 Buddha with lotus flowers and waves

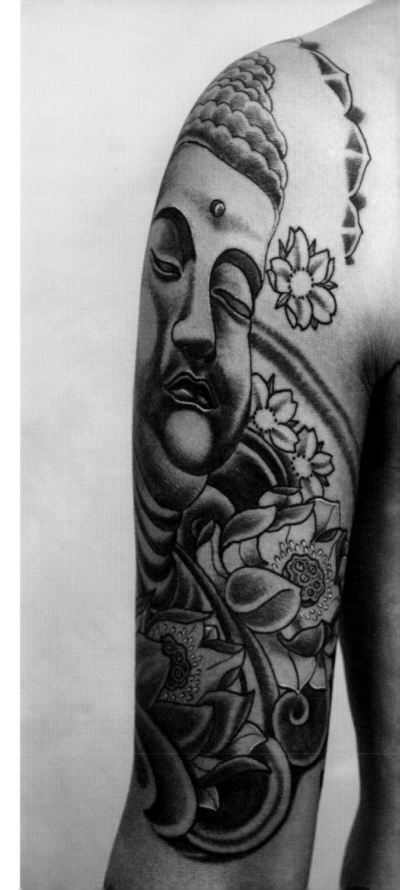

EUROPE

LUXEMBOURG CITY POISSY OPORTO VENICE ATHENS
MADRID LONDON TENGEN BERLIN HAMBURG WÜRZBURG
AMSTERDAM TØNSBERG COPENHAGEN BUDAPEST
ST PETERSBURG WARSAW KRAKÓW ZAGREB

DAN SINNES LIONEL FAHY MIKAEL DE POISSY NUNO COSTAH MASSIMILIANO 'CREZ' FREGUJA SAKE
DENO CHRIS LAMBERT CLAUDIA DE SABE LITTLE SWASTIKA PETER AURISCH CARO WILSON
SEBASTIAN WINTER SIMONE PFAFF AND VOLKER MERSCHKY SUSANNE 'SUSA' KÖNIG RICO SCHINKEL
COLIN DALE RÓBERT BORBÁS DMITRY BABAKHIN KAROLINA CZAJA VICTOR PORTUGAL ZELE

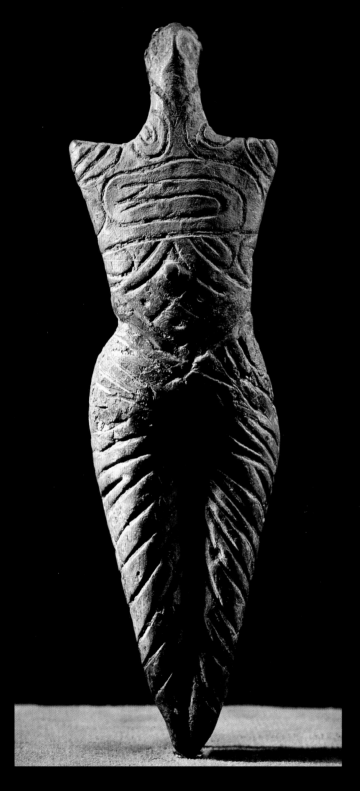

Tattooing in Europe has had a dynamic history as empires changed, populations fluctuated and social forces (particularly religious and academic) influenced cultural practices. Some of the earliest evidence for tattooing has been found in Europe and, despite a common perception about European tattooing 'disappearing' at some point in the historical record, research keeps revealing new evidence to construct a continuous history. French explorer Charles Pierre Claret de Fleurieu, writing in 1791, noted that modern European tattooing was not only common, but of great antiquity: 'We should be wrong to suppose the tattooing is peculiar to nations half-savage; we see it practised by civilized Europeans; from time immemorial, the sailors of the Mediterranean, the Catalans, French, Italians and Maltese, have known this custom, and the means of drawing on their skin, indelible figures of crucifixes, Madonas [sic] &c. or of writing on it their own name and that of their mistress.'

Tantalizing evidence from the Upper Paleolithic era indicates possible prehistoric tattoo traditions in many places in Europe. Figurines with incised lines on the body may represent tattoo marks or other forms of body modification. Famous artefacts such as the Löwenmensch (Lion Person) from Stadel-Höhle, Germany – Europe's oldest anthropomorphic artefact at approximately 40,000 years old – bear such designs. Other sculptures that might show tattoos include the Venus of Hohle Fels, which is c. 35,000 to 40,000 years old, and the many Cucuteni-Tripolye figurines from western Ukraine and north-eastern Romania from the 4th and 5th century BCE (see image 2). Feasible tattoo tools dating from 12,000 years ago were found in France's Grotte du Mas-d'Azil caves.

Ancient Tattooing

The earliest incontrovertible evidence of ancient tattooing in Europe can be found on the body of a famous mummy – Ötzi the Iceman – discovered by hikers during an ice melt in the Italian Alps near the border with Austria in 1991. Dating to c. 3,300 BCE, he wears sixty-one small tattoos that appear to be therapeutic in nature. Many of the tattoos correspond to anatomical changes in the body due to disease, which were seen during imaging sessions to investigate the corpse for clues to his life and death.

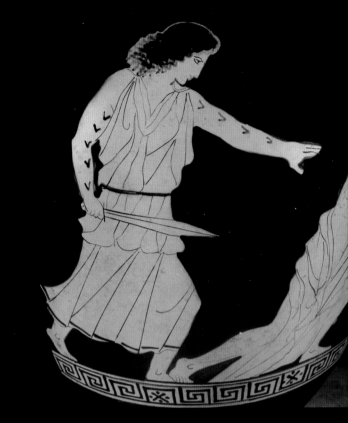

In the classical world, tattooing was practised in both ancient Greece and Rome, particularly with regard to the penal marking of slaves and criminals, often on the forehead. When the Roman Empire adopted Christianity, penal tattooing was criticized, but not prohibited. In order to preserve the sanctity of the face, Constantine the Great banned facial tattooing and suggested marking the hand or leg instead. His edict from the year 316 CE states: 'let him not be marked on his face, since the penalty of his condemnation can be expressed both on his hands and on his calves, and so that his face, which has been fashioned in the likeness of the divine beauty, may not be disgraced'.

Romans also practised a form of military tattooing. Vegetius, writing in the 4th century, noted that legionnaires and auxiliaries in the Roman army 'should not be tattooed with the pin-pricks of the official mark as soon as he has been selected, but first be thoroughly tested in exercises so that it may be established whether he is truly fitted for so much effort'; this suggests that the tattoo mark was an important badge of honour. Romantic tattoos were also present in ancient Rome. St Basil the Great, the 4th-century bishop of Caesarea, is said to have condemned the tattooing of a lover's name that he observed on someone's hand.

Among the so-called 'barbarian' peoples of Europe, tattooing was documented on Thracians and depicted on Greek pottery as geometric marks on women's arms and legs (see image 3). Celtic peoples, such as the Gauls, may have also engaged in permanent body marking; Roman coins show Gallic people with marks on their cheeks of geometric, animal and plant-like motifs, although it is unclear by what method these designs were rendered (see image 4). The Picts, another Celtic group, are often cited as having had tattoos that were famously depicted in ahistorical drawings by illustrators John White and Jacques Le Moyne de Morgues. In fact the Picts may have actually engaged in body painting or branding; if they tattooed, their marks certainly did not look like Renaissance floral and zoomorphic illustrations. Celtic tattoos associated with modern (technically Gaelic) Irish culture did not emerge from historical practice, although the popular neo-Celtic tattoo movement has created new traditions for those who want to celebrate this cultural heritage using images derived from art forms such as illuminated manuscripts.

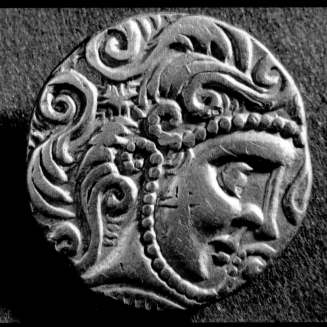

5 Heinrich Seuse as envisioned in a painting by Francisco de Zurbarán, 1636–38
6 Pilgrimage tattoos on German diplomat Heinrich Wilhelm Ludolf in an anonymous early 18th-century portrait **7** Traditional Croatian tattoos (top) with contemporary Croatian revival tattoo (bottom)

Christian Tattoos

The myth that tattooing disappeared from Europe during the Middle Ages due to religious edicts is contradicted by evidence that tattoos were present on different types of Christian bodies. What was discouraged in the mid-8th century was 'heathen' tattooing, which attests to its presence in Europe at that time. Christian tattooing in the Holy Land began as early as the 6th century. In Europe, Crusaders had small crucifix marks (which may have been brands or another form of body modification) inscribed on their wrists to identify themselves as Christian.

Penitent practice also occasionally involved tattooing; in the 14th century Heinrich Seuse (Henry Suso) pricked a Christogram on his chest as a sign of his devotion to Jesus (see image 5).

From the 16th century and through to the 19th century, ample evidence of tattoos on pilgrims to the Holy Land appeared in print and image (see image 6), which may have encouraged secular tattooing on home soil. Many of these accounts offered details about how tattoos were rendered, perhaps inspiring others to mark themselves, and discuss travellers recruiting their tattooers to craft customized,

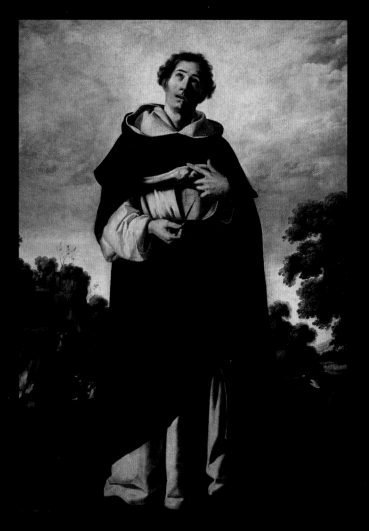

non-religious designs. Scottish traveller William Lithgow published a thorough account of his tattoo session in 1612 (alongside illustrated reproductions of the designs) in which he received a traditional Jerusalem cross tattoo; he also had the artist add a crown honouring King James I with the motto 'Vivat Jacobus Rex'. The next day he returned to the artist to have several lines of text inscribed in celebration of his ruler. Pilgrimage tattoos took place on European soil as well. In Loreto, Italy, from the 16th century, a vibrant devotional tattoo tradition inscribed images similar to the ones that the faithful received in the Holy Land, in addition to portraits, pictorial memorials to the dead and marks of romantic love.

In the Balkan region, a long history of tattoos has been documented on Catholic women, especially in Albania, Bosnia and Croatia (see image 7). These tattoos appear to be heavily syncretic and blend motifs derived from Roman Mithraic symbolism with tattoos found on indigenous Middle Eastern groups, such as the Kurds. As such these tattoos may predate their eventual Catholic affiliation, perhaps even reaching back to Thracian women's practice. Balkan tattoos share significant similarities in both aesthetics and meaning to Middle Eastern and North African tattooing; black, geometric forms on the hands, arms, chests and faces of women often served a talismanic function. Balkan women also wore tattoos to signal their religious identity as Christians, perhaps in contrast to the majority Muslim population, some of whom presumably wore traditional Bedouin designs. The past decade has seen the start of a revival of these Balkan tattoos, which are being inscribed as marks of cultural heritage, often with a non-religious meaning.

Secular Tattoos

At the same time that Europeans were inscribing marks of faith, they were also getting a host of designs related to everyday life, particularly initials, names and other small motifs. Women also received tattoos, although they are mostly absent from the archived documentation that usually surveyed men's bodies; a print from 1773 shows a female fishmonger with initials and a date tattooed on her wrist.

Travel accounts frequently document people of European heritage getting Western tattoo designs from indigenous practitioners. Monsieur Dièreville, a French surgeon who spent a year travelling in Acadia in 1699 on a mission to establish

trade connections, related that: 'Many Frenchmen have undergone the ordeal who could provide evidence of it; for myself, I am not curious to wear such marks.' He described the images that the French had tattooed as 'all types of images, crosses, the name of Jesus, flowers' and further notes that 'these marks can not be erased'.

Another source for early tattoo descriptions are newspapers from 1730 onwards, which feature announcements of criminals and their crimes together with advertisements for runaways

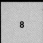

deserters and escaped convicts. One particularly detailed example, from the *Newcastle Courant* of 27 January 1739, described an English thief as having 'on his Breast mark'd with Indian ink, the Pourtraiture of a Man at length, with a Sword drawn in one Hand and a Pistol discharging Balls from the Muzzle in the other with a Label from the Man's Mouth, God damn you, stand.'

Much of the documentation of this secular practice comes from the surveillance that recorded marks on the bodies of sailors and prisoners. This therefore fuelled the common perception in Europe from the mid-18th to late 20th centuries that associated tattooing with the maritime or criminal worlds. These populations probably did have a higher percentage of tattooed individuals, due to various psychological and cultural factors, but a range of other people also had their bodies inscribed. From the 1760s, European (especially British) ships' crew lists, surveys of dock workers and prison rosters record numerous identificatory tattoos, including initials, names and crosses, but they also record description of a wealth of elaborate, pictorial tattoos. Therefore the Description Books for dockyard workers at Deptford, England, which began being recorded in 1765, noted that shipwright John Hoxton 'has St George mark'd on his right arm,' while sawyers William Henry and Thomas Towning wore their initials, respectively, 'Markd WH right hand' and 'Markd TT rt hand'.

One of the most famous lists that records sailors' tattoos came from William Bligh after the mutiny of his ship HMS *Bounty*. His 'Description List of the Pirates' provides many descriptions of tattoos, some clearly Pacific Islander in nature, but many with obvious Western origins. In one example, Bligh described seventeen-year-old Peter Heywood as being: 'very much tatowed. On his right leg tatowed the three legs of the Isle of Man, as upon the coin'. A particular treasure trove of tattoo descriptions appeared after 1836 when Britain formalized the recording of crew lists in printed Description Books, which had columns specifically allocated for the recording of tattoos as a means of surveillance and identity attribution.

Criminology and Social Perceptions

Towards the end of the period marked by European colonialism and missionary activity that destroyed many of the world's indigenous tattoo traditions, tattooing suffered a further setback with the emergence of a scholarly line of inquiry based on the pseudo-sciences of eugenics and anthropometry, which asserted that tattoos were one of the definitive characteristics of criminal personalities. Given that criminologists, such as Alexandre Lacassagne in France and Cesare Lombroso in Italy, almost completely confined their inquiries to those in prison or institutionalized for mental illness, it is not surprising that they reached conclusions that were derogatory to tattooing. This 'research' and the publicity surrounding it resulted in a dark period for tattooing in Europe and the United States. Lingering stigmas damaged the reputation of tattooing in continental Europe more than elsewhere, with the percentage of tattooed people per capita falling behind that of the United Kingdom or the United States, a phenomenon that persists today.

Italian criminologist Cesare Lombroso perhaps caused tattooing the worst damage with his patent abhorrence of the practice, which he popularized widely through his many articles and books and in press coverage of his work (see image 8). Writing in 1896 he warned people to avoid tattooing at all costs, noting that 'when the attempt is made to introduce it into the respectable world, we feel a genuine disgust, if not for those who practise it, for those who suggest it and who must have something atavistic and savage in their hearts. It is very much, in its way, like returning to the trials by God of the Middle Ages, to juridical duels – atavistic returns which we can not contemplate without horror'.

These caustic perceptions of tattooing drifted far beyond the small world of criminology. In his design treatise *Ornament and Crime* in 1908, Austrian architect Adolf Loos castigated tattooing on Westerners, commenting: 'The modern man who tattoos himself is a criminal or a degenerate . . . Tattooed men who are not behind bars are either latent criminals or degenerate aristocrats. If someone who is tattooed dies in freedom, then he does so a few years before he would have committed murder.'

European prisoners did, of course, get extensively tattooed, especially in 19th- and early 20th-century France and most of 20th-century Russia. In both countries prisoners embraced tattooing to counteract the depersonalization of incarceration and to visualize social and political protest. French military prisoners in Biribi (Algeria) and Tataouine (Tunisia) in North Africa were extensively tattooed with images ranging from

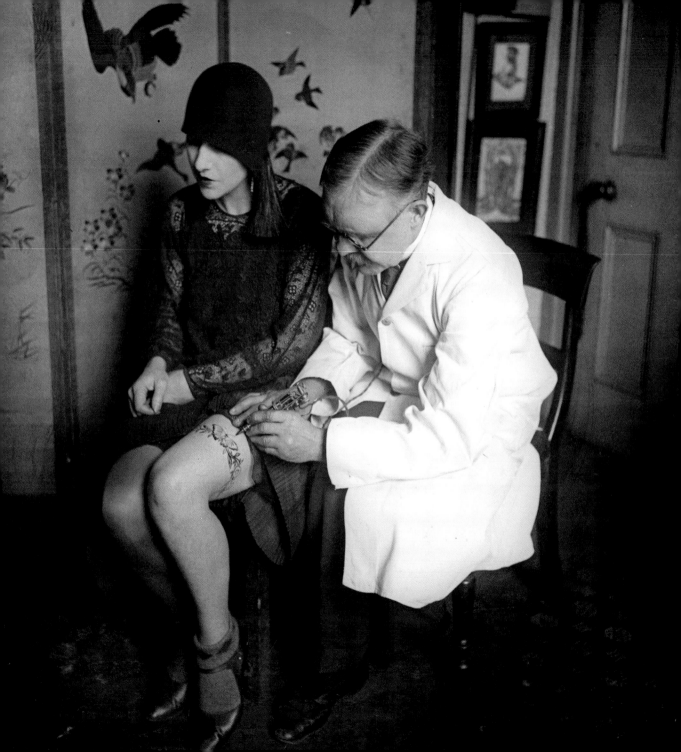

George V) and the Duke of Clarence (later Prince Albert) made headlines when they acquired tattoos while visiting Japan in 1881 (their father, Edward VII, had received a Jerusalem cross tattoo in the Holy Land in 1862, and the brothers also added to their tattoo collections when they passed through that region). Tsar Nicholas II of Russia and King Frederick IX of Denmark also sported body art among others at the most elite levels of society; many socialites also wore designs on their bodies.

Across Europe in the late 19th century, artists embraced the aesthetics of Japanese tattooing and incorporated them into what had previously been basic black line work images. Shading and colour became common and renowned artists, such as Sutherland Macdonald (see image 12), George Burchett and Christian Warlich, inscribed large pieces across the backs and chests of their clients; in addition to Japanese motifs, they often reproduced scenes from European paintings and prints or smaller images drawn from European decorative arts. Classic folk tattooing, which was deeply rooted in the maritime world, proliferated and flourished in Europe's port cities and urban areas. Artists such as Tattoo Ole (Hansen) in Copenhagen, Tattoo Peter in Amsterdam and Herbert Hoffmann in Hamburg were typical busy street-shop artists who enjoyed long, flourishing careers.

Like the United States and Canada, Europe had its fair share of heavily tattooed celebrities in the late 19th and early 20th centuries. Early public appearances by tattooed transculturites gave way to circus sideshow attractions, such as Captain Costentenus (whose Burmese-inscribed tattoos were validated by Austrian dermatologist Ferdinand Ritter von Hebra), who appeared at the London Aquarium before his subsequent move to the United States to work for Barnum. As with developments across the Atlantic, by the dawn of the 20th century, the tattooed attraction business largely became the purview of women, who emphasized their sex appeal (see image 13). In Europe, tattooed women performed at fairs,

of the legacy of shame about tattoos generated by 19th-century criminologists, combined with an aversion to tattooing stemming from the infamous concentration camp prisoner-numbering system during World War II. An exception was in the United Kingdom where Les Skuse founded the Bristol Tattoo Club in the 1950s. He connected with Japanese artists and generally tried to promote tattooing as a positive and artistic practice, as well as hosting what can be considered the first tattoo conventions.

Changing social mores of the 1960s and 1970s resulted in a renewed interest in tattooing by a broader cross section of Europeans, and new artists across western Europe were attracted to the profession by a ready clientele. By the late

1970s, the design revolution pioneered by the American tattoo renaissance soon trickled across the Atlantic after European artists began corresponding with people such as Ed Hardy and travelling to US tattoo conventions where they witnessed the exciting new movements in tattooing. Although European artists had already been gathering in small private groups to exchange inspiration, from 1984 Henk (Hanky Panky) Schiffmacher began hosting influential tattoo conventions in Amsterdam that were open to the public and helped give greater exposure to tattooing.

In the wake of changing cultural attitudes towards the human body and a broader customer base that included countercultural and subcultural individuals such as hippies and punks, artists

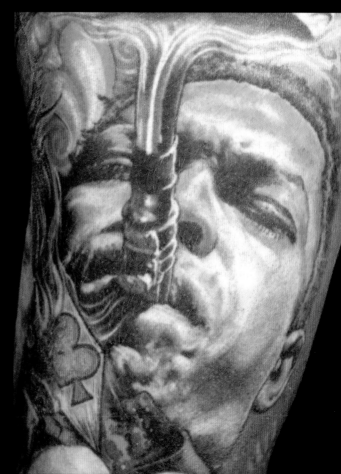

including Lal Hardy and Alex Binnie (see image 14) in the United Kingdom, Tin Tin in France, the Leu Family in Switzerland, Gian Maurizio Fercioni in Italy, Doc Forest in Sweden and Tato Svend in Denmark embraced the freedom to experiment with new motifs and techniques. Binnie can be considered the father of European blackwork because he pushed these new abstract geometric forms further than any other artist working in Europe at the time. Tin Tin and Felix and Filip Leu (see image 15) pioneered a new form of realism, different to the black and grey work that emerged from the barrios of the United States, which rendered portraits and other realistic scenes with heavily saturated colour. This work has been embraced and replicated worldwide and forms one of the major genres of tattooing today.

Tattooing in the 21st Century

By the end of the 1990s tattooing had become widespread around Europe, if not yet adopted by as large a percentage of the population as in the United States. Eastern Europe saw the most precipitous rise in numbers of artists and tattooed citizens, due to the spirit of experimentation and freedom embraced by youth culture in the post-Soviet era together with a near absence of non-prison tattooing during the years of Communist rule. Tattooed celebrities, especially sports stars and musicians, have, in recent years, inspired many Europeans to follow suit. As in the United States and Canada, tattooing has moved from being centred in major urban areas to a more widespread distribution with shops in small towns. French newspaper *Libération* estimated that the number of tattooers in France alone grew tenfold over the course of a decade, with around 4,000 artists working in the country today. *The Economist* calculated a 173 per cent increase in tattoo shops in Britain between 2003 and 2013.

Tattoo conventions now take place in most major European cities and attract large crowds. Today, per capita, the United Kingdom has been reported to have a higher percentage of tattooed citizens than the United States (where it is nearly one in four adults). The current British passion for tattoos reflects the country's history as the one place in Europe where tattooing continued to thrive during the mid-20th-century slump that became more entrenched elsewhere. Most other European nations now have significantly tattooed populations as well; a recent study in France found that 12 per cent of women have tattoos, whereas an estimated one in five people aged twenty-

five to thirty-four wear them. Given how long tattoo stigmas lingered, this represents an impressive overcoming of social taboos. Italy and Germany, in particular, have widespread tattoo cultures that have emerged in the new millennium.

In the 21st century, tattooing has become a viable option for self-expression throughout Europe with an incredible array of genres being practised. In addition to traditional 'Western' tattooing and contemporary styles such as realism and 'tribal' blackwork, one can find artists faithful to Japanese or Polynesian styles or inventing new traditions, such as the neo-Nordic movement. Tattooing may be more vibrant, more varied and present on more bodies than ever before in European history. **AFF**

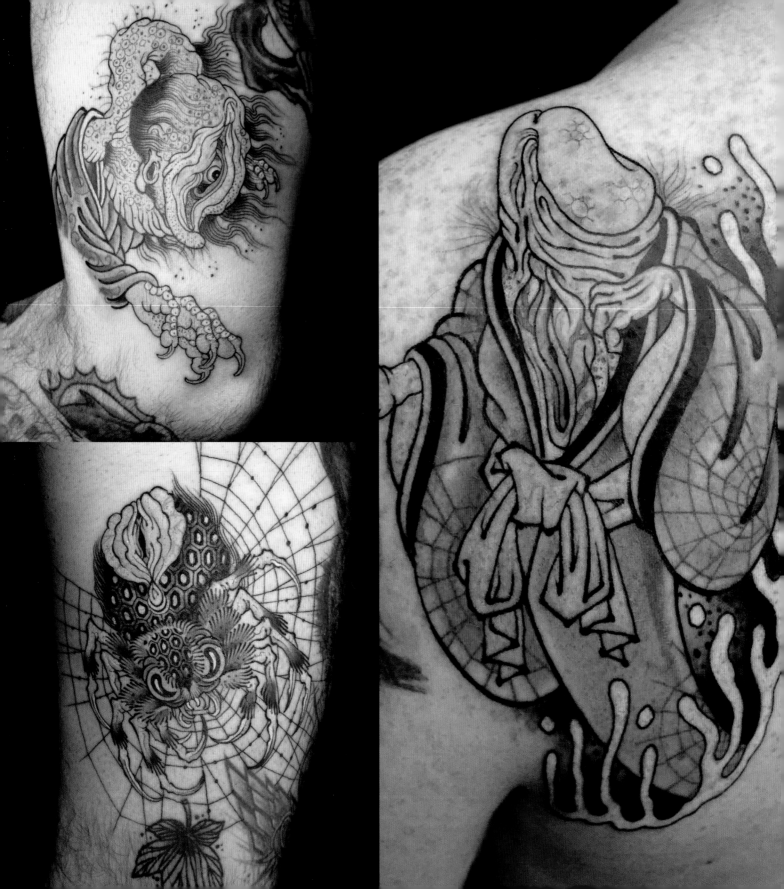

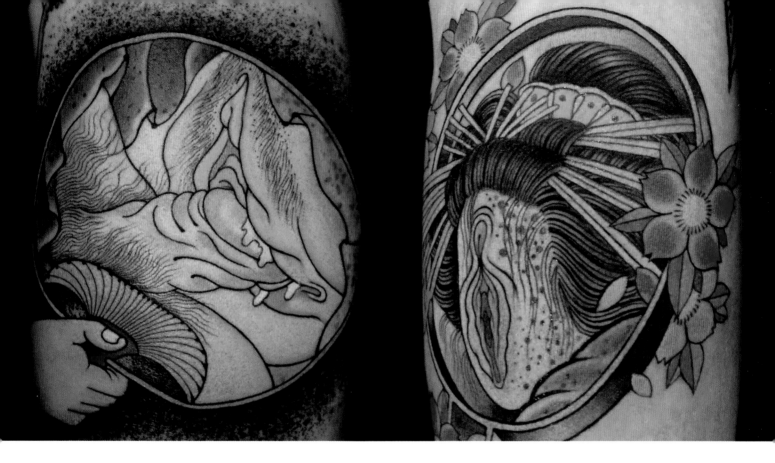

DAN SINNES

STYLE JAPANESE, CONTEMPORARY **INFLUENCES** *SHUNGA,*
JAPANESE ART **LOCATION** LUXEMBOURG CITY,
LUXEMBOURG

Dan Sinnes creates unique, often shocking tattoos inspired
by *shunga* – a style of Japanese erotic art usually produced as
woodblock prints. His meticulously crafted tattoos feature
images of people or animals that have penises or vaginas either
as faces or embedded within the design. Traditionally, *shunga*
depicts people engaged in sexual activity, usually fully clothed
but with exaggerated genitalia. Although the nude body was a
common sight at Japanese public baths, it was not usually
eroticized. The genitalia represent a 'second face' on the human
body that can express the primal passions that the human face
is required to conceal according to social customs. In a twist on
tradition, however, Sinnes uses that 'second face' in place of the
actual human or animal face.

Sinnes points out that *shunga* tattoos are not as common
as other Japanese tattoos. He was introduced to the idea of
tattooing these images by an older Swiss tattooer who

1 *Shunga* demon 2 Spider morphed with female genitalia
3 Hermaphrodite figure in kimono 4 Hand holding fan with
erotic scene 5 Mirror reflecting a geisha with genital-
transformed face

7–8 Tattoos inspired by classic Japanese print imagery: a monkey and an old man **9** Design blending classic Western motif with Japanese aesthetics: a panther with skull headpiece

7 8 9

inscribed one on him. He says that initially he 'didn't realize all the stories behind *shunga*'. He expresses a prosaic fascination with his theme: 'Genitals, it's a thing you're living with every day, we give it names, some love it, some hate it . . . some make songs about it.' Sinnes' *shunga* tattoos are usually small – he prefers 'one-shot' tattoos (rendered in one session) that are ideally suited to being inscribed on the convention circuit or at guest spots in other tattoo studios. Most of his *shunga* clients are other tattoo artists.

Although he also enjoys working in a more traditional Japanese style, one of the reasons he likes creating small genitalia tattoos is that he can 'find a little space to put something small and bold'. Sinnes essentially reinvents *shunga* in his tattoo work; he devotes time to looking at Japanese art and tattoos, and pushes the *shunga* image beyond its typical aesthetics. His colours are brighter and bolder, and he puts patterns within the tattoos that take

the genre outside its traditional parameters. Sinnes collects *shunga* images and Japanese erotic art books, as well as images of traditional Japanese tattoos. In Luxembourg he has a reputation for his traditional Japanese sleeves, as well as his script tattoos.

Sinnes started work as an optician as a way to make money to collect tattoos, before he took on a tattoo apprenticeship. Since 2000 he has been tattooing, working mainly in Luxembourg City, but he travels as much as he can. Sinnes says that he has learned the most through travelling and doing guest spots with other tattooers. Travelling gave him the opportunity to talk to other artists and observe their work, and he now opens his shop to fellow tattooers from around the world. He was first attracted to tattoos because he wanted to be 'other' than the typical person. He particularly enjoys 'that you can draw on somebody' and that person can walk away with a permanent piece of art that he created, especially if it is *shunga*. **AKO**

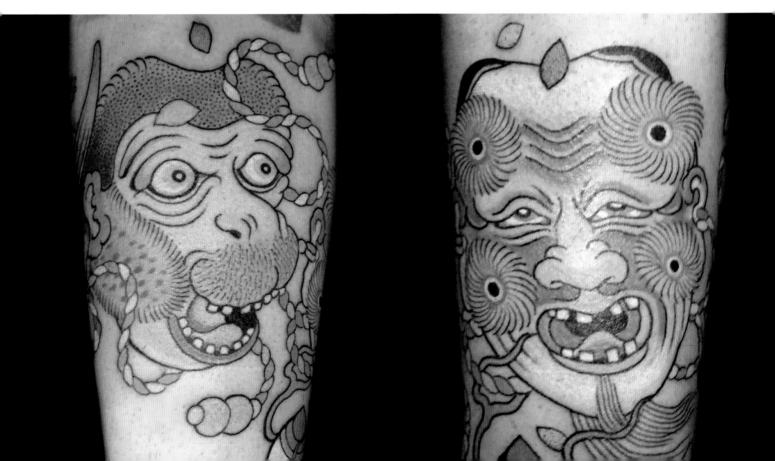

STYLE EXPERIMENTAL **INFLUENCES** CHILDREN'S BOOKS
LOCATION ITINERANT / FRANCE

1 Fox, artichoke and deer with flowers 2 Mermaid with patterned hair 3 Minimalist flower, moon and star

LIONEL FAHY

Lionel Fahy is in search of the pure line. Although to an outsider his designs may look easy to render, his distillation of a concept down to a simple line – without losing meaning or impact – proves very challenging. He regards his minimalist work as a venue for storytelling; or, as he describes it to clients: 'I'm just like a tool between you and yourself.' Fahy started tattooing when he was a punk rock teenager and decorated his friends with blackwork tattoos. After briefly attending art school to study illustration and spending years touring as a professional musician, he has settled into tattooing, dividing time spent with his family, his music and his travel schedule. His tattoos differ depending on his clients: his international customers travel great distances to obtain his spare, line-focused, almost naive illustrations on their bodies, whereas his French clients go for heavy blackwork. As he is not located in his own shop, Fahy limits his designs to one-session works. This means he spends time corresponding with his customers to get a sense of the story they want to tell. He explains: 'We have lots of time, we can talk, discuss . . . and we can build something together.' His simple colour palette and stark line work help to integrate the tattoo with the customer's body. 'Many artists forget that in ten years the thing that looks the best is the skin you didn't tattoo, it makes the tattoo look much more poetic . . . soft . . . I try to explain to people, use your space, use your skin, make things more readable.'

Fahy sees the purpose of life as expression: 'In society . . . you're not allowed to be sensitive, you have to be tough all the time, and through drawings and music you can express yourself in your own way.' He feels fortunate to be able to help others express themselves through his tattoos. **AKO**

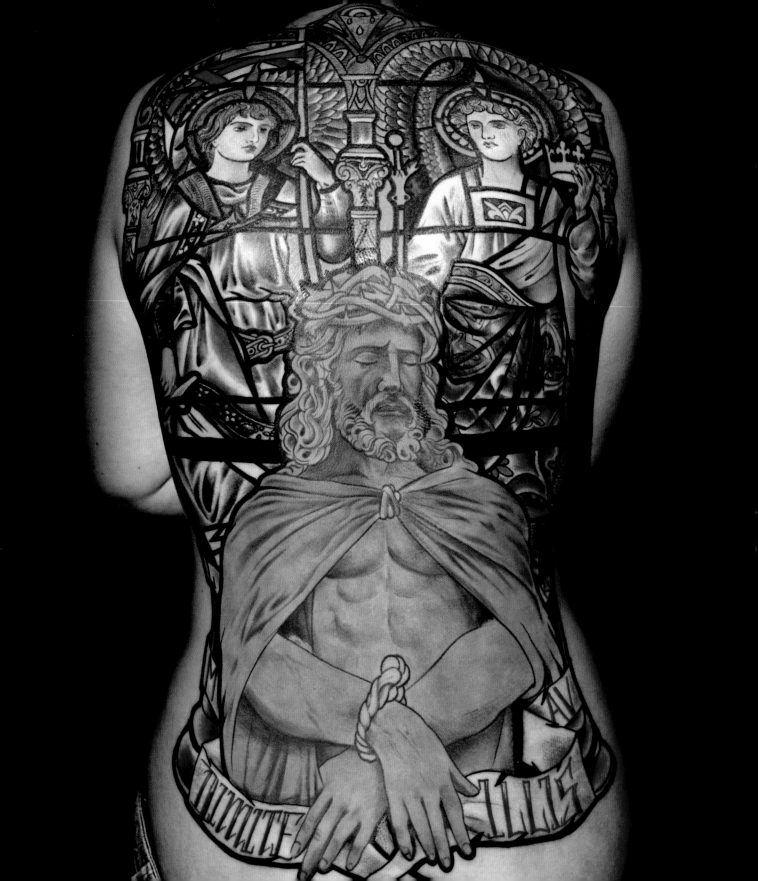

MIKAEL DE POISSY

Mikael de Poissy works with bold, graphic lines surrounded
by incredibly vibrant colours. His tattoos glow like the stained
glass windows that inspire him. He describes his style as French
neo-traditional and explains that it comes from France's cultural
past: 'Stained glass windows have become my personal
signature, 60 per cent of [the world's] stained glass heritage
is in France.' Like other cultural tattoo artists around the globe,
de Poissy draws on his personal heritage – Greek, Latin, Celtic,
Catholic and French – to influence his work.

De Poissy started tattooing when he was eighteen years
old and he quickly realized that it was a 'lifelong calling'. He had
been apprenticed by the time he was nineteen and by twenty-
one he had opened his first shop in Paris. 'I don't remember
whether the artistic side of the business was my prime
motivation . . . but the art built over the years as my profession
evolved and I developed my own style.' Like many other French

1 Black and grey Jesus flanked by archangels
2 Joan of Arc

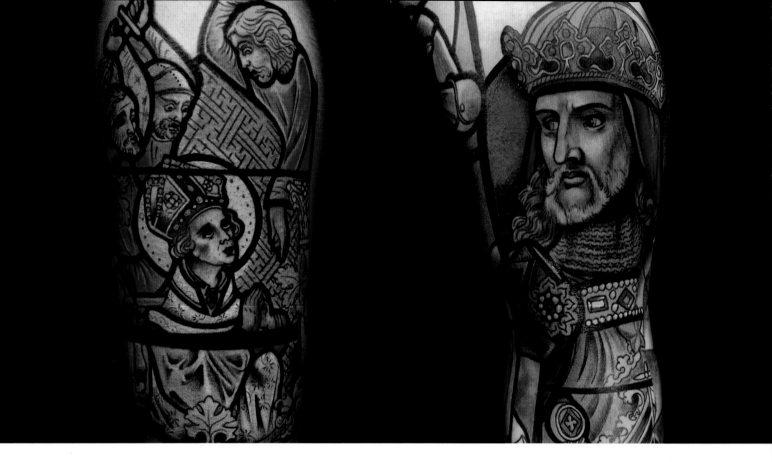

3 Murder of Thomas Becket, 12th-century Archbishop of Canterbury **4** Charles Martel, 8th-century Duke and Prince of the Franks **5** De Poissy working amid examples of his inspiration

tattoo artists, de Poissy started out designing blackwork. He showed his love of French historic and religious imagery by creating tattooed statues in shades of grey. He credits travel and exposure to other cultures to broadening his palette; he now also includes Japanese styles in his work. However, his luminous, stained glass works are well-known; clients come to him with specific historic preferences – they want a stained glass tattoo from a particular historic period, with a particular theme or even specific saints, but they leave the rest to him: 'My clients trust me completely. I have a lot of clients with a passion for history like me, even historians or just ink collectors who want a "de Poissy!"'

De Poissy's stained glass tattoos have a radiant quality, as if they are lit from within. The vivid colours of the glass are surrounded by heavy black lines, some of which intersect the design as if they were supporting the ancient glass they reference, and create a visual cage to contain the colour. The

saints and figures featured in his stained glass designs are peaceful and contemplative, either meeting the viewer's eyes directly or gazing off into the distance. They are clearly inspired by actual windows. De Poissy spends considerable time drawing historic religious imagery in museums, churches, cathedrals and libraries. 'The tattoos that I create take form in my mind over a period of weeks. When my idea is clear, I put it on paper . . . it's created in my head over a few weeks.' The frames are intentional; de Poissy uses the framing he sees on doors or balconies in architecture and combines these observations with the delicate colours of stained glass saints to create a literal window on the client. The results are completely unique and de Poissy's distinctive work is instantly recognizable. Fittingly, he himself is inspired by tattoo artists who work in pioneering ways, regardless of the graphic style. 'These are the people who have founded the art of tattoo . . . progressing it into a pure art.' AKO

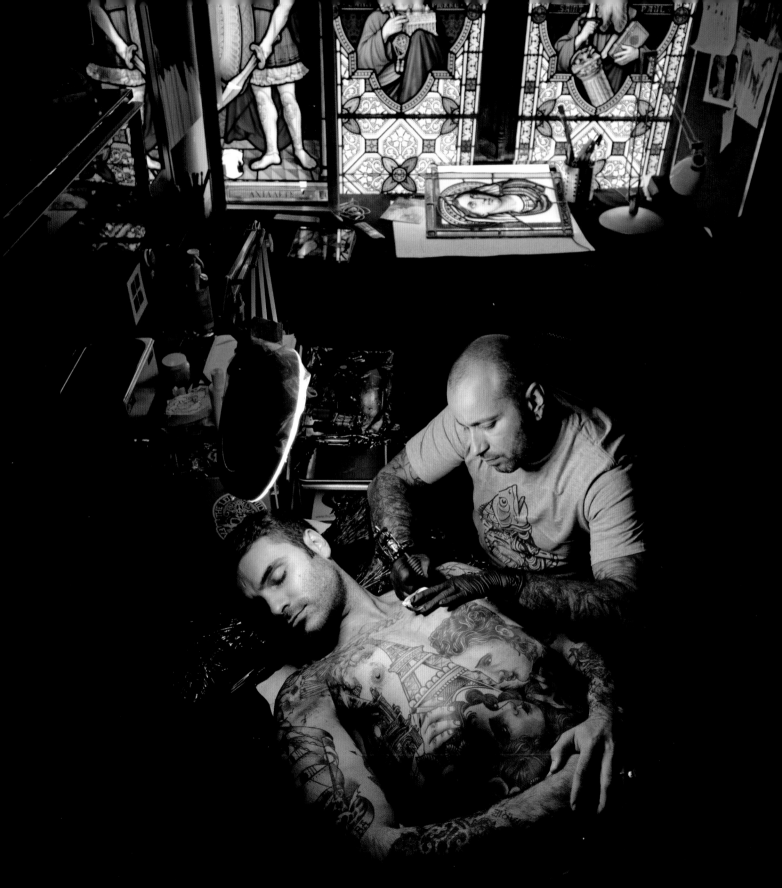

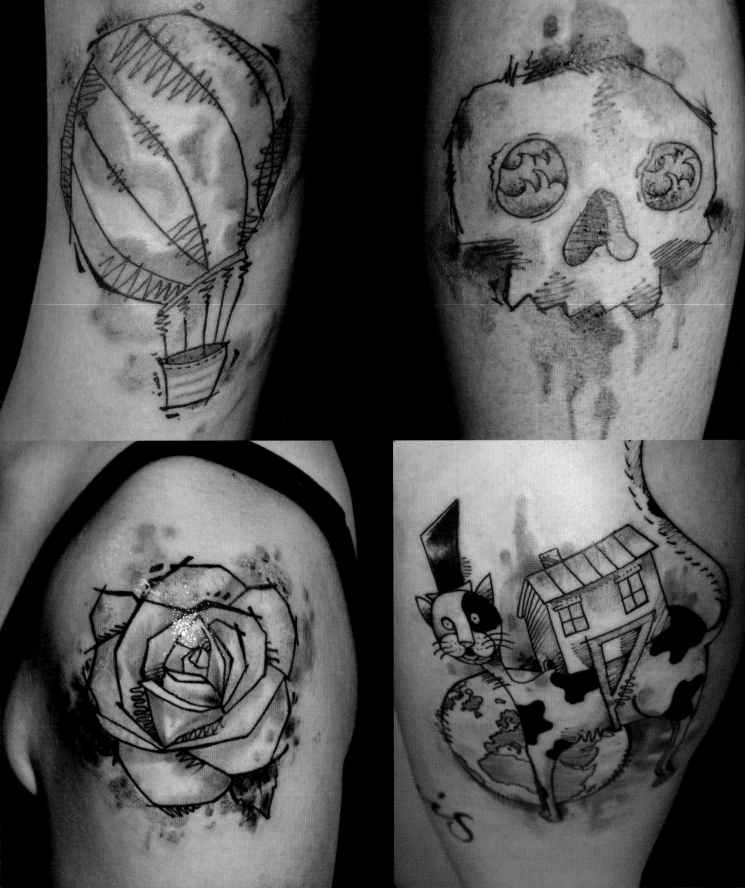

STYLE CONTEMPORARY **INFLUENCES** GRAFFITI, WATERCOLOURS, CARTOONS, NATURE
LOCATION OPORTO, PORTUGAL

NUNO COSTAH

Nuno Costah's tattoos come straight from the pages of whimsical children's books – the figures are wacky, the bright, cheerful colours look like watercolours splashed on the skin and the line work seems drawn rather than tattooed. Although he works in more traditional styles as well, Costah prefers cartoons and animals, and these images feature in his tattooing, as well as in his illustration and street artwork. 'My inspiration comes from the street . . . I always observe the people in the streets, and then I make my own characters. Nature also inspires me . . . I love to draw animals, birds and fish.'

Costah's first foray into art was through street art; he started working in graffiti in the late 1990s and then got an apprenticeship in a tattoo shop. He was initially drawn to tattoos by images that he saw in skater and surf magazines and punk music videos.

When he creates a tattoo, he first works up the image in watercolour on paper and then reproduces that image on the client's body. Costah uses many colours to achieve the wet ink quality in a finished tattoo; he mixes them directly on the skin and uses strong colours for contrast. He is renowned for his cartoon-like tattoos and clients often come to him with a character that is related to their families or friends. Other clients want him to create something unique and original, he says, and 'give me the freedom to do what I think is best'.

One of the striking characteristics of Costah's work is the positivity of the images: they are happy, cheerful-looking cartoons that are created with bright colours. According to Costah: 'I think the world has a lot of negative . . . so when I´m creating something I like to explore the positivism, harmony and happiness.' His goal is to make people smile when they see his art, to give people the ability to dream and bring 'hope and joy to the world'. AKO

I Deflating hot-air balloon 2 Watery skull 3 Rose with watercolour effect 4 Cat-cow hybrid animal carrying a house on its back 5 Pirate looking through spyglass and sailing in a paper boat

MASSIMILIANO 'CREZ' FREGUJA

Quietly and without fanfare, Massimiliano 'Crez' Freguja has been producing classic Japanese tattoos in Marghera, on the outskirts of Venice, for more than a decade. Early exposure to tattoos as a child sparked his interest in the art form. His father, a sailor who got tattooed in India in the 1960s, wore faded tattoos that fascinated him. He saw other tattoos on people enjoying the beach of his home town of Alberoni, on Lido island near Venice. Inspired by these tattoos, at the tender age of nine he self-tattooed five dots 'like a dice' on his forearm with a needle-and-thread apparatus. Later, as a teenager into punk rock and skateboarding in the 1980s, many of his idols sported tattoos. He noticed that nobody in Venice was tattooing at the time 'so I started myself'. When he was fourteen, he built his first machine and began to tattoo in earnest.

In 1993 Crez switched to professional equipment and started working in a variety of styles. Tattooing even helped

1 Monkey samurai 2 Bodysuit with assorted traditional motifs

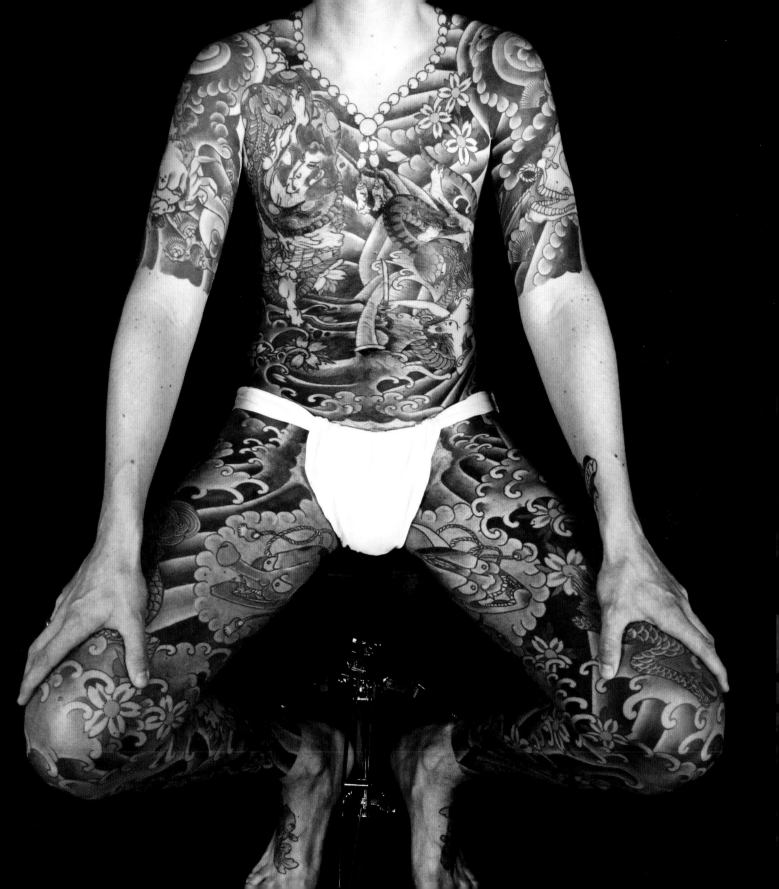

3 Koi with maple leaves and water **4** Dragon back piece
5 Elbow with clouds, wind and lightning **6** Dragon with
maple leaves and waves **7** *Oni* (demon) back piece

3 4 5 6 7

strengthen his relationship with his father, who had seen him as a 'rebel kid' yet who 'surprised me, asking to have his old stuff covered'. A strong interest in dragon tattoos – many of which adorn the bodies of his clients – gave way to an emerging passion for Japanese art and culture. His first trip to Japan in 2003 marked a turning point in his career. He spent time with the Ryu family, after which he made the decision to switch exclusively to the *horimono* style. Over the past twelve years, Crez has returned to Japan for at least a month every year, where he has 'worked with other colleagues and listened to all the critiques they made'. Continually researching the history and culture behind the images he inscribes, he comments: 'I've been visiting all the places I've studied in books.' He is currently apprenticing his wife, Manekistefy, and acknowledges that 'teaching apprentices was necessary for me to refine my knowledge; there is no master without a student'.

Crez cites Yokosuka Horihide as his main inspiration and states: 'His bodysuits remain the best I've ever seen. I'm honoured to be his friend and to have the chance to visit him when I want.' From Horihide, Crez says that he has 'learned that a good tattoo can be done only by a good person; if your behaviour offends your customer, he will be upset with the tattoo you did, no matter how good it is'. He concludes: 'Constant practice is very important, too, drawing and tattooing daily has to be balanced with sport and healthy food in my experience to keep body and mind fresh and far from negative thoughts.' Crez remains passionate about *horimono*: 'Japanese tattooing is a never-ending journey. . . . It is a cultural journey to research and learn about tales and history, and a journey in style and elegance. The challenge is to make the body look better than before.' His elegant traditional designs certainly achieve that, transforming bodies into swirls of dark clouds and waves punctuated by a panoply of characters from Japanese lore. **AFF**

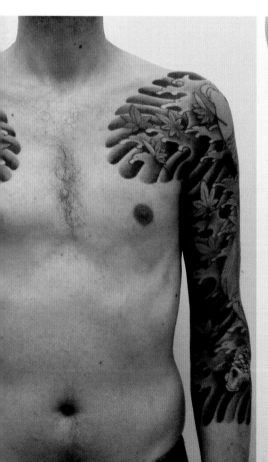
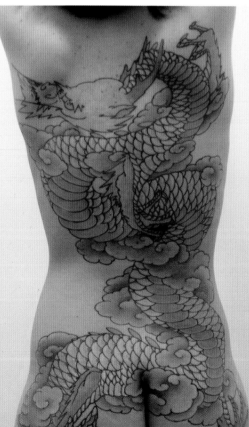
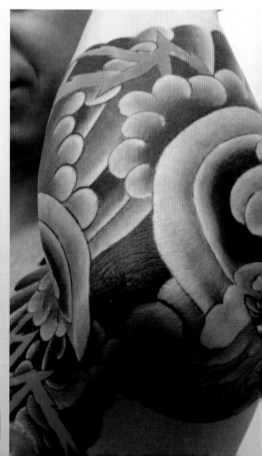

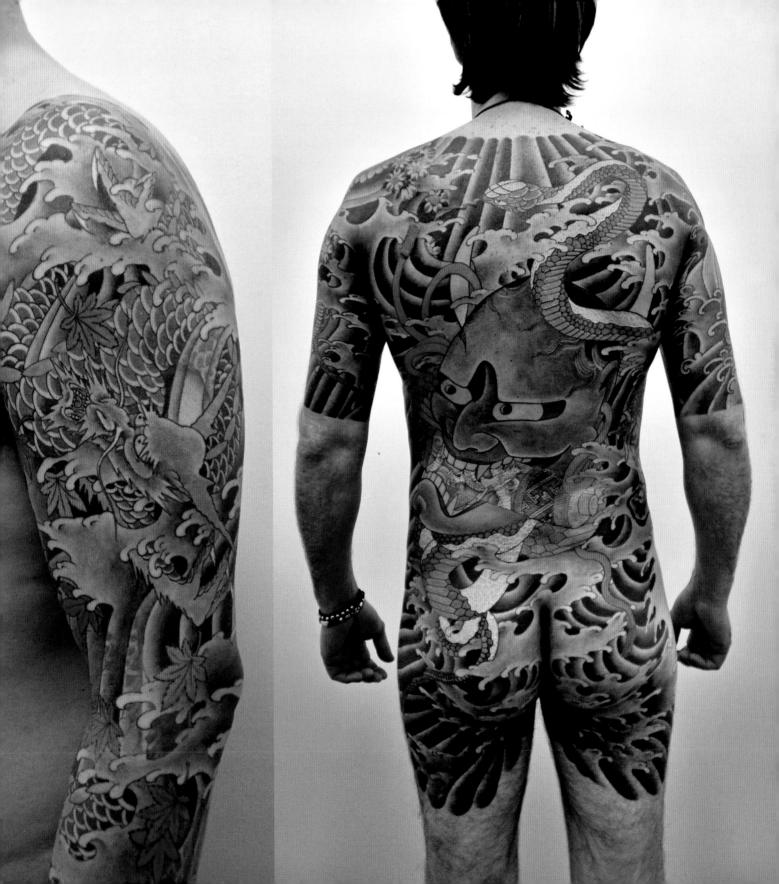

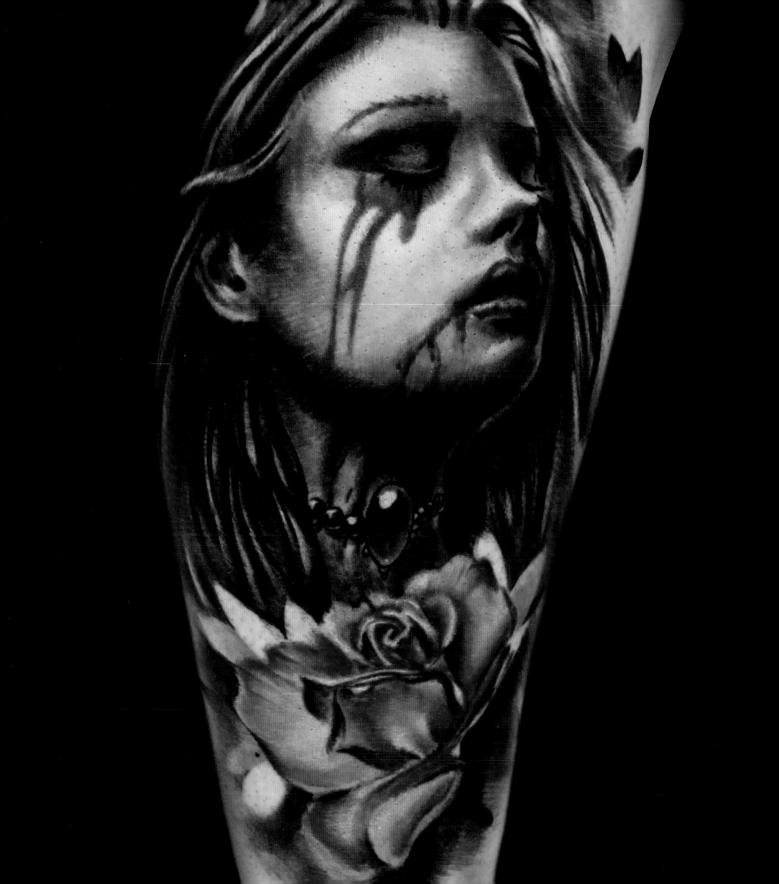

STYLE REALISM, CONTEMPORARY **INFLUENCES** GRAPHIC ILLUSTRATION, GRAFFITI, PORTRAIT PAINTING **LOCATION** ATHENS, GREECE

SAKE

Sake's unique and breathtaking tattoo compositions meld the classical with the modern. He brings together two diametrically opposed styles – colour realism and graphic illustration – and the organic and novel results are works that could be found in a contemporary art gallery. His portfolio contains striking tattoos of beautiful realistic faces or skulls surrounded by items, such as jewelry or flowers, with colourful flourishes and splotches in the background that seem more rooted in graffiti or abstract art.

Sake describes his journey as one in which 'I started breathing in 1994 when I entered the world of art through graffiti' and to this day he remains an active and influential graffiti artist, 'burning walls' with the Till Death Squad. His tattoo career began in 2001, when he trained first under Andreas Marnezos, then Manos Remboulis and finally with artist Mike the Athens, who he credits as helping him reach his highest technical and spiritual levels. In 2005 he opened his own studio, Sake Tattoo Crew.

Sake integrates his various influences seamlessly. Although some pieces have more realism incorporated and others contain more graphic elements, in all his tattoo work there is a perfect harmony of styles combined with the light and dark aspects of the imagery. The way he depicts female faces – and the expressions those faces bear, with tear- or blood-streaked cheeks – clearly indicates the inspiration he draws from the darkly romantic illustration work of Victoria Frances. Ravens are a much-loved animal and theme in his tattoos, and this adoration is translated through careful shading and colouring of the feathers and the mood depicted in their eyes. The results of Sake's creative work might be considered haute couture for the skin: custom-designed, intricate, executed with extreme attention to detail, high fashion art for the skin. KBJ

1 Female portrait with smeared make-up 2 Raven and crying woman

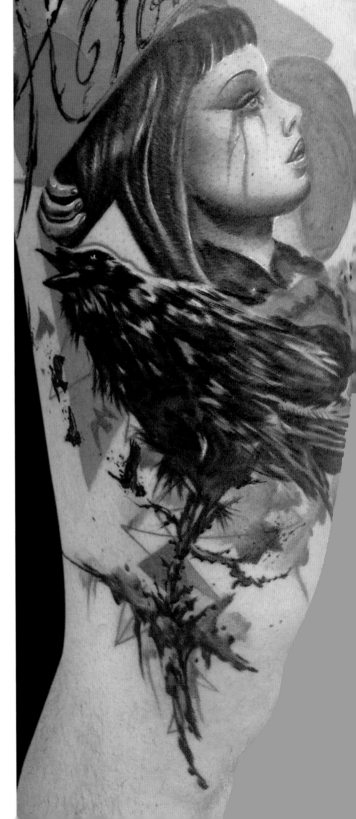

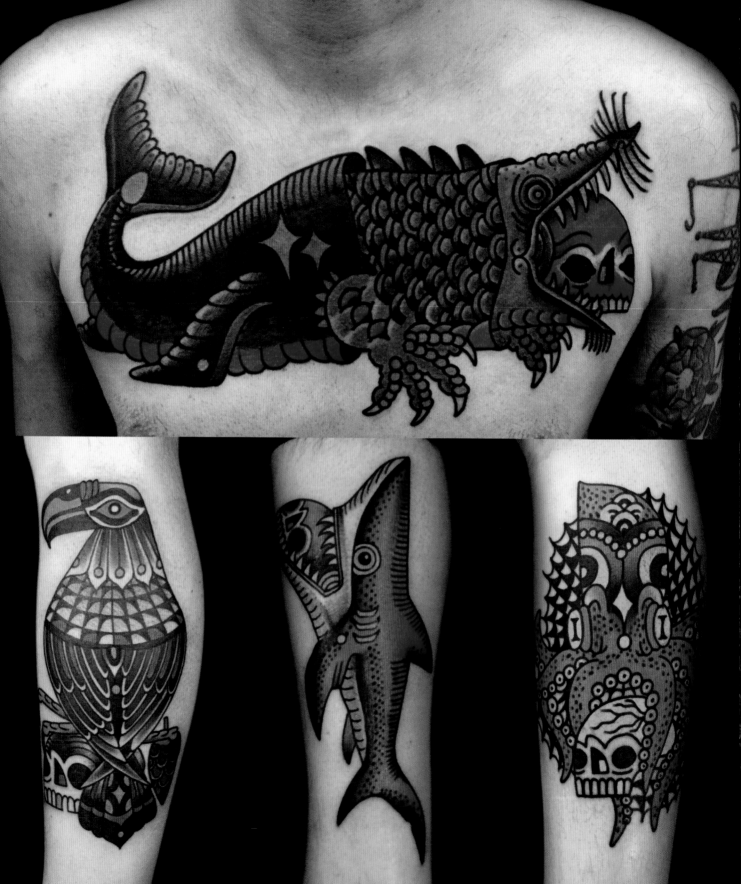

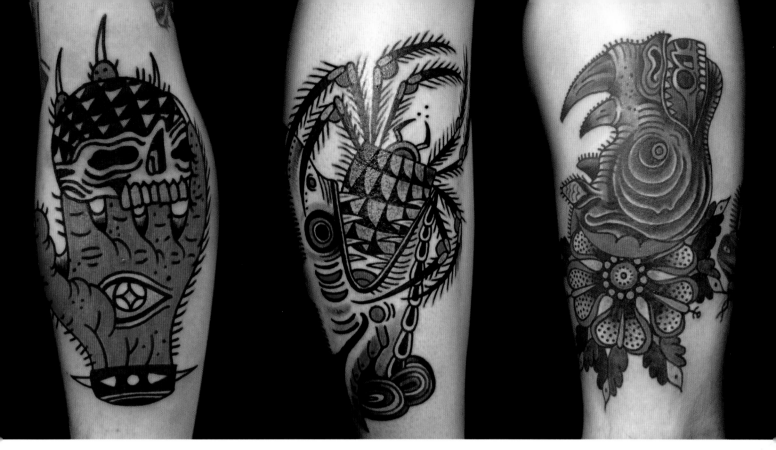

STYLE CONTEMPORARY **INFLUENCES** SURREALISM,
OLD SCHOOL TATTOOING **LOCATION** MADRID, SPAIN /
LONDON, UK

1 Fish-monster eating skull 2 Graphic eagle holding skull
3 Shark devouring skull 4 Octopus-spider hybrid with
skull 5 Skull impaled on talon-like fingers 6 Shark consuming
spider-like creature 7 Rhinoceros emerging from flower

DENO

Deno studied philosophy at the Universidad Autónoma de Madrid
in Spain and now finds himself playing out existential absurdities
on the skins of his tattoo clients. He works between Circus Tattoo
in Madrid and Seven Doors in London, and he also creates art
on walls and on canvas. Deno's strange, surreal, nightmarish and
witty visions recall the work of fellow Spanish artist Joan Miró, a
comparison that establishes as good a place as any to start when
trying to get to grips with his unique tattoo style. Deno's designs
are weird, scary and uncanny. Metamorphoses often happen:
coffee pots turn into spiders, elephants' trunks transform into
snakes, animals devour each other, towers sprout branches.
Deno conjures a world of magic, contradiction and excess.

Deno's signature flourishes – the strange combinations of
eyes, doorways, skulls, snakes and swallowing beasts rendered
in a flat, solid, illustrative style – have been much copied. He
remains ahead of most of his peers simply through the sheer
heft of his tattooing, which is always solid, strong and restrained,
despite his frequent excursions into fantasy subject matter.
His work thus creates an overall effect of an odd (out-of-)
timelessness. Despite the postmodern clashing of icons, the lack
of concession to contemporary tastes in the construction of his
tattoos makes Deno's work appear as if it comes from some
alternate past. He produces even the wildest combination of
symbols and signs in a clean, precise style, with minimal reliance
on ornament or extraneous detail. The brilliance of his work is
immediate and powerful. Whereas others may be tempted to
burden already excessive imagery with superfluous additions,
Deno sticks to fat, black lines and solid, smooth colour blocks,
with choppy shading added sparsely only when required. ML

STYLE OLD SCHOOL INFLUENCES EARLY MID-20TH-CENTURY AMERICAN TATTOOING, CAP COLEMAN, SAILOR JERRY, OWEN JENSEN LOCATION LONDON / LEEDS, UK

CHRIS LAMBERT

1 Parrot and rose 2 Coquettish sailor girl
3 American eagle vs Japanese dragon

Chris Lambert is obsessed by the aesthetics of classic American tattooing from the 1920s to the 1940s. He is equally fascinated by the Japanese influence on Western tattooing during the same period, particularly in the oeuvres of Cap Coleman, Sailor Jerry and Owen Jensen. Lambert, who graduated in fine art from the University of Leeds and is a former muralist and graphic designer, currently tattoos out of Nine Tails Tattoo in London.

Lambert's output sits comfortably in the lineage of great Euro-American tattoo artists, who since the first half of the 20th century have worked across the disparate palettes of the West and Japan, creating novel and exciting pieces. Although this blend of styles seems effortless in Lambert's tattooing, it is a combination that has become rare in recent years. The first

4 5 6 7

4 Eagle holding Masonic symbol 5 Eagle flying away
with skull 6 Native American woman 7 'Rock of Ages'
memorial motif

generations of professional Western tattoo artists up to 1945 were deeply enamoured of Japanese work and they introduced oriental motifs and techniques into their practice: eagles fighting dragons, demure geisha pin-ups, Western rigged ships riding waves resembling those painted by Hokusai. Since the late 20th century, however, traditional Western and Japanese tattoo styles have increasingly been regarded as separate genres and few artists work across both disciplines.

Lambert is one of the only tattooers working in the United Kingdom today who successfully synthesizes Japanese with Euro-American tattoo traditions in ways that were common a century ago. His work resonates with a deep and sincere love for the traditions in which he works and the source material that provides him with such rich inspiration. His work is neither pastiche nor an ironic nod to the conventions of Western tattooing. On the contrary, his work expresses authenticity, care and respect for those whose designs he appropriates and redeploys.

An avid amateur tattoo historian of this period, Lambert holds one of the finest collections of early 20th-century American tattoo designs in the United Kingdom. His tattooing exhibits remarkably close attention to the details of how tattoos looked and were produced in the early 20th century. To replicate this aesthetic, he reproduces the technical details of that period, using modern inks and standards.

His attachment to the lineages of Western tattooing is apparent in his restrained colour palette of black, yellow, red and green – the inks commonly used on both sides of the Pacific until the 1970s. This self-imposed restriction when combined with an adherence to nostalgic touches, such as loose, choppy shading, ensures that Lambert's work not only revives the iconography of the past, but also recreates the entire timeless romance of the aesthetics. By treating each element of traditional tattooing with such care and reverence, each of Lambert's tattoos manages to be a history lesson etched in skin. ML

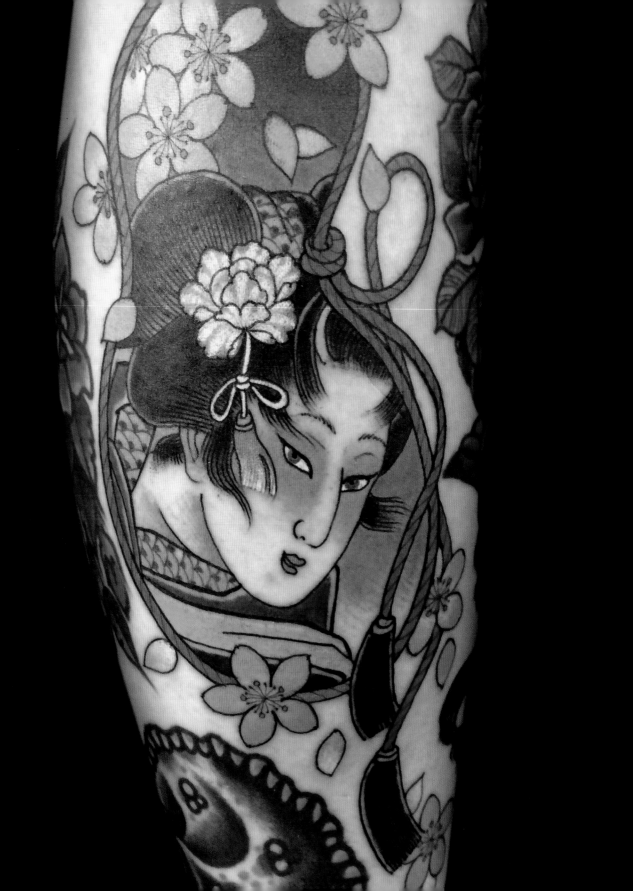

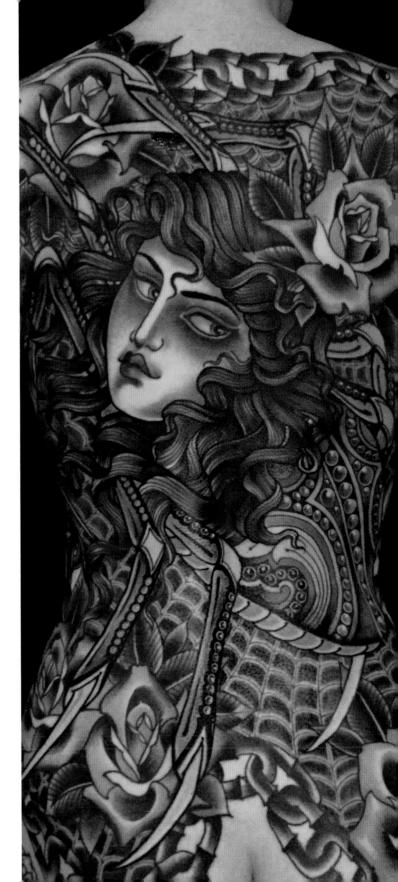

CLAUDIA DE SABE

Claudia de Sabe is regarded as one of the most talented
practitioners in London, a city saturated with talented tattoo
artists. This passionate and rapaciously intelligent Italian
tattooer, artist and curator made London her home nearly a
decade ago. Currently tattooing out of upstart studio Seven
Doors in Brick Lane, de Sabe has long been a shining light in
the generation of UK-based tattoo artists who came of age
before the current wave of television shows, media saturation
and sneaker endorsements made tattooing seem to the general
public like a career choice rather than a vocation.

 Having honed her craft across a range of dominant trends,
de Sabe is primarily known for her signature style – a dark,
deep, but delicately rendered Japanese style that is faithful to
ukiyo-e traditions, but still recognizably modern. She manages
to combine slender line work, intricate detailing (especially in
the frequent use of fabric and embroidery motifs) and soft

1 2

1 Geisha vignette with cherry blossoms
2 Westernized version of the Japanese *Jorogumo*
(spider lady) with roses

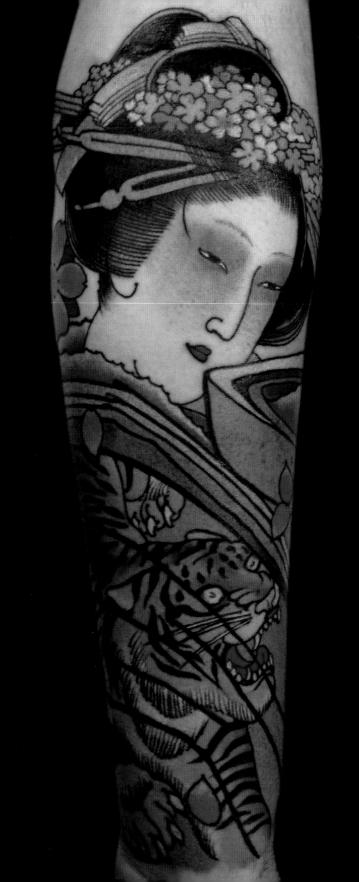

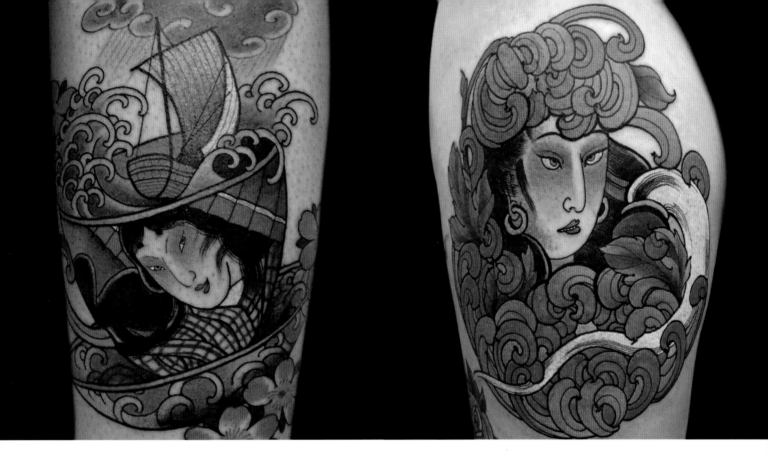

3 Geisha with tiger-patterned kimono 4 Boat sailing
in geisha-adorned teacup tempest 5 Woman morphed
with chrysanthemum

pinks, greens and blues with intense, solid fields of blacks, greys
and olives, with the resulting pieces – whether small one-shots
or huge back pieces – remaining powerful, effective and
timeless without becoming macho and regressive.

Her choice of iconography also relies on counteracting
darkness and light: a dainty geisha whose kimono is covered
with a snarling tiger; a rabid panther set against falling, pink
cherry blossoms; a beautiful, ebony-haired lady's head placed
on the body of a vicious electric blue spider. Her back piece
projects are particularly stark, often involving layers of heavy,
cascading clouds and waves in deep shades of black that offset
foreground images of women's faces or flowers in a range of
pastel shades. Her skilful use of negative space allows deceptively
delicate images to emerge from the rich, detailed background.

Dark, powerful tattoos that also possess a lightness of spirit
and a compositional fluidity pose an extraordinarily difficult
artistic challenge, but in de Sabe's work these two opposing
impulses combine to make a whole that is greater than the sum
of its parts. Her work in other mediums than tattoo ink in the
skin also reflects this – even when working on paper in layered
liquid acrylics, her work retains a taut balance of shade and shine.

A minute in her company reveals not only a deep, abiding
passion for tattooing's history, but also its brightest current
manifestations. As such, de Sabe is making her name as a curator
of contemporary and historic tattoo art, including exhibitions
at London's Somerset House. In 2012 she masterminded the
exhibition 'Kokoro: The Art of Horiyoshi III', which brought silk
and paper paintings by one of the world's greatest living tattoo
artists to the United Kingdom, to widespread critical acclaim.
In 2014 de Sabe published *Time: Tattoo Art Today,* which brought
together commissioned painting, drawing and sculpture by
tattoo artists from across the globe, including Ed Hardy, Mr
Cartoon, Filip Leu and Paul Booth, as well as young, up-and-
coming artists, such as Valerie Vargas and Sarah Carter. ML

LITTLE SWASTIKA

Marc Riedmann, who has adopted the artist name Little Swastika, creates pioneering work that taps into a deep sense of spirituality but also innovates new forms for tattooing. Based in a private studio in rural Germany, he pushes the boundaries of tattoo aesthetics. He explains: 'The more I can make my tattoos not look like tattoos, the more I'm satisfied.' He relishes working fast and his philosophy is to 'not really have rules' and be 'open to almost everything'.

As a teenager, Riedmann initially became interested in tattooing as an expression of freedom and individuality. He notes: 'Tattooing was always a subculture for me, a part of rebellion, a part outside the norm and mask of our society.' He inscribed many of his early tattoos himself, first by hand and later with a machine that he fabricated from electric hair clippers and a variety of found materials, including pieces of Lego. Later he became interested in many other forms of body

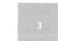

1 Geometric patterning and the word 'love' uniting four bodies 2 Abstract graffiti-influenced designs melding two bodies 3 Mandala-inspired, ten-person design with abstract elements

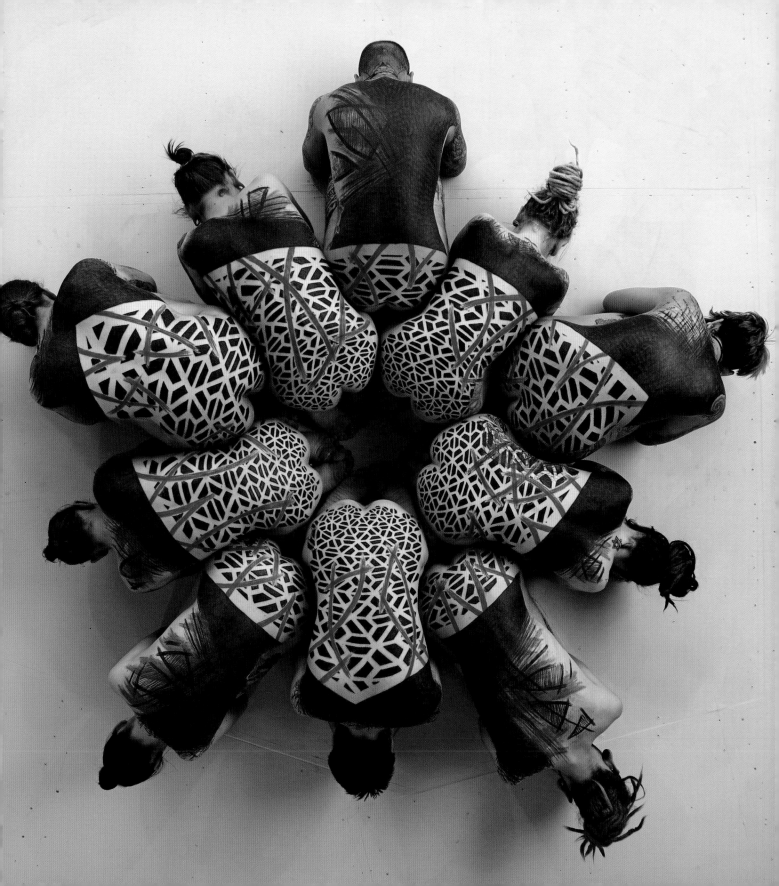

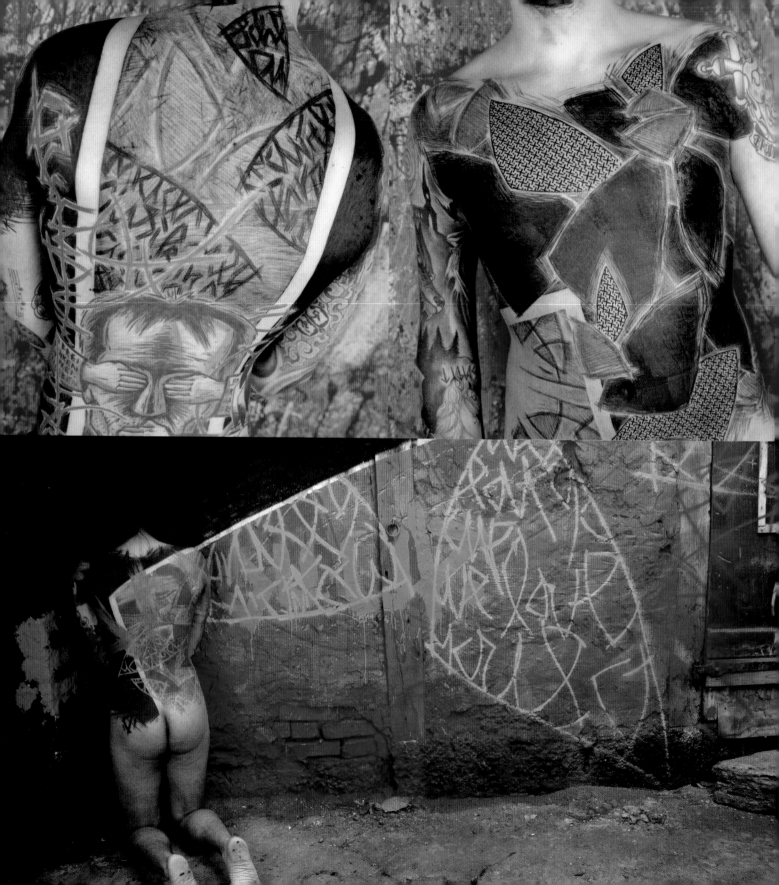

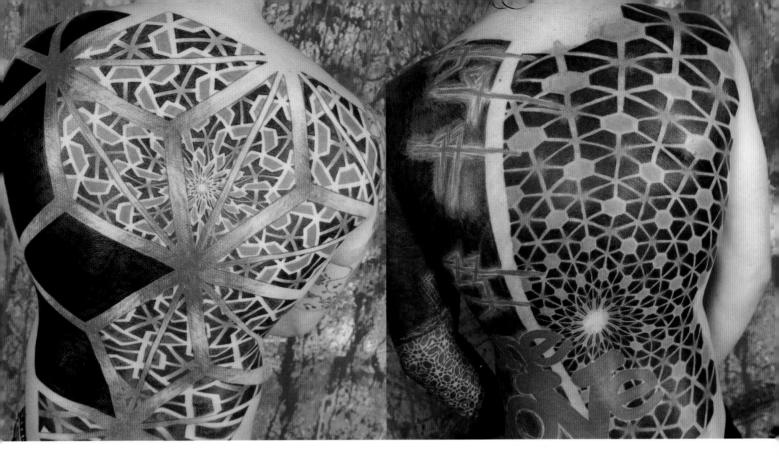

4 Back piece evoking pastel drawing 5 Abstract composition with textile patterns 6 Graffiti-inspired piece that integrates with architecture 7–8 Mandala-influenced designs with graphic and abstract elements

modification and had his own body significantly altered with tattooing, piercing, implants and other procedures. Drawn to the ritual and spiritual aspects of body modification, he experimented with tattooing himself and getting tattooed by others using traditional techniques without a machine.

After gaining an apprenticeship and adopting a new 'sterile or die' attitude, Riedmann opened his first shop in 2005 and made the move to working outside a traditional urban space. Disturbed by the trend towards tattoos as fashion rather than subculture, he scaled back his tattoo practice and focused only on his signature style and ambitious pieces. He also became part of a global artistic movement to reclaim positive meaning for the swastika symbol, which he uses in his art, as well as in his artist name and the name of his first tattoo studio.

Several artists have experimented with tattoos that span multiple bodies, but Riedmann has developed the concept on an incredible scale. Whereas most of these tattoos usually span only two bodies and connect halves of small motifs together, Riedmann fuses entire back pieces across three, four or even ten bodies. Such enormous tattoos require a strong willingness from each tattoo client to be part of a collective work. Riedmann's brilliant designs, however, also ensure that each piece stands on its own as an individual tattoo.

His clients also need to be highly dedicated to his style. Getting tattooed by Riedmann is an intense experience. He works in a remote area and clients have to 'really travel, not just come by plane and bus'. He describes the commitment his clients need to make: 'A full back piece is normally only three sessions. For most people it's almost like a ritual to get a full piece done with me. Its brutal and brings them over their own borders.' Riedmann's finished designs reflect this ritual process and speed of working. They evoke an amalgamation of the free spirt of grafitti and abstract art, combined with the reverence of sacred geometry. AFF

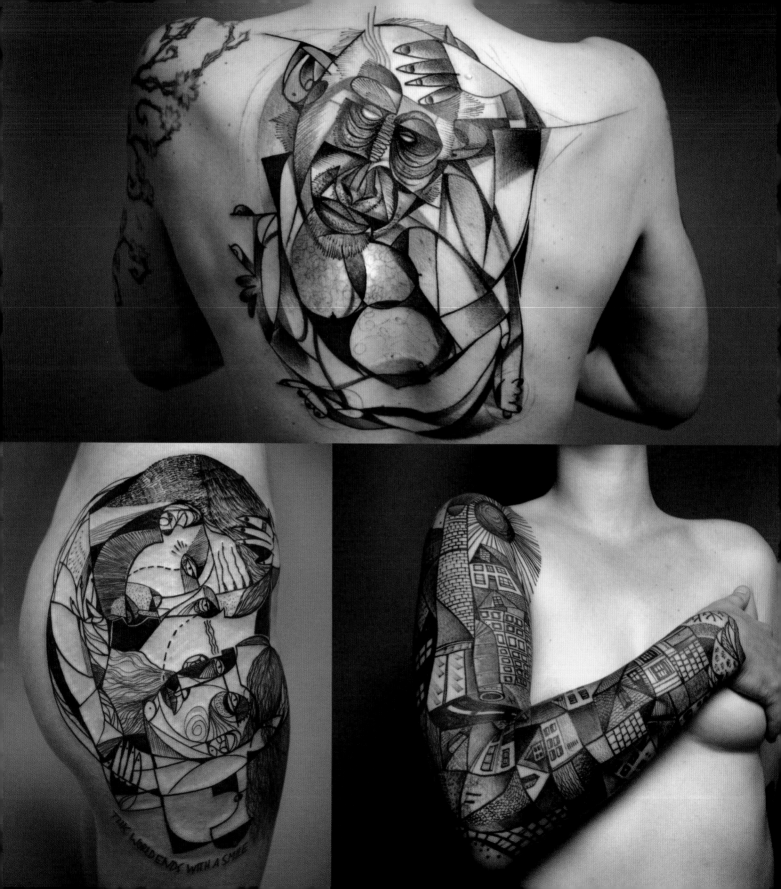

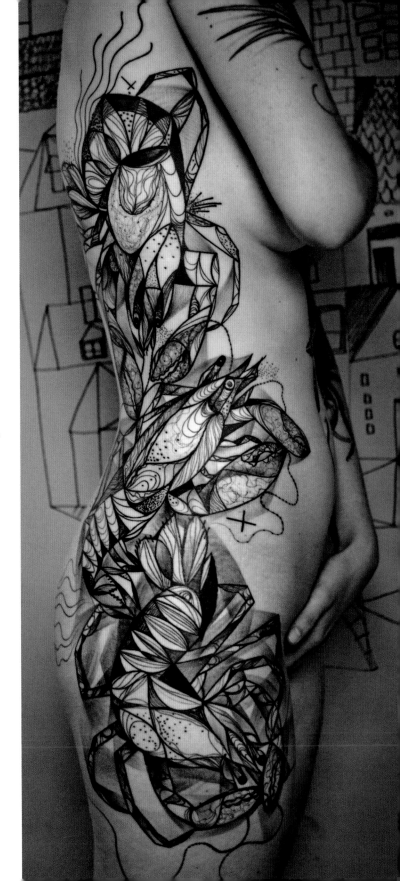

PETER AURISCH

Peter Aurisch crafts tattoos in a distinctive artistic style influenced by Picasso-esque cubism, Italian futurism and a more generalized abstraction that strays far from the usual folk art aesthetic characterizing representational tattooing. He belongs to a strong group of young artists from the past decade who have shattered the boundaries of traditional tattooing by eschewing hard outlines for the artist's individual signature style. His tattoos look like paintings and drawings (which he also produces), but rendered on skin instead of canvas or paper.

The name of Aurisch's tattoo studio, Nevada Johnny, and the mythologizing behind it, reflects his self-professed desire to be a Wild West pioneer. Rather than a street shop, his anonymous location (only revealed once you book an appointment) reflects the intimate and completely custom fine art tattooing he practises.

1 Ape 2 Figures embracing 3 Architectural collage
4 Aquatic abstraction with lobsters

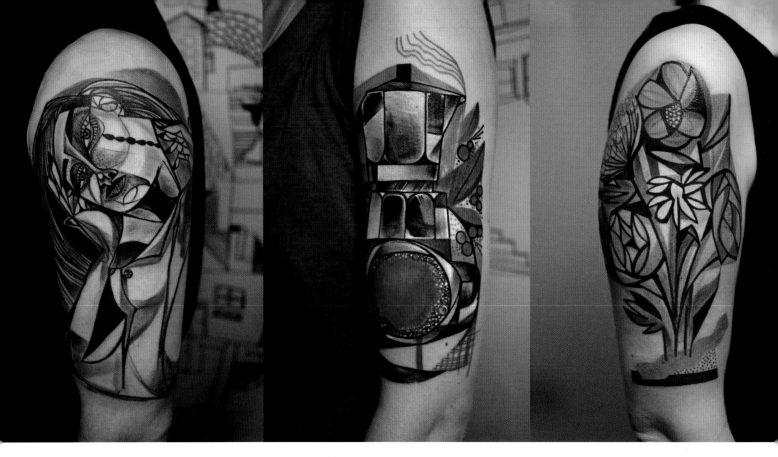

5 Crying woman 6 Coffee pot 7 Bouquet of flowers
8 Desk piled with books 9 Cubism-influenced portrait

The studio where he works, with fellow artist and girlfriend Jessica Mach and their friend Manuel Mathow, includes a guest room, kitchen and bathroom, 'so it's more like an apartment'. He only books one appointment per day 'to focus on our work and the client'. This private space creates a relaxed environment and 'you can walk around naked without any observers'.

The angular lines that often jut out beyond the boundaries of his tattoo designs harden what might otherwise be rather saccharine subject matter. Beyond his interesting line work, Aurisch deploys colour in an unconventional way, allowing it to seep out from where it might be expected in a more traditional tattoo design, and usually limits his palette to one or two bold choices that amplify the symbolism of the design. Aurisch's subjects typically include human faces, animals and natural objects, such as trees and flowers, but occasionally he goes beyond those parameters. His reworking of classic tattoo motifs like the rose ruptures expectations of what a tattoo can look like. He works independent of outside influence and ensures that his personal vision shines through: 'I try to not use any reference from the internet. I always put a little bit of myself into every piece.'

Although Aurisch could fill appointments months in advance, he prefers to plan no further than two months ahead: 'I can always work on new ideas and nobody has to wait too long for an appointment.' Despite his fame, he works by himself and stays humble and true to the art of tattooing: 'I don't have a secretary or somebody cleaning my shop. I'm really not into all the tattoo business around me', which Aurisch says, is 'more or less all about money and fame.' His clients come from all over the world and he marvels: 'I'm very thankful that there are people who like what I do. They travel around the world just to get a tattoo!' Joking about the intimate relationship he has with his clients, Aurisch comments, 'I used to call them lovers because they can see the same things that I see in my works.' AFF

STYLE EXPERIMENTAL **INFLUENCES** PATTERN
MAKING, SHADOWS, BAUHAUS DESIGN
LOCATION BERLIN, GERMANY

CARO
WILSON

Caro Wilson began tattooing inadvertently. Asked by several friends and a future artistic partner to inscribe them, she became 'intrigued by the impenetrable intimacy that it created at each tattoo . . . I basically wanted this link to people.' She thought her friends were 'crazy' to have her tattoo them because she was 'convinced I didn't know how to draw and thought that "people like me" [women with degrees in cultural studies] don't become tattooists'. That background in cultural studies deeply informs Wilson's philosophy and her intellectual approach to rethinking the typical relationship between client and tattooer. Currently working on her second master's degree at Humboldt University of Berlin (in cultural sciences, her first was in museum studies), she has an insatiable passion for critical and analytical knowledge. Few tattooers are as comfortable reading and discussing Derrida and Barthes as they are inscribing skin, but Wilson uses texts by such authors to inform her unique approach.

1 Maibritt: feeling the power

Her work process centres on the elements of time and trust that exist between the client and her as artistic facilitator. First meetings with clients are casual conversations over coffee or beer; she then draws directly on the skin and discusses the design further, sometimes over several sessions. Never taking a deposit or expecting clients to return, she prefers that they 'have at least one night's sleep between the design and the tattoo' and wants 'this process to function on trust and responsibility, because . . . this is what makes you own your tattoo. If you come to me and don't really know what you want and in the end you get a Celtic sleeve because the process helped you realize that that's what you want, then I have done a good job.'

Wilson works primarily out of private spaces, which she admits is 'controversial' but she adheres to the doctrine that 'hygiene should be paramount where ever you work'. Non-commercial spaces 'revealed [themselves] as the best way of developing my work, where intimacy is paramount. Maybe I would change my mind if I could find a shop where I can close the door, be with a naked person in the room without having to fear any disturbances and, at best, have a kitchen to make food, because food is THE best painkiller.'

Wilson sees her role as an enabler, orchestrator and consultant. As one who is not a classic draughtsman, she realized her niche was to take clients' ideas and strategically place them on the body. She refers to her client consultations as 'gymnastics class' and encourages people to 'move around, see how your skin stretches, where it stretches more, where to put the curb so it will transform smoothly and not break. This is what gives harmony'. She is frank about what she can and cannot do: 'Yes, I will never give you an amazing Japanese dragon back piece. But that's not the point, and there are other people who do this very well. What interests me is to focus on the body, not on the design by itself. Any design can be good, but not [every] design can fit nicely [anywhere] on the body.' **AFF**

STYLE OLD SCHOOL **INFLUENCES** MARITIME ART, FOLK ART, JAPANESE TATTOOS **LOCATION** HAMBURG, GERMANY

SEBASTIAN WINTER

Sebastian Winter's bold and clear-cut tattoos are explicitly rooted in the traditional Western style. Winter, who describes himself as an 'outline fetishist', creates works with strong line work and a high degree of legibility. Using classic images that take up such 'basic human issues as love, hate, humour, desires, nostalgia, wanderlust, perishability, luck and life', his work continues the Euro-American tattoo legacy. He is also fond of lettering tattoos and values the motifs of Japanese tattooing.

Winter, who is a trained graphic designer and former student of the Academy of Fine Arts in Gdansk, also benefits from his experience as a graffiti artist. 'Graffiti is [in] a way similar to the traditional way of tattooing', explains Winter; both are based on the same principles. Hard outlines define both graffiti and traditional tattoo compositions, while the rest of these images consist of blocks of colour and shaded light and dark areas.

After his studies, having learned the craft of tattooing as an apprentice under Daniel Lonien, he started working at Absolut Tattoo in his home town of Heidelberg, together with Lars Walkling. Today Winter's base is Immer and Ewig Tattooing in Hamburg – a city with a rich history of traditional tattoo culture. Iconic figures, such as Hamburg's Christian Warlich and others from the origins of professional tattooing in harbour cities around the globe, serve as a model for his work.

Winter relishes the high degree of personal freedom his profession allows him and enjoys the diversity of his customers. His favourite works are those that convey tattooing as folk art. For Winter the traditional elements of old school tattooing define the medium; if a tattoo does not contain them, 'it is merely pigment in someone's skin'. **ow**

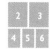

1 Skull with rose 2 US Marine Corps bulldog mascot
3 Fantasy woman with skull and floral headdress
4 Classic female portrait with rose 5 Antarctic scene
with penguin and stars 6 Norse Valkyrie figure

STAY GOLD

STYLE CONTEMPORARY, EXPERIMENTAL
INFLUENCES PHOTOREALISM, GRAPHIC DESIGN, PATTERNS
LOCATION WÜRZBURG, GERMANY

1 Beauty and death united 2 Fly enveloping a client's head 3 A collage of text and image

SIMONE PFAFF AND VOLKER MERSCHKY

Simone Pfaff and Volker Merschky's exceptionally innovative tattoos generally combine photorealistic motifs and elements, such as patterns, lines and typography. By contrasting bold and filigree components with an explicit separation of light and dark, their works achieve a powerful effect. Their frequent depiction of brushstrokes references the medium of painting. By contrast the collage-like compositions have a graphic design look and feel. The fragmentary character of their designs and the use of black, grey and red is typical of their artistic collaboration.

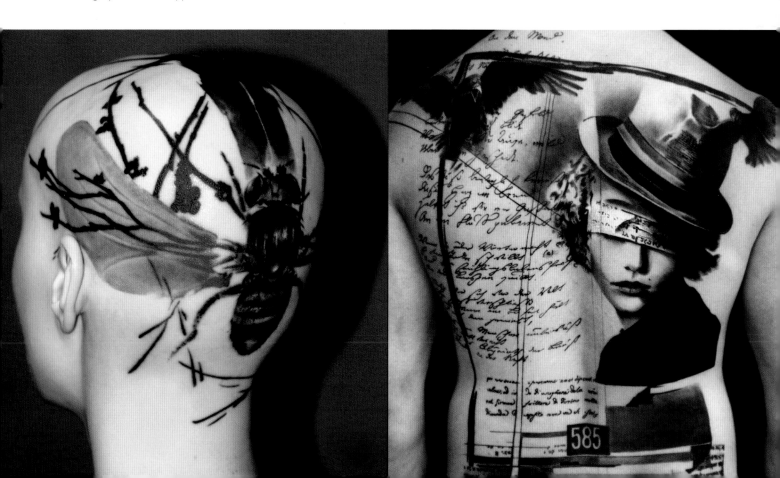

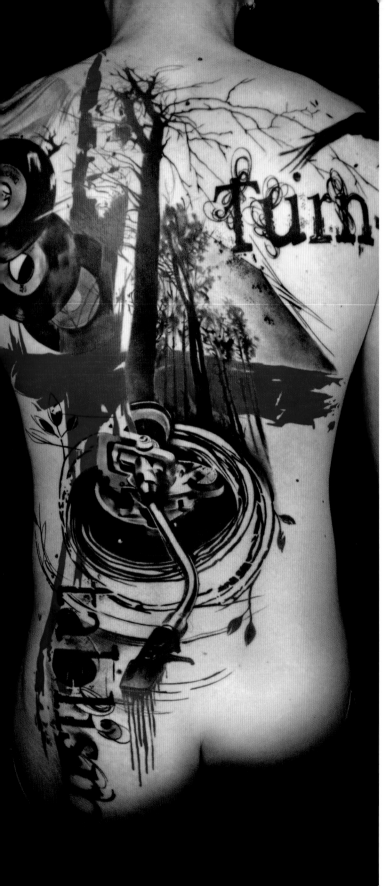

4 Turntablism theme 5 Skull wearing a crown
of thorns 6 Realism and abstraction combined
7 Abstraction reminiscent of a rose window

The artist duo describe themselves as inspired by 'life
and death'. In their tattoo work, the pair fuse antagonistic
elements, often creating images that address issues of beauty
and perishability. They therefore value the volatile nature
of skin as opposed to paper or other conventional artistic
media used as a base for painting, printmaking or drawing.
Unlike other media, skin is a living organ subject to different
conditions and with certain qualities that play a decisive role
in the possibilities and limitations of artistic production.
Merschky and Pfaff set out to 'follow the rules of permanency'
and create long-lasting tattoos. This is clearly visible in their
distribution of black in striking contrast to blank spaces with
the comparatively light skin colour. The frequent use of a
saturated red creates a further contrast that makes their
tattoos instantly recognizable. Furthermore, their designs
are also mostly asymmetric.

The two have known each other for twenty-five years.
Merschky grew up in a German municipality that once housed
a US military base and he was impressed by the different types
of tattoos he encountered there. After his first attempts at
tattooing at the age of sixteen, he studied interior design at a
technical college. Meanwhile, Pfaff worked as a graphic designer
until Merschky introduced her to tattooing. Although the duo
are fascinated by working on living canvases – which they
describe as 'extremely fulfilling and never boring' – they are by
no means confined to only tattooing as a mode of expression.
Their copyrighted brand name, Realistic Trash Polka, points to
their diverse output, which includes painting, the music project
Dobbs Dead, photography and fashion design. Their brand
name references the tattoo genre of realism, whereas 'trash'
refers to the reused graphical elements in their work. Merschky
explains that they also integrated a musical genre, polka, into
their name as a way of conveying how 'parts of their
compositions fuse as notes to a piece of music'.

Initially, Pfaff and Merschky had a difficult time finding
clients who wanted to have Trash Polka designs tattooed
on their bodies. Today, however, their novel, untraditional
aesthetics have become an inspiration for tattooers all
around the world. The uniqueness of their style, paired
with their consummate technical skills, keeps them working
freely on clients in their studio, Buena Vista Tattoo Club,
creating their own highly distinctive brand of art. OW

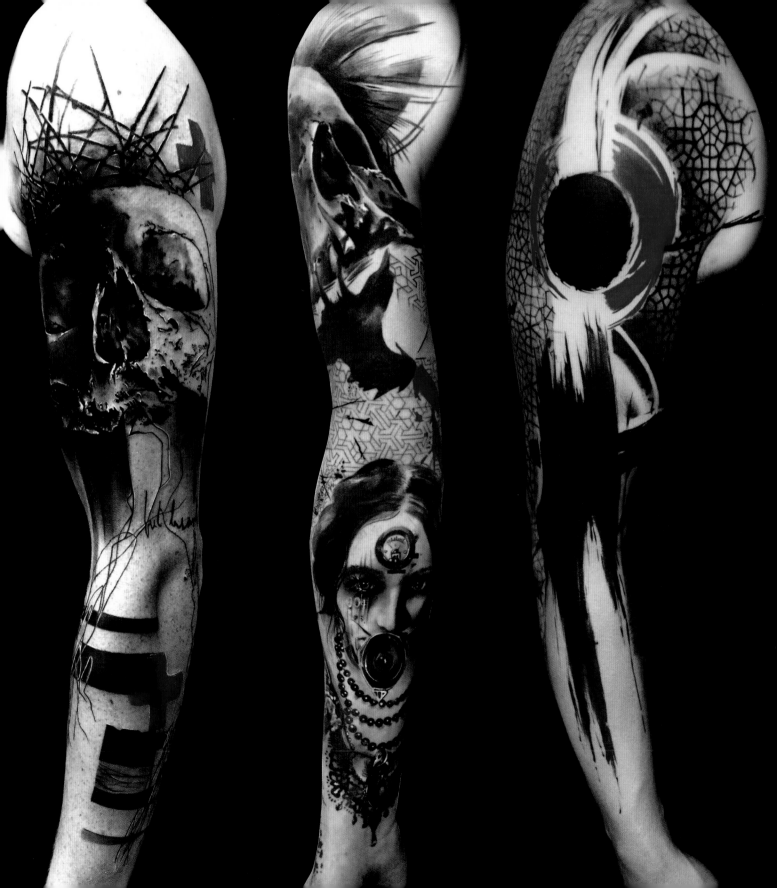

SUSANNE 'SUSA' KÖNIG

Susanne König is a visual innovator in the depiction of animal tattoos. The animal kingdom has traditionally provided inspiration for a huge number of tattoo motifs, including eagles, snakes, fish, swallows, tigers and butterflies. Not only has she expanded the range of species usually seen, she has also taken the way of representing them to a different level. 'The repertoire has broadened extremely', she reports, 'people no longer stick to animals that represent honour and courage.' König takes an anthropomorphic approach and equips her wildlife with human, often imperfect, traits. She conveys these characteristics with attributes such as clothing, but she also depicts her mainly black animal figures with distinctive human expressions.

König's graphic, clear-cut aesthetic derives inspiration from art forms ranging from copper engravings and contemporary art to antiques. She also works with non-animal themes and creates often quirky imagery. Aside from tattooing, she is involved in several art projects, including unique pencil works that she renders on disposable paper coffee cups.

König originally studied graphic design and wanted to be an illustrator, but she turned to tattooing instead in 2009 and with her mentor Kelu she established the Black Thorn Tattoo Studio. She currently works at Salon Serpent in Amsterdam where she says, 'the exchange with my colleagues does me good'. Amsterdam attracted her as a place that she finds 'straightforward'. This also applies to the animals she depicts – they don't pretend, but rather convey unfeigned emotions. This forthrightness corresponds with her requirement for a good tattoo: 'I want the beholder to feel something. Amazement, joy, shudder, you name it.' ow

1 Kraken attacking ship 2 Anthropomorphic bird
3 Hunter's shelter 4 Anthropomorphic banana 5 Portrait of a human-like poodle in Victorian garb 6 Fox sleeping inside a heart-shaped den 7 Smiling cat drinking coffee

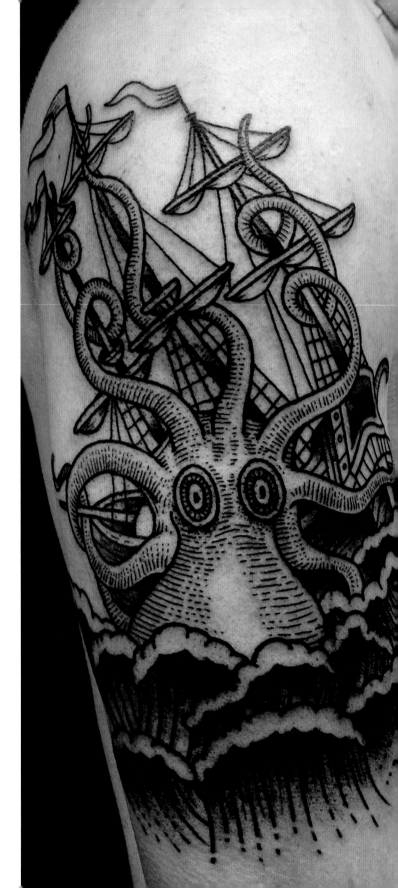

STYLE REALISM INFLUENCES SURREALISM,
H. R. GIGER'S BIOMECHANICAL ART, AIRBRUSH ART
LOCATION TØNSBERG, NORWAY

RICO
SCHINKEL

Rico Schinkel's tattoos brilliantly exemplify and innovate the
biomechanical style. He was introduced to biomechanical art
through the *Alien* movie franchise. At first he tattooed and
drew replicas of the creatures designed by H. R. Giger for
the *Alien* movies, but after careful study he developed his
own individual biomechanical style. He is also an accomplished
airbrush artist and has produced biomechanical works on
canvases, cars, motorcycles and even a paddle steamer.

Schinkel has spent fifteen of his twenty years as a tattoo
artist working in the biomechanical style. He was born and
trained in Rostock, Germany, a place he describes as 'the most
Gigerized town in the world'. A move to Norway, where the
biomechanical style was relatively unknown, gave him the
opportunity to expand his portfolio to other styles, such as
realism and black and grey. Today he will replicate a Giger piece
for a client, but he prefers to produce his own unique tattoo art.

Schinkel explains the appeal of 'Gigerization': 'You can
combine biomechanical with everything; you can Gigerize a
house if you want to. For a body part you should follow the
given movement and flow of the muscles, which only really
works with freehand.' Freehanding a tattoo achieves and
enhances the biomechanical style: the tattoo uniquely fits the
curves, textures and flesh movements of each client's body.

Like Giger, Schinkel depicts women as strong, sexual and
maternal figures, with ornate metal headpieces and armour.
However, unlike Giger, he depicts a softness in their eyes and
lips that makes them bittersweet. Giger had intense nightmares
that filtered into his designs, whereas Schinkel merely has a
deep admiration for Gigeresque biomechanical art. KBJ

1, 4 Collage of characters from the *Hellboy* movies
2 Sleeve with exoskeletal patterns 3 Portrait grouping
with female face, ape-like creature and skulls

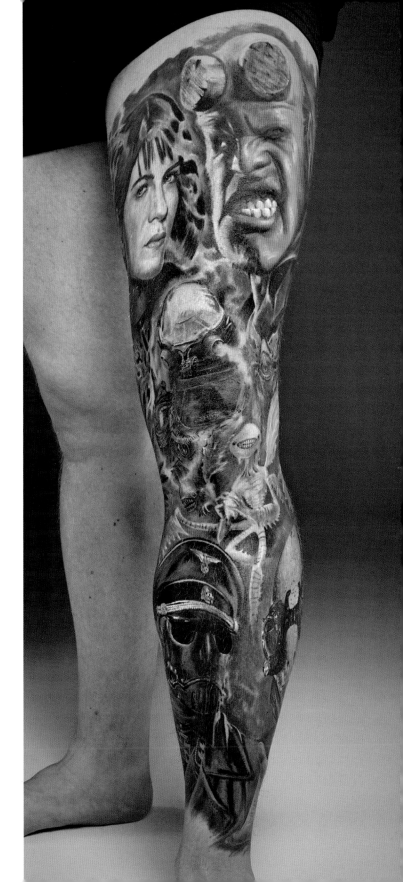

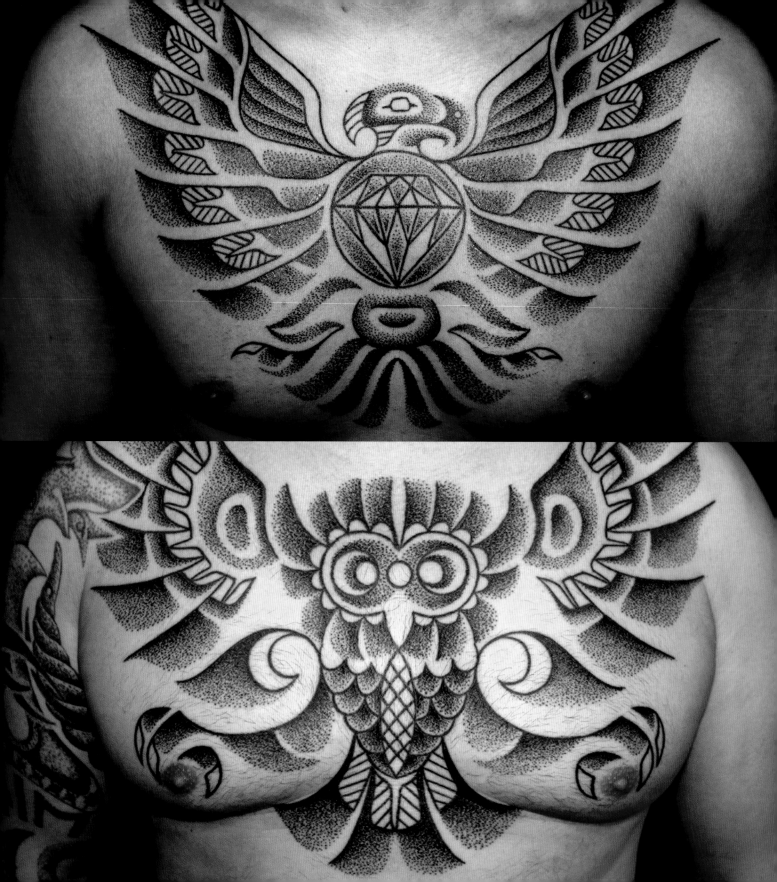

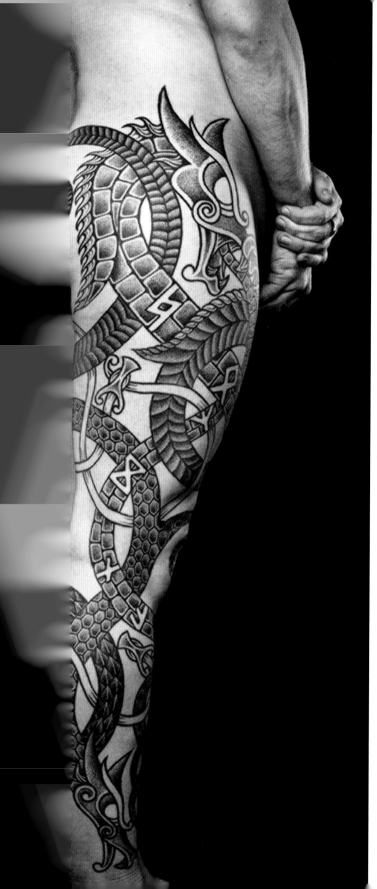

STYLE BLACKWORK **INFLUENCES** INDIGENOUS ART, SHAMANISM, VIKING ICONOGRAPHY **LOCATION** COPENHAGEN, DENMARK

COLIN DALE

As Colin Dale sews, hand-taps or hand-pokes human skin, he breathes new life into ancient tattooing practices by re-enacting and rekindling ancient tribal customs to make the human body more sacred. He was born in Canada, but lives in Copenhagen where he is one of the world's foremost tattoo artists practising traditional techniques today.

Dale has significantly promoted hand-tattooing by refusing to work with machines when he travels the world tattoo convention circuit. When he works at Viking markets throughout Scandinavia, he typically travels with a custom-made bone tool that is designed to hold different configurations of needles. Dale has also mastered the use of natural pigments (soot, ochre, human ash) that many clients prefer because they are natural.

Dale has similarly mastered different tattooing styles – from the bold form-line designs of the Haida on Canada's Pacific Northwest Coast and the geometric blackwork of Polynesia

1 Hand-tattooed Haida-style eagle 2 Hand-tattooed Haida-style owl 3 Neo-Nordic dragons entwined around leg

4 Yggdrasil – an immense tree in Old Norse cosmology
– here merged with a human figure 5 Yggdrasil rendered
more abstractly 6 Hand-tattooed bodysuit inspired by
Pacific Rim cultures, including Haida and Polynesian

and Oceania, to the organically rich, neo-Nordic designs of the Vikings and other northern peoples. Dale has sought inspiration from these and other indigenous traditions in his quest to create visually striking contemporary works. When he adds the painstaking patterning of dotwork designs to his neo-tribal tattoos, Dale's work conveys the endless possibilities that can be created on the human canvas.

Dale focuses heavily on neo-Nordic tattooing, a term he himself coined to describe this contemporary artistic movement. He borrows compositional ideas from Japanese traditions and creates similar skin-worlds, which he calls 'blood gods' because they depict the portraits and deeds of Thor, Odin, Loki and Tyr, among other mythical figures and creatures. Dale notes: 'Although I've done a lot of Nordic designs over the years, the actual gods have eluded me. Much like the Japanese, who design entire bodysuits around a particular god, hero or myth, I've been wanting to do the same using the Viking sagas as

inspiration. While Yggdrasil (world tree), the Fenris wolf, Thor's hammer and the Midgard Serpent are popular subjects, I've been wanting to do some more narrative pieces based on the actual sagas and inspired by Viking picture stones, like those found across Scandinavia. However, as most of these stories are based on the gods, I've had to develop a way of depicting human figures realistically, while staying consistent in style with the menagerie of other creatures I've drawn over the years.'

Dale's timeless artistry separates him from most tattooists working today. Instead of pushing tattoo art forward, he looks back across time to discover the original sources of inspiration and traditional techniques that initially gave rise to tattooing. He channels the magic and spirituality inherent in giving and receiving traditional tattoos. Every tap, poke or stitch is like a whisper from the past and these lasting marks transport people to a different time and place in which the beginnings of tattooing itself first took place. LK

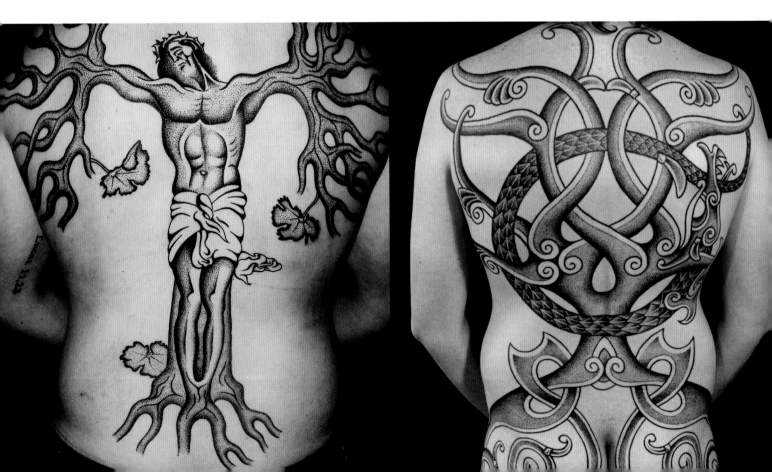

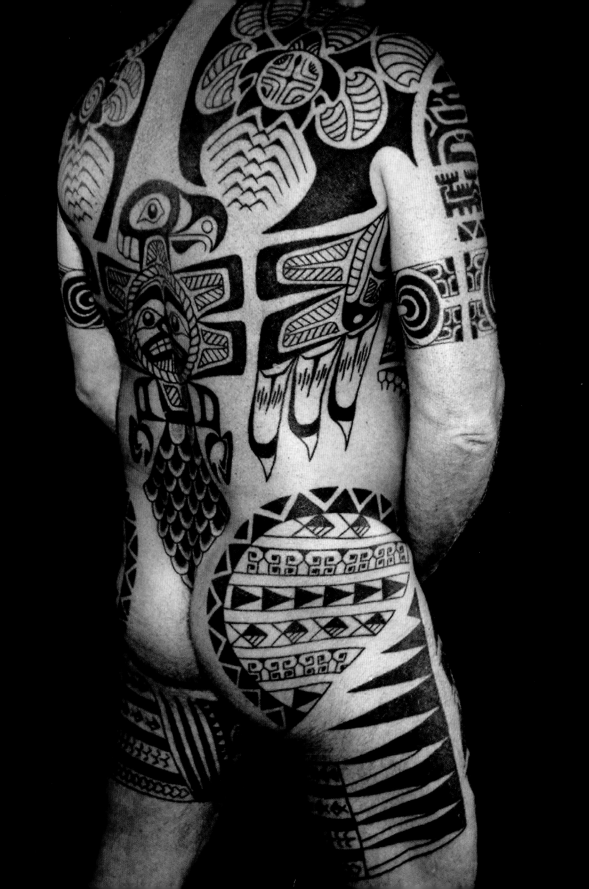

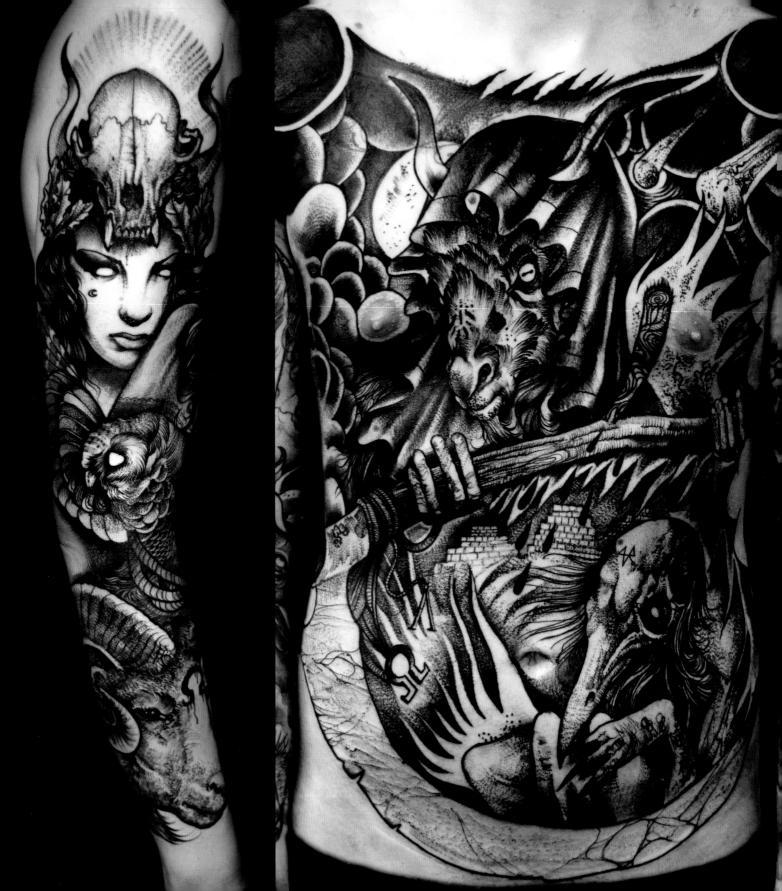

STYLE BLACK AND GREY, CONTEMPORARY
INFLUENCES ENGRAVING, ILLUSTRATION, ART NOUVEAU,
SURREALISM **LOCATION** BUDAPEST, HUNGARY

RÓBERT BORBÁS

Róbert Borbás has a tattoo style that blends Albrecht Dürer's engravings, the art nouveau illustrations of Alphonse Mucha and heavy metal music artwork. Beauty, depth, dark intensity and ferocity mark the intricate line work of his black and grey tattoos. Describing his highly emotive and coldly precise tattooing, Borbás says: 'The core of my style is in the line work because I love to have realistic elements and still keep an illustrative vibe.'

He prefers to work exclusively on large-scale tattoos and his subject matter typically consists of skulls, animals, mythical creatures, occult symbols and Norse folklore, all of which are rendered with a dark grace. Recalling the Death and the Maiden motif of Renaissance music and art, his work transfixes and simultaneously conjures contradictory emotions, such as pleasure and fear, towards each piece. Borbás has long been drawn to the macabre: 'I was always obsessed with metal album cover imagery, like Iron Maiden's skeleton mascot Eddie, and all the grim creatures used. Those were a huge influence on me. Ever since I can remember, I have been interested in topics like death, the occult and ancient myths. Through the centuries, the ways people imagined and portrayed death was a really strong part and element of art, regardless of the form or medium.'

Working as a freelance illustrator and designer under the name Grindesign, Borbás has created artwork for metal bands, including Metallica, Kreator, As I Lay Dying and Aborted. He began tattooing in 2012, at the age of twenty-four, and found the transition from pen and paintbrush to tattoo machine a natural and logical step. He continues to design original artwork for bands and other clients, and believes that process both complements and inspires his tattooing. **KBJ**

1 The Queen of Nature – Terra Mater 2 The Bringer of Death and Armageddon 3 Nordic mythology female character with raven headpiece

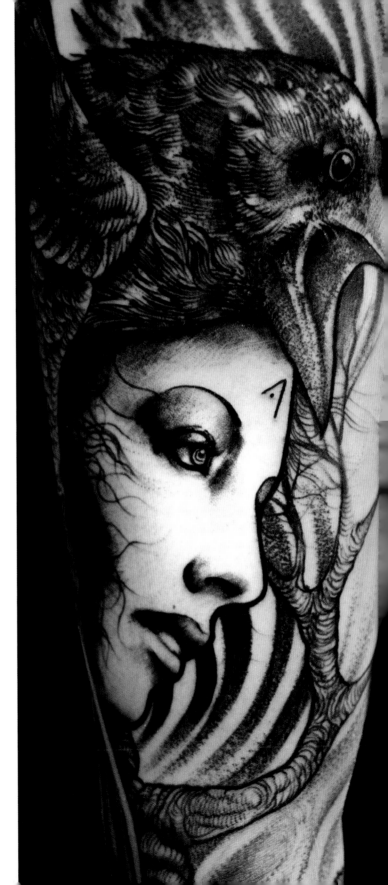

DMITRY BABAKHIN

STYLE BLACKWORK **INFLUENCES** PACIFIC ISLANDER ART, HISTORICAL EXPLORERS' ACCOUNTS, TRAVEL ADVENTURE STORIES **LOCATION** ST PETERSBURG, RUSSIA

An unlikely Polynesian tattoo master, Dmitry Babakhin inscribes timeless blackwork designs far from the jungles and beaches of the Pacific Islands. Working in St Petersburg, Russia and also travelling throughout Europe to tattoo at conventions and guest spot at other shops, he attracts clients looking to transform their bodies with enormous, bold patterns. His passion for Polynesian designs comes from their ornamental nature, and he particularly likes 'how they are anatomically connected to the body'. He enjoys the narrative content of traditional tattoos and explains how this results in a particular dedication to each client: 'I draw a personal design for every customer, considering his or her anatomical features and personal story. Sometimes drawing a design takes more time than tattooing itself.'

1 Arm design inspired by indigenous traditions
2 Traditional Marquesan calf designs 3–4 Designs influenced by Marquesan and Maori patterns
5–7 Leg tattoos based on Marquesan motifs

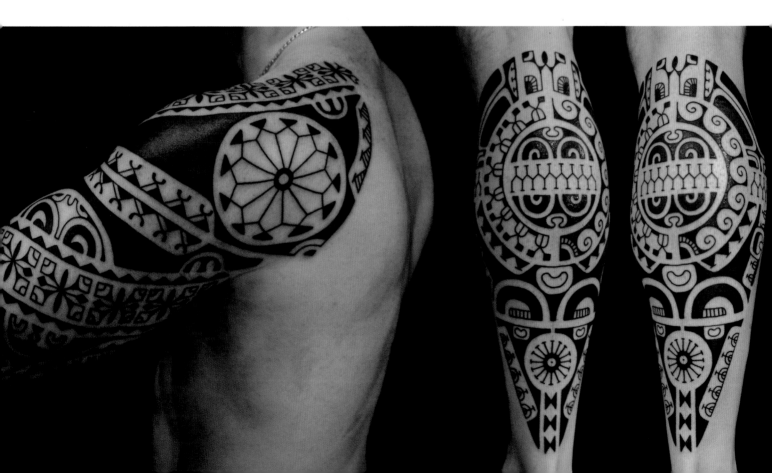

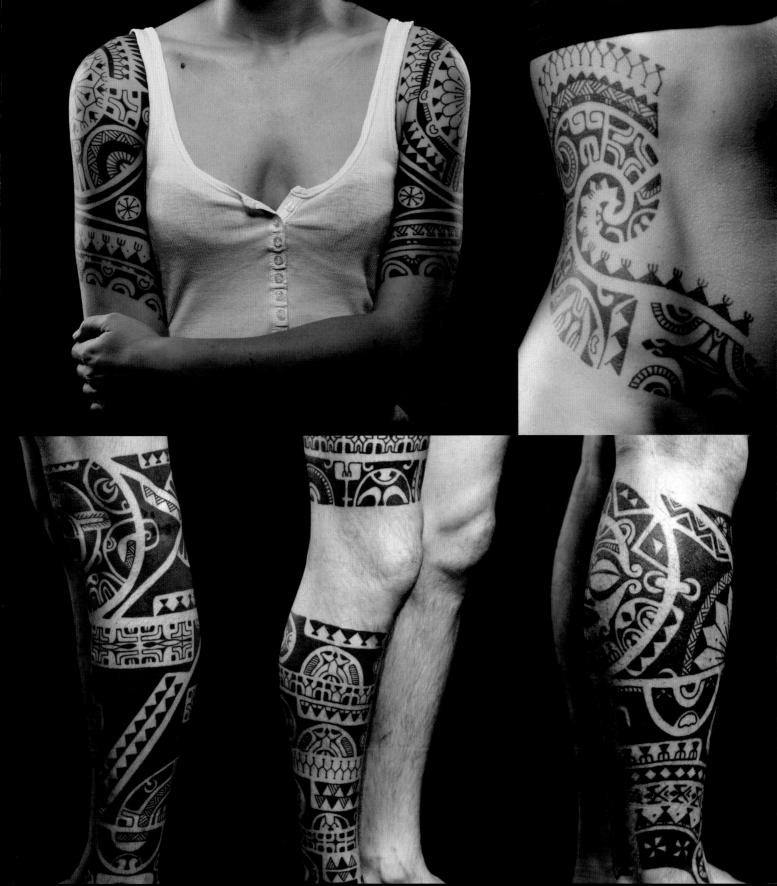

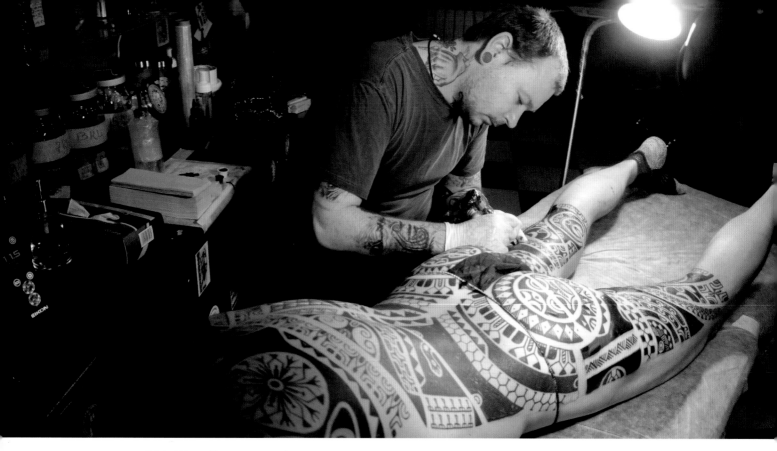

8 Babakhin working on an extensive Marquesan-inspired bodysuit **9–11** Marquesan-inspired designs

Babakhin was born in 1981 and was exposed to tattooing as a teenager when tattoo magazines and foreign rock culture, with its often heavily tattooed musicians, became widely available in post-Soviet Russia. He wanted to be 'cool' like them. He recalls a childhood love of travel adventure stories, including Robert Louis Stevenson's books about the Pacific Islands, which explains why Polynesian designs particularly appeal to him. When he acquired his first tattoo at the age of fourteen, he says, 'my life changed forever'. The piece, which he tattooed on himself, was a Leo Zulueta design that he copied from a magazine. In 2001 he began tattooing in a shop and in 2006 he became the owner of Bang Bang Custom Tattoo Shop.

Inspired by a melange of Pacific Islander cultures, Babakhin specializes in the starkly geometric Marquesan designs described in early 19th-century explorers' accounts of those islands. His work also incorporates designs inspired by Samoan and Maori patterns, as well as other Pacific Islander cultures.

Occasionally, he works in a more free-form contemporary tribal style. Babakhin was named Artist of the Year in the Polynesian Tattoo Awards in 2013. This is a testament to how the spread of global tattoo culture can result in masterworks in places far removed from their design origins.

Babakhin conducts considerable research into the history of Polynesian designs and uses rare books and prints as source material. He cites books on Marquesan art by Karl von den Steinen, Ralph Linton and Willowdean Handy as influential. Many of Babakhin's tattoos transform his clients into characters who could come from the pages of these antique books. He has also read the account of Adam von Krusenstern, who travelled to the Marquesas in the early 1800s and documented the extensive tattooing seen there. Some members of Krusenstern's team were actually tattooed and in a sense Babakhin is continuing that legacy by inscribing these patterns on European skin thousands of miles away from their origins. **AFF**

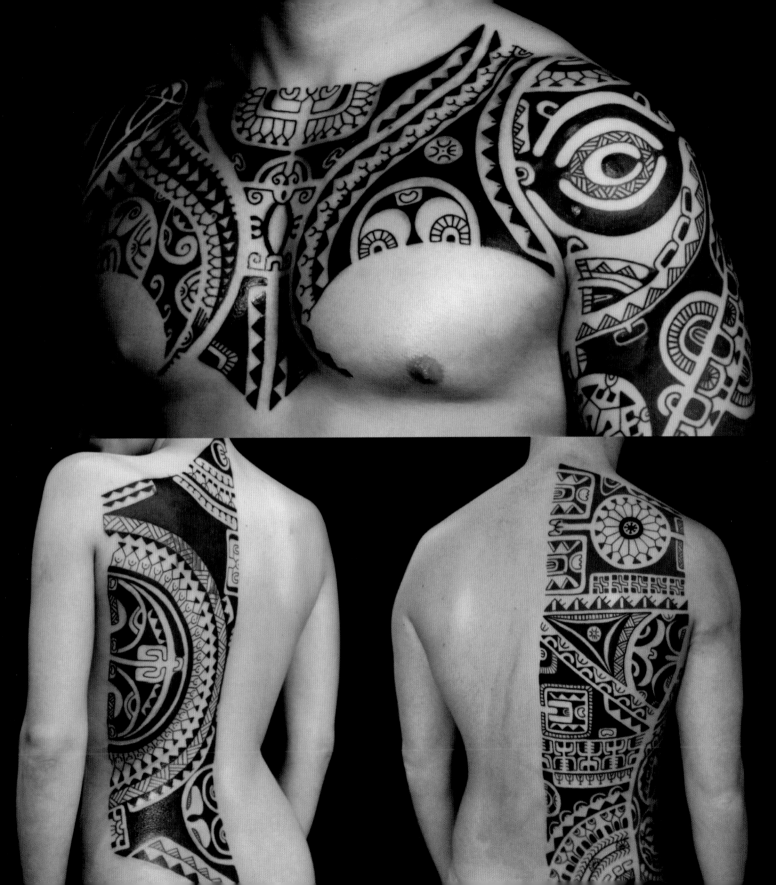

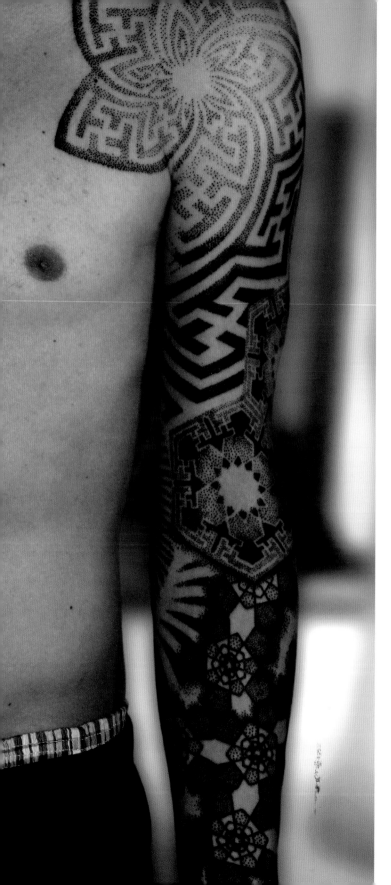

STYLE CONTEMPORARY BLACKWORK **INFLUENCES**
INDIGENOUS ART, TEXTILE PATTERNS, ARCHITECTURE,
EMBROIDERY **LOCATION** WARSAW, POLAND

KAROLINA CZAJA

In her private Warsaw atelier, away from the tumult of Poland's capital city, Karolina Czaja decorates the bodies of her clients with elaborate patterns, dot by dot. Her pioneering technique employs both machine tattooing and hand-poking. She explains the lure of the latter: 'Hand-poking is like an echo of old tattoo traditions, allowing for free "energetic transfer" between the tattooist and the bearer.' Czaja's passion for tattooing began when she explored traditional craftsmanship while studying at Folk University in Wzdów. She focuses on ornamental art and gains her inspiration from ethnic sources, including traditional textile patterns, embroidery and architecture. Some of the symbols she incorporates into her designs are from Asian and Polynesian culture, whereas others have their origins in Slavonic motifs. Czaja's style progressed from early experiments with the black designs that are characteristic of the Marquesas Islands and Micronesia to her current sophisticated dotwork projects.

Process is vital to Czaja, and she needs silence and tranquillity to work. To enable her artistic energy to flow, she decorated her studio, Primitive, in an ethnic style, aiming to create an 'alternative environment' for clients. Located in an area of single-family homes, her studio does not stand out: 'It's a way to narrow down the number of people coming here,' she admits. 'I like to focus my attention on one person per day and to minimize the sense of being a chaotic workshop selling skin images.' Her ornamental designs help people to understand the symbolic meaning of tattoos and she encourages clients to search for inspiration in their own past and culture. For Czaja tattooing is 'the highest form of art – the magic one because you can change [some]one's life giving . . . a part of you'. TM

I Geometric floral sleeve 2 Aztec-inspired design
3 Geometric patterns in red and black 4 A melange
of patterns from textiles, architecture and other sources

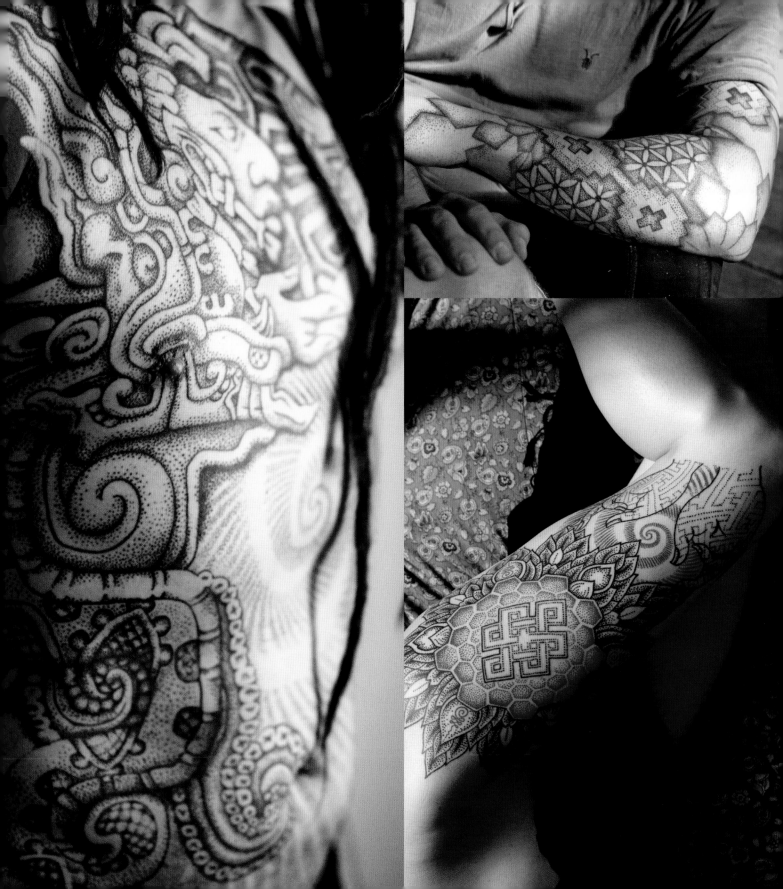

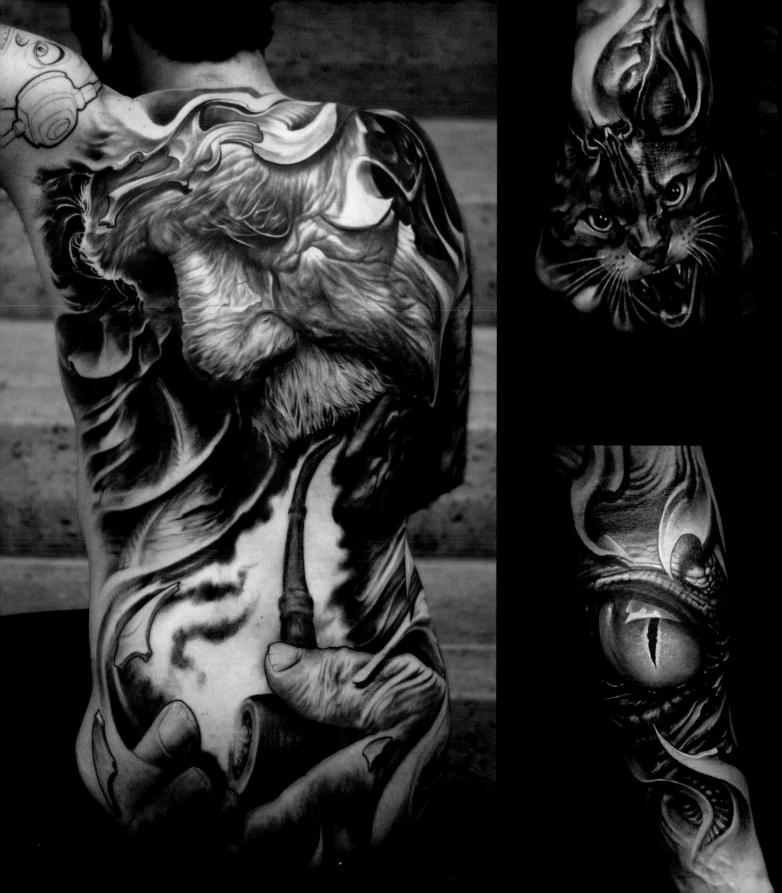

STYLE BLACK AND GREY, REALISM **INFLUENCES** HEAVY METAL MUSIC, SURREALISM, ABSTRACTION **LOCATION** KRAKÓW, POLAND

VICTOR PORTUGAL

When renowned Uruguay-born artist Victor Portugal decided to settle in Kraków, the local tattoo fraternity celebrated. Portugal's presence in that picturesque Polish city has significantly influenced the tattoo community. His name arouses feverish excitement and has become synonymous with extraordinary black and grey tattoo art. When he first started working in the mid-1990s, Portugal's approach was influenced and inspired by the tattoos of heavy metal idols: 'I think that it raised in me [a] willingness to be the same.' His breakthrough came when he was exposed to the work of Paul Booth in one of the professional tattoo magazines. Those images set him on course to become a tattoo artist.

Early on in his career, Portugal achieved widespread accolades as the prince of dark and sinister tattooing. The gloomy, terrifying works from the 1990s conjured nightmares and aroused dread. Later, his style changed direction and

1 Old man smoking a pipe 2 Hissing, demon-possessed cat 3 Dragon's eye peering out from arm
4 Crying, biomechanical-influenced masked woman
5 Abstracted bone- and horn-like designs

6 Female face paired with skull 7 Woman about to mutilate her face
with scissors 8 Biomechanical woman thinking 9 Elegant female face
morphing into tattered ribbons

6 7 8 9

moved towards surrealism and abstraction. He also engages in other tattoo genres, for example, biomechanical imagery and pieces that appear three-dimensional. Portugal prefers to work in the black and grey style, although he sometimes adds touches of colour as an accent to a project. He also favours working over large areas of the body in order to achieve a more spectacular final effect. Although he is inspired by everything around him, he now avoids browsing tattoo magazines, so as not to become influenced by other artists.

Regarding his process, Portugal explains: 'I like to work with references from my clients . . . to take advantage of their ideas to make my original projects.' Exuding confidence, he often completes tattoos in a single session and he frequently draws freehand directly on to his clients' bodies. He does not like situations in which his clients impose a restrictive vision. Portugal also puts a strong emphasis on creating a convivial work atmosphere in his studio.

Portugal's subject matter ranges considerably from skulls to female faces to images from nature to biomechanical motifs. Each individual project, however, strongly focuses him: 'I [want] every tattoo to be unique. All the time I seek something original, unusual . . . I work in a style in which people explore, therefore I am also looking for something impressive, astonishing.'

According to his clients and his colleagues, Portugal is a truly unique person and this explains why his tattoo work is so stunning. In describing himself, Portugal says: 'I am a calm person, I prefer to be unknown rather than famous. I have a lot of energy. I must have my place, to feel free.' When Portugal feels the need to take a break from the hectic city, he seeks new energy in nearby forests. Nature calms and eases him. Nonetheless, he considers tattooing his ultimate calling and a path to new adventures: 'Tattoo is my [way of] life. My passion. I never have enough of tattooing. I'm always open to new ideas, creativity and challenges.' TM

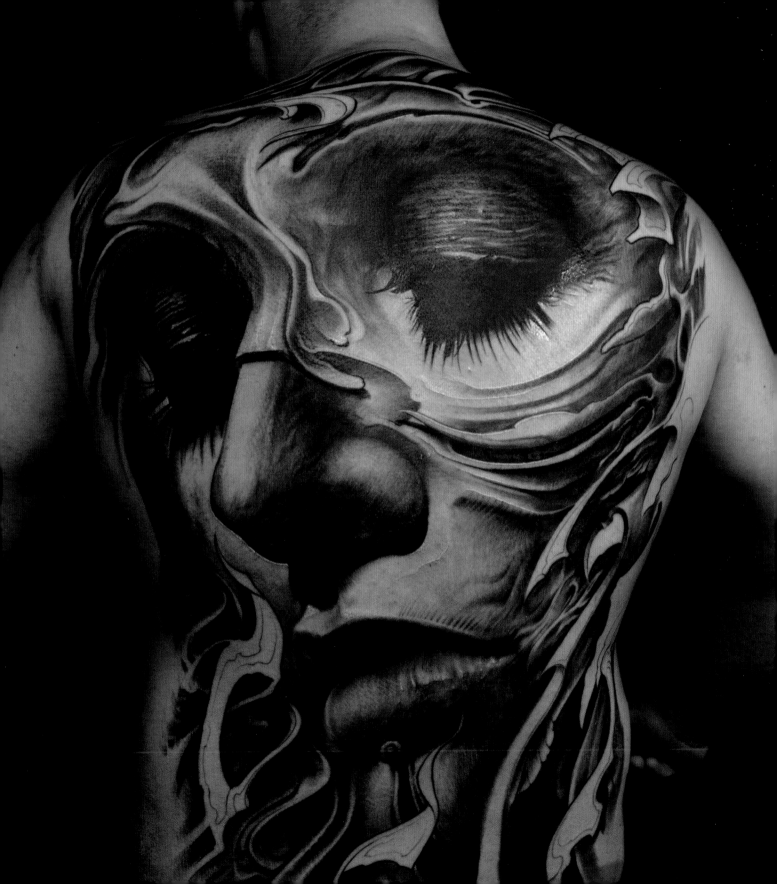

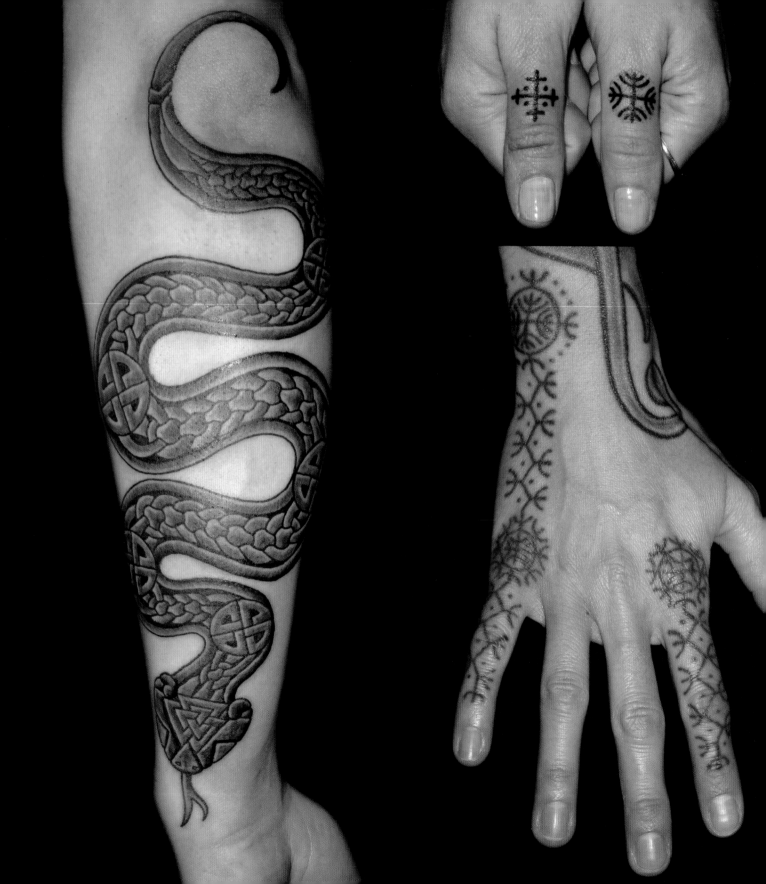

STYLE BLACKWORK, BLACK AND GREY **INFLUENCES** BOSNIAN AND CROAT CULTURE, ILLUSTRATION, MILITARY, WARRIOR CULTURE **LOCATION** ZAGREB, CROATIA

ZELE

Ninoslav Zelenovic (better known as Zele) specializes in two quite different forms of tattooing, both of which are related to his native Croatia. He is at the forefront of a movement to revive the traditional, geometric blackwork Bosnian Croat tattoos that have nearly died out in the Balkan region. A war veteran, he also designs tattoos related to the military and favours designs that include 'patriotic heraldic and military insignia, monument-like representations of knights, armoured angels, Viking warriors and other themes appealing to police, security, armed forces and war veterans such as myself'.

Zele was born in 1973 and raised in Sibenik, a medieval town on the Dalmatian coast. He started tattooing in 1989, but his progress was interrupted by service in the Croatian army during the Balkan conflict of the early 1990s. These roots influenced his interest in tattoos of 'history-based ornamental designs of hero-centric warrior cultures like Vikings, Celts, Maori and Iban

1 Celtic-inspired serpent 2–3 Hand designs utilizing traditional Bosnian Croat patterns 4 Traditional Bosnian Croat design with Christogram addition

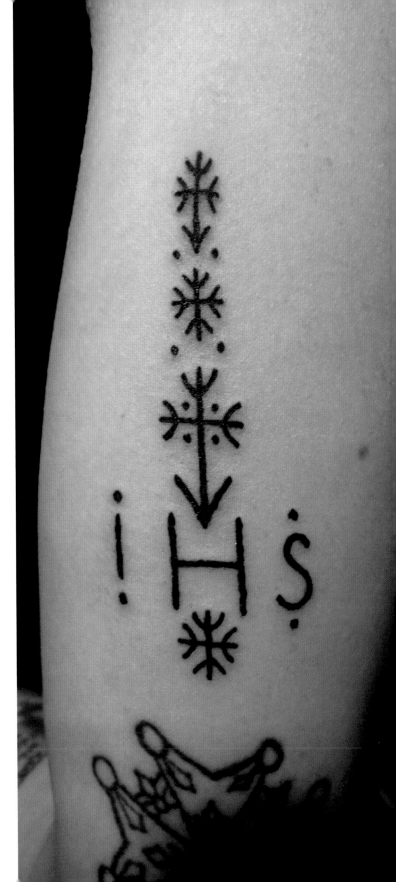

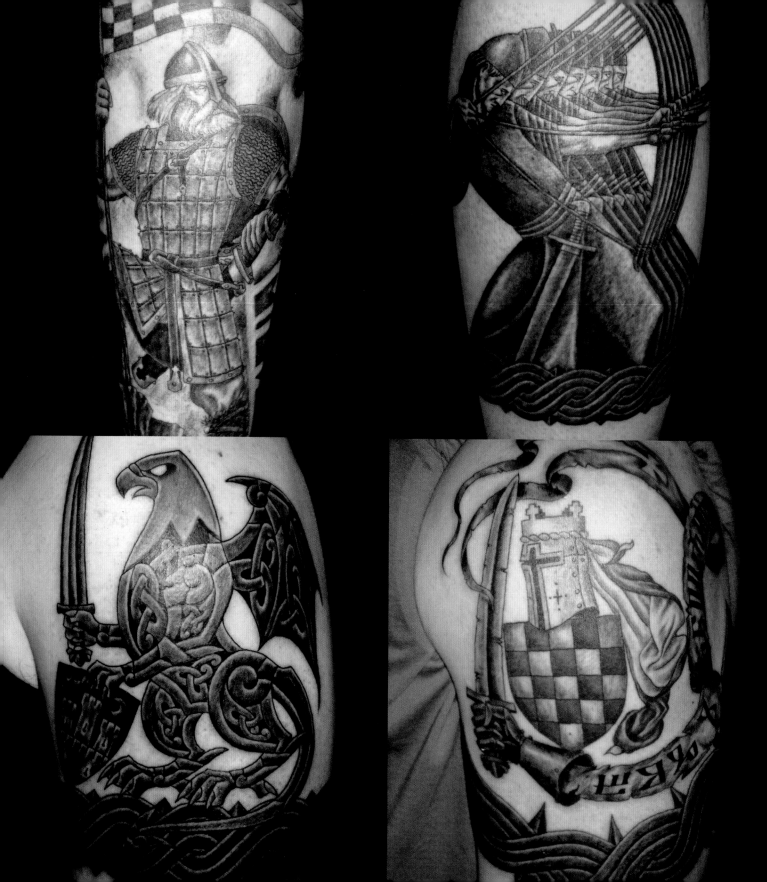

5 Knight in armour 6 Line of archers 7 Heraldic eagle
with Celtic knotwork patterning 8 Herald with sword,
gauntlet, helmet and shield 9–10 Traditional Bosnian
Croat designs

tribes'. In 1993 he left military service and began an apprenticeship with Sailor Ivan Svalj in Zagreb; then in 1995 he travelled to the first Amsterdam tattoo convention, where he says, 'I had the privilege of meeting and receiving advice from the tattoo grandmasters of the period'. He took over Sailor Ivan's shop in 1997 when he retired due to sight problems.

Zele first encountered traditional Bosnian Croat tattoos during his military service in 1992 when he saw them on refugees and 'was immediately fascinated by their raw beauty'. He further explored them when he started tattooing full time and read descriptions by Roman chroniclers from the 7th century. Zele deeply appreciates the persistence of these tattoos and notes: 'This beautiful tradition survived waves of Christianization, Westernization and Islamization during Turkish invasions when it served to preserve Croatian cultural and religious identity, and Communist modernization, so it deserves my best effort to help it survive the dreaded globalization, today's most effective killer of cultural identities.'

In 2000 he embarked on a trip to Bosnia with tattoo culture journalist Travelin' Mick to document the fading indigenous tradition. He describes the experience as 'uneasy'; they 'searched remote, war-torn villages looking for old people with traditional tattoos. This trip was not without danger for the region still bore the fresh scars of war, ruins still smelled of burning, landmines were around' and they encountered 'armed nervous locals and unclear boundaries'. Zele takes pride in the fact that he and Travelin' Mick 'brought this beautiful and endangered custom to the attention of the international tattoo public as the only European tattoo tradition that survived uninterrupted from the pre-Christian era well into the 1960s, when it started losing mass popularity in its original communities due to being percieved as "primitive" by outsiders'. His revitalization of these tattoo designs for the next generation makes him 'pleased to have taken part in saving this tradition in public memory rather than just anthropological books and journals' and has saved it from becoming extinct. **AFF**

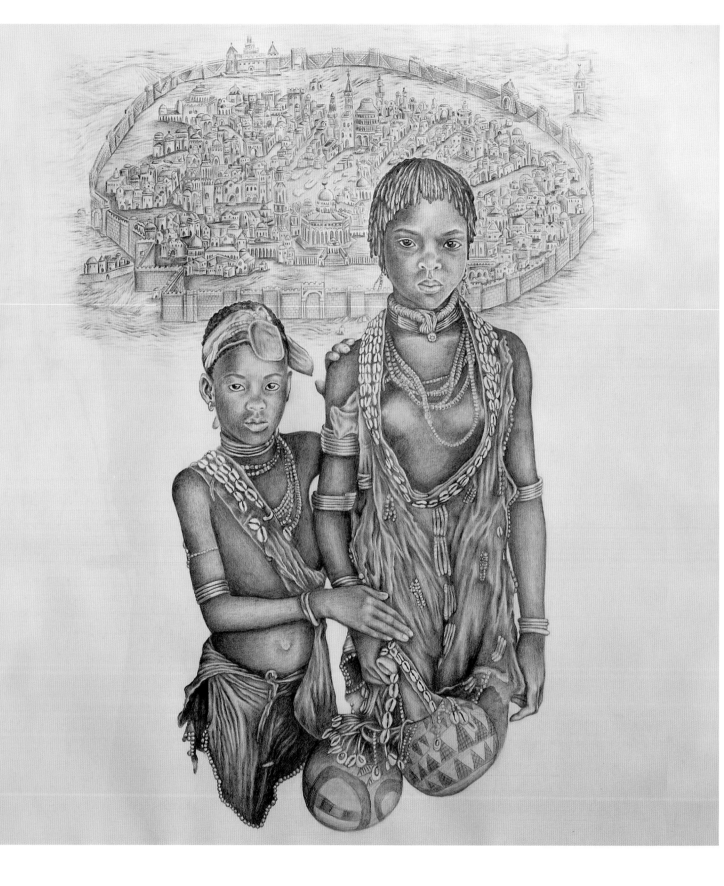

AFRICA
AND THE
MIDDLE EAST

CAIRO CONGO NORTH CAMEROON BENIN MUIZENBERG
JOHANNESBURG MUEDA PLATEAU TEL AVIV JERUSALEM AMMAN

ORNE GIL POLI SOMALOMO TIRGA POLI SAM IJE SHAUN DEAN RASTY KNAYLES
PIUS YASMINE BERGNER RAZZOUK FAMILY HUZZ

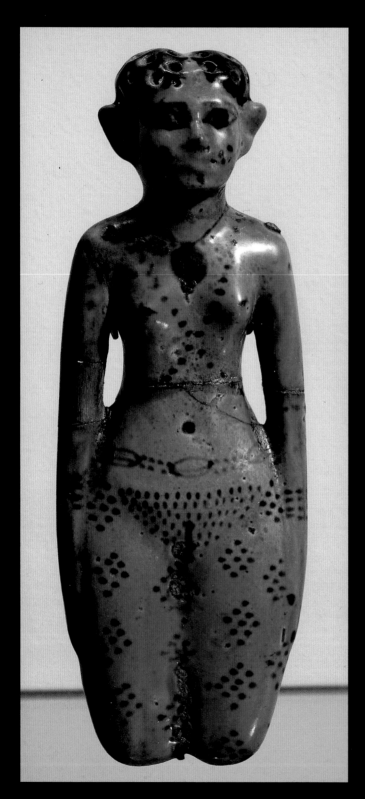

Africa and the Middle East possess incredibly rich tattoo histories of deep antiquity. Unfortunately, long legacies of colonization and missionary activity have caused most of the indigenous traditions across this broad geographical area to either become extinct or significantly wane. In areas in which tattooing lingers but has been declining, these important cultural marks can only be seen on the bodies of community elders. The indigenous tattoo revival movements witnessed in other parts of the world, such as the Pacific Islands, have not yet reached the African and Middle Eastern populations who might be excited to reverse trends towards unmodified skin and who, due to being nomadic and technologically unconnected to the outside world, may not know of such possibilities.

However, vibrant traditional tattoo practice continues in certain isolated pockets, particularly in West Africa. In several major urban areas, tattooing influenced by other cultures from both the West and East has gained popularity, especially among members of youth culture. Designs ranging from geometric blackwork to traditional Americana-style motifs to photorealistic black and grey portraits have emerged as viable options for self-expression in this region of the world among cosmopolitan populations.

Ancient Practices

Tattooing in sub-Saharan Africa may date as far back as 84,000 years. Bone tools discovered at the Blombos Cave archaeological site in present-day South Africa are believed by some scholars to have been tattooing implements. The earliest visual evidence for tattooing in the Africa-Middle East region may come from ancient Mesopotamia. Clay Ubaid figurines from prehistoric Mesopotamia (c. 4000–5500 BCE) feature incised lines in the pubic region that possibly represent body art and align with later tattoo practice in nearby areas, such as Egypt for which incontrovertible evidence exists.

In Egypt a wealth of evidence for ancient tattoo practice emerges in the historical record. Women appear to be the only gender tattooed in Egypt; their tattoos were possibly associated with fertility or sexuality or were merely decoration. Heavily incised predynastic figurines from c. 4000 BCE may depict tattooing. Numerous Egyptian and Nubian mummies dated between 2000 and 500 BCE have been found with tattoos, including Amunet, the mummy of a priestess of Hathor, and

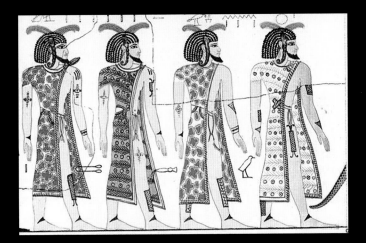

women dancers who wear intricate dot patterns in their pelvic regions and elsewhere on their bodies.

Faience figurines from the Middle Kingdom (c. 2000–1700 BCE) known as 'Brides of the Dead' feature similar abdominal patterns, as well as diamond shapes on their legs and X-shaped torso markings that may represent tattooing (see image 2). Paddle dolls from the same period also feature markings that may be tattoos, including crocodiles and images of the hippopotamus-lion-crocodile-hybrid goddess Taweret.

In the New Kingdom (c. 1570–1293 BCE), other faience objects show female musicians and dancers marked on the thigh with images of Bes, a god who protected women in childbirth. Tattoos have also been found on male Nubian mummies with marks on the hands and face, which are believed to be penal marks or marks of religious faith. Egyptians also documented tattoos on their neighbours. The tomb of Seti I, who reigned c. 1294 to 1279 BCE during the 19th Dynasty, features paintings of four Libyans with geometric patterns on their arms and legs (see image 3).

Christian Tattooing in the Holy Land

Tattoos marking the Christian faith have existed in the Middle East and Africa for nearly as long as Christianity itself has existed and are among the most historically persistent forms of global tattooing. As early as 528 CE, Procopius of Gaza wrote of Christians tattooed on their arms and shoulders with crosses, Christ's name, the acronym INRI and other Christian

symbols, including fishes and lambs. These marks, in addition to expressing devotion to their faith, may also have helped confirm the identification of one Christian to another. In the 8th century, Egyptian Christian monks began tattooing the small, inner wrist tattoos seen commonly on Coptic Christians today. This practice may have been inspired by the cross tattoos neighbouring Ethiopian Christians inscribed on their faces and arms.

In addition to marking faith, tattoos have also transformed the skin of pilgrims during visits to the Holy Land. Christian pilgrimage tattoos employ an unusual technique, seen only in a few other cultures, whereby the design is transferred to the skin prior to tattooing using a stamp (see image 4). Writing about the tattooing he witnessed in 1697, Henry Maundrell described a process that remained little changed over centuries: 'They have stamps in wood of any figure that you desire; which they first print off upon your Arm with powder of Charcoal;

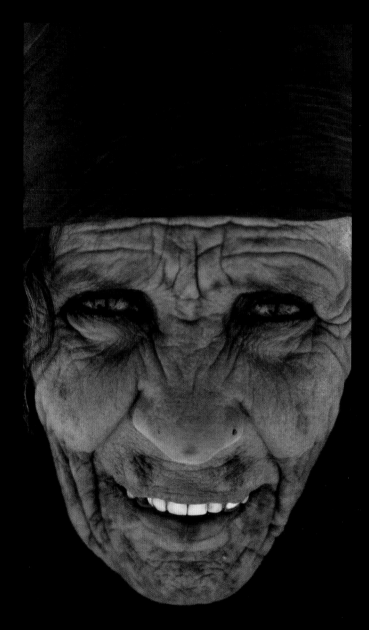

then taking two very fine Needles, ty'd close together, and dipping them often, like a pen in certain Ink, compounded as I was inform'd of Gunpowder, and Ox-Gall, they make with them small punctures all along the lines of the figure which they have printed.' In recent decades electric machines and modern inks have replaced the hand-poking technique, but the wood blocks and classic designs endure.

Christian tattooing persists today, particularly on pilgrims of Armenian, Syrian, Ethiopian and Egyptian descent who visit Jerusalem and other Holy Land cities, often around Easter. The Razzouks (see p.244) – Coptic Christians of Egyptian descent – are prominent among the families who continue the pilgrimage tradition in the Middle East. They began tattooing in Jerusalem when their ancestors emigrated there in the 18th century. In Egypt, Coptic artist Girgis Gabriel Girgis regularly travels from his day job as an engineer to apply tattoos in the evening outside Cairo's St Samaan church; his intense devotion to his faith helps continue this link to the past. In Ethiopia, Christian women wear crosses on their foreheads and additional markings elsewhere on their bodies, especially along their jawlines and on their necks.

Indigenous Tattoos in the Middle East

Tattoo traditions have existed among various non-Christian groups in the Middle East, particularly those with Bedouin ancestry. However, recent, more conservative interpretations of passages in the Qur'an that can be construed as prohibiting tattooing have effectively constrained new practice among Muslims. Elaborate tattoo traditions among the Kurds in the northern part of Iraq and the southern part of Turkey continue to the present day and may have originally been related to tattooing in the Balkan region of Europe. Kurdish tattoos (see image 6) are called *deq* and generally protect their bearers from harm by warding off the 'evil eye' and offer healing. Geometric patterns primarily adorn the face, hands and forearms, and also sometimes the neck, torso and feet.

Many Middle Eastern tattoo traditions have become extinct, however. In Iraq, as recently as the 1930s, both men and women had talismanic tattoos inscribed, primarily to ward off or cure disease. Purely decorative tattoos also existed in this region, often to enhance women's beauty. Tattoo artists in Iraq were predominantly female and ink (made from

ampblack) was sometimes mixed with human milk. Iraqi tattoo designs remained simple and consisted of geometric patterns of dots and short lines; they were inscribed across many parts of the body, including the hands, forearms, face, torso, legs and ankles.

North African Tattooing

Among Amazigh or Berber groups, tattooing (*oucham*, meaning 'to mark') used to be commonplace, especially in Morocco, Algeria and Tunisia, and among nomadic Tuareg groups, particularly in Mali. Today it survives in isolated areas on the skin of elders, but does not appear to be practised on younger generations (although another form of body art – henna body painting – continues to thrive). Many Amazigh groups, who practise a syncretic blend of Islam mixed with indigenous tradition, have in the past found a way to align their tattoo practice with Islamic precepts, as in the Middle East; however, increasingly fundamentalist movements in the Islamic world seem to have deterred practioners from keeping the practice alive in North Africa.

Amazigh tattooing has been primarily a female practice with tattoos worn on the faces, hands, arms, torsos, feet and legs of women and usually inscribed by female tattooers. However, children, both boys and girls, were often tattooed with protective marks, especially if they had siblings who died. Mainly talismanic in nature, these tattoos protected women from evil spirits and harm, or provided other benevolent effects, such as enhancing fertility. A few Amazigh groups have also had male tattoo traditions (the ancient Libyan example from the tomb of Seti I may be a predecessor to such practice). Traditional Amazigh tattoo patterns, rendered in black, range widely from geometric patterns such as crosses to Islamic symbols like the hamsa (the protective hand of Fatima, daughter of the Prophet Muhammad) to abstract forms from nature, including palm leaves.

Sub-Saharan Africa

Tattooing has existed for centuries among a vast array of traditional groups throughout sub-Saharan Africa. Much of the tattooing in sub-Saharan cultures combines the non-pigmented scarification more commonly seen in this part of the world with the black marks of tattooing, creating a hybrid form of body

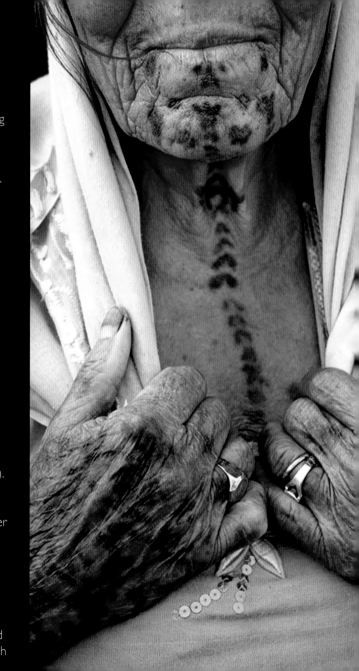

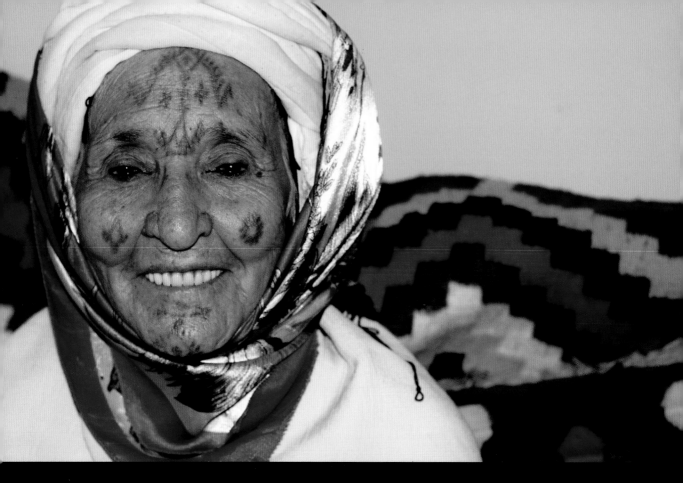

modification – essentially dimensional tattoos. From east to west and north to south, tattooing or pigmented scarification has been recorded on dozens, if not hundreds, of African-heritage groups.

Unfortunately, 20th-century interventions as a result of colonial and missionary presence caused significant decline in African tattoo practice. As elsewhere in the world, Christian missionaries discouraged traditional art forms they found to be inappropriate. The decline of traditional lifestyles, especially in the late 20th century as rural residents began to dwell in outsider-controlled 'camps', hastened the loss of cultural traditions. The rise of HIV and fear of practices that produce blood may also have contributed to the discouraging of such practices by health officials and a reluctance of younger generations to continue tattooing.

Among the many traditions that seem to have disappeared, the Fang in West Africa created intricate patterns, often derived

om nature, by two different tattooing methods on faces
nd bodies that often had a therapeutic, talismanic or spiritual
unction. Geometric and probably ornamental Malagasy
attooing, once widespread across numerous groups on the
land of Madagascar, had all but disappeared by the 1950s.

With respect to surviving tattoo practice, many Fula-heritage
roups that populate the Sahel – traditionally nomadic peoples
who mix North African and sub-Saharan African ancestry –
ctively inscribe skin with images inspired by nature. Elsewhere
n West Africa, the Yoruba cover extensive areas of the body
nd face with elaborate kolo designs; youth culture continues to
mbrace this practice, ensuring its survival. Among the Makonde
n Mozambique, the continuation of tattooing is precarious with
he last remaining practioners largely retired and quite elderly.
n Ethiopia, Afar and Menit people tattoo their faces, but with
ifferent patterns to their Christian neighbours.

Tattooing in the 21st Century
Globalization has left its mark on tattooing in Africa and the
Middle East, with urban practitioners working in imported
tyles and occasionally inventing new genres. For example,
Arabic script tattoos draw on a long Euro-American lettering
radition and the more recent trend towards getting Chinese
anji characters inscribed. Such artists tend to work in major
rban areas, predominantly in South Africa and Israel, and are
sually, although not always, of European heritage. Despite the
on-traditional focus of these new urban artists, they may be
oised to play a role in the revival of dwindling or extinct
ultural practices by offering to train potential tattooers about
afe practices in handling blood-borne pathogens and other
ways to tattoo so as not to create health risks for those wanting
o wear traditional societal marks.

The seeds of revival of many historical African and Middle
Eastern traditions are starting to be sown as visiting tattoo
nthusiasts document and share images of the extant
ndigenous tattoos they encounter on their travels. Although
here is something uncomfortable about the impetus for such
evitalization coming from outsiders of the same colonial
eritages that decimated traditional tattooing, hopefully in
everal decades careful revitalizations of historical practice
nd reinventions of extinct practice may have emerged, as

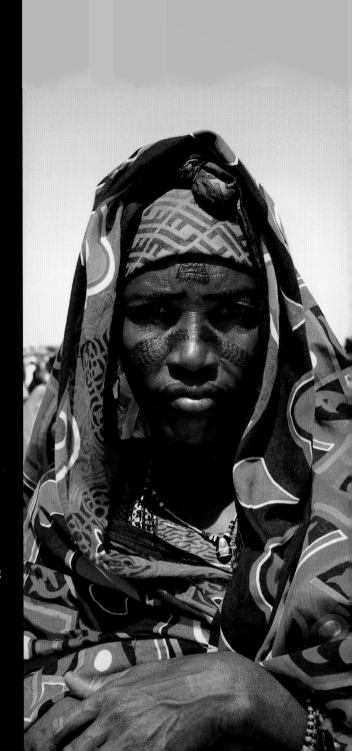

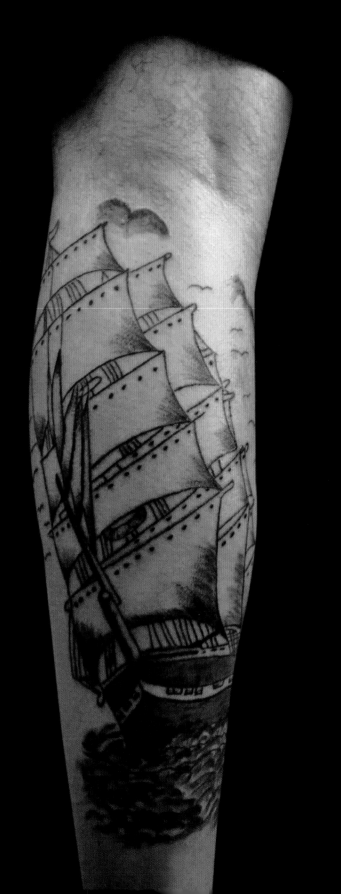

STYLE CONTEMPORARY, OLD SCHOOL
INFLUENCES TRADITIONAL WESTERN TATTOOING,
EGYPTIAN CULTURE LOCATION CAIRO, EGYPT

ORNE GIL

One of only a few artists working in Cairo, Egypt, Orne Gil loves traditional old school tattoos, although she most often finds herself rendering intricate tattoos of Arabic calligraphy. Originally from Venezuela, Gil studied in Italy, where she also worked in a tattoo shop. After finishing her degree and tattoo apprenticeship, she returned to Cairo and set up Nowhereland Studio.

Despite the perception that tattooing is unusual in Egypt, Gil sees traditional tattooing all around her – tattooed women from the Sinai, Coptic Christians with crosses on their wrists, the tattooed faces of Bedouins, as well as a growing number of younger Egyptians, who are expressing new ideas about democracy through ink. She tattoos many Coptic Christians who 'feel the absolute necessity of being marked and identified with their own religion'. Most of her clients, though, are Muslim; she even occasionally tattoos fully veiled women, but usually in private sessions. Many Islamic commentators interpret the Qur'an as indicating that body modification is a sin; however, her clients often use this art form to express their devotion. Gil works with calligraphers to design various styles – Diwani, Persian, Thuluth and Kufic, as well as surahs and basmala. These intricate and beautiful calligraphic tattoos are expressive, even if you cannot read the language. They function both as written pieces and as art, bridging the gap between the two.

Gil also works in typically 'Western' styles that include her favourite old school imagery, such as skulls, ships, flowers and daggers. She has introduced another Western innovation to Egypt: the tattoo convention. In 2014 Gil organized the Cairo Tattoo Expo: 'The public that attended were people really interested in our work, and so we were very pleased . . . although it was small, it was the first step.' Gil and her colleagues are making tattooing more visible in today's Middle East, as they marry ancient traditions with the modern. AKO

1 2

1 Full-rigged sailing ship 2 Freestyle Arabic calligraphy back piece

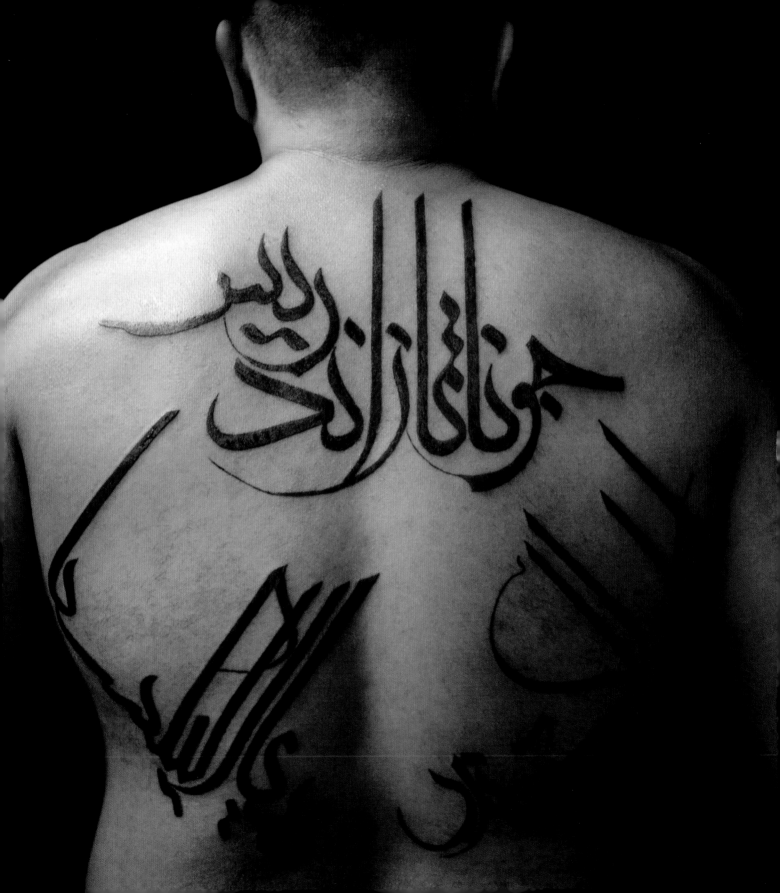

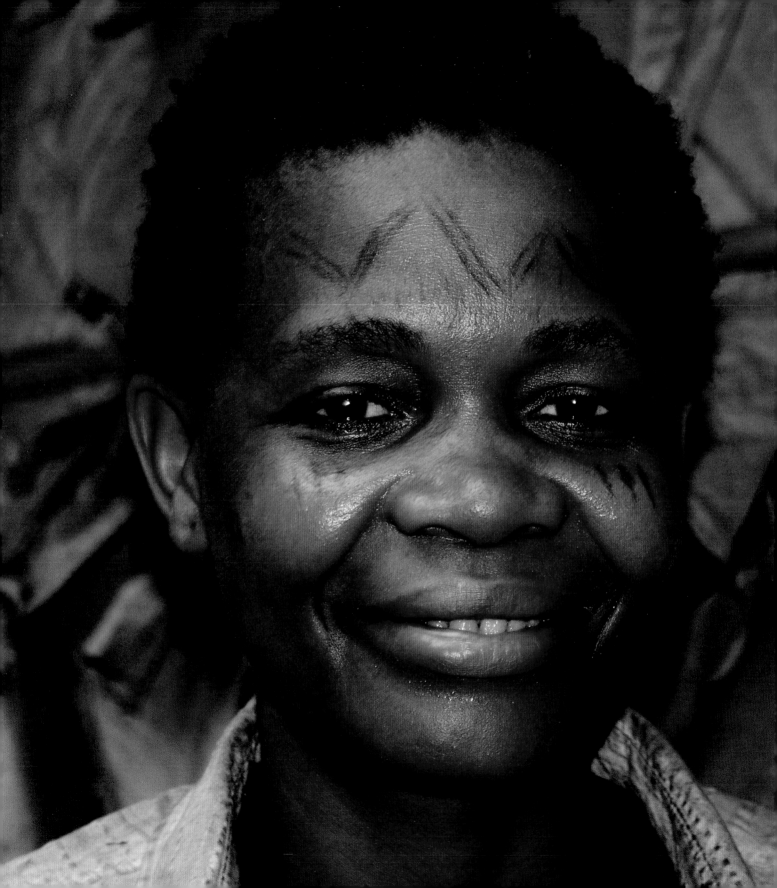

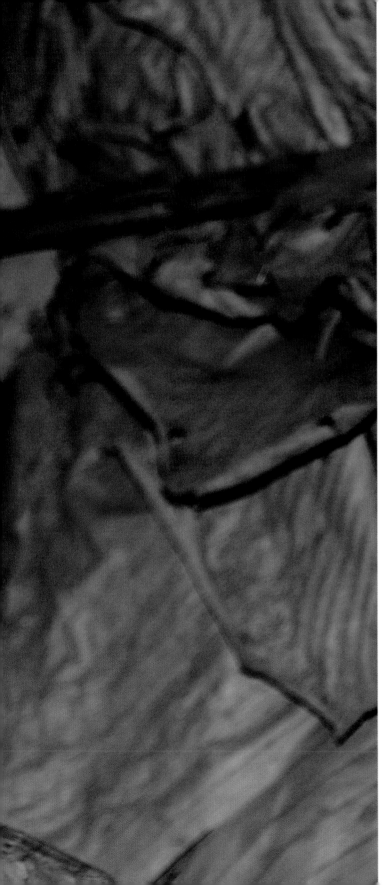

POLI SOMALOMO

Poli Somalomo does not have an ID card nor does she own a mobile phone. She has no idea how old she is (although she is probably in her late fifties). She only knows that she belongs to the Baka Pygmy Somalomo clan, that she has had two husbands and eight children and that her grandmother, Yambassa, taught her how to tattoo. Somalomo, like her parents and grandparents before her, was born in a nomadic camp but now lives in a settled camp. She still leaves the settlement every three months to reconnect with *ejengi* (mother jungle). As one of the last remaining Baka tattooists in the Congolese jungle, Somalomo is proud to keep alive an ancestral tradition once practised by most forest peoples. Together with tattooing (*tele*), Somalomo practises ear and nose piercing (*yuku*), the sharpening of front teeth (*sange*) and branding on female arms (*batabata*). Tattooing is by far Somalomo's favourite art form since she can 'draw on her family's and friends' faces and bodies'. Somalomo works

I Classic *tele* geometric facial tattoos

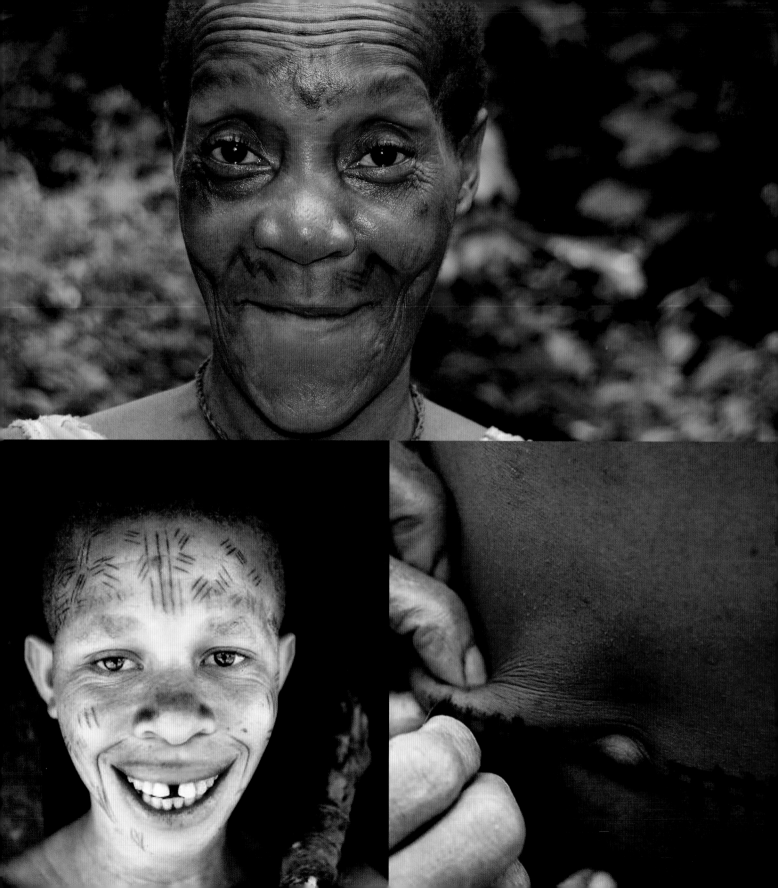

on demand and is occasionally compensated with smoked bush meat (a Baka delicacy), honey or salt. Her second husband supplies the needles, razor blades and small knives that she uses to tattoo; he is an experienced hunter who exchanges animal skins for these tools. She stopped using the traditional bamboo tools used for tattooing in the 1980s when razor blades appeared in the local market. She carves the design into the skin and then rubs charcoal and sticky berry juice into the wounds.

Somalomo observed her grandmother Yambassa drawing symbolic plant and animal forms on people's faces and she memorized the patterns. She has inscribed thousands of the quintessentially Baka, zigzag tattoos on both temples near the eye. Somalomo says her favourite pattern – the forehead spider – 'balances' the face like a third eye. Her version of this spider image was inspired by her grandmother's, but she adapted the design to her own style with a bigger body and smaller legs to 'cover big Baka foreheads'. Clients choose custom designs for

their cheeks, an important facial area for the Baka; five years ago the 'net tattoo' was in high demand. Many young women who adopted net-hunting techniques from neighbouring Bantu villages enjoyed their new activity so much that they decided to honour the raffia nets by incorporating them into their tattoos.

Although the Baka way of life is changing as the Congolese jungle opens up to new roads, timber and mining companies, schools and missions, Somalomo continues to adapt her tattoo practice so that this Baka art form is preserved. Despite French nuns who tell her to stop tattooing because it is 'dirty,' dangerous or belongs to the past, she is in the process of apprenticing her thirteen-year-old niece. She is also incorporating non-traditional motifs into her practice: scorpions (some filled in with red ink), sardines (tinned Moroccan sardines are the new sensation in the region), snakes (inspired by Indian cobras seen in magazines) and a strange boat demanded by a teenager whose father has worked as a carrier in a fluvial port. JR

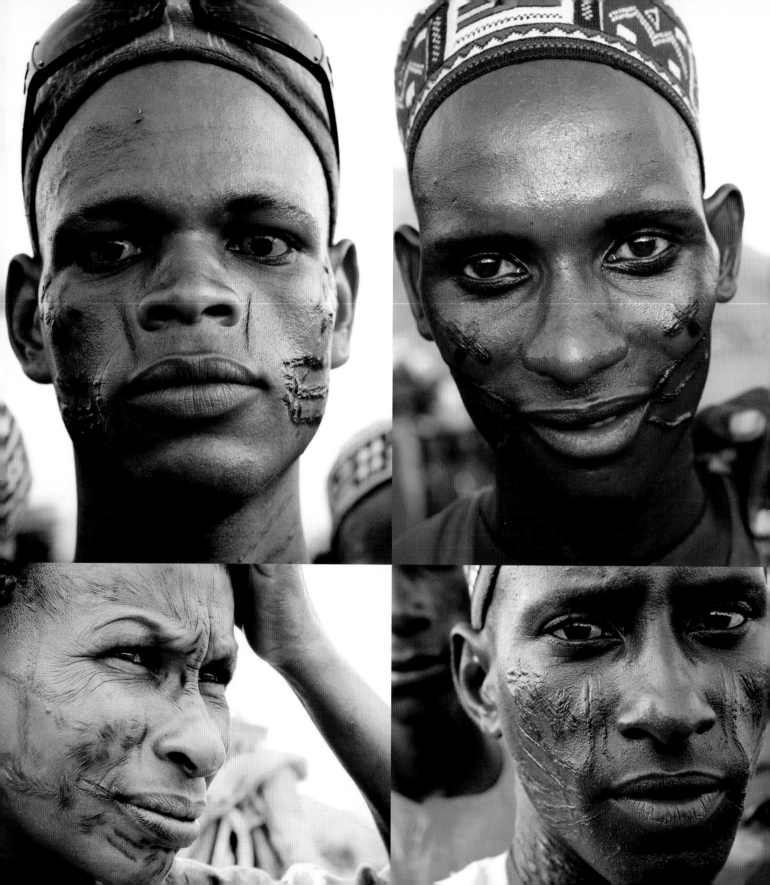

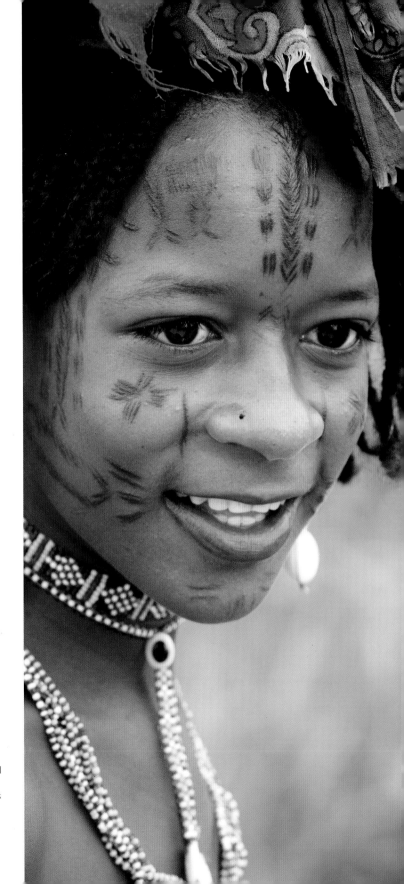

TIRGA POLI

Tirga Poli, a nomadic Fulani tattooer in her early twenties, works in the Cameroonian plains of the Faro River, close to the Nigerian border. She practises her craft on weekly market days and before ceremonies that include marriages or *Gerewols* (dating parties). Since she is still single (as the daughter of the local chief she can postpone her marriage until her early thirties), she has spare time to engage in other forms of body art as well as tattooing; she creates complex hairstyles for her sisters and friends, and applies henna to their hands and feet.

In addition to body art, Poli crafts elaborately engraved calabashes with designs that are reminiscent of spiky facial and neck tattoos. For the Fulani calabashes represent economic wealth, whereas faces manifest their clan and ethnic identity; the uniting of these two art forms therefore creates a direct relationship between these two elements of Fulani culture – the calabash becomes anthropomorphized.

1	2
3	4

5

1 Tattooed young man at a *Gerewol* ceremony 2 Traditional tattoos of protection and cultural heritage 3 Older woman with extensive tattooing 4 Young man with enough tattoos to marry 5 Young girl with traditional clan tattoos

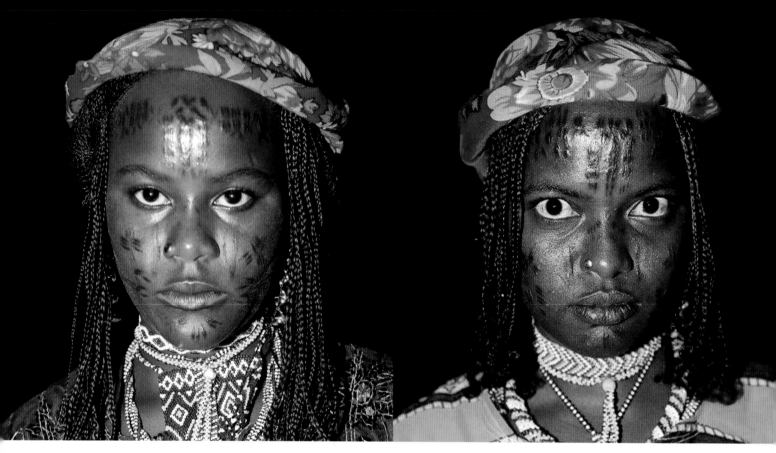

6 7 8

6–8 Traditional female facial tattoos with pigmented lower lip

The choice of symbols and signs she marks on bodies and calabashes reflects Poli's understanding of the Fulani relationship with nature and the universe. The patterns embody Fulani ideas about family, fertility, social rank, milk, cattle, water and tracks. The broad field of design of the nomads' decorations, unified and undivided as the background to the motifs, reflects Fulani attitudes towards land and ownership; as nomads, the Fulani do not lay claim to any particular place and they stay in one location only for as long as it suits them.

The sparsely wooded grassland of the savannah region in which Poli lives is also demonstrated in the widely spaced patterns of her tattoos and calabash decorations. Each motif, particularly the spiky designs, calls to mind how far apart Fulani camps are from one another. At the same time, the elaborate network of lines represents the occasional sense of togetherness that Fulani groups experience, particularly during the rainy season. The fine lines with which all her motifs are drawn echo the typically slim and moderate features of the Fulani people.

Traditionally, Fulani women also have their gums and lips tattooed. Poli does not enjoy performing this type of tattoo work because it is very painful for both the client and the tattooist. Only Fulani women request these tattoos, which are believed to make women more attractive to men. To accomplish these tattoos, Tirga uses needles to inject a black powder made of burned oil and karité or shea butter (a cosmetic product). She inscribes up to seven layers of the pigment, although many clients cannot tolerate the pain of so many layers of tattooing in such sensitive areas.

Although Poli finds this particular tattoo work unpleasant, she recognizes its benefits. With a mischievous smile she acknowledges that if a young woman is searching for a lover, she needs to be aesthetically pleasing: 'Listen to me, tattooed gums and a silver tooth — that is what's attractive. A woman should not have red gums. Her gums need to be dark. A nice smile attracts men.' The darkness of tattooed lips and gums heightens the whiteness of the teeth and emphasizes a woman's smile. JR

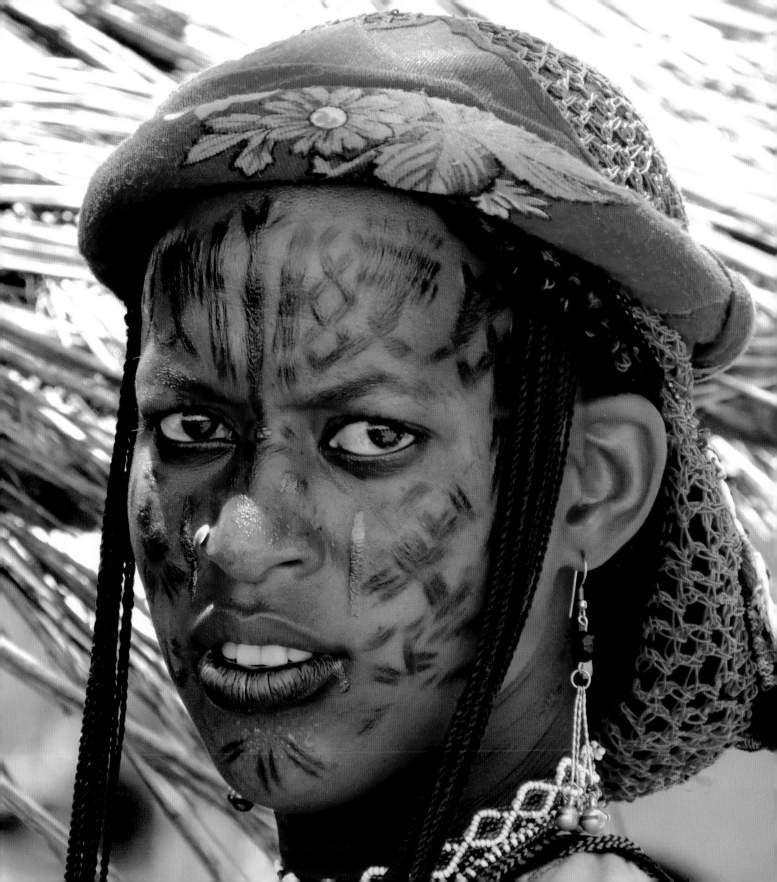

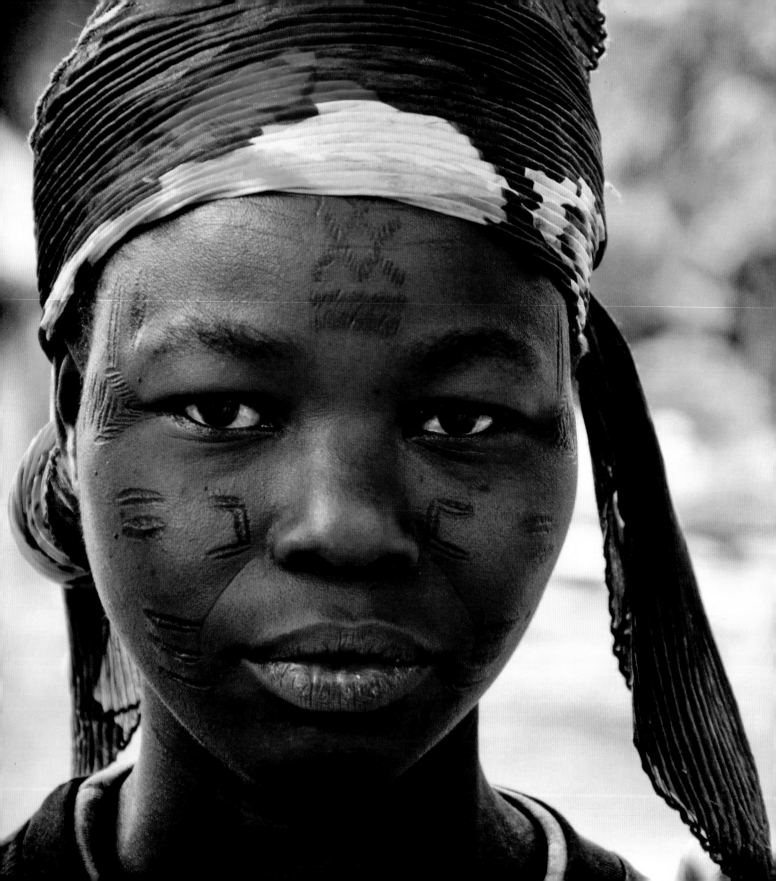

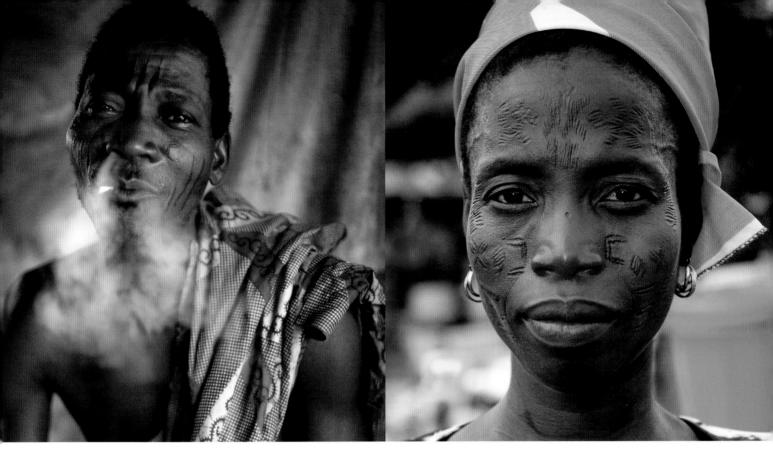

STYLE INDIGENOUS **INFLUENCES** NATURE, POPULAR CULTURE **LOCATION** BENIN

1 Woman with animal symbol on forehead and traditional societal marks 2 Traditional facial marks 3 Mother with *aarin omo ni* (sun) 'mother's pride' tattoo

SAM IJE

Tattoo master Sam Ije, also known as Sammy, is continuing a nearly extinct tradition as he inscribes his fellow Yoruba—Ije women with decorative designs that enhance their beauty and sustain their cultural heritage. Although tattooing has ceased among most Yoruba-speaking groups, it persists in this south-eastern part of Benin because it lacks the heavy Christian and Muslim missionary influences of neighbouring Nigeria, where the majority of Yoruba-speaking people live.

Ije's father, who tattooed during Benin's colonial period, taught him the art form, although his father inscribed tattoos as part of traditional rituals or for medical and magical purposes. Ije is now teaching John, one of his sons, who plans to continue with the family tradition. In addition to tattooing,

Ije conducts male circumcisions (the most important rite of passage in Ije society) and therapeutic scarification (to treat headaches, problematic relationships and so on).

Ije is a purist who prefers traditional Yoruba—Ije body and facial tattooing; he will not introduce new patterns and designs, despite the demands of the younger generation. His best clients have always been middle-aged women who choose classic patterns to beautify their faces and bodies. Clients usually choose a standard motif from Ije's catalogue, although sometimes they leave the choice to him. They drop their payment into a bowl of water, at which point no refund is possible. Ije charges based on the intricacy of the design, usually around US $2 (about £1.35). His technique involves puncturing the skin with a ten- or twelve-needle bunch or slashing the skin with a knife, then rubbing in pigment made from soot, powdered charcoal or juice from *efo odu* (a traditional medicinal plant). Ije tells clients to rub palm kernel oil and other darkening substances on to the surface every morning after bathing. **JR**

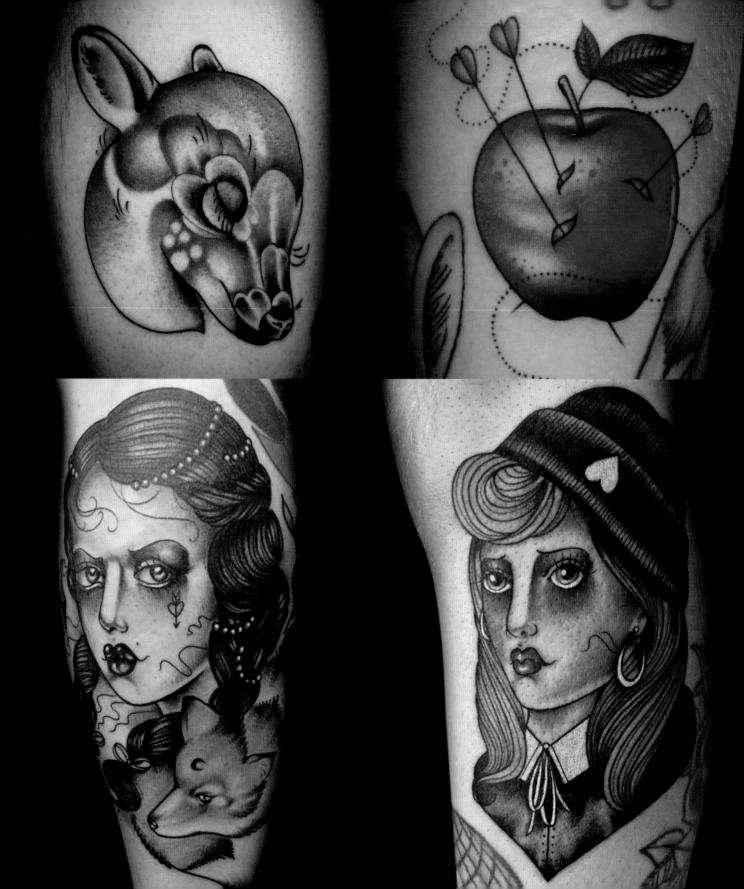

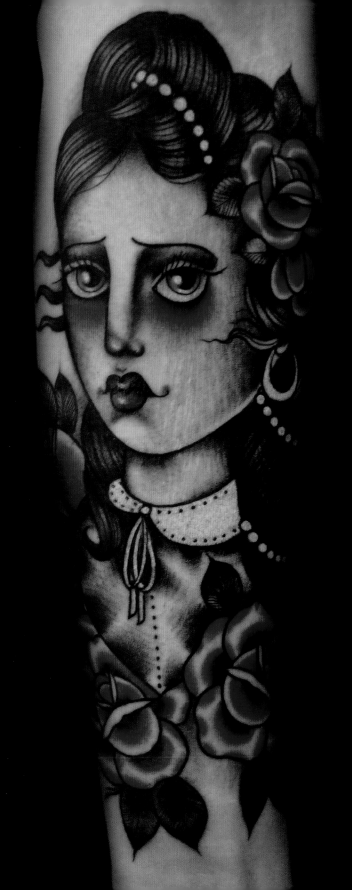

SHAUN DEAN

Shaun Dean's tattoo style, with its bright, pure and simple use of colour and delicate black line work, is reminiscent of the beautiful Victorian wallpapers and other decorative arts of British designer William Morris. Many of the motifs found in Dean's tattoo portfolio also place him within the Victorian decorative style: animals (such as birds, deer and foxes), fruits, foliage and flowers. About his style, Dean says: 'I am influenced by neo-traditional tattooing, but also the old masters and Victorian paintings of ladies, which I always put a modern twist on. I would describe my style as a mix of neo-traditional with hints of Baroque and Victorian influences. I really love old prints of animals and vintage botanical paintings.'

Inspired by women from Victorian art, such as those painted by the Pre-Raphaelite Brotherhood, Dean's depictions of women bear all their expressiveness in their big eyes, styled hair and clothing or head ornamentation, rather than in their pouty closed lips and firm, plump cheeks. Whether in colour or black and grey, his women, although represented in a neo-traditional style, are the epitome of feminine strength and beauty, and are rendered in a precise and delicate way without smiles or frowns.

Dean always wanted to be an artist. As a child he was a graffiti artist of sorts, and after high school he attended art school to develop his skills. He worked briefly as a graphic designer, but felt stifled and unhappy in that area. At eighteen, he got his first tattoo and with it came the revelation that he wanted to pursue tattooing. He then apprenticed at a tiny tattoo shop in Durban, in the South African province of KwaZulu-Natal, and later moved to Cape Town, where the tattoos of Tamar and Jon Case inspired him greatly. He currently lives and works in Muizenberg, at a tattoo shop close to the beach: it's quieter, more relaxed and he can surf at lunch or before work. **KBJ**

1 A fawn napping 2 Apple pierced by arrows
3 Raven-haired beauty with face tattoo and fox stole
4 Blonde woman with knitted hat 5 Classic pin-up
with roses

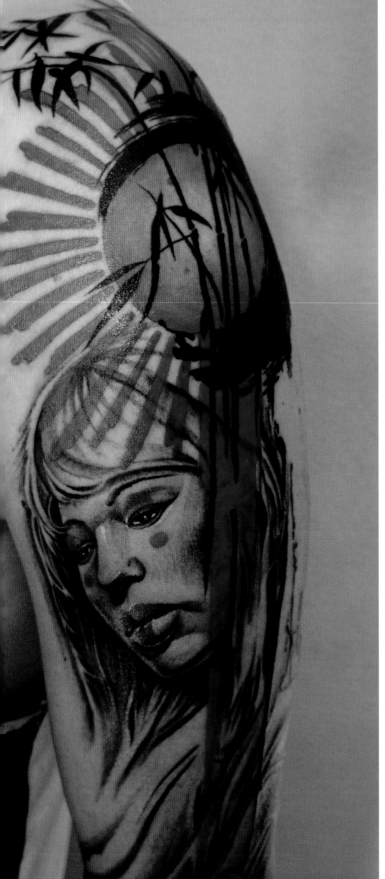

RASTY KNAYLES

Johannesburg-based Rasty Knayles assuredly moves between black and grey realism and bold, colourful new school themes. He is as comfortable recreating the famed 'Smiley Grin' character of pop surrealist Ron English as he is putting an individual spin on the classic Chicano sad clown girl. In all his tattoos, one element remains constant: there is a soft depth to his shading, apparent in perfectly modelled cheeks and eyes. His figurative work best expresses the symbiotic relationship between graffiti and tattooing, which allows Knayles to push the boundaries of both mediums.

Rasty began writing graffiti in 1999 when he was seventeen. The initial inspiration came from Johannesburg's burgeoning hip-hop scene and it eventually became the catalyst to his taking a seemingly disparate artistic path. 'My first proper encounter with tattooing was painting a tattoo studio around 2002; that was also when I got my first tattoo,' he recalls.

1 Geisha with bamboo and sun 2 Calf piece showing scarred woman with skull helmet

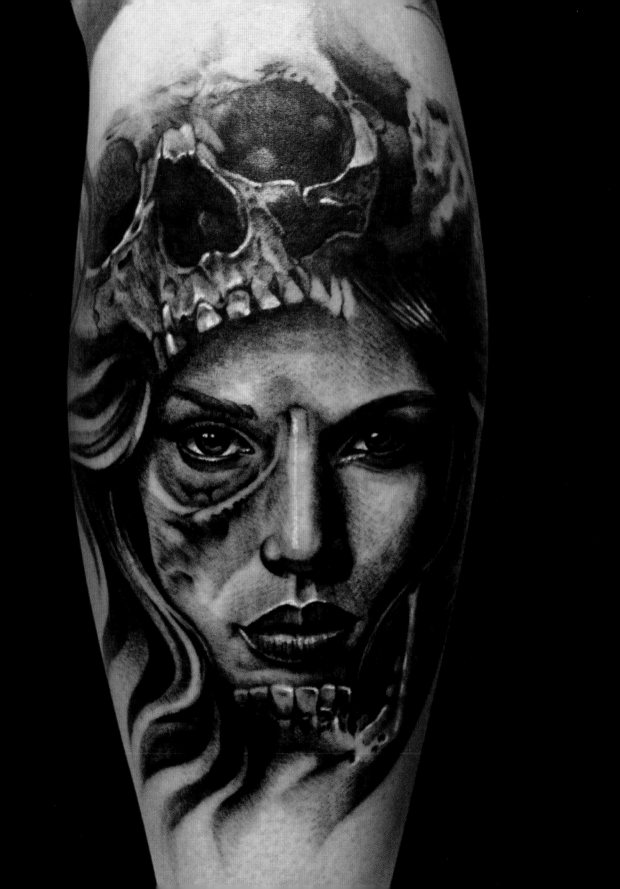

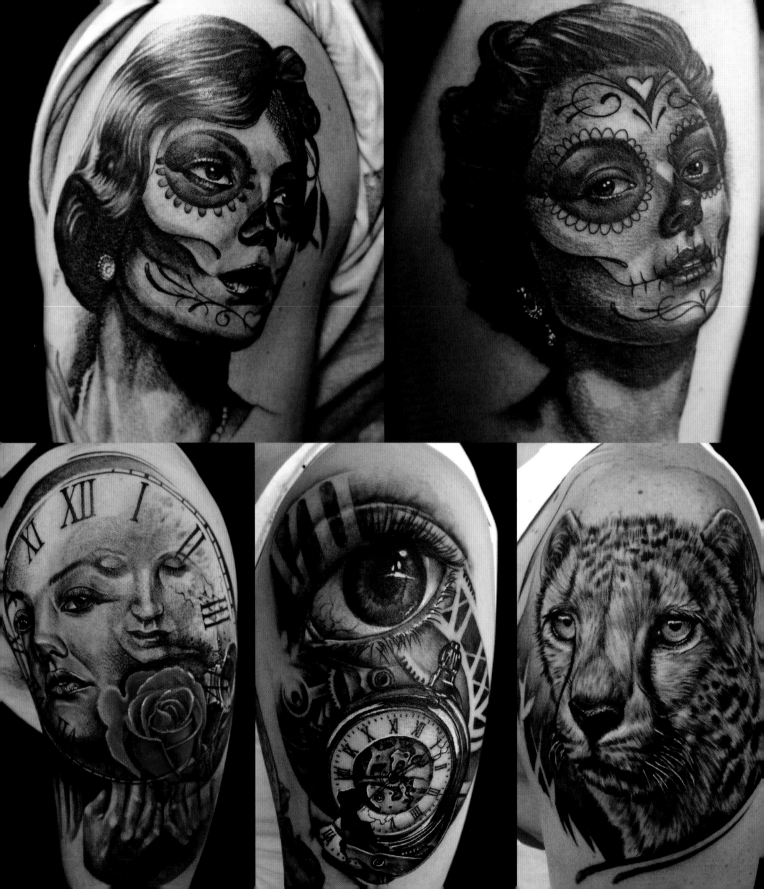

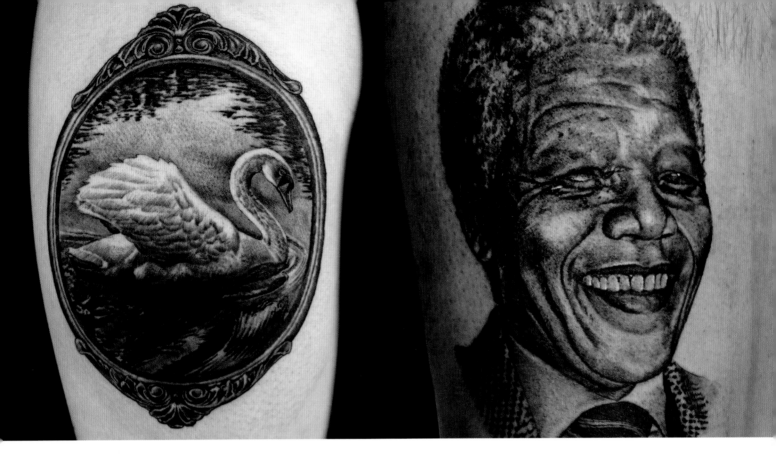

3–4 Female portrait faces in *calavera* make-up 5 Clock face reflecting women's faces with rose 6 Broken pocket watch overseen by a woman's eye 7 Cheetah with yellow eyes 8 Swan in decorative frame
9 Nelson Mandela portrait

'I had always been fascinated by tattoos, but never given too much thought to trying it because it was so difficult to get an apprenticeship.'

At the time tattooing in South Africa was 'fairly popular' but 'nowhere near as mainstream as it is now', Rasty recalls. 'If you saw someone with sleeves they were either a tattoo artist, a bad ass or in a band.' Through a fellow graffiti writer, Wealz130, Rasty gained an apprenticeship at Anima Mundi Tattoos in Johannesburg, where his background gave him an advantage.

'I personally believe that good graffiti artists make some of the best tattoo artists. I think what you learn through graffiti about the importance of style, originality and perfecting your craft are crucial tools that help you a great deal in tattooing,' says Rasty. 'Having spent years practising graffiti and developing these skills, I already had an upper hand when I started tattooing because I didn't have to learn these things from scratch in addition to the tattooing techniques.'

At his 1933 Classic Tattoos shop, the aim is to 'create original and exciting art that might inspire other artists to do the same'. The space, shared with Grayscale graffiti store, proposes a merger of the two disciplines and forms a hub in Johannesburg's emerging arts district. 'As a graffiti artist you always want your work to be seen by as many people as possible', he admits, 'and what better way than [to] permanently mark it on a walking canvas?'

Rasty's favoured styles – black and grey realism and new school colour – are consistent with the desires of his local client base. 'These days religious black and grey seems to be the most popular at our studio, also oriental style is always popular,' he says, but he believes there is room for expansion. In South Africa, 'we are a few years behind the rest of the world,' he comments, 'but soon we will have some amazing artists making a name for themselves on an international level.' Leading this movement, Rasty is inspiring a new generation of talented South Africans ready to push the nation's artistic output to new heights. NS

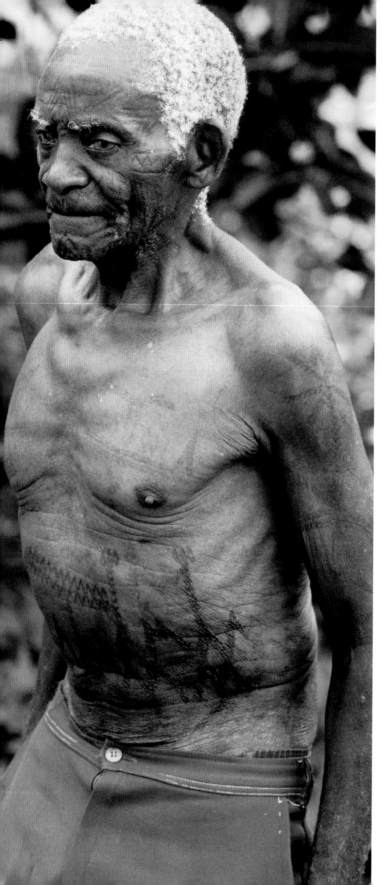

PIUS

Nonagenarian Pius is one of the last Makonde tattoo masters of Mozambique. His affectionate nickname, Nãuka (or Switchblade), references the tattooing tool he used to ply in his younger days. He learned his skills from his father and was heavily marked by him with various designs of palm trees (*nadi*) on his torso. Traditional Makonde tattoo practice is a form of skin-cut or scar-tattooing. Pius recalls: 'Sometimes it took three sessions to produce the desired tattoo. If a client's skin was light, one meeting with me was usually enough. Some boys and girls with darker complexions lost their courage if they had to be tattooed a second or third time, and they never completed their tattooing. Those who ran away were ridiculed because for the Makonde the tattoo ritual was a sign of courage. And people did not want to marry someone who was unmarked.' After the painful incisions are made, vegetable carbon from the castor bean plant is rubbed into the cuts, producing a dark blue colour. The tattoos are then washed with water and oil prepared from castor beans is applied with a feather for healing purposes.

During the Mozambique War of Independence (1964–1974) and Civil War era (1976–1992), the communist Mozambique Liberation Front (FRELIMO) aimed to integrate all tribal peoples into one nation and outlawed customs of 'primitive individual expression'. In turn, tattoo masters stopped apprenticing disciples. Pius says that under FRELIMO: 'There was no god, and no tattoos. Because god was the gun. And I have not tattooed since 1962.'

Recently, however, Makonde youth have been seeking out the last generation of tattooists to reaffirm their tribal roots and identity. One young man, named Anselmo, convinced Pius to tattoo his navel with a traditional pattern. Halfway through the session Switchblade stopped, saying: 'I only see shadows now. I can no longer tattoo.' LK

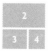

1 Pius wearing the thousands of marks made by his father
2 Two Makonde 'best friends' with intricate facial tattoos
3 Pius tattooing a young Makonde man with a penknife
4 Profile view of *lichumba* tattoo patterns

STYLE BLACKWORK **INFLUENCES** INDIGENOUS
TATTOOING, SACRED GEOMETRY, POLYNESIAN ART
LOCATION TEL AVIV, ISRAEL

YASMINE BERGNER

Yasmine Bergner translates sacred geometry into tattoos that are simultaneously delicate and graphically bold. She uses angles, shapes, dotwork and fine lines to create unique decorative and symbolic pieces that occupy a spiritual space on the bodies of her clients. Bergner attended the Bezalel Academy of Arts and Design in Jerusalem, but reflects that although she knew she wanted to be an artist at the time, she was unsure of her direction. She later pursued a master's degree in art therapy at Lesley College in Boston, Massachusetts.

Bergner turned to tattooing after having spent a few years in India, where she was exposed to both hand-tapped tattooing and spirituality, both of which changed the course of her life. After returning to Tel Aviv, she decided not to continue working as an art therapist; instead she sought out the first tattoo artist in Israel and apprenticed with her. She began to explore tattoo culture and worked on developing her own

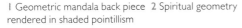

1 Geometric mandala back piece 2 Spiritual geometry rendered in shaded pointillism

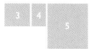

3 Petroglyph-inspired pointillist back medallion
4 Concentric broken circles **5** Spiritual geometry, symmetry and pointillist lacework

style. She was exposed to geometric tattoos and Polynesian designs, yet was 'intuitively attracted to geometry and math art'. Bergner started to conduct her own research and exploration of spiritual geometry and biology, and forged a niche for herself in Israel as an expert in the field.

'Sacred geometry is what makes us see the world in a holistic point of view, everything is the same from the microcosmos to the macrocosmos . . . that's why sacred geometry and dotwork art have become very significant in the tattoo world today, because it has a very powerful influence that is both physical and spiritual . . . even the act of tattooing itself is very meaningful and imprints something new in our DNA.' Bergner tries to impart this spiritual connection to tattooing to her clients; she makes sure that they understand the impact and importance of the tattoo process. 'I always regard a tattoo as a talisman, a cameo, a rite of passage . . . it seems [that] although I gave up my former profession as an art therapist, it came in through the back door. Now I'm like a

tattoo therapist.' She works with her tattoo clients to select designs that both decorate and signify meaning.

Bergner's meticulously crafted black pointillist and line designs highlight the idea that geometry underpins the biological world and makes itself evident in nature, with shapes such as the nautilus or the centre of a flower. She creates concentric circles and polygons, and translates them into complex images that ornament the bodies of her clients. 'The skin is like a canvas, we design ourselves, we adorn ourselves, it's the same as finding your personal imagery on a page or on a sculpture, but you do it on your skin, so it's much more influential and deeper.' Bergner counsels her clients to not 'do anything that is not empowering for them' with their tattoos. This concern connects Bergner to her roots as an art therapist, when she helped people relate to their emotional world through the artistic process. Bergner continues to help her clients discover that emotional and spiritual connection, but now through wearable art. AKO

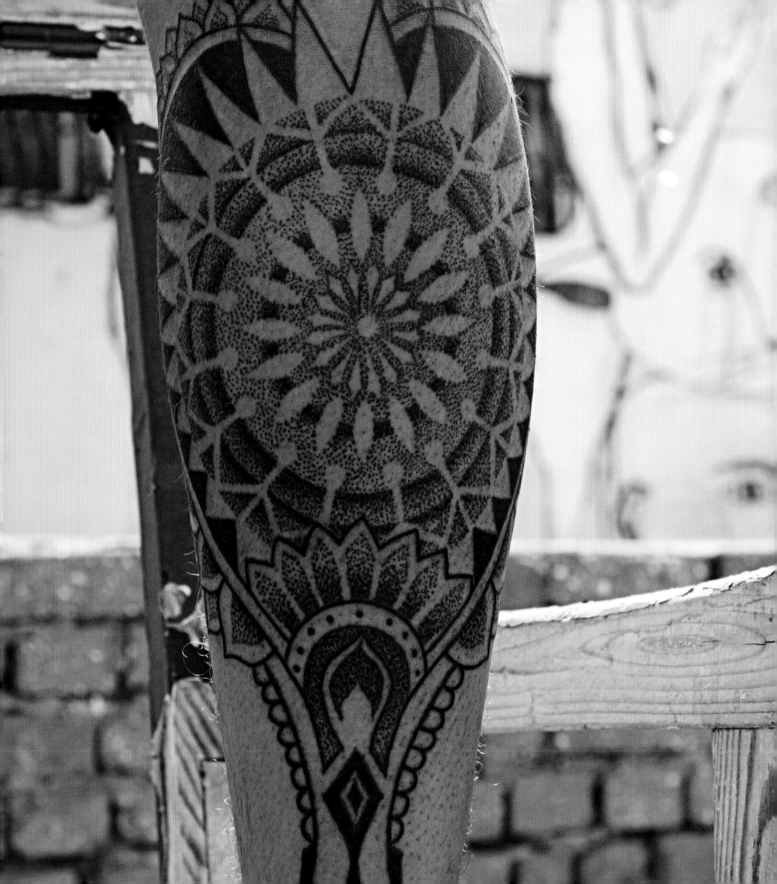

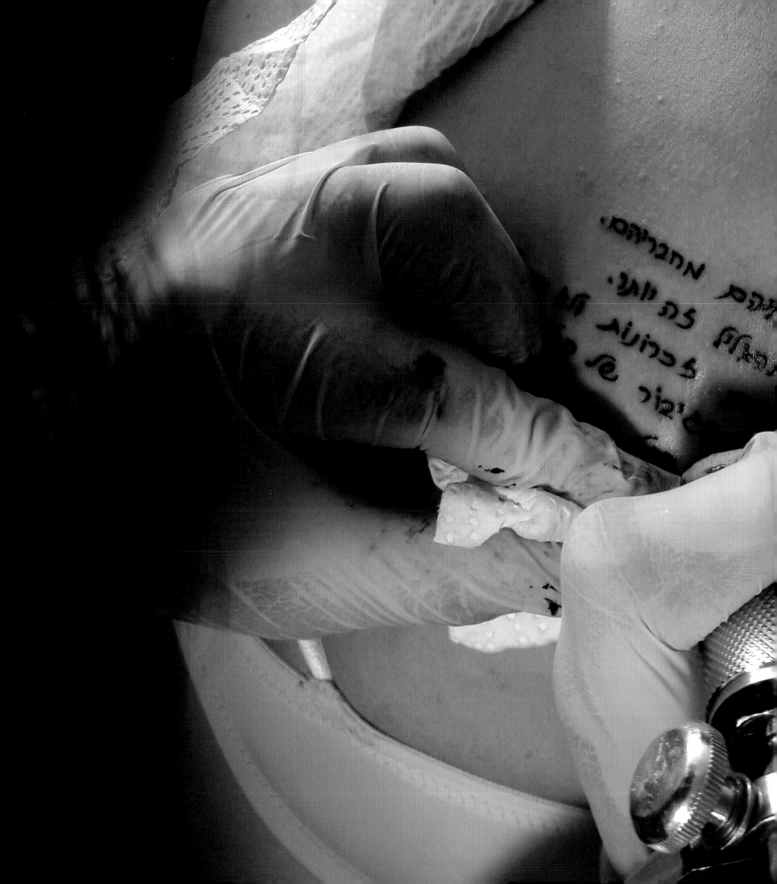

RAZZOUK FAMILY

The Razzouk Family has been tattooing Christian pilgrims to the Holy Land for 400 years when a Coptic ancestor, Jeriusus, moved there from Egypt. They maintain a collection of historical woodblocks used for printing patterns on the skin, some of which date back to those early years. Wassim Razzouk learned the art from his father: 'At first I wasn't convinced about it, but then I understood the responsibility behind it as the next generation of the heritage . . . it seems that the art is truly in our blood.' He feels 'grateful for the honour, which lies inside this status I was given'. Despite his initial reluctance to follow in his father's footsteps, Razzouk effuses: 'I fell in love with this art and [it became] my main job in the end.' His wife, Gabrielle Predella, currently tattoos alongside her husband in the shop. Razzouk describes how he trained her to become part of the family business: 'I met her three years ago and, noticing she has an artistic hand and loves to draw, I suggested teaching her the

I Hebrew script representing a poem that the client wrote

2 Classic 'arms of Jerusalem' after William Lithgow **3** Resurrection with twelve apostles and Holy Spirit dove **4** Jerusalem cross in progress **5** Jerusalem cross with laurel and crowns **6** The name 'Ariel' in Hebrew *stam* writing (Torah script)

tattoo art. First she hesitated, thinking it was a crazy idea, but later on she fell in love with it as well.'

Although traditionally pilgrimage tattoos were mainly given to Orthodox Christians, 'more and more Catholic pilgrims of a variety of ages are appearing in the studio to get their pilgrimage tattoos'. Razzouk comments: 'I have noticed a growing interest in traditional tattoos, and it's interesting to see that people, especially young people, are going back in history and appreciating it. I noticed that while tattooing pilgrims from the Catholic sect they asked me to tattoo the Jerusalem crosses from the old woodblocks (for example, one with three crowns and palm branches) rather than the simple, plain version.' Orthodox pilgrims tend to make special trips 'during the Easter holiday period to follow the road of the saviour before the Last Supper (the Via Dolorosa). During this time hundreds and often thousands of pilgrims from all over the world come to the Holy Land. The Orthodox, especially the ones that have Arabic,

Armenian and even Russian origins, see getting tattooed as a major part of their trip to the Holy Land.'

The tattoos have special meaning for Arabic Christian pilgrims because 'after 1948 and especially after 1967 . . . the state of Israel made entry for Arabs extremely difficult, even for Christians.' Razzouk tells the story of one woman from Iraq who recently visited his shop, noting that the last time she had been in the Holy Land was as a child in the 1960s: 'She was too scared to be tattooed back then, so her mother, who wanted to be tattooed with her, said she [would] wait for the next visit.' In the interim, her mother passed away. 'I had the honour to tattoo her while she was crying, telling me she [was] doing it as if her mother was there. Her entire family was tattooed by my grandfather and father . . . these tattoos definitely move me and create a connection between me and the person in front of me.' With such historical connections, the Razzouks continue to keep alive a vital commemorative and sacred tradition. **AFF**

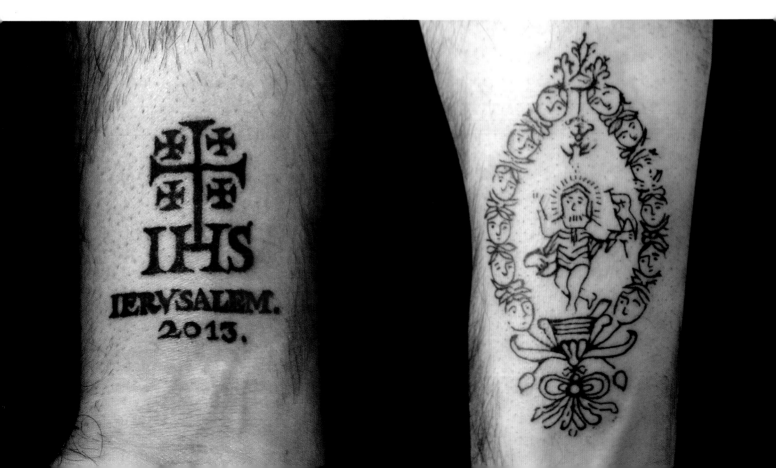

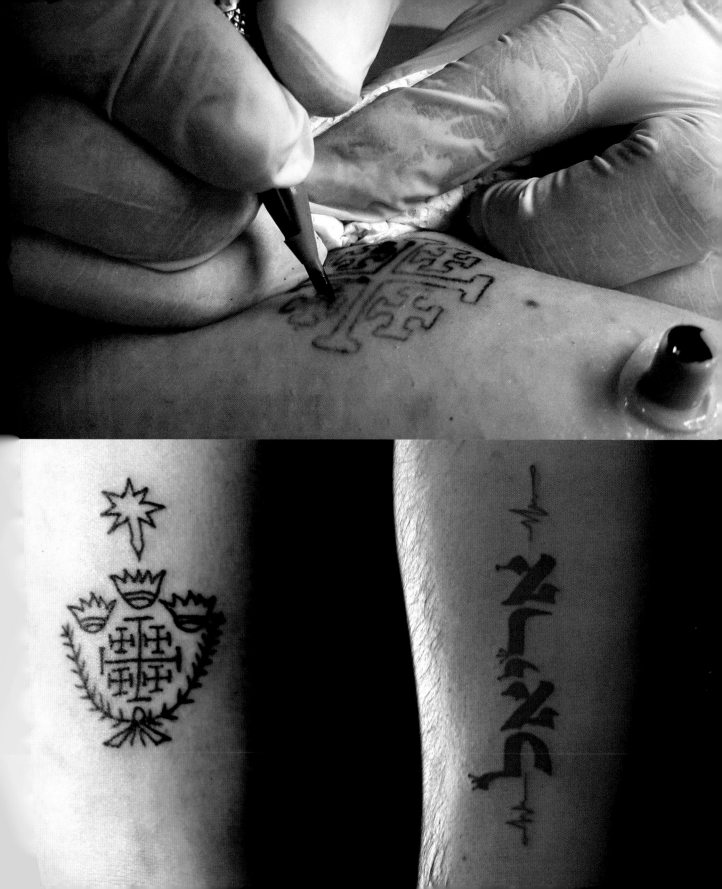

STYLE CONTEMPORARY, CALLIGRAPHIC **INFLUENCES** ARABIC CALLIGRAPHY, REALISM, GRAFITTI **LOCATION** AMMAN, JORDAN / DUBAI, UNITED ARAB EMIRATES

HUZZ

Not yet thirty years old, Hazim G. Naouri (who uses the artist name Huzz) has developed an impressive career in tattooing. He initially became interested in the art form as a child in the late 1990s, when he saw tattoos on the imported American television show *Kung Fu: The Legend Continues* (1993–97). At the time, there was no tattooing taking place in his native Jordan, but questions about tattooing lingered in his head. Ever the artist, Huzz excelled in art classes at secondary school and 'drew with [a] pen for anyone who liked art on their skin, school uniform, even shoes'. Several years later, he took the opportunity to get tattooed by a travelling Lebanese artist and acquired a dragon tattoo in the middle of his back. Huzz realized that he could do better and began to experiment with tattooing. Crafting his first machine from 'a car dynamo, spoon, sewing needle and a pen', he began tattooing his friends and gained a reputation in Amman for being 'the first person to

1 Stained-glass Virgin Mary with sacred heart
2 Dreamcatcher with bird

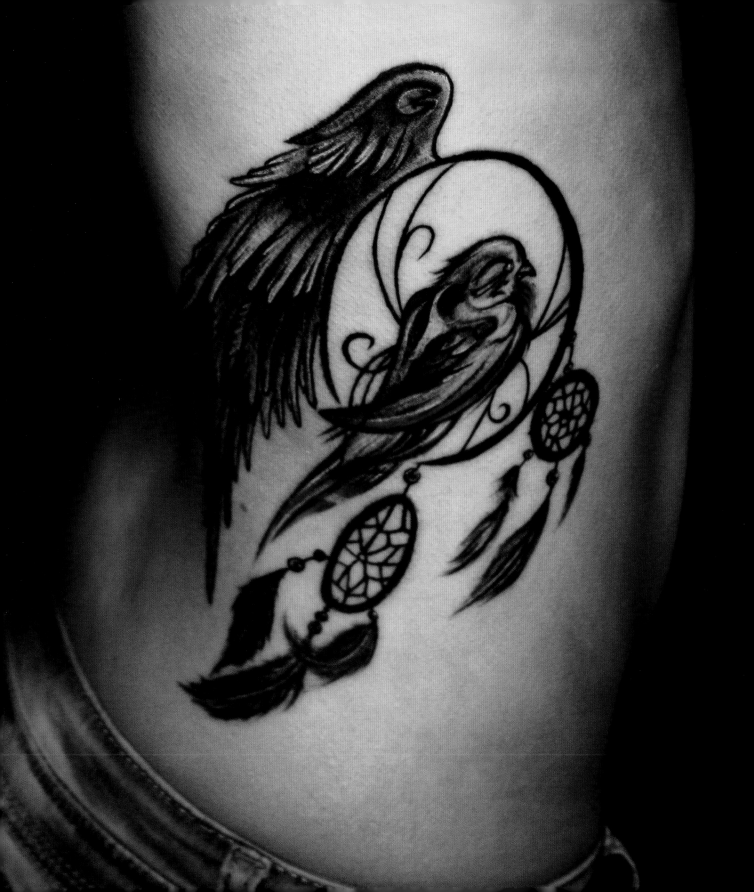

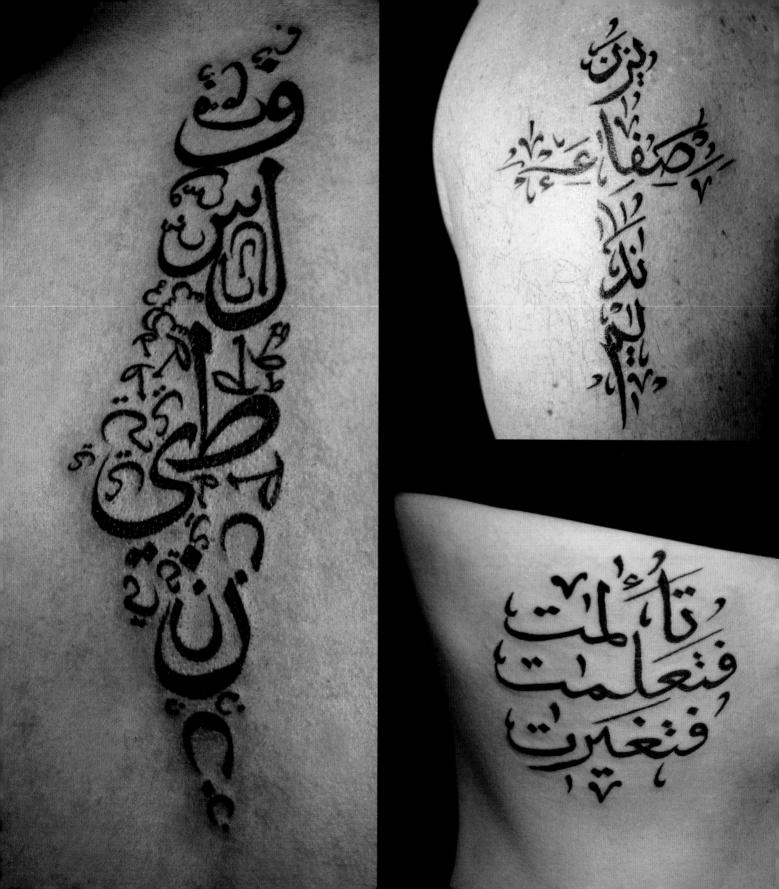

3 Arabic script in the shape of Israel 4 Arabic script in the shape of a crucifix 5 Circular calligraphy 6 Handala, symbol of Palestinian rights, with a map of Israel 7 Double image of crucifixion

give proper tattoo designs to people'. A nascent business started to evolve out of his parents garage.

By 2006 Huzz had received tattoo following blood-borne pathogen certification; he opened a shop in 2007 (the first in Jordan) and acquired equipment via mail order from the United States in 2008. After 'nine long years of tattooing alone', he attended an international convention in China in 2010. There, Huzz recalls: 'After meeting international artists like the legendary Paul Booth and being exposed to several art styles, I went back to the Middle East with full power to tattoo people on a different level'. Later he travelled to the United States to attend another convention where, after meeting artists such as 'Bob Tyrrell, Rich Pineda and other perfectionists', he was inspired to teach tattooing to others. He now mentors four artists in his Amman shop, owns shops in other parts of the Middle East and travels regularly to tattoo and teach in the region.

Huzz has pioneered a particular skill for Arabic calligraphy. The graceful black lines of these tattoos form elegant visual images and patterns, which provide a way for those of Muslim heritage to get inked in a non-representational way that aligns with Islamic tradition and teaching. However, he also enjoys tattooing a wide range of images and comments that he has been 'forced to master all styles and tattoos based on all tastes' because for many years he was the only person working professionally in his part of the world. His portfolio, therefore, features everything from black and grey portraits and geometric blackwork to full-colour work. Huzz also creates art in a variety of other media, including elaborate airbrushed designs that envelop cars and motorcycle helmets, as well as grafitti and painting on both canvas and glass. A multitalented artist, his love for tattooing is only one way in which he fulfils a mission that he describes as 'my responsibility to allow people to express their thoughts on any surface'. AFF

ASIA

HONG KONG BEIJING TAIWAN SEOUL BANGKOK
SINGAPORE TOKYO NAGOYA SAIGON KOLKATA
DIMAPUR NEW DELHI KATHMANDU

JOEY PANG LEON LAM TANG PING YANG 'YZ' ZHOU ANDY SHOU
KIL JUN AJARN THOY ELSON YEO TAKU OSHIMA HORIMITSU GENKO
DANIS NGUYEN OBI MO NAGA MANJEET SINGH MOHAN GURUNG

Tattooing has had a vibrant, ongoing history in mainland Asia. The earliest tattoos are thought to be on prehistoric *dogu* figurines made during the Jomon period in Japan. Dating between 13,000 and 300 BCE, these mysterious anthropomorphs feature incised lines or other body decoration that may represent Neolithic tattooing. Documentation and evidence for most Asian tattooing is limited before the 19th century, and is found primarily in ancient Chinese texts that describe their own practices and those of surrounding people. If we stitch together these ancient accounts, however, with European colonial observations and anthropological and photographic documentation of the 20th and 21st centuries, an increasingly rich story of tattooing in this part of the world continues to unfold.

Many indigenous tattoo practices survive in Asia today, perhaps more so than in other parts of the globe. European colonialism did not have as great an impact on tattooing in many areas of Asia, particularly in India and the mountainous regions of China and South East Asia. The interior areas where tattooing persists were either impenetrable or simply not interesting or lucrative enough for colonial powers to explore. Thailand, which never fell prey to colonial usurpation, and Japan, where tattooing existed in the underworld despite government prohibition, can also boast vigorous traditions. Central Asia, however, lacks any traces of indigenous tattooing in the modern era, although the discovery of a number of rare, tattooed mummies has secured its importance in tattoo history. In the far north of Asia, Arctic peoples such as the Siberian Yupik and Chukchi tattooed traditional patterns on male and female faces, hands and occasionally other parts of the body. These practices largely endured until the 19th century, when conservative Orthodox Christian attitudes towards the body (brought by Tsarist colonials) disrupted the tradition; today, only a few people wear these designs. In contemporary urban areas of Asia, global styles of tattooing have exploded onto the scene since the beginning of the 20th century.

Ancient Tattooing

In Central Asia, the discovery of tattooed mummies has uncovered two different and long extinct tattooing traditions. At ancient burial sites in the Altai Mountains in Siberia, male and female Pazyryk mummies have been found with elaborate zoomorphic tattoos. These six mummies appear to have belonged to an elite level of society, and recent DNA analysis suggests they have Indo-European roots. The so-called 'Ice Maiden', discovered in 1993 near Ukok, has been dated to the 5th century BCE. The well-preserved tattoos that cover her arms include stylized deer, a panther-like creature and a fantastical cervine-griffon hybrid. A male mummy (excavated in 1929) has more extensive tattooing, including on one of his legs. In addition to having big cat, deer or antelope-like creatures and various hybrids similar to the Ice Maiden's, his mix of motifs includes rams and a large catfish-like design. The Pazyryk are related to the Scythians whose tattoos were described by Herodotus in the 5th century BCE, based on earlier accounts.

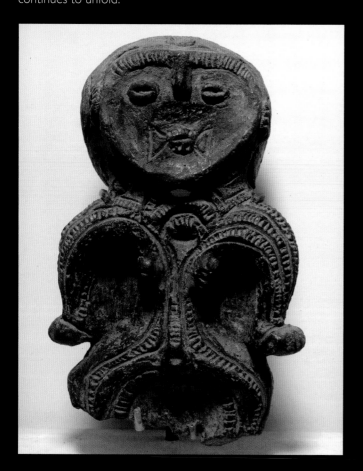

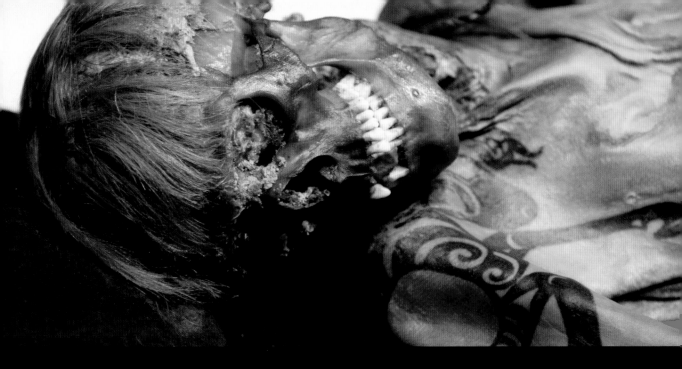

Evidence suggests that the Tarim Basin mummies discovered in the far north-west of China also have Indo-European origins; DNA analysis is supported by features such as red hair and tartan fabrics found with the bodies. Dating from around 1800 BCE to the 1st century CE, a number of the mummies, which were well preserved by the region's arid desert climate, wear bold, geometric patterned tattoos, especially on their hands and forearms. Both male and female mummies feature these curving, extensive designs. One of the females has two oval-shaped marks on her forehead. Ancient Chinese writers may have documented these people when they were still living – Wang Bo, for example, wrote about tattooed central Asian people in the 1st century BCE.

Ancient Chinese texts, from the 3rd century BCE well into the middle of the next millennium, tell of tattooed Yue 'barbarians' living south of the Yangtze River in what may correspond to the mountainous areas of far southern China (especially Yunnan province) and northern South East Asia. Thought to be apotropaic, these tattoos were described in positive terms due to their power to avert evil influences. Zuo Si, a poet of 300 CE, wrote: 'Warriors with tattooed foreheads/Soldiers with stippled bodies/Are as gorgeously adorned as the curly dragon.' Tattoos are still found in this area today, but whether they have derived f_____ _____ _t practice is unclear. In addition

to discussing tattooing in other southern-bordering groups, numerous Chinese texts from the first half of the 1st millennium CE also mention tattooing to the north of China; practices that had perhaps survived from the Scythian and the Tarim Basin societies or related groups. Among the many designs described were 'embroidered feet' and 'embroidered faces', bodies tattooed like animal skins, and motifs that extended from ankle to calf. Reasons given for the tattoos ranged from indications of marriage to marks of valour.

East Asia

As with groups such as the ancient Greeks, the Chinese have had a longstanding aversion to marking the body. This dislike is rooted in Confucian philosophy, which advises people to avoid injury to the skin, hair and body as a token of the filial piety necessary for civilized society. Penal tattooing, however, is well documented from at least the Zhou era (around 1100– 256 BCE) and well into the 2nd millennium CE, with the Yuan dynasty legal codes (1279–1368) that documented many specific tattoo-based punishments. During 900–1200, texts document the emergence of military tattoos in China. While most of this marking seems to be a form of identification, some of it may have been protective or an expression of devotion.

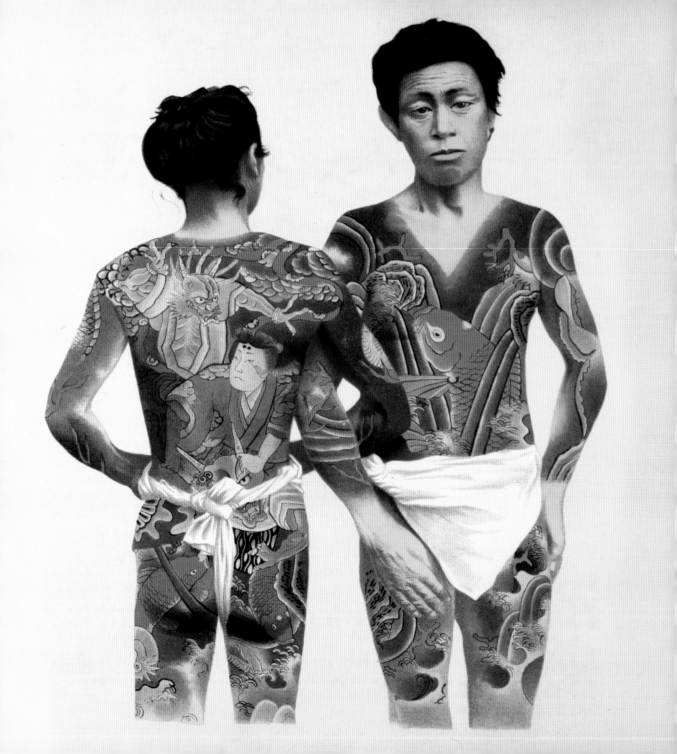

Around the same time, historical and literary works record the emergence of voluntary figurative tattoos. Duan Chengshi's 9th-century, thirty-volume *Youyang Zazu* (a miscellany of Chinese and foreign legends and hearsay) notes an astounding array of tattooed designs on a wide variety of people, from policemen and other officials to street ruffians; one vignette suggests that street vendors in Jingzhou used needle stamps to quickly imprint small designs on the skin. Another text, the *Wudai shi ping-hua* (c. 947–48), describes ruler Liu Zhiyuan as tattooed with 'an immortal fairy maiden' on his left arm, a 'treasure-snatching green dragon on his right', and a 'yaksa who laughs at Heaven' on his back. In addition to representational designs, texts also describe language, including poetry, tattooed onto Chinese bodies. The most famous of the literary discussions of Chinese decorative tattoos, the 16th-century *Shui hu zhuan*'s (*Water Margin*) describes the extensive figurative tattoos of a band of Robin Hood-like bandits. This story was based on oral and textual accounts of these men that date back to the 12th century.

The phenomenal full-body Japanese tattooing known as *horimono* or *irezumi* (see image 4) has relatively modern roots that derive from this Chinese novel. Imported to Japan in 1757 (transliterated as *Suikoden*), it became wildly popular. The stories were transformed into kabuki plays, and the tattooed heroes were illustrated in *ukiyo-e* woodblock prints that turned the textual descriptions of men covered in dragons, flowers, fire, wind, tigers, demons, warriors (and more) into visual depictions. The number of tattooed heroes expanded in the Japanese versions, and Edo-era people, especially those of the merchant and new *chonin* (townspeople) classes, adopted similar designs on their own bodies, imitating these compelling characters. The tattoos proved particularly popular with firemen and the *otokodate* ('street knights'), as these groups of people channelled the heroic spirit of the *Suikoden*. The series of prints produced between 1827 and 1830 by Utagawa Kuniyoshi were particularly inspirational.

As more people desired these elaborate tattoos, a professional tattoo industry emerged in Japan with artists calling themselves *horishi*: adapting the prefix *hori-* (carver) from the world of *ukiyo-e*. Families of tattooers arose with traditional apprenticeship arrangements. Even as early as the Bunka period (1804–8), however, Japanese authorities sought to suppress this

new form of tattooing and publicly shamed those who wore these tattoos. After Japan was 'opened' to the West in 1852–54 as a result of Matthew Perry's diplomacy, tattooing was banned on Japanese bodies, although it was still permissible for visiting Europeans and Americans who sought exotic souvenirs. These bans lasted until after World War II, although the practice persisted clandestinely, especially among members of the Japanese criminal underground, the Yakuza. Many tattooers working today can trace multiple generations of apprenticeship far back into *horimono*'s history.

Elsewhere in Japan, long-standing indigenous tattoo practice existed among the Ainu, who inscribed striking black moustache-like designs around women's mouths and extensive geometric net-like designs on the forearms and hands. It is thought that the Ainu could be descendants of the Jomon, which may lend credence to an interpretation of the marks on those figures as tattoos. Sadly, the Ainu were subject to the

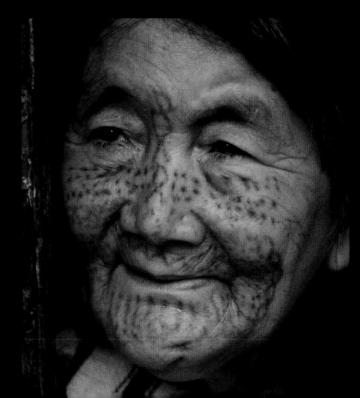

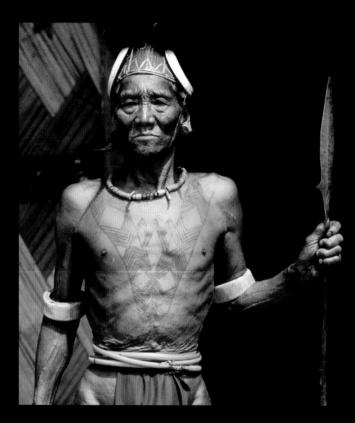

6 Contemporary Upper Konyak headhunter from Nagaland, India **7** Contemporary Ramnami man with devotional tattoos, India **8** Contemporary Rabari woman in Goa, India

same laws banning *horimono*, and despite initially resisting, their tradition ended in the 20th century.

Like the Chinese, Japan also has a history of penal tattooing. First documented as early as the 8th century, this penal practice had become illegal by 1720. Before *horimono*, the Japanese have little cultural record of extensive tattooing. Chinese texts, however, refer to tattooed Japanese during the Han dynasty (25–220 CE); these may have been referencing practices like those of the Ainu. The Japanese also inscribed *irebokuro* tattoos that pledged one lover to another through the tattooing of small dots.

Indigenous tattooing survives today in several places in East Asia. The most active practice appears to be among the Dai in Yunnan. Men are tattooed more heavily than women, with motifs of tigers and dragons often interspersed with script that decorates male muscles to emphasize bravery and strength or serve a protective function. Women's tattoos consist of flower designs usually on the backs of the hands, and a dot placed between the eyebrows. Elsewhere in Yunnan, Derung/Dulong women have marked their faces as far back as the Ming dynasty. Although the practice appears to have lapsed, some elders still wear the impressive networks of dots, diamonds and short lines that form butterfly-shaped motifs across the central part of their faces.

On the island of Hainan, off the southern coast of China, a few elderly women wear an incredible form of tattooing that features curvilinear and geometric lines branching over their faces and bodies; men wore three rings on their wrists in a practice now apparently extinct. Further up China's east coast, on the island of Taiwan, traces of a tattoo culture can still be found today on a handful of elderly women. Several different ethnic groups were traditionally tattooed, including the Paiwan, whose headhunters wore serpent motifs or anthropomorphic representations of their victims on their arms, chests and backs, whereas women wore marks on their arms, hands and legs.

South Asia

The tattoos of the Arunachel Pradesh and Nagaland highlands (in far north-eastern India) extensively mark faces with simple, linear motifs. In some groups, both men and women wear tattoos as cultural identifiers. Among the Naga, especially the Konyaks (see image 6) and Laju/Nocte (who also reside across

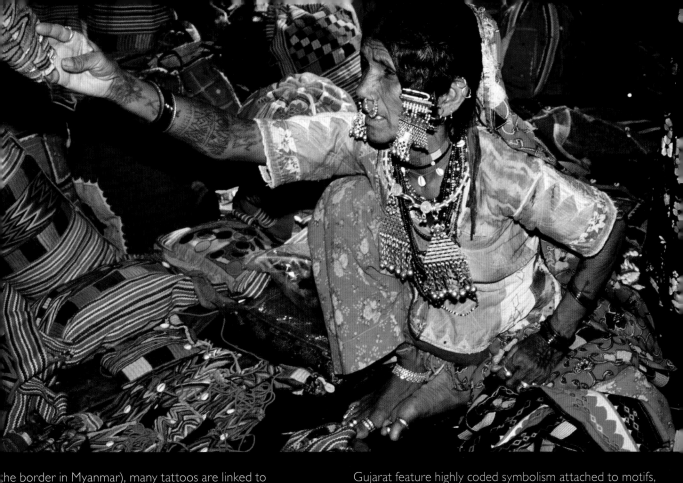

the border in Myanmar), many tattoos are linked to headhunting traditions. Since headhunting is no longer practised, however, some of the designs are dying out. Body tattoos reminiscent of petroglyphs and other early forms of art cover broad swathes of skin on community elders. Apatani women wear a long line dividing the centre of the face and stripe-like motifs on the chin. According to lore, Apatani women were tattooed (as well as modified with nasal piercings stretched to fit large plugs) to make them unattractive to men from neighbouring tribes. Although the facial tattooing practice was officially banned in the 1970s for being 'inhuman', it still exists (in a more limited fashion) today.

Further south, on the Indian subcontinent proper, women and men wear extensive marks across a vast array of groups in all corners of the region. Women in the Kutia Kondh and Gaddava groups in Orisha province on the east coast wear geometric designs on their faces. The extensive Rabari and Bharwad tattoos that adorn women's arms, legs and faces in

Gujarat feature highly coded symbolism attached to motifs, some of which may trace their lineage to ancient Harappan script markings (see image 8). The tattoos offer fertility and commemorate skills and endurance; only married women can wear leg tattoos. Not all indigenous tattoo traditions in South Asia stem from antiquity. Among the Ramnami (an untouchable Ram sect in Chhattisgarh in central India formed in the 1890s), religious adherents repeatedly tattoo the Sanskrit word 'Rama' over their bodies to pay respect to their Lord who is the seventh avatar of the Hindu god, Vishnu (see image 7).

Colonialism introduced Western-style tattooing to port areas. When sailors went ashore on leave, many of them, particularly the British, sought maritime tattoos that were highly popular in the 19th century. Even today in the markets and streets of coastal cities like Mumbai, tattooers ply their trade with rudimentary, home-made machines run on batteries and crafted from found objects such as fan motors. Their simple designs incorporate classic images pertinent to India, including

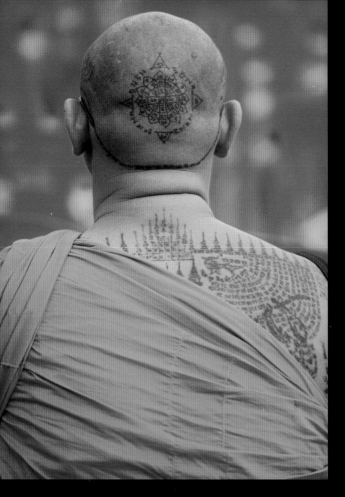

apotropaic uses, some *sak yant* imbue the bearer with the power to influence other people, including to attract lovers. Although once spread across South East Asia, today *sak yant* are predominantly found in Thailand with limited practice in Myanmar, Cambodia and Laos. Heavily syncretic, *sak yant* blend indigenous animist beliefs with imagery borrowed from Buddhism, Brahmanism and Hinduism. Thus tigers coexist with animal deities such as Hanuman, Ganesha and Garuda and human gods like Vishnu. These figurative motifs are mixed with geometric designs and script. Although *sak yant* traditionally use Khmer script, which suggests Cambodian origins, this appears to have entered the visual vocabulary after Thailand overtook the Angkor kingdom in the 15th century. Originating during the Ayutthaya period (1351–1767), *sak yant* flourished in Thailand without interruption until the influence of European Christians in the early 20th century. The latter's denigration of tattooing as uncivilized caused a small dip in the practice, especially after a royal decree ordered people to cover up their tattoos. However, in the 21st century, in part due to Western interest in the practice (most prominently US actress Angelina Jolie), a wave of renewed popularity has ensued.

Historically, tattoos were present on a wide variety of bodies in South East Asia, but as has often been the case across the world, government intervention and the legacy of colonialism erased much of the practice. Across the region one popular tattoo was the 'trousers' or 'pants' worn by men in Vietnam, Laos, Northern Thailand and Burma (now Myanmar). This featured elaborate zoomorphic motifs carefully arrayed in ornate frames and sometimes linked with script or small filler designs. Believed to have originated in the Mekong Basin as early as 3,000 BCE, these tattoos spread to surrounding areas. As the practice expanded, so did the area covered on the body. The Shan and the Palaung, for example, who reside in the northern hills of Indochina, inscribed their entire bodies, adding in hybrid creatures that blended Hindu and Buddhist deities. Few traces of these tattoos remain today. In the 13th century, King Tran-Anh Tong (inspired by Confucian Chinese philosophy) outlawed tattooing in Vietnam. This led to a reduction in the practice, although it persisted in remote areas as well as adjacent kingdoms. However, by the late 19th century, influence from British and French colonials

tigers and cobras as well as adaptations of Hindu gods and goddesses, such as Vishnu, Shiva or Ganesha, in a small-motif format. Sometimes woodblocks are used to print the patterns, a practice that may have been introduced by British travellers who had seen this technique in the Holy Land and passed it on when they arrived in India. These unsanitary tattooing environments have been dying out as numerous modern, professional shops have opened in recent years across India.

South East Asia

The most well-known tattoos from South East Asia are the 'magical' *sak yant* tattoos (see image 9). During the tattoo process, the tattooer ritually transfers power to the client, resulting in tattoos believed to protect their bearers. The tattoos prevent injury and accident, or even make people invincible to serious threats such as gunshots. Besides these

caused a significant decline in the practice in Laos and Myanmar, as well as the last vestiges in Vietnam.

Today, tattoos persist across various groups of hill tribes of the remote, mountanous northern part of Indochina. The most notable of these are the Chin women and girls in Myanmar, who obtain extensive (and painful) facial tattoos that abstract local flora and fauna (see image 10). Networks of lines represent spider's webs, dots mimic leopard spots, diamond shapes evoke reptile skin, tiger whiskers appear on the cheeks. In one group, the Ubun Chin, almost the entire face is tattooed solid black. Living examples still exist among the Karen, the Bru and the Katu.

Contemporary Tattooing

Prior to the 21st century, tattooing had been slow to catch on in mainland Asia as a means of expressing personal identity, despite the presence of Western-style tattoo shops in major port cities such as Hong Kong. In the 1990s, more individuals, especially those involved with subcultures, began to adopt Western-style tattooing. In Japan, for example, rockabilly adherents added their own reworkings of classic Americana tattoos to their pompadours and leather jackets. With the rise of the internet and the spread of global celebrity culture, which features many heavily tattooed musicians and actors, some Asian celebrities have been following suit, albeit usually with small, discreet marks. This trend appears to be most prevalent in India, especially among Bollywood actors. Even in South Korea – where conservative attitudes towards the body have stifled most body marking (with the exception of plastic surgery, which is incredibly popular) and only medical professionals can legally tattoo – pop stars and others in the public eye have adopted the fashion for getting tattooed.

Throughout East and South East Asia, motifs derived from traditional Japanese tattooing are highly popular, although Western-style work, especially black and grey, has become standard contemporary practice, especially in major urban areas in India. Many shops have opened to serve the significant expatriate and tourist clientele, and a number of artists working in these areas are expatriates themselves. Certain genres, such as dotwork, which often features designs inspired by Buddhist and Hindu art, have been imported from the West.

The revivals of dying indigenous practice seen elsewhere in the world are only starting to emerge in mainland Asia. In many of the remote highland areas in South and South East Asia, there are still some individuals with tattoos, although active practice has generally lapsed. Revitalizations elsewhere in Asia are, however, not as necessary, because of the persistence of a healthy number of tattoo traditions. In Japan, although the rise of using *horimono* to mark Yakuza gangster status in the early 20th century harmed public perception of tattooing, it also kept the art form alive. Today, as it sheds that stigma, growing numbers of people are willing to commit to tattoos. In Thailand traditional Buddhist tattoos never stopped being widely inscribed; and while a brief drop in practice occurred in neighbouring Cambodia during the Killing Fields era, it is now recovering. In South Asia, the sheer volume, diversity and broad distribution of people across both well-populated and remote areas has ensured the preservation of a wealth of tattoo traditions. **AFF**

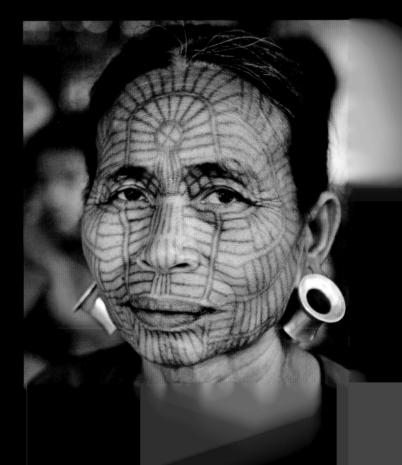

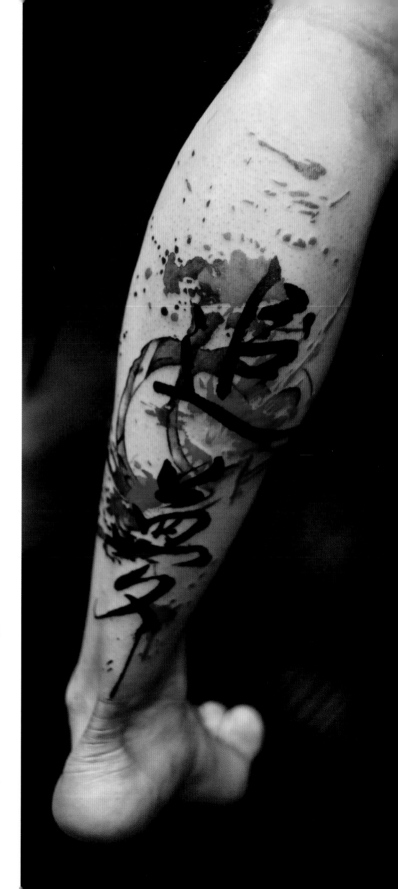

JOEY PANG

Joey Pang's brushwork tattoos float on the skin of their wearer, using negative space to merge the person's body with the tattoo. Her background in calligraphy and body painting helps her meld tattooing with traditional Asian art to create a unique approach to permanent body decoration – one that uses the body as part of the design, rather than simply using the body as the canvas.

Pang is one of several female tattooists in Hong Kong who has carved a niche for herself that is uniquely her own. After studying design and make-up, she made a transition to tattooing as a way to make her drawings on the skin permanent. 'It is a medium that allows me to be creative on people . . . body art is a very special art form, which combines two souls', she explains. Although she does work in Western styles, Pang is renowned for her pioneering translation of Chinese paintings into body art – delicate brushstrokes that appear like ink

1 Traditional calligraphy merged with brushstrokes and abstract colour 2 Delicate birds and bamboo

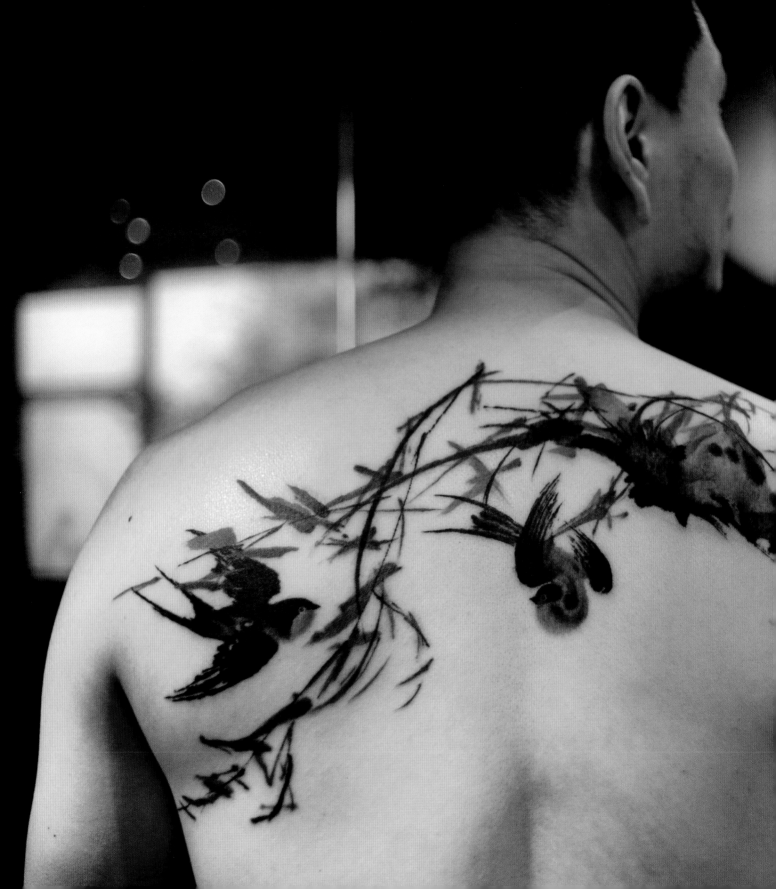

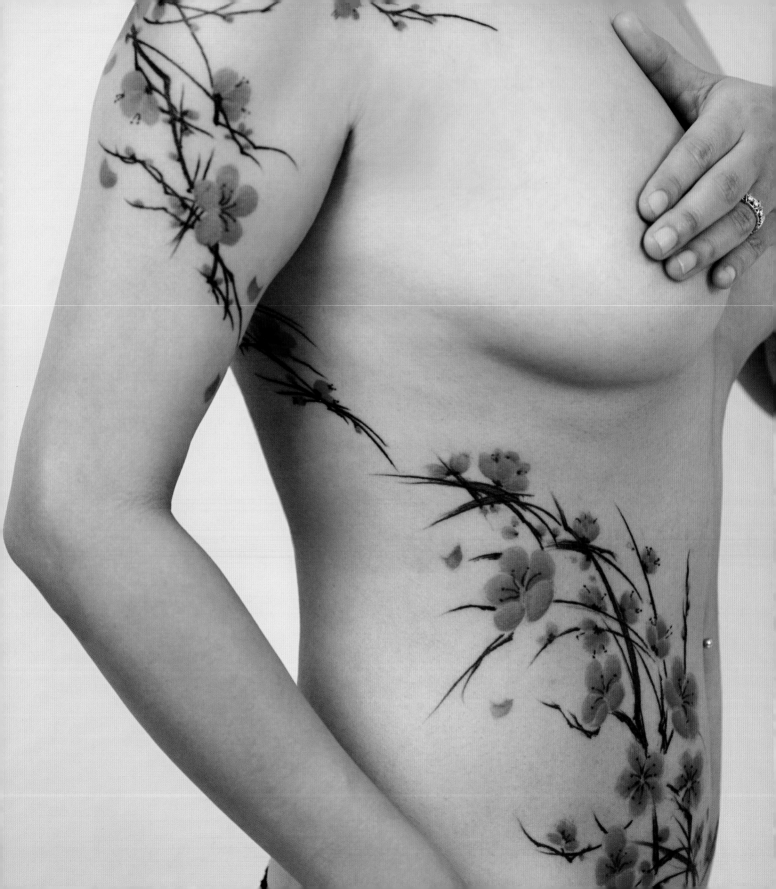

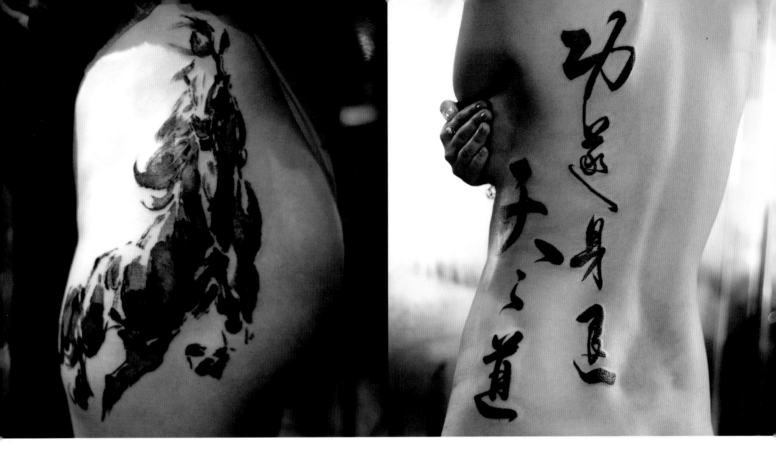

3 Cherry blossoms updated and uniquely positioned across the body 4 A brushwork horse that looks like it emerged from a painting 5 Bold calligraphy with asymmetrical body positioning

splashed on the skin. These intricate images of flowers, animals and landscapes evoke the simplicity and beauty of East Asian ink wash painting on paper, a style in which the goal is not simply to create a likeness of the image, but to capture its spirit.

Pang began studying calligraphy and painting when she was at school in Hong Kong, and when she started tattooing she continued her studies with a calligraphy master. She felt that it was her 'personal mission to promote genuine Chinese calligraphy art' in tattooing, especially with the rise in popularity of the mainly inaccurate Chinese and Japanese-style characters used in Western flash. She applied her traditional calligraphic skills and training to develop a simple, striking style that appears to be ink brushed on the body rather than tattooed.

In addition to her Chinese calligraphy influences, Pang also tattoos in traditional Japanese styles, which she describes as the opposite of the Chinese style. Japanese-style tattoos 'fill up the skin like a suit covering the body' and include bold colours and shapes with no negative space or skin showing –

the negative space between larger designs is filled in with smaller designs. Pang works with her clients to incorporate their ideas into her style, making the resulting work a collaborative piece.

Pang travelled extensively while she was learning to tattoo. She went from Thailand to Europe and then back to Hong Kong, looking at how different studios and artists worked. She has since created a comfortable studio space – Tattoo Temple in Hong Kong – that promotes communication between artist and client. Her philosophy is that the studio should not be noisy or scary, and the artist and the client should enjoy the creative process together, allowing the client's idea to be translated into their tattoo by the artist. She reflects that, in the past, tattooing in Hong Kong 'used to be a rough business', which catered to drunks and Triad gang members. 'It wasn't an art form at all and tattooists . . . were basically mechanics.' Pang's ultimate goal, through her work, is to create art, not simply tattoos: 'Art is unique and has soul.' AKO

STYLE EXPERIMENTAL INFLUENCES ABSTRACT
EXPRESSIONISM, CHINESE CALLIGRAPHY AND PHILOSOPHY
LOCATION HONG KONG, CHINA

LEON LAM

Leon Lam's tattoo art defies traditional labels and boundaries. His work is a symphony of personal expression, ink and skin; it is as if abstract expressionist Jackson Pollock, Zen master calligrapher Muso Soseki and composer Beethoven had come together to create music and art for the human body and soul. Each original and utterly unique piece becomes a freehand expression of Lam on the bodies of his clients. When questioned about his working process, he explains: 'I don't really have a specific way to start the tattoo, but when I meet the right person, then I can express myself freely.'

Lam's tattoos reflect a Zen philosophy in that he allows the lines to flow out of themselves freely. His vision unfolds in a dialogue with the body he inks, and his tattoos therefore truly become art in motion with that life. However, he never renders arbitrary or haphazard strokes; instead his free expression follows the map provided by a client's body curves, resulting

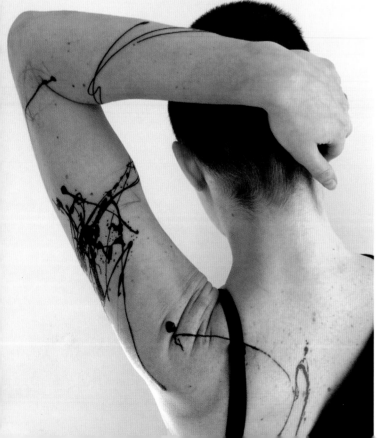

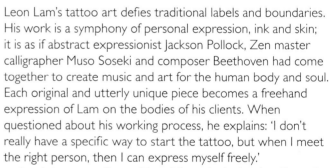

1 Extending lines from the body to the environment
2 Scribbles on the body 3 Paint-like drips flowing over the arm and hand

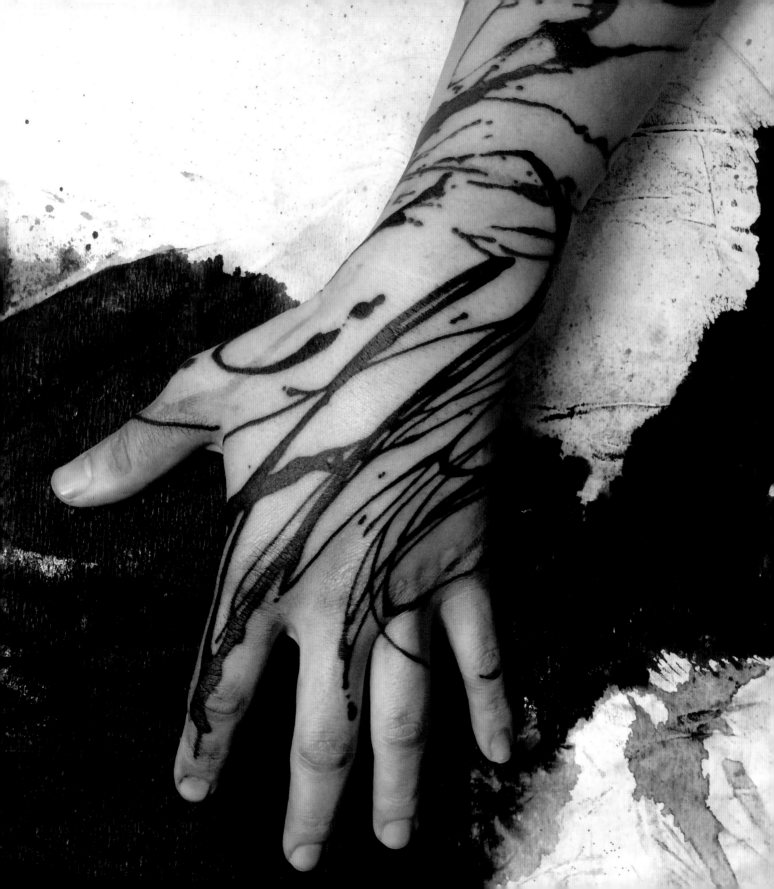

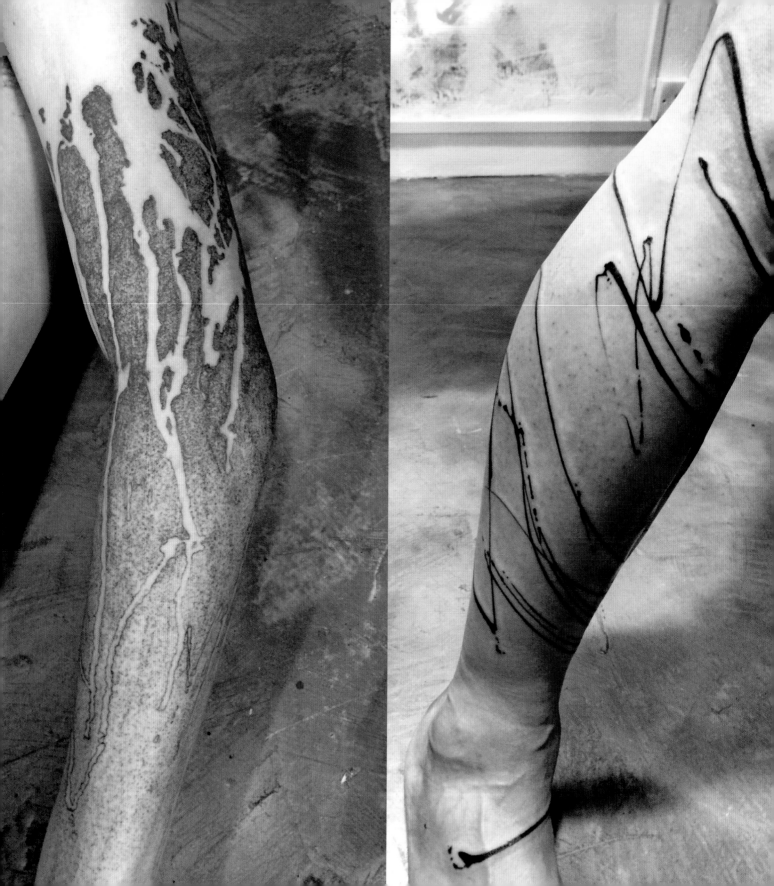

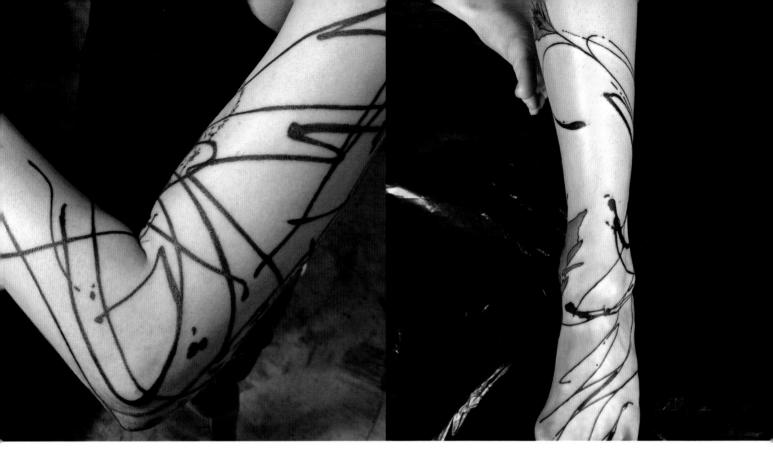

4 Negative space abstraction **5** Calligraphic lines on the leg **6** Lines reminiscent of dried streaks of paint **7** Scribbles mixed with a touch of colour

in a harmony of freedom and determination. Wilson Chik (a Butoh dancer and artist of the mind-body movement in Hong Kong) has expressed the words that Lam feels best encapsulate his own artistic identity: 'A skin priest, whose devotion is to navigate through the body landscape, artfully drawing ink from soul, spirit to surface.'

Although each and every one of Lam's tattoo designs is crafted in a highly original way, he also maintains a cohesive portfolio and programme of style: 'My visuals and techniques are constantly in evolution with my inspiration. It is important to go ahead and experiment, but without forgetting what I have done before. I try to keep a link with my previous work. Through the year I create my own palettes of textures and [graphics], and this gets updated every time that I try something new.'

Lam's tattoo experience started at the age of thirteen, when he gave himself his first tattoo. Later, when he was nineteen, he met tattooist Fred Neuville, who encouraged him to pursue the art form. Lam later apprenticed with Neuville after he had completed his studies in industrial design. Although Lam was born in Saigon, as a child he moved to Lyon in France. In the early days of his professional career, he lived and worked all over the world, but he eventually returned to Lyon and opened his own studio. It was there that he fell in love with art; there was a little gallery called La Rage next door to his studio that opened his eyes to a whole new world. During this period, he also met the Chinese photographer Wen Fang and she introduced him to Chinese calligraphy, painting and philosophy.

In 2005 Lam relocated to China and started travelling around the continent of Asia. This adventure fundamentally changed his life and tattoo aesthetic: 'Years of travel, especially my journey in and around Asia, led me into the heart of Chinese calligraphy and philosophy. And [I met] a string of creative people, whose knowledge and kindness greatly influenced and changed my perception and concept of the world and art.' KBJ

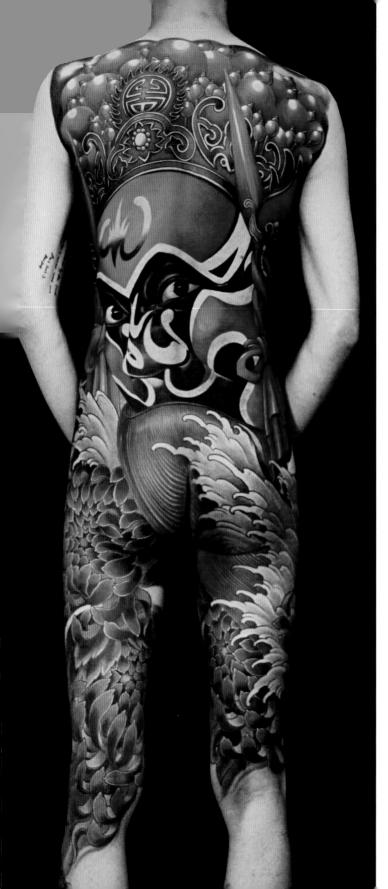

STYLE CONTEMPORARY, JAPANESE **INFLUENCES** ASIAN
ART **LOCATION** BEIJING, CHINA

TANG PING

Tang Ping is a pioneer of the art of contemporary tattooing in China. In the face of burgeoning interest among the country's youth culture in the late 1990s, he began tattooing. He recalls: 'When I started in China, I couldn't find a teacher. I could only learn on Google. When I started, all my customers were my good friends.' In 2000 he opened his shop, Zi You Tattoo; he passionately asserts 'tattoo is my life, not only my work'. A romantic at heart, he admits that his wife of the last ten years offers him advice and feedback, and is his biggest inspiration.

Ping's style melds Asian art with other influences. His chosen colour palette dazzles; he has updated the traditionally subtle hues of Asian art to grafitti- or airbrush-like supersaturated hues that evoke sparkling jewels and psychedelic art. He notes: 'Most of my genre is Asian style, but sometimes I try to do other styles. I think different styles can [inform] each other.' The relationship between cultural influences makes his work dynamic and surprising. His artistic vision is often transformational; for example, what might be a staid, classical *horimono*-influenced back piece becomes a compositional masterpiece that pushes the central motif to the edges of the body and envelops the client as if the image were printed on fabric tightly swaddling the person underneath.

Of the massive change in attitudes towards tattooing in China in recent years, Ping says: 'So many people accept and love tattoos. I am very happy to see that.' He has become an ambassador for Chinese tattooing and travels widely. At the London Tattoo Convention in 2010, he won first place for the best back piece – a vibrant, glowing skull surrounded by lush peonies. This work typifies Ping's preference for large tattoos, which allow him ample creation space to balance 'power with *morbidezza*' (softness). This interplay between boldness and delicacy keeps viewers of his tattoos enthralled. **AFF**

1 Masked demon with peonies and waves
2 Hindu deity 3 Demon attacking

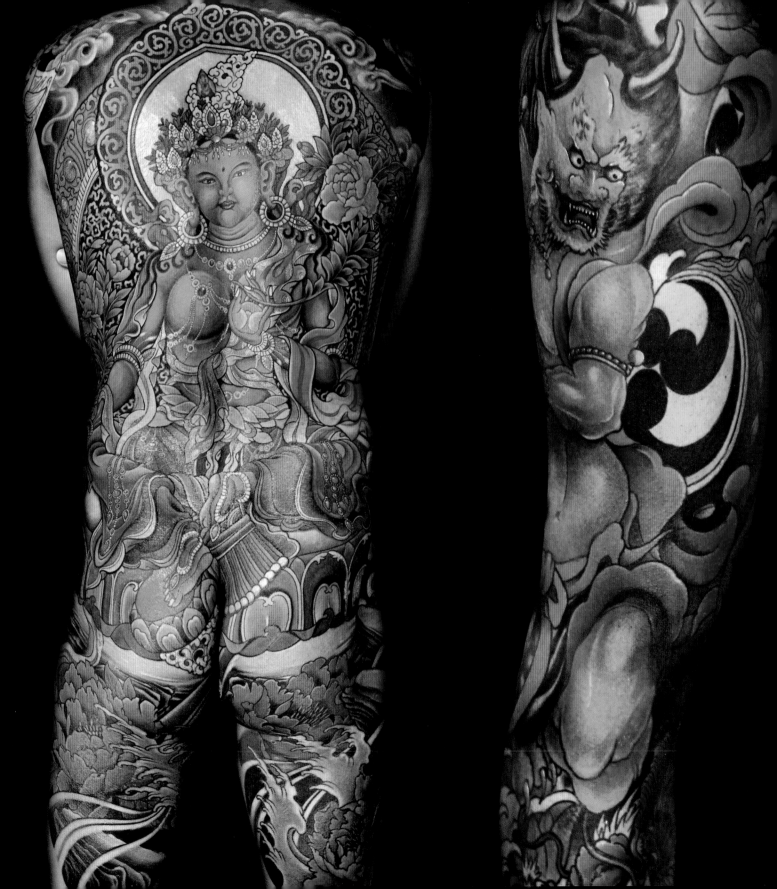

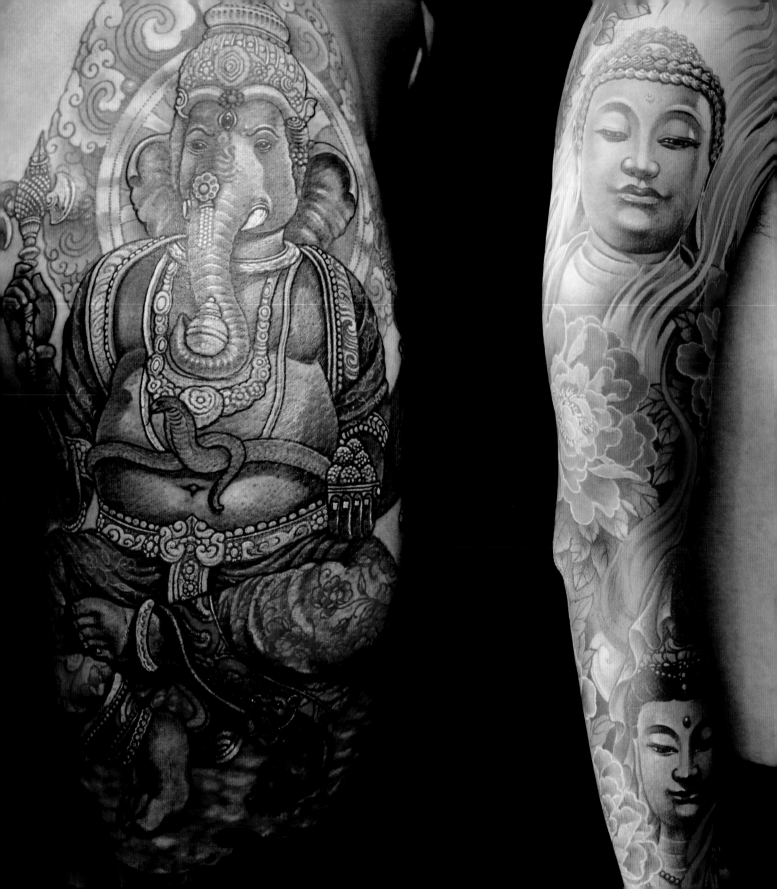

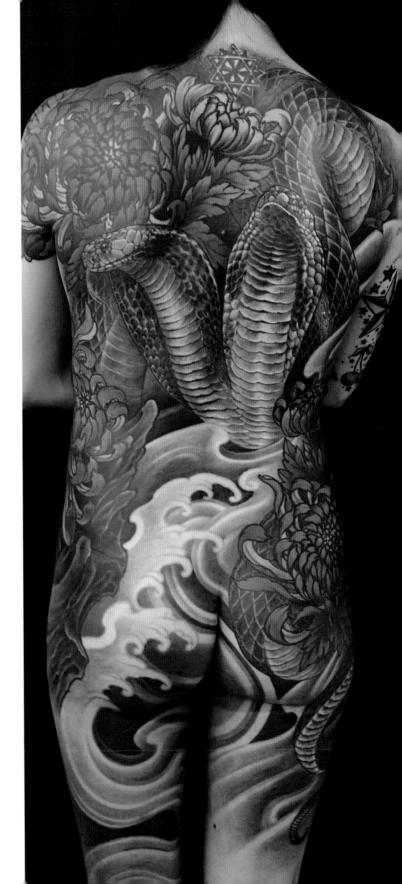

STYLE CONTEMPORARY, JAPANESE
INFLUENCES REALISM, ASIAN ART AND CULTURE
LOCATION BEIJING, CHINA

YANG 'YZ' ZHUO

Yang Zhuo (who uses the nickname YZ) produces some of the most artistic tattoos coming out of China, where tattooing has experienced renewed popularity after many centuries of disapproval. Born in 1980 in the small northern town of Haicheng, Yang first became exposed to tattoos on the skin of men in his town that he humorously describes as 'bad as crap'. Later at art school, he discovered a love for rock music and saw many tattoos on the musicians he encountered. While learning to play guitar, he also began to tattoo his friends.

From 2003 Yang began to focus on tattooing and moved to Beijing. In 2005 he travelled first to Singapore and elsewhere in Asia, and then in 2006 to the London Tattoo Convention, which, he says, 'changed my career and my life'. Yang is particularly thankful to convention organizer Miki Vialetto and recalls that London 'taught me so many things about tattooing'. Doors opened for Yang to travel extensively and learn from fellow tattooers around Europe.

Yang considers Swiss artist Filip Leu, who began tattooing Yang's bodysuit in 2008, to be a significant inspiration and mentor, and cites his admiration for 'the structure he created which is strong as armour'. Although Yang enjoys working in various styles, he is particularly drawn to traditional Asian work and elements relating to Chinese art. His passion for tattooing is apparent when he acknowledges the 'freedom and good life' the art form has created for him, and the range of emotions inherent in tattooing: 'You should get a tattoo! You'll experience expectancy, anxiety, pain, hate, dedication, insistence, extrication, honour, pride and glory! This is how a tattoo feels.' AFF

1 Hindu deity Ganesha 2 Buddhas with peonies
3 Cobra in river with peonies

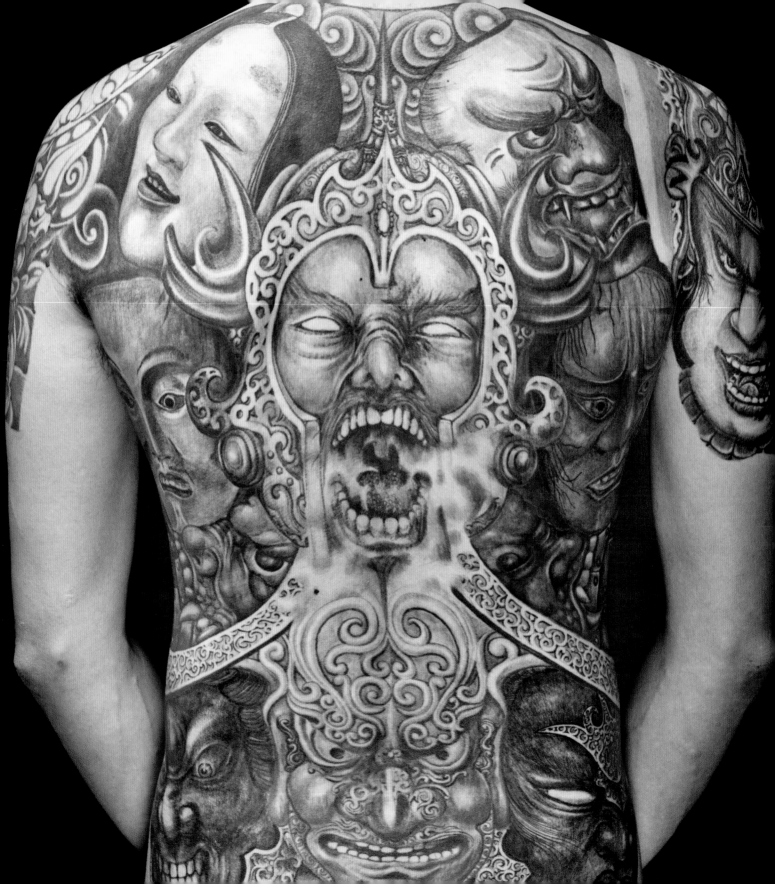

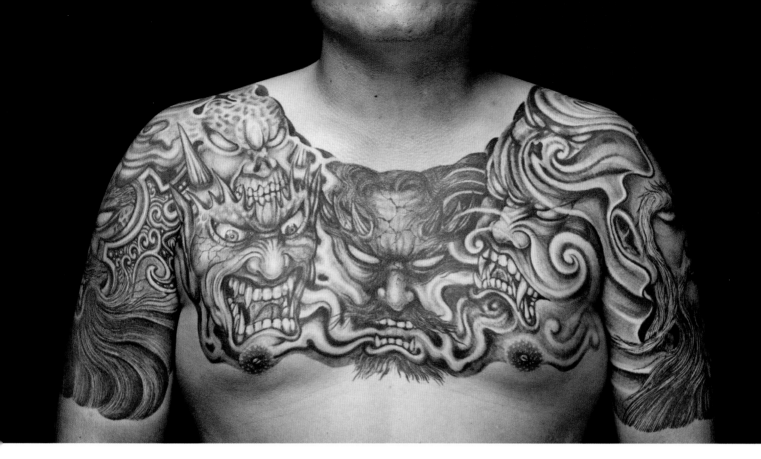

STYLE BLACK AND GREY **INFLUENCES** JAPANESE *UKIYO-E* PRINTS, JAPANESE TATTOOS, BIOMECHANICAL ART
LOCATION TAIWAN

ANDY SHOU

When looking through the vast black and grey tattoo portfolio of Andy Shou, one experiences an intense sense of power radiating from each piece – from the warriors, gods and beasts in the background imagery to the wonderful depth of black. The intricate, gradual shading and subtle highlights on the faces of his figures render them lifelike and yet like stone. Shou says: 'My style of art is single black ink; at most, I add a little high-gloss white. Black is my favourite because it is the most powerful and mysterious colour. I avoid using colour for my tattoo works because various colours will neutralize the type of effect and power I want my tattoo works to deliver on a person. I choose black for its sense of raw power.'

Shou's neo-Taiwanese style often depicts several big figures together in one beautifully balanced collage: traditional images such as *shishi* (guardian lion), Guanyin (deity of mercy) and a lotus, Nio guardians and Buddha are depicted alongside more Western-style icons including wolves, eagles, demons and skulls.

1 Kabuki masks infused with a horror aesthetic
2 Demon faces with smoke and wind

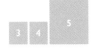

3 Ancient sage in contemplation 4 Life and death revealed in an ancient Buddha 5 Emperor-like figures presiding over demons

His tattoo composition changes the dynamic of the central motif in striking ways. The tattooed skin becomes the storyteller of fantastical, old mythical tales told in a contemporary novel way. Of his style, he remarks: 'The Japanese *ukiyo-e* tattoo is [a] gorgeous colourful spirit and Taiwanese tattoo style is typically with single black colour with deep underground society roots. The nature of Taiwanese tattoo creation is to pursue the root cause of the underground society. It is also its destiny. My tattoo style and philosophy are derived from the original ideology of ancient tattoo and totem, which sees body art as an armed deterrence.'

Raised in an arts-oriented family, Shou taught himself how to tattoo. Tattooing was not a respected profession in Taiwan and few tattoo artists practised there, least of all those who could teach the craft. It took witnessing a very beautiful tattoo to change his own perception of the form, when he recognized tattooing's uniqueness of expression.

After this pivotal encounter, he began studying the art of tattooing. He gained experience and improved his technique by tattooing friends, who he considers his best and most valued teachers.

Chiang-Hsun, an inspirational art teacher who Shou highly respects, once said: 'Beauty is the most precious wealth – the more you share, the more you receive. You see the stars in the sky from others' exclamation; you see the sunset from others' infatuation; and you see flowers blooming from others' praise.' This memorable quote captures the essence of tattoo art for Shou. In pursuit of beauty and art in his work, he launches himself into the unknown and lets spontaneity guide his way: 'I like to create [a] kind of pursuit of [the] unknown and allow my curiosity to lead me to the future. I think that is what makes life interesting; just like when I create body art. The spontaneous creative moment is always the most exciting and inspiring [one] that drives my art.' **KBJ**

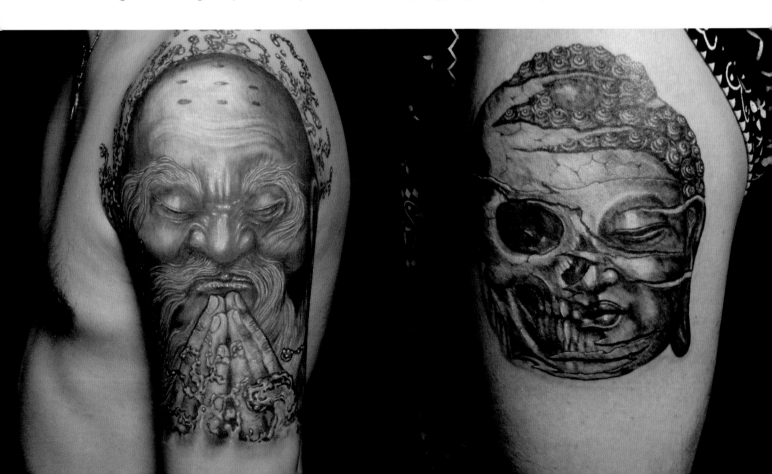

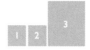

1 Photorealistic tiger 2 Marilyn Monroe portrait
3 Vignette with embracing skeletons

KIL JUN

Kil Jun found his calling in tattooing while on a leave of absence from university studies in fine art. Deciding to become a tattoo artist in South Korea is not for the faint-hearted – tattooing by anyone other than a licensed medical professional is illegal and tattoos also bear stigma. Kil Jun describes the hardships he faces: 'It's hard to be recognized as an artist in Korea. Nothing is easy, purchasing tattoo supplies, appointments with clients, etc. As tattoos are not popular . . . it's not easy to have a consultation with clients due to their lack of knowledge . . . about tattoos.'

After a year of apprenticing in a Korean tattoo shop in 2007, Kil Jun realized that he needed to travel to perfect his craft. He travelled around the United States working guest spots in Los Angeles at Phillip Spearman's Inkworks Tattoo and in Virginia at Billy Eason's Capital Tattoo; he cites Eason as a particular mentor. He works mainly in two genres – realism and traditional old school-influenced work. However, he notes, given the constraints of working in Korea, 'I am not picky on the genres of tattooing. I do all genres. (To survive as a tattoo artist in Korea, there's no option but to do everything.)'

Born and raised in Seoul, Kil Jun has a deep commitment to changing tattoo culture in his home country and pioneering advances in the art form. Admitting that he does not earn much income tattooing there, he humbly asserts: 'It is worthwhile tattooing in Korea when clients are satisfied with the work. If it was for money, I would have moved to another country.' Given the constraints posed by tattooing's illegality, Kil Jun works only by appointment, with clients often having to wait months for a session. A perfectionist at heart, he sums up his tattoo philosophy as one of 'satisfaction and happiness'. **AFF**

1 Tiger 2 Figure seated in lotus 3 Portrait head
of a ruesi 4 Ajarn Thoy performing the beginning
of a tattoo ceremony

AJARN THOY

A master of the Thai tattoo practice of *sak yant*, Ajarn Thoy
inscribes devoted followers with magical patterns (*yantras* or
yan) in his private sanctuary (*samnak*) in Bangkok. He uses the
traditional Thai tattooing technique of applying ink with a long
metal tool (*khem sak*); this resembles an oversized needle and
often features a small sculptural decoration on the end that
holds the tattooing needles. *Sak yant* is a spiritual form of
tattooing that includes ritual practice and transcends the
usual tattoo experience. Incredible power is invested within
the ancient Khmer script, geometrical shapes, animals (such
as tigers and elephants) and gods and goddesses syncretically
blended from Buddhism and pre-Buddhist religious traditions

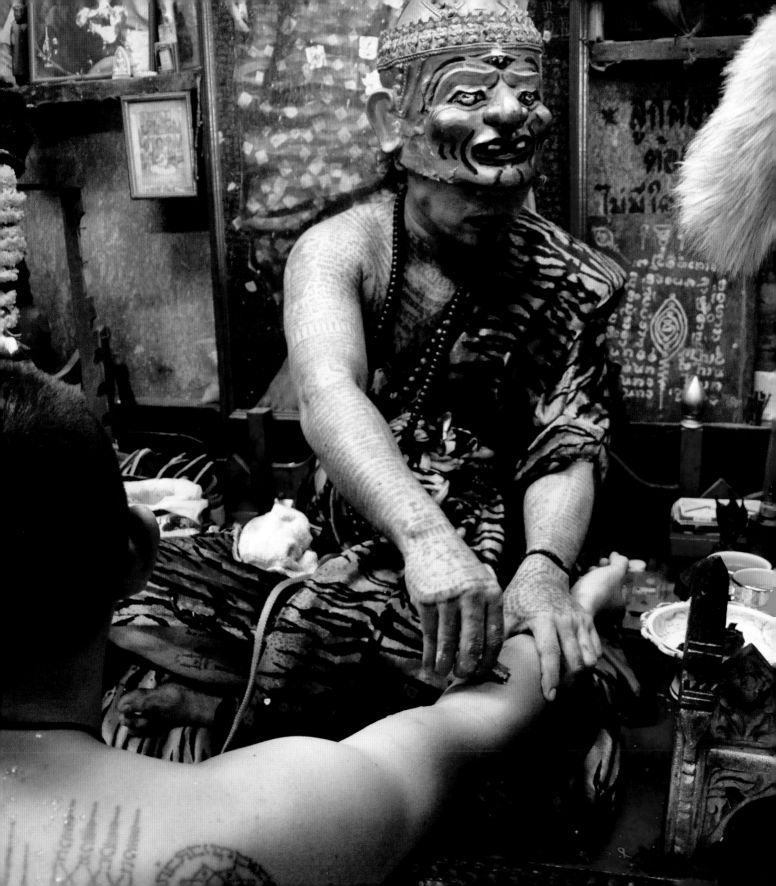

that Ajarn Thoy carefully marks on to the skin of those seeking his services. Designs are usually rendered in black ink, but at the client's request occasional touches of red can be incorporated. Ajarn Thoy's compositions reflect a unique collaboration between artist and client, and his exceptional artistry shines through, particularly in the expressive faces of his human figures.

Every year each tattooing master recharges their magical power during an annual Wai Khru ceremony in which Ajarn Thoy celebrates with his disciples who pay him respect. During the ceremony, the master dons an elaborate gold mask that covers the top of his head and most of his face. He wraps himself in robes (in Ajarn Thoy's case, tiger-patterned fabric) and enters a trance-like state to channel the spirit of Ruesi Por Gae (the Great Hermit). At the end of the ceremony, blessings are given to devotees from all around the world. Ajarn Thoy continues this tradition, at times tattooing while embodying the spirit of Ruesi Por Gae. One of many *sak yant* tattooers across

South East Asia, Ajarn Thoy has developed a committed following: 'People that come to me have a belief and faith in my *sak yant* because I emphasize the right way and because of the time that I have dedicated to study *sak yant*.'

To become a *sak yant* master is no easy feat. Born in 1967, Ajarn Thoy felt his calling early in life and became a master at the young age of fifteen. He relates: 'The path to becoming a master isn't that easy. I have become a monk and a ruesi [a hermit sage] to study about all the magic and mysterious things and to take a lot of time to meditate to understand them. You need to have power from inside the soul to help people in a positive way.' His role as a tattooer is one of protector rather than beautifier, because *sak yant* tattoos protect their wearers from a variety of dangers. Ajarn Thoy is open to inscribing men and women from all backgrounds – Thai and traveller alike – and he welcomes anyone interested in this special form of tattooing to visit him in Bangkok. **AFF/TM**

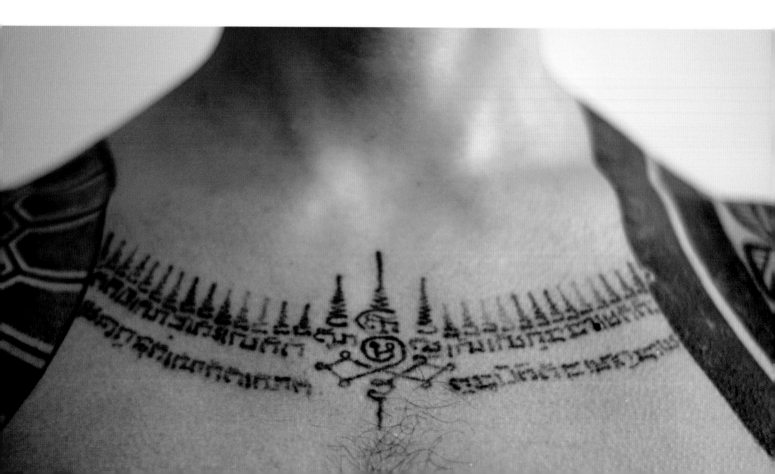

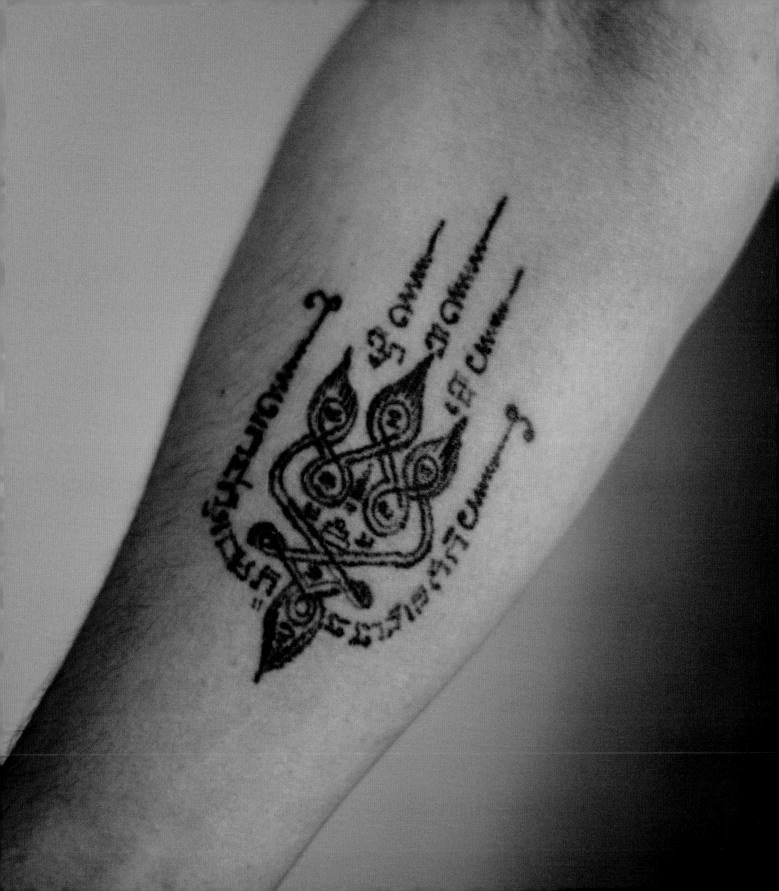

STYLE CONTEMPORARY, REALISM, JAPANESE
INFLUENCES ASIAN ART, WESTERN ILLUSTRATION
AND TATTOOING LOCATION SINGAPORE

1 Merging of woman with *calavera* make-up and
Trash Polka style 2 Japanese dragon back piece
3 Anime-inspired woman with anatomical heart
surrounded by phoenix

ELSON YEO

Elson Yeo's mastery of a diverse range of tattoo styles reflects
his upbringing in Singapore – one of the world's cultural crossroads
where East and West have mixed for centuries – as well as his
extensive travels to tattoo in guest spots around Europe. When
asked if he concentrates on any particular genre, Yeo comments
that he never wanted to pigeonhole himself in his tattoo art:
'I guess the best way of describing my "style" would be the very
pursuit of a style'. He clearly relishes the challenge of mastering
new forms of tattooing and rendering them at the highest level.

Yeo began tattooing through a traditional apprenticeship 'in a
dingy, hole-in-the-wall, proverbial Chinese triad-owned bikers'
tattoo parlour'. He describes his mentor as 'probably the last
guy you'd even want to glance at in a bar' but admits his early
experience taught him that 'respect and passion was, is and
will always be paramount in tattoo artistry'. Later he worked
at several other shops in Singapore and opened his own shop,
thINK Tattoo, in 2007. Yeo is committed to his clients and
never schedules more than one appointment a day to ensure
he fully focuses on each custom piece.

Throughout his fifteen-year career, Yeo has inscribed colour-
saturated realism, black and grey, neo-traditional 'oriental' and
even blackwork, as well as fusions of these styles. Some of his
most fascinating tattoos merge newer 'Western' styles – like
that of German artists Simone Pfaff and Volker Merschky (see
p.184) with whom he has guested or the new 'watercolour'
work – with Asian influence. He has also specialized in tattooing
over scars. Ultimately, Yeo's genre-hopping work mirrors his
philosophy: 'Learn and live by all the rules; then break the hell
out of each and every one of them once you master them.' AFF

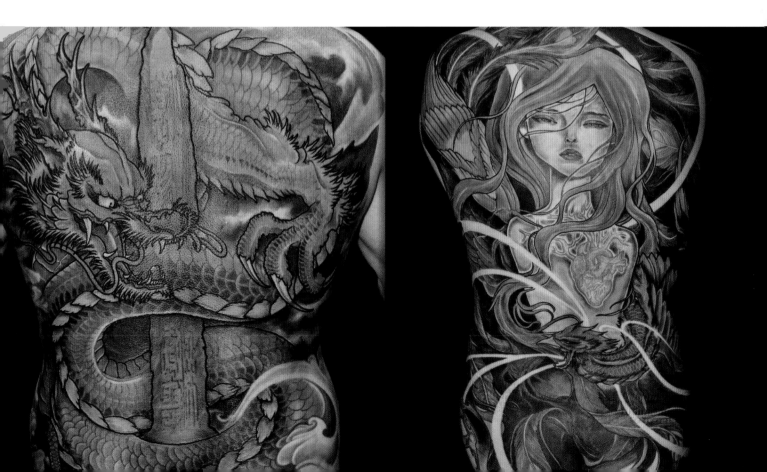

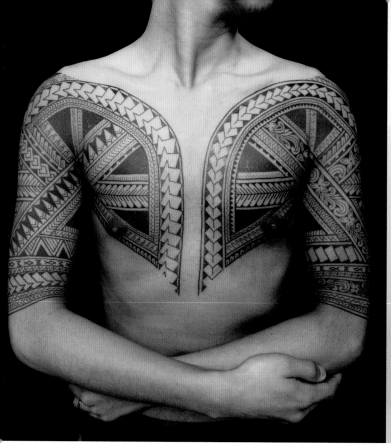
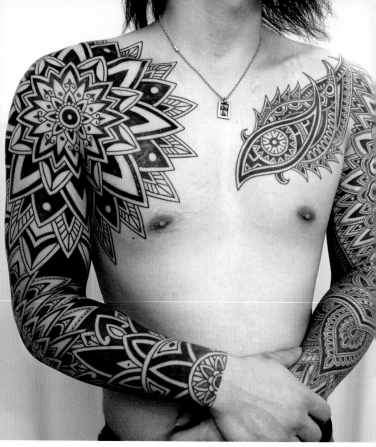

STYLE BLACKWORK **INFLUENCES** INDIGENOUS PACIFIC ART, GEOMETRY **LOCATION** TOKYO, JAPAN

1 Chest and arm design with Micronesian and Polynesian-inspired patterns 2 Geometric-floral sleeves 3 Marquesan bodysuit 4 Pacific Islander motifs blended with modern geometric forms 5 Headpiece evoking decorative art borders

TAKU OSHIMA

When most people think of Japanese tattooing, they imagine traditional motifs derived from the *ukiyo-e* tradition (a style of Japanese art that depicted subjects from everyday life). Taku Oshima's tattoos provide a striking contrast to such assumptions. He is an artist charmed by the colour black who has completely surrendered to its influence. His monochromatic works and geometrically perfect compositions challenge the human silhouette and contradict traditional Japanese tattoo aesthetics.

Oshima first considered a career in tattooing when a friend suggested that his sketchbook designs might make interesting tattoos. His tattoo adventure began in Goa, India, in the 1990s, when he inscribed Borneo-inspired motifs on the bodies of trance music fans. Oshima's work remains faithful to this blackwork style, but he blends Pacific Island designs with more modern themes. His tattoo inspiration from world cultures came from his study of anthropology. He describes his relationship to blackwork philosophically: 'Human life is like a black dot on the immaculate light. It keeps changing size and shape until melting into immaculate light again. This is my imagination of black and white.'

Oshima's creative process begins in an initial meeting with each client. He gleans the germ of an idea that will take its final form on his client's skin. Oshima enjoys working collaboratively, though he admits at times that process compares more to a sumo wrestling fight in which his vision jostles with that of his client.

Blackwork tattooing has not achieved the popularity in Japan that it has gained elsewhere. Oshima's clients often have to travel many miles to his Tokyo studio. He also experiments with mehndi (henna body painting) and designs clothes and jewelry. Ultimately, however, tattooing is his passion. **TM**

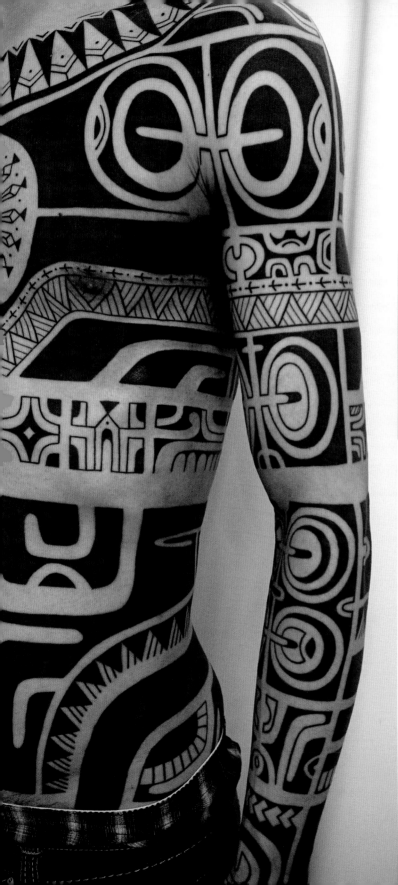

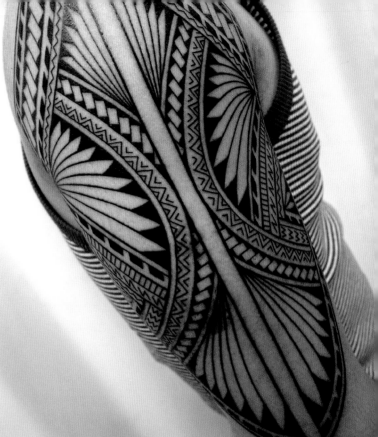

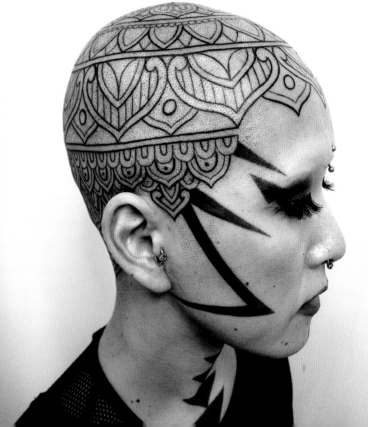

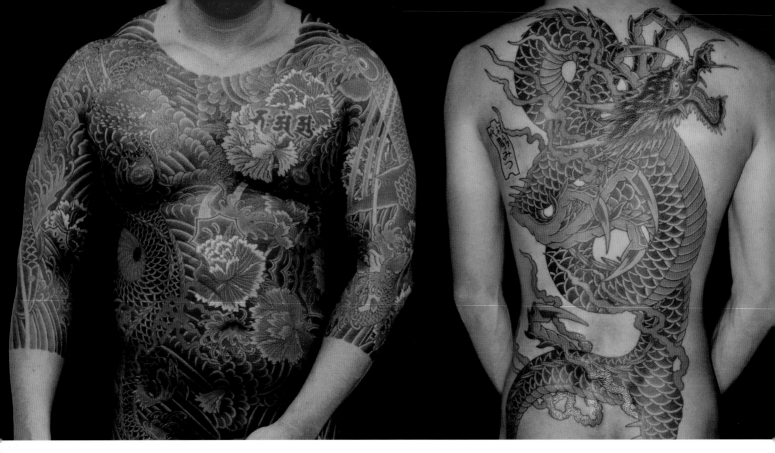

STYLE JAPANESE **INFLUENCES** JAPANESE ART AND
CULTURE **LOCATION** TOKYO, JAPAN

1 Bodysuit with dragon, peonies and koi 2 Traditional dragon back piece 3 Dragon rendered in contemporary graphic style

HORIMITSU

Horimitsu crafts bold, powerful versions of traditional Japanese *horimono* using both *tebori* hand-tattooing tools and contemporary machines. He undertook a twenty-year apprenticeship with master tattooer Horitoshi I, who he cites as his biggest influence. Those origins show in Horimitsu's choice of classic themes and images, but his compositions push the boundaries of tattooing to intriguing new places. He says of his tattoo philosophy: 'I am a successor to the world of *ukiyo-e*, and while carrying on that tradition, I strive to develop it into something that no one has ever seen before.'

Stylistically, while paying homage to the codified traditions of classical Japanese tattooing, Horimitsu updates his compositions in various ways. He deploys a striking palette of vivid, saturated

colour and uses the hallmark chiaroscuro shading of *horimono* judiciously. He renders background elements of water, waves, clouds and rocks in a starker style than is typical, evoking textile patterns or graphic design. This juxtaposition of background and foreground creates a lively contrast between the figurative motifs of dragons, flowers, koi and characters from Japanese lore, such as folk hero Kintaro. Central motifs are depicted large and push at the edges of the body in dynamic fashion.

Horitmitsu's muscular line work infuses his tattoos with a forceful energy that makes his creatures and figures seem to leap off the skin. His dragons particularly impress; they emerge gnarled, projecting a self-satisfied attitude that suggests centuries of hard battles and fierce protection. If one word could sum up Horimitsu's unique style it is 'calculated': each line is carefully placed, each area of shading deliberately considered, each shape assessed for its compositional power, each colour weighed for how it might emphasize a particular element of a design. **AFF**

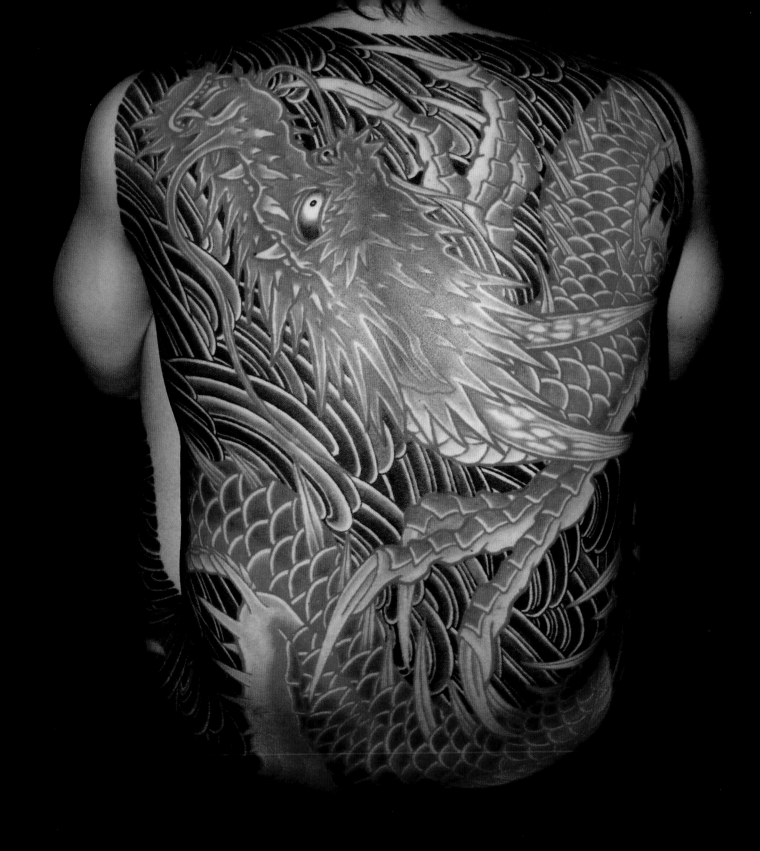

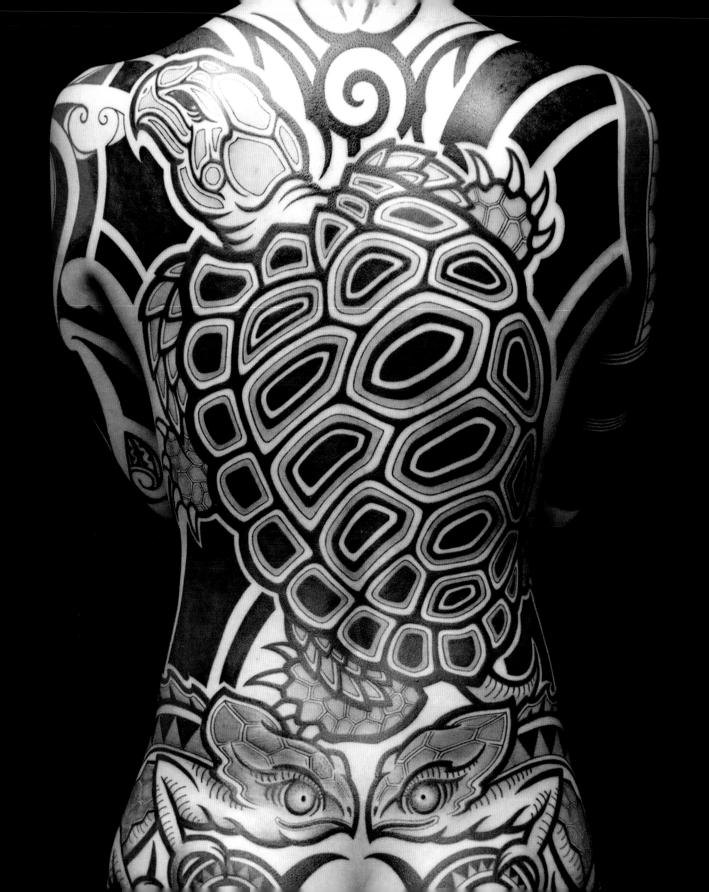

STYLE CONTEMPORARY, JAPANESE **INFLUENCES**
EVERYDAY LIFE, THE CITY, NATURE, COMICS, JAPANESE ART
AND CULTURE **LOCATION** NAGOYA, JAPAN

GENKO

Genko tattoos at the forefront of Japanese practice but, unlike
many Japanese artists, he works in various genres from traditional
horimono and designs drawing on Western new school and old
school to blackwork. Compositional experimentation is the most
striking aspect of Genko's work. Often the central figures of his
compositions burst outside of the frame of the body – taking
up more space than would be usual in a traditional visual
arrangement of motifs. All his designs, including the blackwork,
have a cartoon-like humour, whether in terms of oversized
features or as an inherent sense of fun and play in the lines.

 Born in Okazaki, a small city in Aichi prefecture, Genko first
discovered tattoos – and the stigmas they bore in Japan – as a
young child. 'One day I bought some sticker tattoos . . . only
to have them discovered by my father who promptly beat
me.' Even when telling his biography, Genko's quirky blend of
whimsy comes through. On his discovery of a passion for heavy

1 Blackwork turtles
2 Ferocious tiger with cherry blossoms

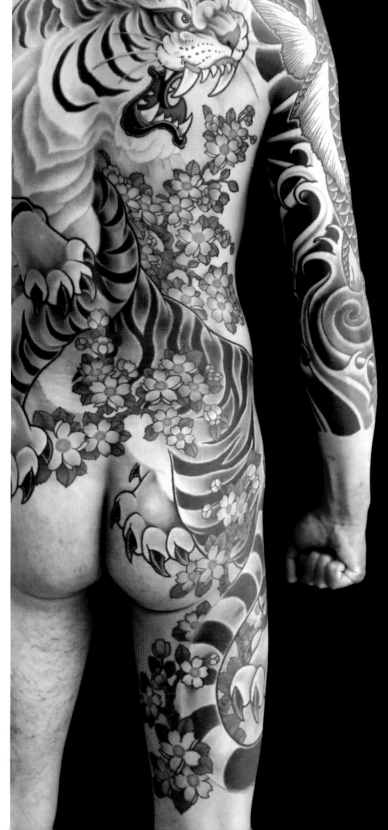

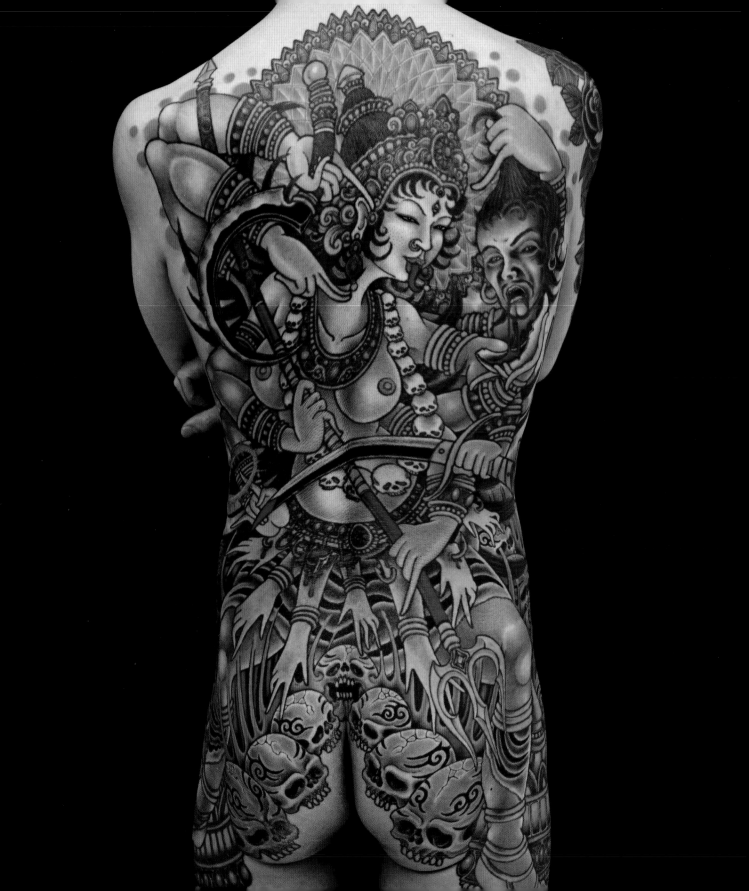

metal he relates: 'Immediately after this I went and purchased a thing called a "guitar". I then spent many years dreaming of becoming a rock star. However, one day I realized that a dream is something you have when you are asleep, so I threw my guitar away, and then for some reason, I felt much better.' He considered following in his father's footsteps into traditional Japanese crafts, but while getting a tattoo at Eccentric in Nagoya, Genko found his calling. After three years of petitioning that shop to give him a job, he finally gained an apprenticeship. The cartoon-like style of Eccentric owner Sabado clearly influenced Genko's work. After working there for eight years, Genko opened his own shop. The design of his shopfront reflects his innovative style – the stark, black modernist background of the façade wears ornamental wallpaper of one, repeated bold design.

Ever humble, Genko insists, 'I don't think I can call myself an "artist."' He carefully balances the desires of his customers with his signature style. During the design process he always considers his clients in the work: 'I simply listen to the wishes of the people who have chosen me to tattoo them and stay focused on giving them what they want . . . I believe two minds are always more creative than one.' He notes that his customers eschew 'copying tattoo designs they've seen' and he crafts only custom work. To ensure that each client receives a unique piece he says he's, 'always searching for something different. To do this I spend a lot of time looking (really looking) at lots of different things'. He cites the city, the mountains and the sea as inspiration, and asserts: 'The use of colour and design is more nourished by the things we see in their real environment rather than seeing them on a screen or the pages of books and magazines.' Genko is passionate about tattooing and hopes that by continuing to work in Japan he might 'do something that will influence and change, in a positive sense, the way society here views tattoos'. AFF

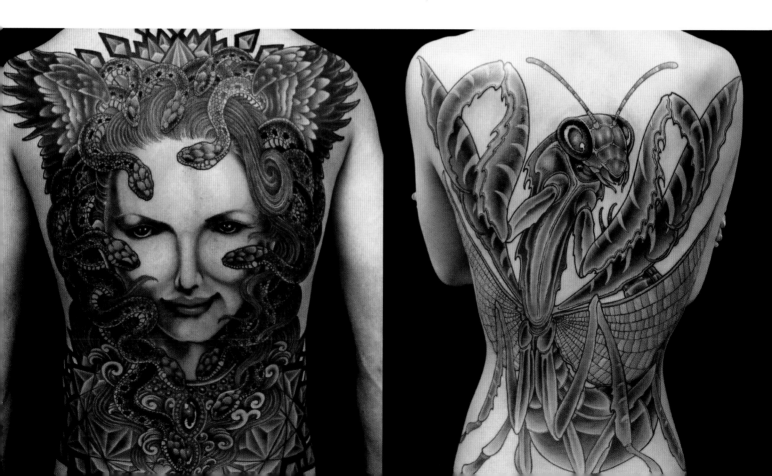

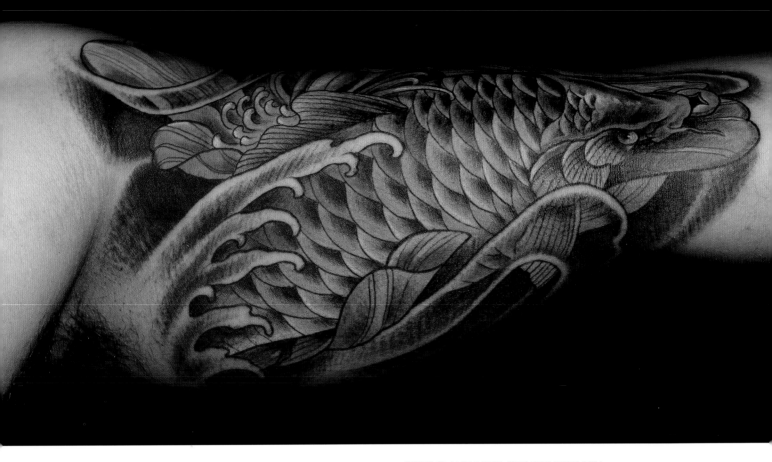

DANIS NGUYEN

STYLE JAPANESE, CONTEMPORARY
INFLUENCES JAPANESE ART, BLACK AND GREY
ILLUSTRATION **LOCATION** SAIGON, VIETNAM

Danis (Dang Thien) Nguyen crafts striking contemporary tattoos that blend influences from classic Japanese tattooing and Western black and grey work. Born in 1978, in the coastal city of Nha Trang, Nguyen studied fine art. He discovered an interest in tattooing when he was eighteen, but says: 'at that time tattooing wasn't popular at all in Vietnam'. Without internet access, all he could study were images in magazines, on DVDs and on the skins of rock musicians. He decided to teach himself to tattoo and relocated to Saigon when he was twenty-five. After inscribing friends for many years, he opened a small home studio when he was twenty-seven. A year later he opened Saigon Ink, which has been in operation for the past decade. There he teaches other artists and occasionally hosts international artists.

1 Koi fish among waves and aquatic plants
2 Peonies and phoenix 3 Geisha in kimono

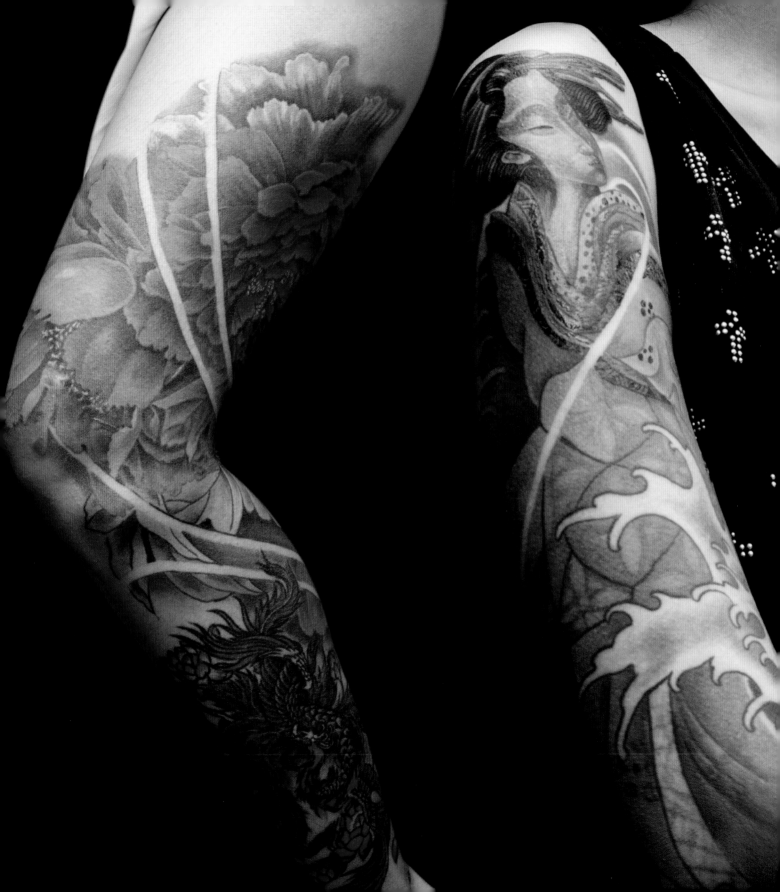

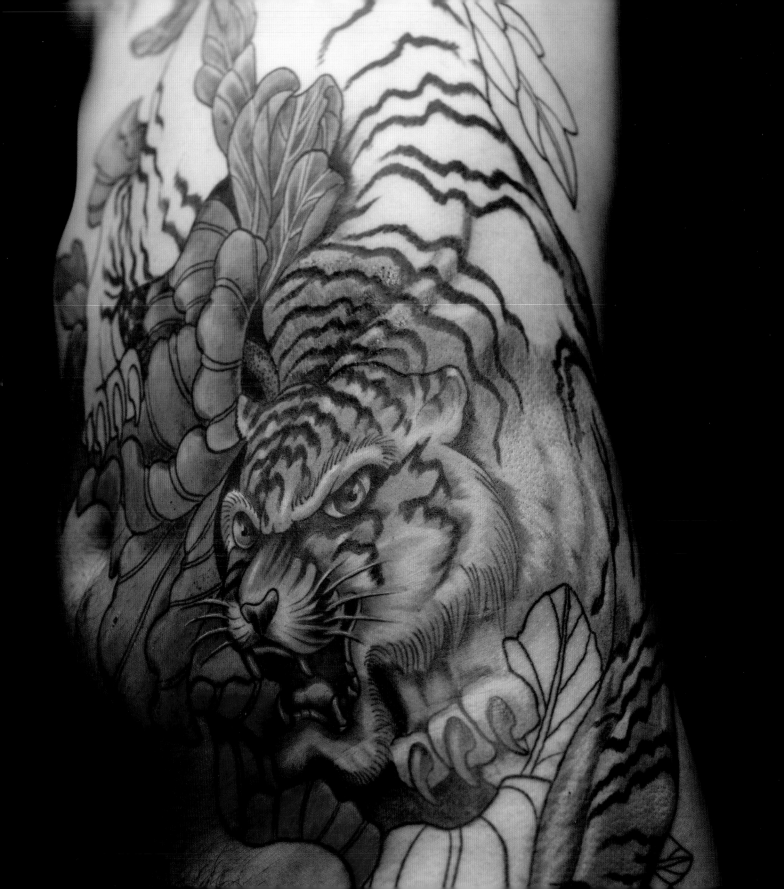

A trailblazer in creating a tattoo community in Vietnam, Nguyen encountered various hurdles: 'Tattooing wasn't popular ten years ago, it was illegal to open an tattoo studio. Most people view tattoo as something "gangster", but these people are the older generation; in their time, the only people who had tattoos were those in gangs, prisoners, drug dealers.' However, the tattoo scene has changed radically in recent years: 'It's [become] more popular [over] the last five years as Western culture comes to Vietnam through tourists. People seem more open to tattooing now.' He describes his current clients and the images they choose to have inked: 'Our customers are mostly business people, officers, designers. They like to get the Asian- and Japanese-themed tattoos, such as koi fish, dragons, hanya masks, lotuses and buddhas, something that means luck, protection, happiness, strength.' Western customers also choose old school, blackwork and geometric designs. He notes his expanding clientele: 'Many young customers, including women, get tattooed these days.

Most of them are script tattoos, letters, names, flowers. Sometimes ladies will get full back geishas or phoenixes.'

Given the variety of his clients and their interests, Nguyen does not feel he specializes in any particular style, although he cites Japanese artist Hiroshi Sakakibara as a particular influence: 'I mostly work from customers' ideas and the style changes for different ideas and stories. The most important things in my style are the lines that form the composition. After that I freehand to make it flow and fit in with the body.' This sense of flow is particularly evident where he adds a painterly style to his Japanese-influenced compositions. His strong black and grey work also evokes a deep understanding of how to place images on the body so they rest comfortably and meld with the skin. Nguyen's tattoo philosophy reflects his interest in Buddhist culture meditation: 'Tattoo comes from the inner soul. Every tattoo has its own meaning, besides the image, each also carries the spirit, message, memories from the person who owns it.' **AFF**

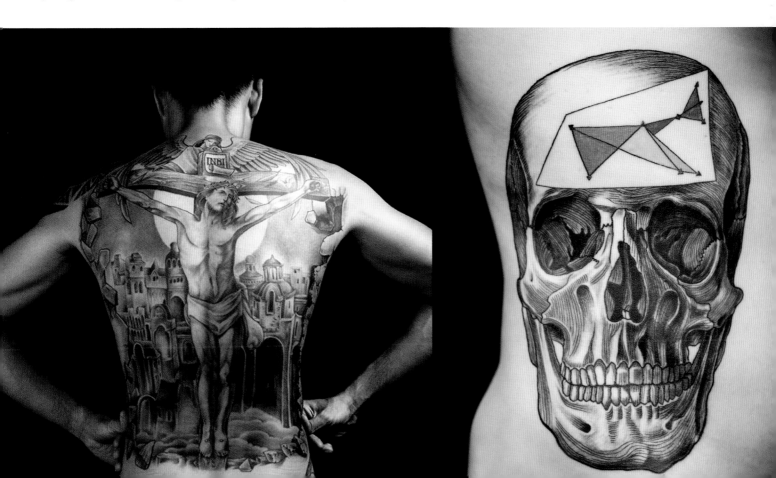

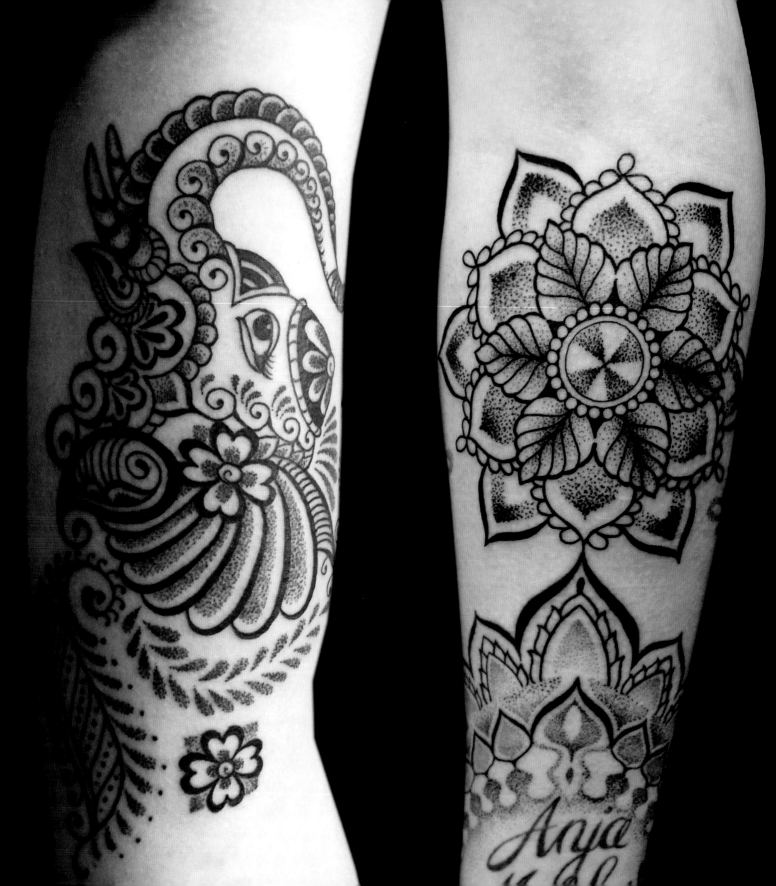

STYLE CONTEMPORARY, BLACKWORK
INFLUENCES SACRED GEOMETRY, BENGALI FOLK ART
LOCATION KOLKATA AND MUMBAI, INDIA

OBI

A tattooer at the forefront of the contemporary scene in India, Obi (a phonetic shortening of his given name Abhinandan Basu) inscribes striking designs that fuse his South Asian roots with global trends. Obi describes his upbringing: 'Basically a refugee colony for Bangladeshi immigrants in south Kolkata . . . a tough but very tightly knit neighbourhood'. A decade ago, while in college in Bangalore, Obi saved up to get his first tattoo, a Western-style 'tribal' arm piece. He recalls it as an epiphany: 'It was love at first sight . . . the very moment I sat in that chair and the needle hit my skin I somehow knew that THIS IS IT, this is what I wanted to do for the rest of my life.'

Although parts of India have indigenous tattoo traditions and street vendors work with home-made machines, modern 'professional' tattooing has been a recent development. After finishing college, Obi moved back to Kolkata, where he learned to tattoo mostly on his own: One of his unlikely mentors in Kolkata was an ex-con deported back to India, who had learned to tattoo during twelve years of incarceration in California. This began a long process in which he 'worked with artists and picked up tricks from them', travelling in India and then abroad. Today, Obi splits time between India and Europe, working in a shop in Mumbai (at Flying Lotus Tattoo), out of a private studio in Kolkata, and guesting in Germany and Norway.

Obi eschews any specific genre and his uniqueness shines through in his tattoos. In contrast to most tattooers who use black ink to render dotwork motifs from sacred geometry, Obi infuses his with vivid colour. He inscribes what he has coined 'bongo'-style works – pieces that blend traditional Bengali folk art with dotwork and other contemporary blackwork influences. His vibrant designs reflect his deep passion for the art form: 'Every day since I found tattooing – or tattooing found me – has been beautiful and uplifting.' AFF

1 Bongo-style elephant 2 Foliate mandala 3 Krishna with lotus and mandala 4 Vibrantly coloured mandala

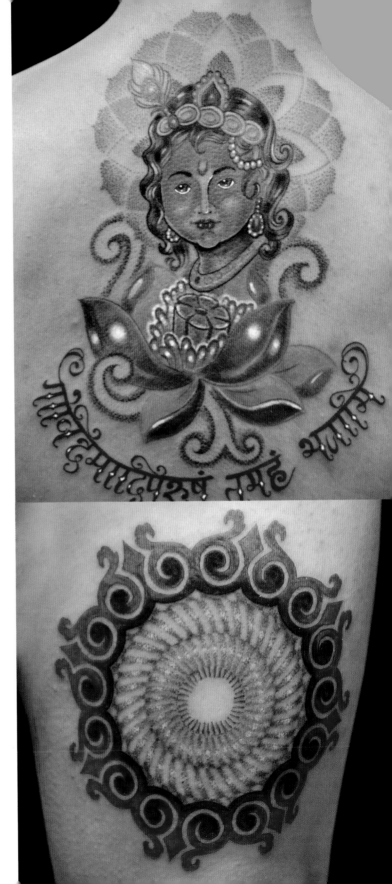

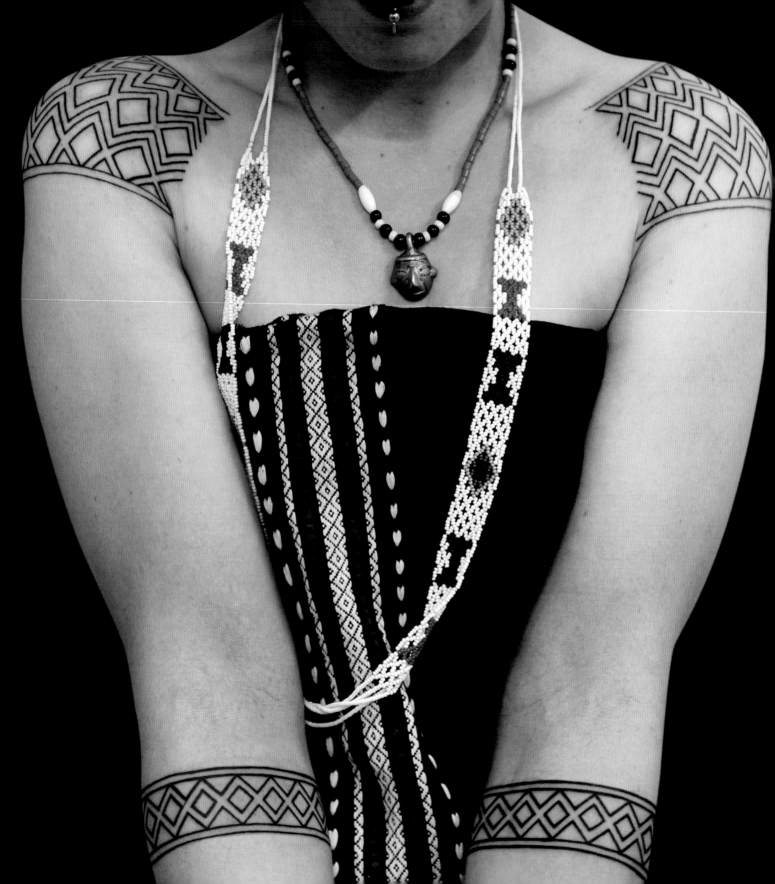

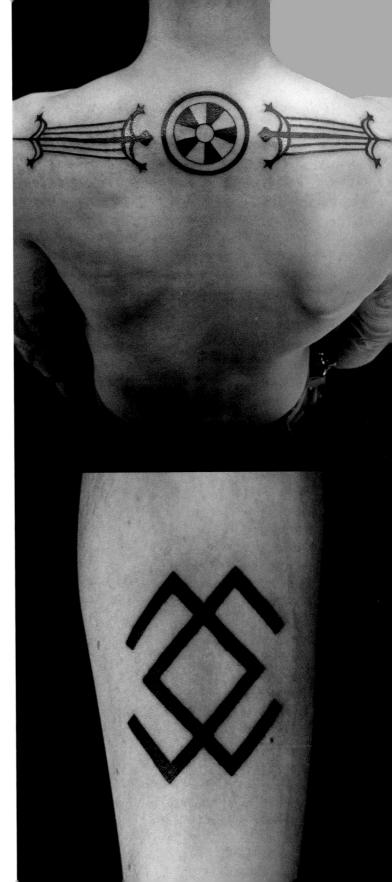

STYLE BLACKWORK **INFLUENCES** INDIGENOUS ART
AND MATERIAL CULTURE, TRADITIONAL NAGA TATTOOS
LOCATION DIMAPUR, INDIA

MO NAGA

Moranngam Khaling (known as Mo Naga) is an ethnic Uipo Naga
tattoo artist. Originally from the north-eastern Indian state of
Manipur, he trained as a fashion designer at the National Institute
of Fashion Technology in Hyderabad, where he started tattooing
almost ten years ago. After tattooing professionally in New Delhi
for several years, he left the capital in 2013 to open the first
tattoo studio and tattoo school in Guwahati – the gateway city
to the Naga homeland. His school is dedicated to promoting Naga
tattoo art and culture through contemporary renditions of
traditional patterns and responsible tattooing. He recently
relocated to Dimapur, Nagaland's largest city.

Mo Naga explains why he avoids foreign tattoo designs:
'Today, the Western tattoo designs that Naga youth see are
completely foreign to their culture. If we can develop tattoo
designs inspired by our local indigenous art and heritage,
tattooing will become more meaningful and more acceptable.'

1 Tattoos influenced by Konyak Naga iconography
2 Design influenced by Naga art 3 Protective
lozenge tattoo

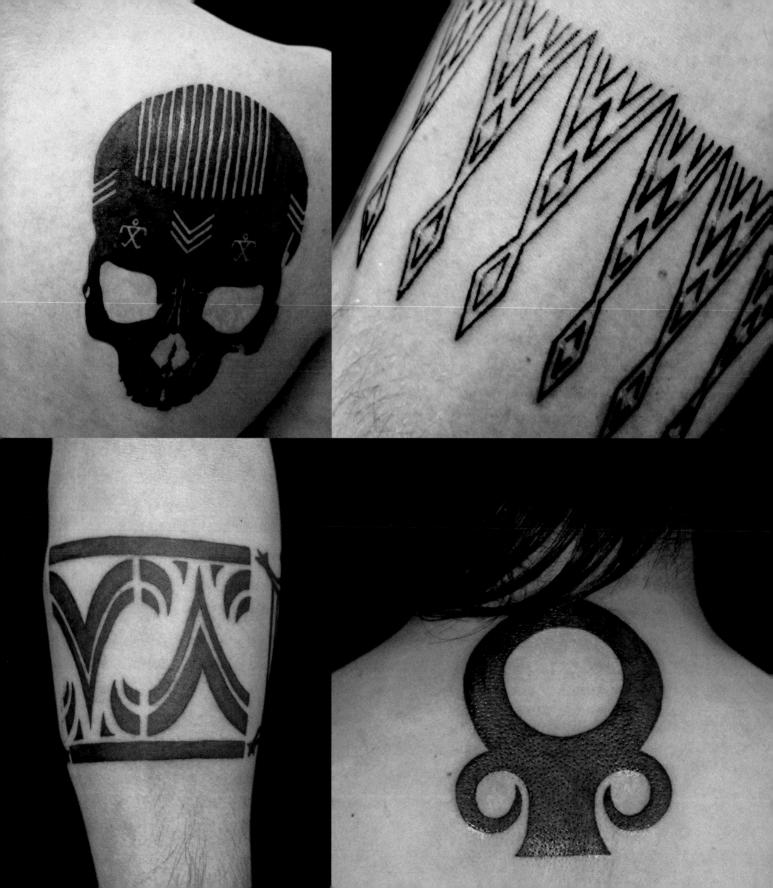

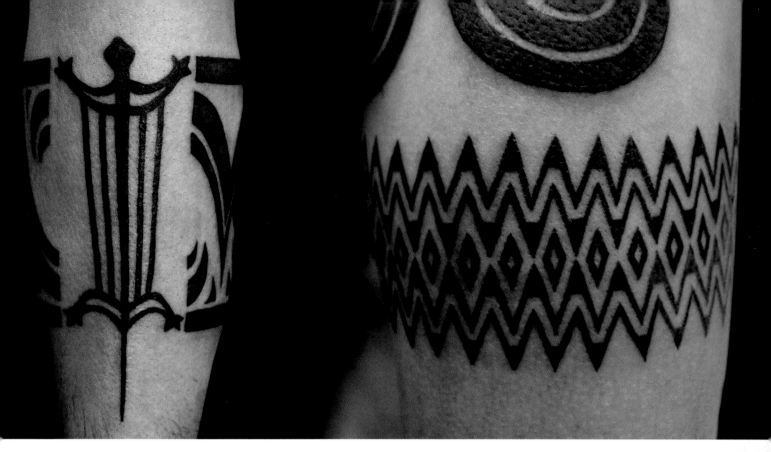

4 Painted skull tattoo based on traditional warrior practices **5** Neo-Naga motif based on a woven shawl pattern **6** Design influenced by Naga art **7** *Mithun* head symbol inspired by Konyak Naga woodcarving **8** Traditional Naga headhunter's tattoo motif **9** Neo-Naga pattern

His bold, geometric tattoo designs are derived from traditional Naga tattoo patterns, textile designs, beadwork, sculpture and objects of material and ritual culture, such as painted human skulls.

Traditionally, Naga tattoos were meaningful marks earned as a result of particular life achievements and were not worn as local fashion statements. Mo Naga believes that creating 'a new line' of contemporary tattoos for Naga people to wear will help preserve this dying ancestral practice. He says: 'Naga warriors may not be headhunting anymore and receiving tattoos for valour, but the relevance of those designs should not be lost. Even now a Naga person can still get a tattoo in accordance with their achievements, just like their ancestors did. In this way, we can preserve our [tattoo] culture and ensure that the noble way of our Naga forefathers does not fade from memory.'

Mo Naga's school was born out of the fact that the craft of tattooing is so essential to preserving Naga history and culture. North-eastern India had not been part of the country's booming tattoo industry, although the region had ample skilled artists. Mo Naga says that he wanted to turn these artists 'into real professionals with our experience in design and art, through safe and hygienic tattooing, and through our understanding of the industry. In turn, the region will become a force and source of inspiration in the global world and culture of tattooing. After all, if Americans, Japanese or Polynesians can boast of an ancient culture in tattooing, why shouldn't we do the same?'

As part of his desire to understand the Naga tattoo legacy, Mo Naga travels to remote tribal villages in Nagaland, Arunachal Pradesh and Manipur to learn about the meaning of tattoos from the last generation of tattoo bearers. He also interviews practitioners about traditional tattoo techniques and rituals. 'There are days when our camera batteries die because we are recording so much information. The elders regale us with so many stories and break out into old songs that might otherwise not be heard unless we rekindled those memories through tattoo.' LK

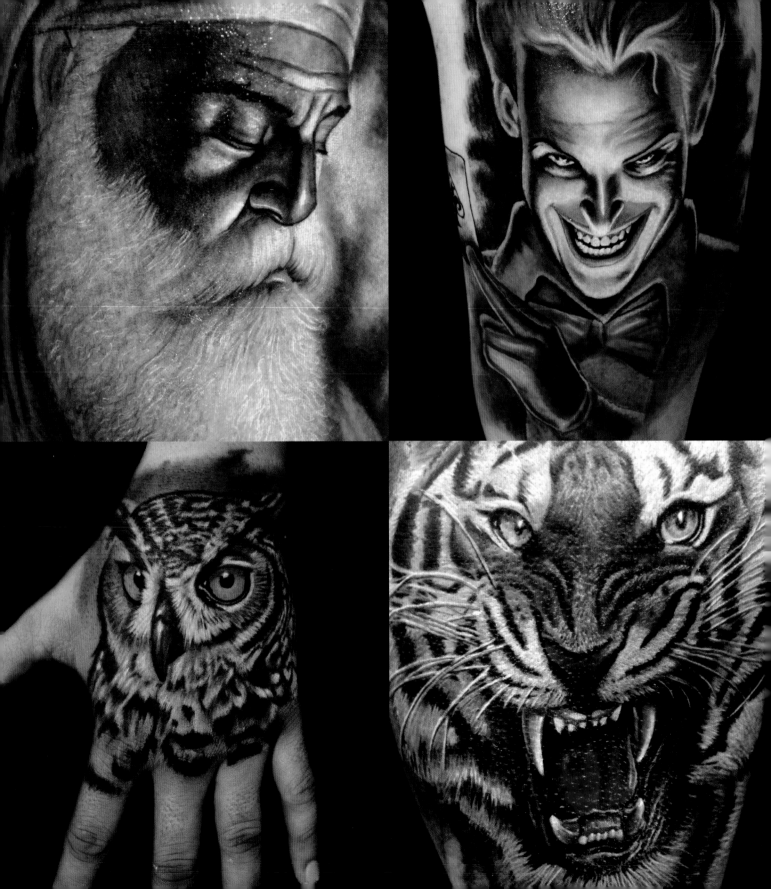

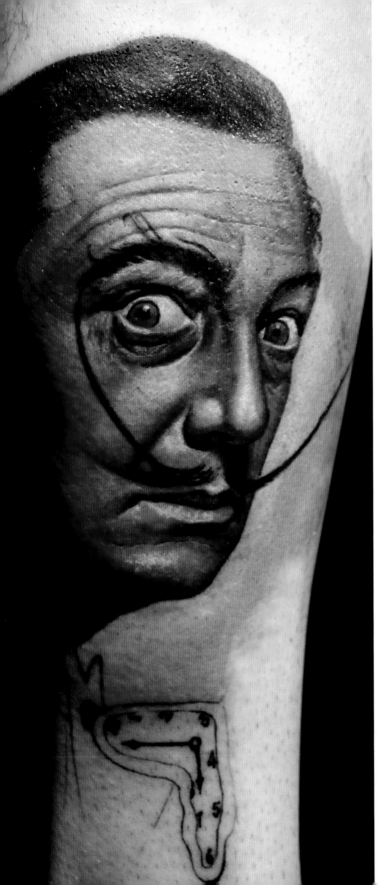

MANJEET SINGH

The realistic tattoos of Manjeet Singh possess so much vigour and excitement that they boldly leap out from the skin as if they might come alive and run away. His use of bright and energetic colours – along with impeccable line work and a precise and harmonious use of contrast – bring such lifeblood to his work. Singh's tattoos seem to give a profound and rich sense of life to the skin they are applied to. His portrait tattoo of Salvador Dalí, complete with furrowed forehead and curious big-eyed expression, looks as though he is about to start speaking about giraffes on fire or melting clocks, while stroking the tips of his exaggerated waxed moustache. The realism in Singh's animal tattoos is also impressive: tigers and owls appear to move and stalk you like prey, their fur and feathers lush and airy, and their eyes glassy and focused.

Singh is a self-taught artist who began his career as a painter, banner line and poster artist for Bollywood. When banner art was taken over by digital printing, he decided to pursue a career in tattooing. He continues to paint realistic graffiti wall art. Singh enjoys tattooing any style, but admits his heart is in colour realism, portraits and biomechanical. The tattoo industry inspires him, with its constant flow of new brilliant artists arriving on the scene with fresh techniques and ideas. Tattooing as an art has a philosophical and cultural significance for him: 'What I like about tattoos is that they describe you and your life, they tell what kind of person you are. In India the tattoo industry is still getting established and people here are still on their way to accepting it with their open hands. I am happy that the tattoo culture is being accepted here in a positive manner.' KBJ

1 The first Sikh guru, Nanak 2 The Joker from *Batman* 3 Owl with abstract background
4 Roaring tiger 5 Salvador Dalí with melting clock

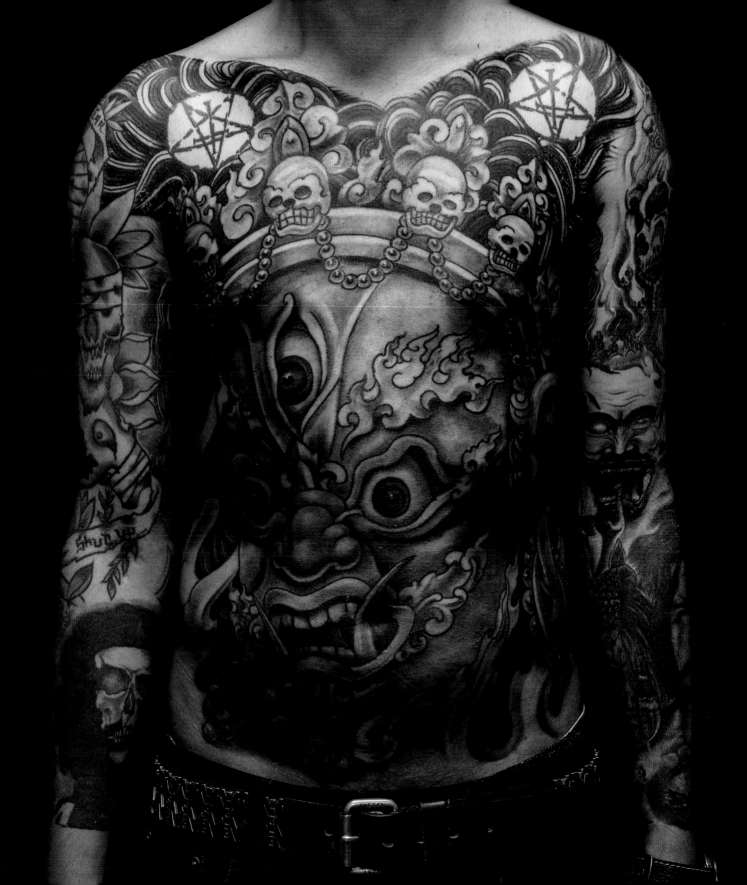

MOHAN GURUNG

Two decades ago, as tattooing started to gain in popularity
in the West, Mohan Gurung was drawn to the art form and
began to learn the process in order to take it back to his home
country of Nepal. He had seen traditional 'old style' Newar and
Tharu tattoos, such as 'Krishna, Shiva, a dot on the chin, and
moon and sun symbols', but 'was more inspired by new tattoos'
and cites hard rock singer Axl Rose's ink in particular. 'I saw new
colours and possibilities [such as] what can be done on paper,

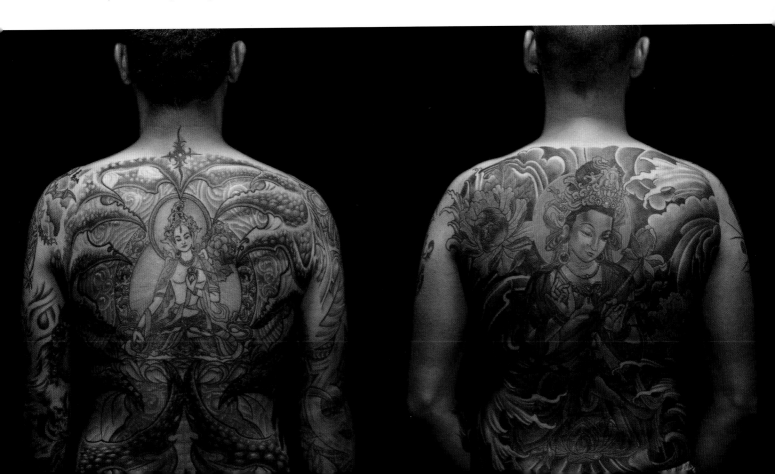

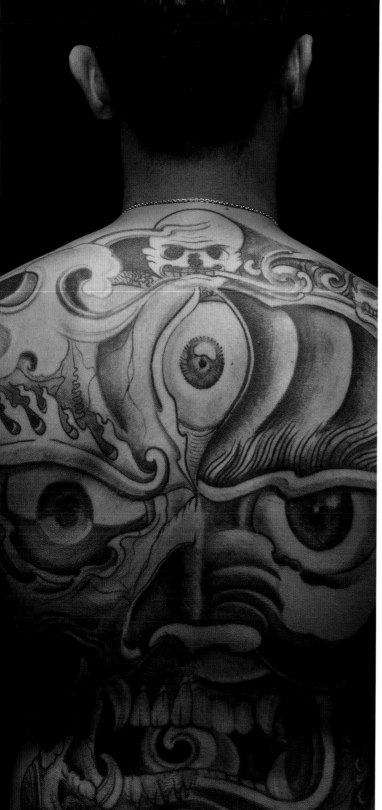

which opened my mind.' After high school, while visiting his brother who was stationed in South Korea on military service, Gurung met a Dutch artist who was tattooing his brother's army friends and got one himself. 'It was the turning point for my life . . . my mind and heart [told me this was] what I was looking for.' He spent a few months there learning how to tattoo and then returned to Nepal to continue his new craft by practising on his friends. 'It was really difficult in those days in Nepal. No internet, no tattoo magazines . . . but slowly I found more sources and the work of great artists, such as Horiyoshi III, Filip Leu and Paul Booth.'

In 2000 he opened his own studio, Mohan's Tattoo Inn, in his home town of Pokhara, but later moved to Kathmandu. Gurung wanted to strengthen the tattoo scene in Nepal; as there were few opportunities to apprentice or buy supplies and equipment, he began to share what he had learned by selling supplies and by organizing an international tattoo convention that has taken place over the last five years. He has a generous attitude to other tattooers and graciously notes that, despite creating potential competition, he has seen an increase in clients: 'If there is more competition, then there is more quality and more people will get tattoos.' He bemoans the period when he 'suffered a lot' because 'he didn't have any supplies, no one to answer my questions about the tattoo process, no platform for exposing [the art], and it was more taboo'.

Tattooing for Gurung is more than simply a job: 'I started it as a hobby. But slowly [tattooing] became everything for me. It's meditation.' Introspective and shy as a child (his mother died when he was only two years old), he started making art when he was four years old, inscribing images on stone with a nail as a tool – an uncanny premonition of his future craft. He is excited that his twenty-one-year-old son is following in his footsteps in the tattoo business. Gurung's clients often want motifs connected to local culture, especially images from Hindu and Buddhist traditions. 'I guess I'm practising the same historical tattooing that we already have around us [only with] a new process and equipment.' Visually his tattoos reflect this contemporary twist, particularly in his large-scale back and torso pieces that blend Western and Japanese traditions with his own. His vibrant compositions radiate the joy he experiences in his profession and reflect his philosophy that tattoos 'give peace, happiness, energy and freedom in my mind'. AFF

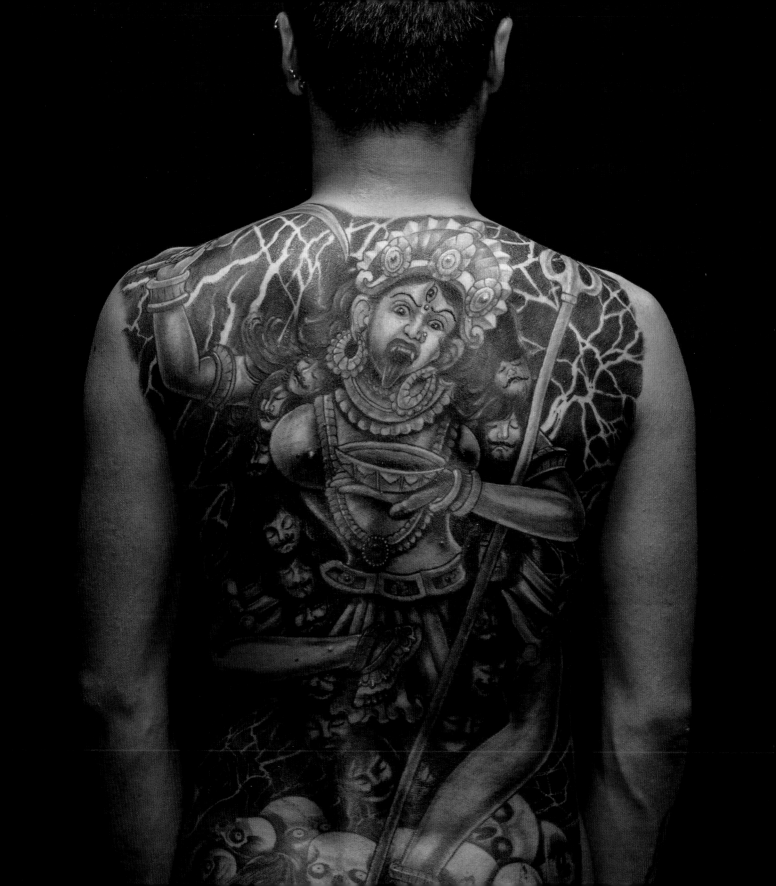

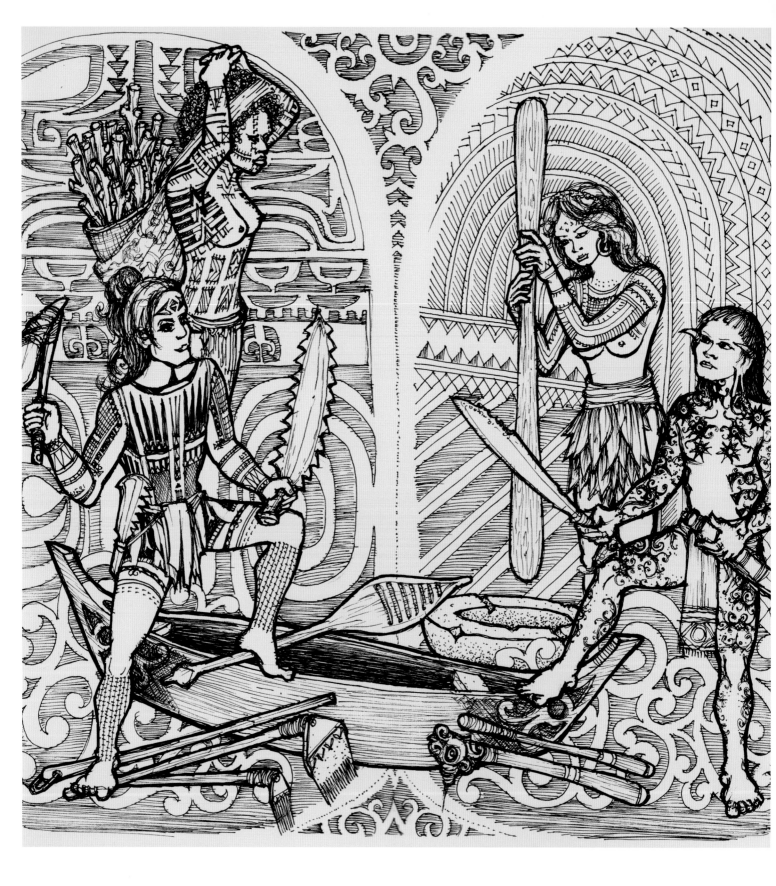

AUSTRALIA AND THE OCEANIC ISLANDS

BRISBANE MELBOURNE MULLUMBIMBY DARWIN WAI'ANAE HONOLULU HILO NADI MOOREA YAP RAPA NUI PORIRUA AUCKLAND MOUNT MAUNGANUI UPOLU HONIARA YOGYAKARTA JAKARTA BUSCALAN KUCHING

ALISON MANNERS BENJAMIN LAUKIS TATU LU JULIA MAGE'AU GRAY KEONE NUNES AISEA TOETU'U RODNEY 'NI' POWELL WILSON FATIAKI MATE LEO PUGRAM MOKOMAE ARAKI MARK KOPUA STEVE MA CHING JULIE PAAMA-PENGELLY SULU'APE FAMILY NUKUMOANA GROUP DURGA ADE ITAMEDA WHANG-OD ERNESTO KALUM

Tattooing in the vast Pacific Ocean region of the world reflects a blend of historical practice, colonial interaction and the global spread of visual language. Recent revivals of traditional arts have simultaneously erupted in numerous countries and territories of the region. Small pockets of indigenous practice also survive in remote places that have been barely disturbed by colonial intervention. At the same time, globally influenced work can be found in many major cities, side-by-side with tattoos inspired by indigenous cultural heritage.

Canoe-borne travellers migrating from mainland Asia to populate the Philippine, Indonesian, Micronesian, Melanesian and Polynesian islands dispersed tattooing around much of the Oceanic area between 3000 BCE and 1000 CE. Specific details o early indigenous tattoos are scarce; however, when European exploration of the Pacific Ocean commenced, ample documentation began to be collected by visitors. Although European presence had decimated much indigenous tattooing practice by the end of the 19th century, in a paradoxical

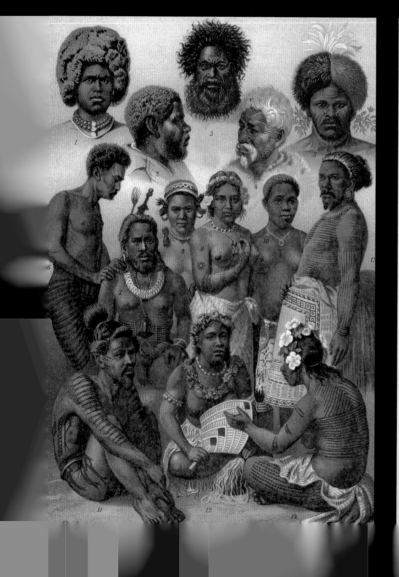

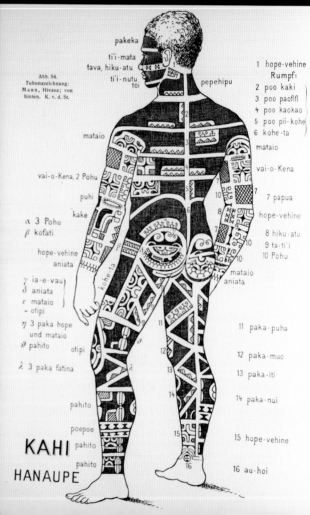

historical twist, the documentation that colonial scientists, explorers and artists collected has served as the foundation for much of the contemporary revitalization of traditional Pacific practices.

All traditional tattoos in Oceania employ some form of solid black design and line work in a range of geometric abstract patterns, often derived from nature. Tattoers also mined nature for tools, using sharpened bone or shell, thorns and other natural materials. Despite the hypothesis that tattooing spread across the Pacific Ocean from a common Asiatic root, historical indigenous tattooing in the Pacific varied immensely from place to place as traditions on isolated islands changed and developed (see image 2). For example, the tattooing that takes place in Papua New Guinea differs strikingly in both aesthetics and meaning from that in either Borneo or Tahiti.

By contrast, although geographically close, Australia's tattoo history started significantly later. Aboriginal peoples are among the minority of global cultural groups who do not have a history of tattooing, although they do practise other fascinating forms of body adornment. Therefore colonial Europeans did not encounter tattooing in Australia; instead, the continent's tattoo traditions emerged from entirely foreign roots, beginning with the designs that were etched on the bodies of Europeans who arrived there in the 18th century.

Polynesia

Throughout Polynesia tattooing varies immensely, from head-to-toe male Marquesan designs to the smaller motifs inscribed on Tahitians and others in the Society Islands. Some tattoo traditions, such as those in Samoa, have survived to the present day little changed despite decades of colonial European and American presence. Other traditions, including those in Hawaii, Tonga and Rapa Nui, completely disappeared from living bodies for decades, if not centuries, and have been captured only in the documentation of visiting Europeans.

Marquesan full-body tattoos represent some of the most extensive tattooing in the region and indeed in the world. Stark black bands on the face and striking geometric patterns covering the entire body marked men from this island group in a unique way. Chest tattoos often signified membership in eating clubs that were especially important in times of famine. Other marks represented coming of age or prowess

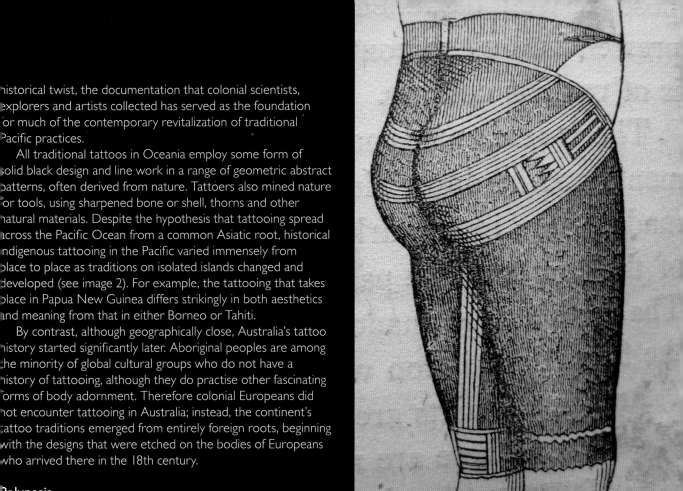

in battle. Visiting US Lieutenant Henry Wise floridly described Marquesan tattooing in his journal, published in 1849; he noted it 'renders them preeminently beautiful' and called one particularly heavily tattooed man a 'hieroglyphical human "picture printing" . . . so very interesting a specimen of goblin tapestry, that Champollion himself might have studied him with much benefit and gusto'. Marquesan women also got tattooed, but less extensively. Marquesan tattooing nearly died out after the French annexed the Marquesas in 1842; however, thanks to the persistence of a handful of artists the practice endured.

Samoan tattoos, by contrast, although similarly dense with black patterning, have traditionally been limited as to the extent of bodily coverage. On men the *pe'a* design spans the body from the lower torso to just above the knees (see image 4).

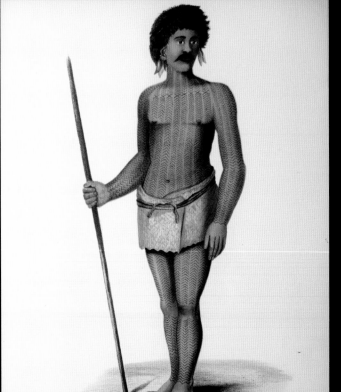

Micronesia

Micronesian tattoo traditions, despite being equally extensive, were less well documented than Polynesian ones. This is perhaps because European explorers made fewer visits to these tiny islands, which were neither on the usual shipping routes nor big enough to serve as regular supply stops. Micronesian cultures across the Caroline, the Marshall and the Gilbert island groups featured extensive body tattooing, especially on the torso, but also along the arms and legs. The practice of tattooing women was often tied to fertility, marriage and childbearing. Most Micronesian tattooing disappeared with the cultural changes that exposure to colonial Westerners brought, but isolated examples of traditional bodysuits have lasted to the present day.

Despite the Micronesian islands being spread across a vast geographical expanse, many designs have common origins in nature. Frigate birds, whose wing bones were sometimes used for tattooing tools, served as good luck motifs. Designs relating to dolphins and sharks (especially the teeth) were also common. In the Marshall Islands, striped designs mimicked the patterns on angel fish. In Yap particularly striking tattoos feature enormous, black, wave-like arches that span the entirety of the back.

Europeans had an early introduction to Micronesian tattoos. The early cross-cultural traveller Prince Giolo, purchased in 1690 by explorer William Dampier in Chennai, India, by way of the Philippines, came from one of the islands in Palau. He was described as tattooed 'all down the breast, between his shoulders behind; on his thighs (mostly) before; and in the form of several broad rings, or bracelets, round his arms and legs. I cannot liken the drawings to any figure of animals, or the like, but they were very curious, full of great variety of lines, flourishes, chequered work, etc keeping a very graceful proportion'.

Melanesia

Tattooing in Melanesia – New Guinea, the Solomon Islands, Fiji, Vanuatu, New Caledonia – suffered significantly as a result of colonialism, although some practices have survived to the present day. Generally, tattooing does not seem to have been as widespread in Melanesia as elsewhere in the Pacific region, with a preference for other forms of body modification such as scarification. All documentation of traditions in this part of the world came from Europeans, mainly in the late 18th and 19th centuries, and therefore a limited window of observation exists

The equivalent women's tattoo, the *malu*, covers the thighs from the hips to the knees. Historically, Samoan tattoo artists received payment of pigs and woven mats for their services, although money is often exchanged today. *Pe'a* and *malu* tattoos signify coming of age and the transition from childhood to adulthood, as well as representing an indelible celebration of Samoan identity.

Among the Maori in New Zealand, tattoos traditionally inhabited only certain areas of the body. People of societal rank who had obtained enough *mana* (a type of spirituality) could receive a *moko* tattoo – spirals, swirls and other curving lines rendered on the face. The most powerful men could eventually achieve a fully tattooed face, although the majority of men had more limited facial tattoos. Women's *moko* involved only the chin and lips. Maori men also wore tattoos on their buttocks and occasionally elsewhere on the body. In terms of technique, historical Maori tattooing – in contrast to other tattooing in the Pacific Island region – was a hybrid form of pigmented scarification with deeply incised or 'carved' lines in the skin rendered with specific tools for each operation.

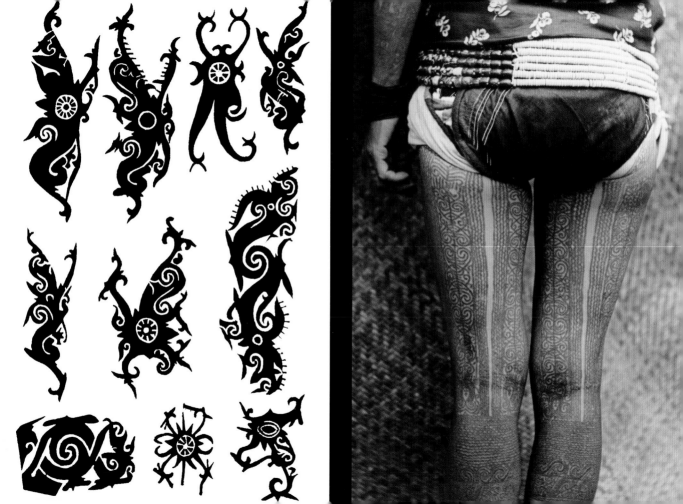

7	8

7 Tattoo patterns from Borneo recorded by Charles Hose and R. Shelford, 1906
8 Kayan tattoo, *c.* 1930 **9** Ibaloi mummy *c.* 1500, Philippines

invaluable documentation of a tattoo practice that featured extensive black geometric designs over much of the body, and they also validate the drawings and textual accounts made by explorers.

Indonesia and Malaysian Borneo

The tattoo history of the numerous Indonesian islands and the Malaysian part of Borneo, which prior to European contact probably numbered in the hundreds, differs visually from other Oceanic practices. On some larger islands and some particularly remote islands, indigenous tattooing has survived to the present day. However, in many places, because of early colonial intervention beginning in the 17th century, practices became extinct, particularly in the eastern part of the region. A number of groups in Borneo use a technique involving carved woodblocks dipped in pigment to print designs on the skin prior to tattooing – a method seen in only a few places around the world.

Historically, Borneo had an astounding number of groups with distinct tattoo traditions. Charles Hose and R. Shelford, writing in 1906, noted that: 'The practice of tatu [sic] is so widely spread throughout Borneo that it seems simpler to give a list of the tribes that do not tatu, than of those who do.' Tattoo styles in Borneo range from the graphically bold Kenyah, Kayan and Iban centipede and dog designs (see image 7) to much more delicate Kayan designs for women, which feature nests and weaves of intricate small lines (see image 8). In the remote Mentawai Islands west of Sumatra, people wear tattoos with long curvilinear lines punctuated by small iconographic motifs.

Tattoos on Transculturites

Although visiting Europeans (and later Americans of European heritage) have long had a history of acquiring indigenous tattoos as part of a process of cultural adoption elsewhere in the world – for example, among Native Americans in North America – in the Pacific Islands a number of men took this practice to an intense level. The recent popularity of 'tribal' designs on Westerners can be seen as an extension of a tradition that began as early as the 1790s, when Jean-Baptiste Cabri, a Frenchman who became an adopted Marquesan, got heavily tattooed and then became an attraction on the

fairground circuit in Europe. One of the explorers who encountered him, Dr Karl Espenberg, remarked how Cabri 'would . . . laugh like a native of Nuka Hiva, to whom he had a great resemblance, as not only his body but the greater part of his face was tattooed'.

In New Zealand, a number of men – often escaped convicts trying to hide their identities, such as John Rutherford and Barnet Burns – were extensively tattooed with facial designs; some of them also returned to Europe to put themselves on display in fairgrounds and circuses. In Micronesia, shipwreck victims, among others, similarly integrated into local populations

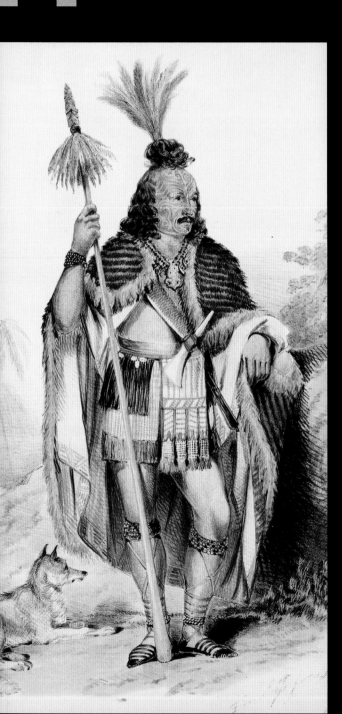

and became extensively tattooed. Horace Holden, tattooed on Tobi after a shipwreck in the 1830s, was described as tattooed in 'South Sea islander fashion over his entire chest and arms'. William Diaper, a beachcomber who travelled extensively throughout Melanesia and Polynesia in the mid-19th century, 'excited the wonder of all by the tattooing on his arms, neck and part of his face'. Occasionally, these adopted Pacific Islanders never returned home but were happy to live out their lives in their newly transformed skins.

Australia
Since Australia lacked an indigenous tattoo tradition, tattoos first arrived there in the 1780s on the bodies of convicts destined for the British penal colonies. Although there does not appear to be any evidence of continued tattooing practice on Australian soil in those early years, some estimates suggest that as many as 35 per cent of men and 10 per cent of the women who arrived in Australia – the vast majority of the early population – had been inscribed with tattoos by the time they disembarked from the transport ships and underwent the extensive process of surveillance that recorded anything present on their skin. Occasionally, heavily tattooed Pacific Islanders would arrive through Australian ports as crew on European ships, as diplomatic visitors or as indentured labourers who had been 'blackbirded', although their presence does not seem to have influenced any nascent tattoo culture in Australia at the time.

Aside from this early history, tattooing appears to have developed in Australia in a similar way to Europe or the United States, although it was more limited in scope than elsewhere and mainly existed on servicemen. It is unclear when Australia's first professional tattoo shop opened, but in 1969, when he was tattooing out of his father's garage, eminent Sydney tattooer Tony Cohen estimated that there were fewer than ten tattoo studios in the whole of Australia. Shortly after, as he and other Australian artists began to learn about the changes happening in the wider tattoo world as a result of the tattoo renaissance and to travel, tattooing expanded in Australia both in terms of a wider clientele and in broader possibilities for designs and motifs.

Among the prominent early Australian artists, Cindy Ray (aka Bev Robinson/Nicholas) established an important niche for female tattooers the world over with her flamboyant,

glamorous style, which contrasted starkly with the typically macho tattooers of the period. Heavily tattooed herself, she travelled around Australia in the 1960s and 1970s as an ambassador for the art form. She described herself as 'the classy lassie with the tattooed chassis' and 'the girl who put the "oo" in tattoo'.

Contemporary Tattooing

Today, tattooing throughout Oceania spans myriad styles, from indigenous work crafted via traditional tools to generalized Western-influenced tattooing. A potential client can acquire a work ranging from a hand-tapped geometric motif by an artist with deep historical roots and a family lineage in the tattoo business to a dolphin design as a souvenir of a beach holiday.

Many contemporary revitalizations and reinventions of Pacific tattoo practice can be traced back to a renewed interest in traditional Samoan *pe'a* and *malu* tattooing that started in the 1960s. By the 1980s, first in New Zealand, then in French Polynesia, other revivals had arisen. From the 1990s, many emerging artists looked to Samoan artists, particularly the Sulu'ape Family (see p.360), to teach them traditional hand-tapping techniques because the practice never lapsed there and has continued to thrive. In places where tattooing had become extinct or almost extinct, tattooers began to seek out copies of the images that foreigners had drafted to use as source material for a reconstructed art form. Artists in the Society Islands, who lack much visual evidence for their own tattooing, have turned to the elaborate patterns inscribed by the neighbouring Marquesas Islands for inspiration.

Although many Polynesian tattooers practise hand-tattooing, they have also embraced new technology. Many contemporary artists prefer to inscribe traditional designs using a machine, rather than by hand. Other techniques have also changed: for example, contemporary Maori tattooing, even when hand-tapped, lacks the dimensionality of the historical form, which both scarred and pigmented the skin. The repercussions of the Polynesian tattoo revival have been felt worldwide as indigenous artists around the world have witnessed the successes of Maori, Samoan and French Polynesian tattooers and realized that they, too, can contribute to reclaiming and reinvigorating historical practice.

In the 21st century, artists have made further progress towards revitalizing defunct practices and crafting new traditions. The important cultural reclamation that started largely in Polynesia has become a dynamic practice in both the Philippines and Indonesia and has been growing in Micronesia and Melanesia as artists, drawn to exploring precolonial history, discover clientele who want to either wear traditional patterns or who wish to update traditional designs to suit the modern body. In Australia, neo-Aboriginal tattooing has emerged to celebrate that culture's art through inscription on skin. Throughout the Pacific Islands experiments in artistic fusion have resulted in cutting-edge designs that combine traditional Pacific Islander designs with those of Western or Japanese/Asian influence. It can only be hoped that over the following decades tattooing will once more become as vibrant and widespread a practice in Oceania as it was in its precolonial heyday. **AFF**

1 Pin-up Jane swinging through the jungle 2 Mermaid
with octopus-like headpiece 3 Updated eagle clutching
snake chest piece

ALISON MANNERS

Alison Manners prefers to tattoo old school designs, but
her colours are flatter and her lines more subdued. Her
neo-traditional version of old school melds crisp hues and
lines with traditional images of birds, eagles, snakes and dragons.
The clean outlines of her drawings, combined with her ultra-
smooth colour work, make her tattoos look almost like silk screen.
Despite not having direct exposure to tattooing growing up,
Manners knew early on that she wanted to learn the craft. She
studied fine art and photography before using her photographs
as an entry into the tattoo world, and then worked her way
through school while finishing her apprenticeship: 'It was hard
and I was very young and naive . . . [I] just tried to be the best
I could.' Manners feels that tattooing as a woman in Australia is
easier than in other parts of the world, since 'there have always
been a fair number of ladies in the industry here'. She has
worked in the United Kingdom and found attitudes there
towards female tattoo artists very different. She focuses on
making her own path, recommending 'just do what you do
with as much integrity and respect for the industry as possible'.

Manners relies on her own vision to create her designs,
balancing the client's idea with her own concept, while pushing
herself to try something new. She always searches for inspiration,
seeking to add depth and detail to her work. Manners is often
inspired by old botanical illustrations of nature, plants and birds.
She also takes themes from fables or fairy tales, and gives them
a new twist, making her imagination a key ingredient in her designs:
'I make what I see in my head, what I think is beautiful.' AKO

BENJAMIN LAUKIS

STYLE REALISM, BLACK AND GREY **INFLUENCES** RENAISSANCE ART, GRAFFITI **LOCATION** MELBOURNE, AUSTRALIA

The photorealist style of Benjamin Laukis takes tattooing to new heights of splendour, seduction and illusion. Like his Renaissance artist heroes – Rembrandt, Raphael and Caravaggio – his tattoos exhibit a profound sense of drama and depth in their realism, along with a skilful use of chiaroscuro. The result transfixes the viewer, who is left questioning whether he or she is looking at a tattoo or a photograph. All Laukis' tattoos – whether portraits of characters, such as Walter White, James Bond, Hannibal Lecter, Jimmy Hendrix, Frankenstein and Iron Man, graffiti-style script or a Day-of-the-Dead painted female face – demonstrate a haunting sense and level of realism that elicits both admiration and disbelief from the viewer.

1 *Breaking Bad*'s Walter White as Heisenberg
2 Alex from *A Clockwork Orange* having the ultra-violence conditioned away with the Ludovico technique
3 Shrouded and graffiti-tattooed skull with ball gag

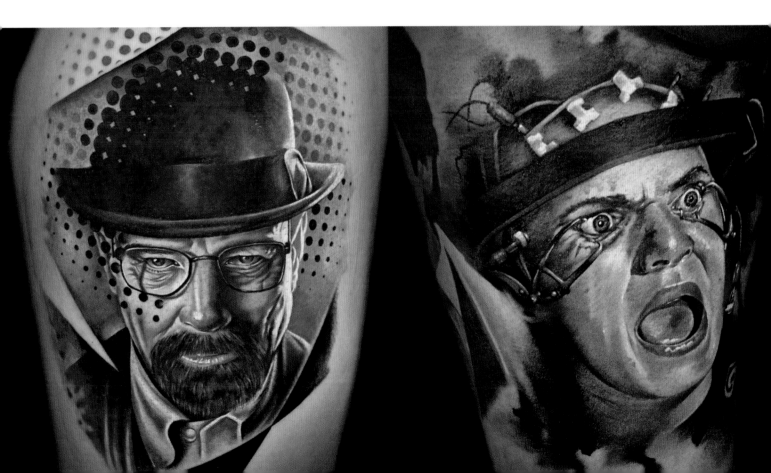

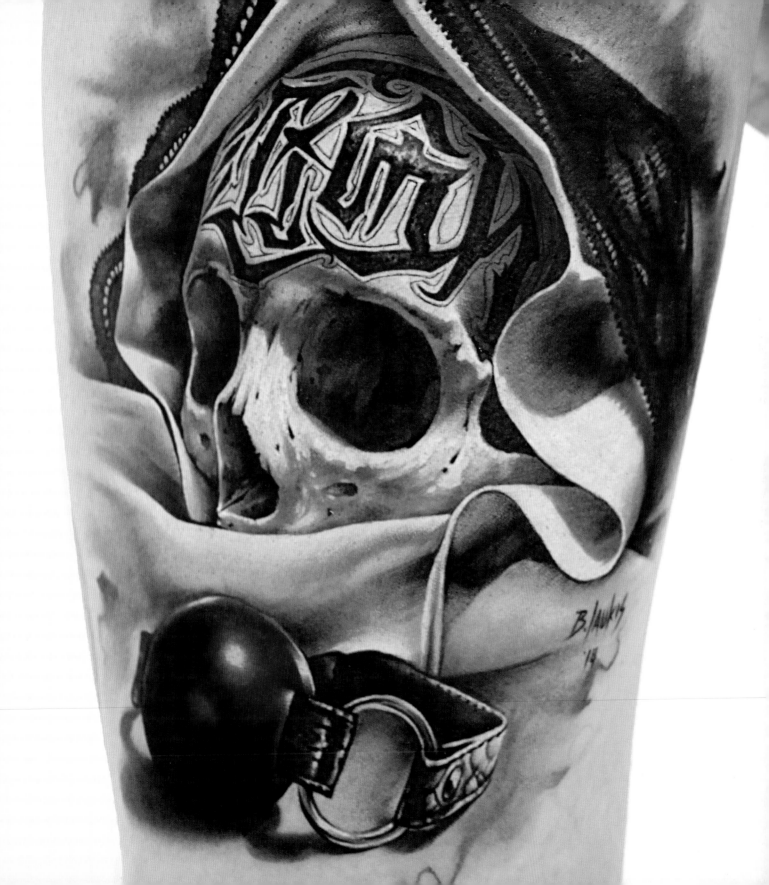

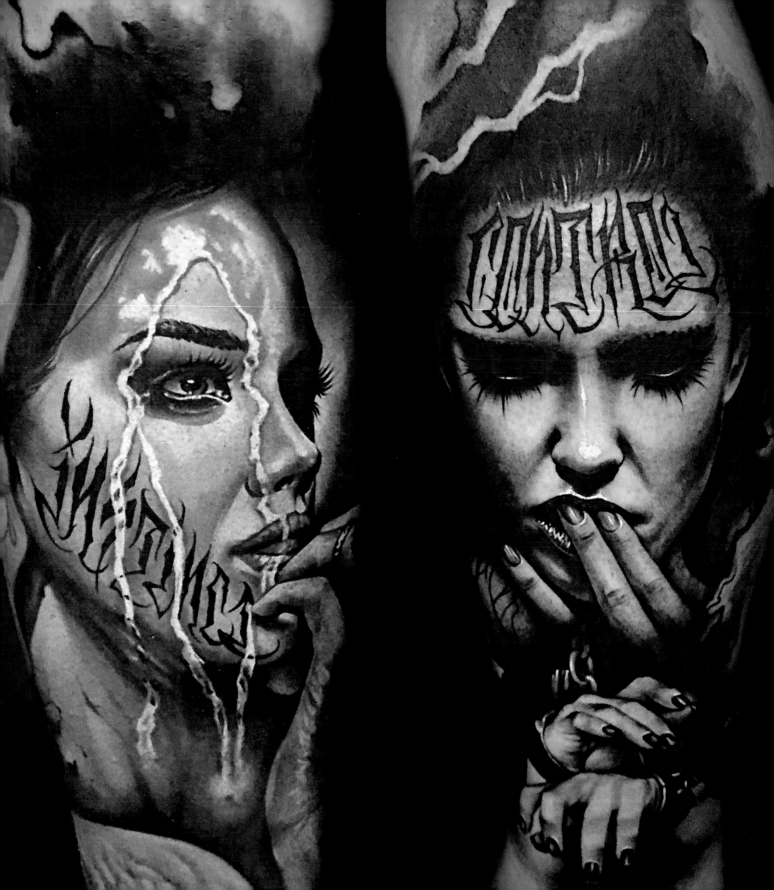

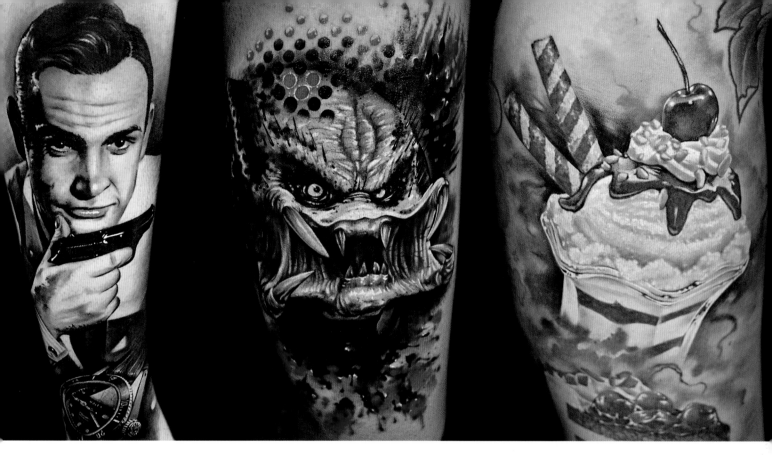

4–5 Noir-inspired female faces wtih graffiti-like tattoos
6 The original 007 James Bond – Sean Connery
7 The Predator 8 Ice cream sundae

Photorealism in tattooing strives to make its subject as lifelike as possible, using texture, shading and highlighting, regardless of what is being depicted. It is therefore highly restricted and requires immense precision. Laukis enjoys the challenge realism presents: he must make the tattoo look exactly like the photograph or portrait, and yet find ways to bring his own signature style to it. He more than meets this challenge with his techniques. The detail he manages to render – from teeth, eyes and hair to burned and scaly skin – makes the science fiction and horror creatures he tattoos, such as the Predator, appear as if they really are in front of you, staring, breathing, stalking you like prey. They make your skin crawl and your heart race.

Laukis has been tattooing for seven years, although it is only over the last four years that he has developed his forte for photorealism and portraits. Besides Renaissance and Baroque art, Laukis draws inspiration from the tattoo work of Carlos Torres and Den Yakovlev, as well as Dmitriy Samohin, Paul Acker, Nikko Hurtado, Carlos Rojas and Domantas Parvainis. He is a self-taught artist proficient in charcoal and oil paint, and also has over a decade of graffiti writing experience.

About his style, Laukis comments: 'There is no secret to tattooing realism, it's just hard work and attention to detail because there is a very limited amount of layering you can do with skin, which means every stroke must be deliberate – there's no room for error. You really have to think ahead, and know your palette. For me, or the way I see it, the lighting really makes or breaks a good realism tattoo.' Skin plays a crucial role in his tattoo pieces: 'The type of skin can definitely alter the outcome of the tattoo, and placement as well; for instance, you wouldn't put a portrait face over an elbow or something, and the clients' skin tones can dictate what shades you use to execute a portrait as well. Skin that is kept from the sun and any other wear and tear is ideal.' KBJ

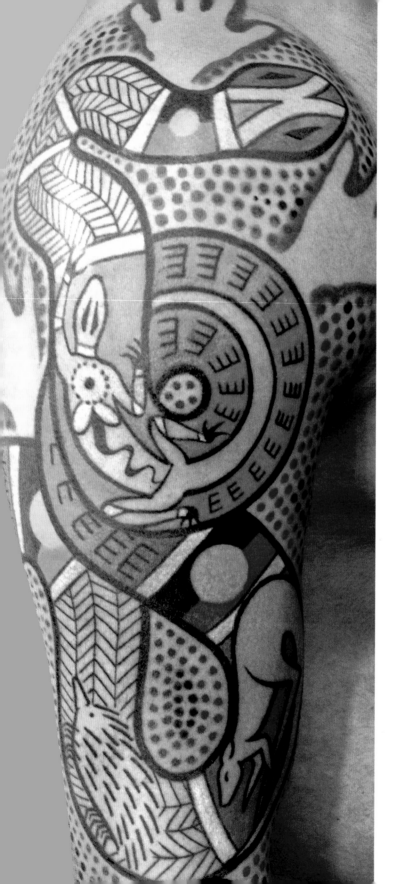

STYLE CONTEMPORARY **INFLUENCES** ABORIGINAL ART AND MYTHOLOGY, AUSTRALIAN FLORA AND FAUNA **LOCATION** MULLUMBIMBY, AUSTRALIA

TATU LU

Tatu Lu has always regarded Aboriginal art as a source of inspiration and is the leading figure of what can be described as the neo-Aboriginal style. Most of her highly customized works reflect personal stories about identity, especially those relating to Australia's Aboriginal people, but nature has also been a guiding influence in her tattooing. Lu describes the origins of the motifs she crafts: 'I grew up in the bush with Aboriginal art around our house as a child and have always had an interest in Aboriginal Australia. The majority of my clients who get this work are of Aboriginal descent and are looking to reaffirm their cultural roots and cultural identities. My other clients hold a deep respect for Aboriginal culture and also nature, and they often express these feelings through ink featuring Australian plants and animals because they are unique symbols of identity down under.'

A characteristic aspect of Aboriginal art is the X-ray style – a traditional form that Lu incorporates into her tribally infused works. As its name implies, animals and humans are depicted with clearly visible internal organs and bone structures. The interior anatomical aspects of an animal or human body – spinal column, heart, throat, breathing bladder (fish) and intestine – are carefully reproduced because they are life-giving sources. These physical elements are considered no less important to the identity of a living being than its outward appearance.

Many of the animals depicted in Aboriginal art are totemic clan symbols and relate to legends concerning their adoption by clans as ancestral relatives. However, X-ray art also features more secular images, such as fish and animals, that are important sources of food. Traditionally, such depictions were not decorative; they were visual requests or prayers to the spirit totems, especially for abundant food harvests. Through assimilating these Aboriginal representations in her tattoo work, Tatu Lu expresses ongoing relationships with the natural and supernatural worlds. **LK**

1 Rainbow serpent with Aboriginal food animals and handprints representing ancestors 2 X-ray kangaroo 3 Dragonfly against traditionally patterned background 4 Kangaroo and emu totem tattoos with dotwork

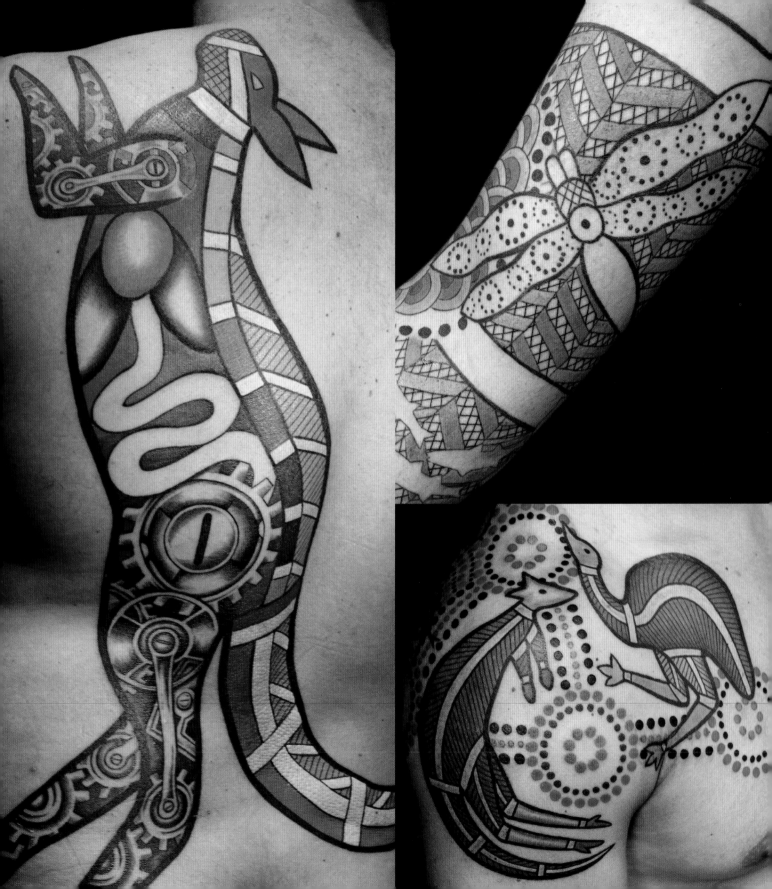

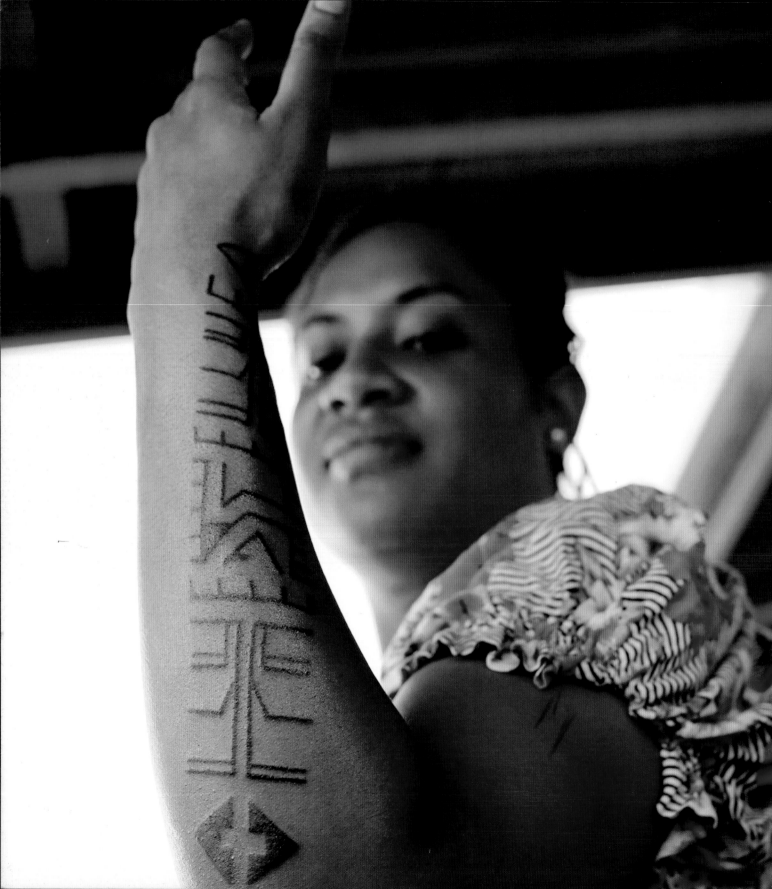

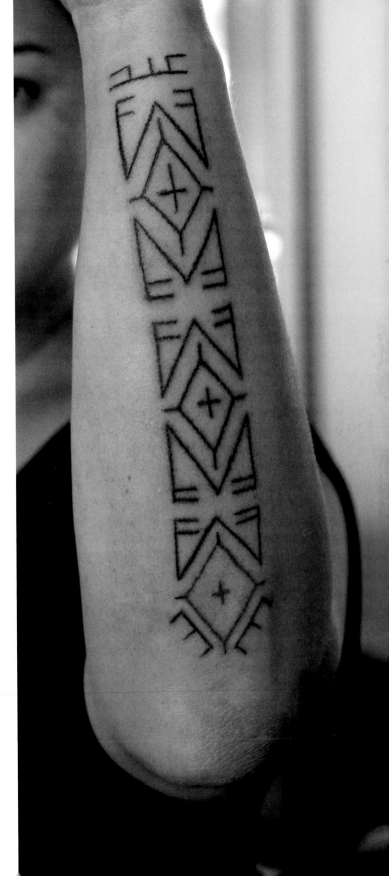

STYLE INDIGENOUS **INFLUENCES** MELANESIAN
TATTOOING AND CULTURE **LOCATION** DARWIN,
AUSTRALIA

JULIA MAGE'AU GRAY

While filming a documentary, *Tep Tok*, about the quest to
reclaim the indigenous Melanesian tattooing that her ancestors
wore, Julia Mage'au Gray was inspired to contribute to the
revival of these disappearing marks. The film seeks to 'bring
light to a vanishing ancient practice through the desire to
reinvent what has been lost'. Gray and her fellow film-makers
travelled to Samoa, where they were inscribed by master
tattooer Su'a Sulu'ape Alaiva'a Petelo. He advised them 'the
only way to keep our *tatu* alive was to "pick up the tools"'.

Gray therefore started visiting other tattooers working
with Pacific Islander revitalizations, including Inia Taylor and Pat
Morrow in New Zealand, Croc Tatau in Rarotonga and Tihoti
Mataura in Taha'a, as well as Australian artist Miriam 'Mim'
D'Abbs. She learned both hand-poking and Samoan hand-
tapping methods, as well as how to make her own tools; she
currently hand-pokes with tools made from 'bamboo or

1–2 Designs recreated from historical documentation
of Papuan tattoos

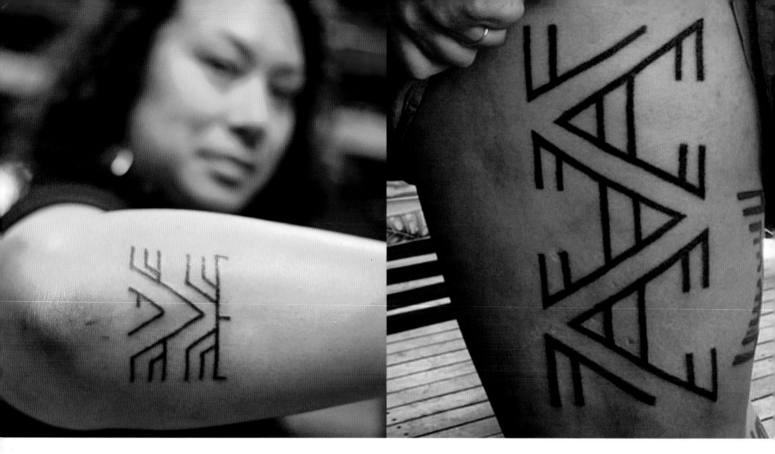

3–5 Designs inspired by historical Papuan tattoos

coconut fronds as the base and tattoo/sewing needles'. By 2013 she had gained the confidence to tattoo herself and her *Tep Tok* collaborators – Natalie Richards, Ranu James and Paia Ingram.

Gray now offers her tattooing to a wider audience and says that her aim in the Melanesian tattoo revival is to 'bring back the practice for our women and also make it accessible for our men'. Her passion is rooted in her personal experience. Born in 1973 in Port Moresby, Papua New Guinea, she also lived in Rabaul on the island of New Britain, from where her family moved to Australia when she was a child. Her grandmother wore extensive traditional tattoos, but sadly 'never got the chance to see her grandchildren wear her marks'. However, Gray was able to get her family's marks inscribed on her own body by Morrow in her home village, Oaisaka. Gray says the event represented 'the first time since my grandmother that someone in my family once again wore our family tattoo in approximately eighty years'.

Gray works with traditional patterns, but updates them for each client: 'Designs are based on the tattoos given to me from the person to be tattooed. So I rework their family tattoos on to their bodies. . . . The designs come from what is around us (fish bone, spear head, etc.); however, the designs are about identifying women and . . . ultimately to show their worth. So the designs I create are based on old ones, but are recreated to suit the person to be tattooed.'

Gray also dances and links this to her practice: 'Tattoos are strongly connected to our aesthetic and how we present ourselves.' For Gray the tattoo revival defines 'a step for our women . . . to gain the respect that has been stripped from us since colonization'. She adds: 'My grandmothers wore our tattoo. My mothers don't. My sisters and I now wear them again.' As with many other revitalizations of indigenous practice, Gray's tattoos represent a powerful form of social activism – beautiful, indelible and visually striking. **AFF**

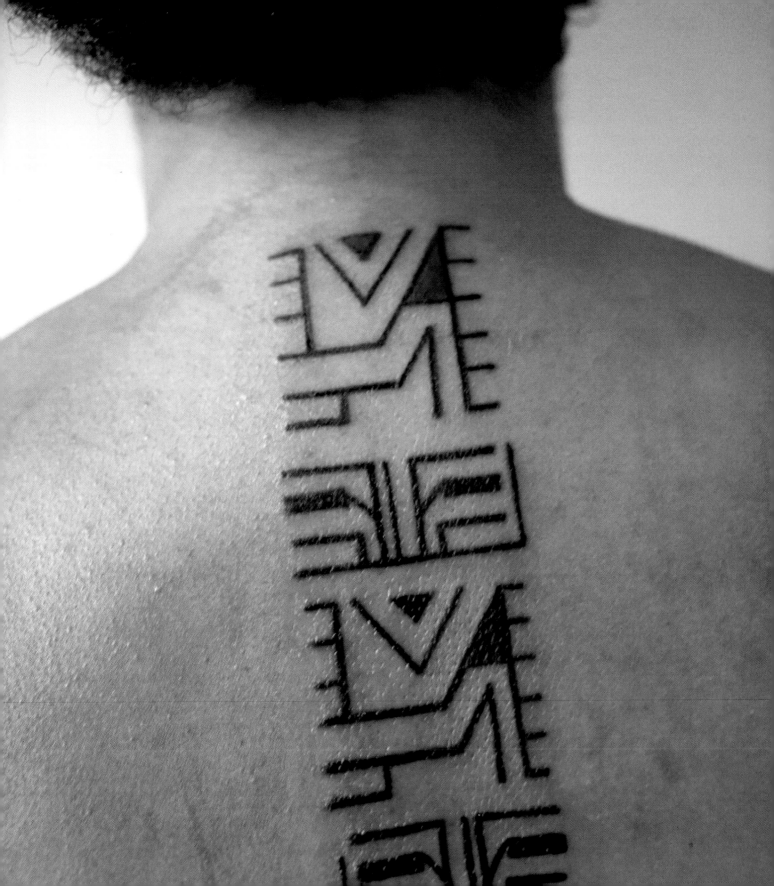

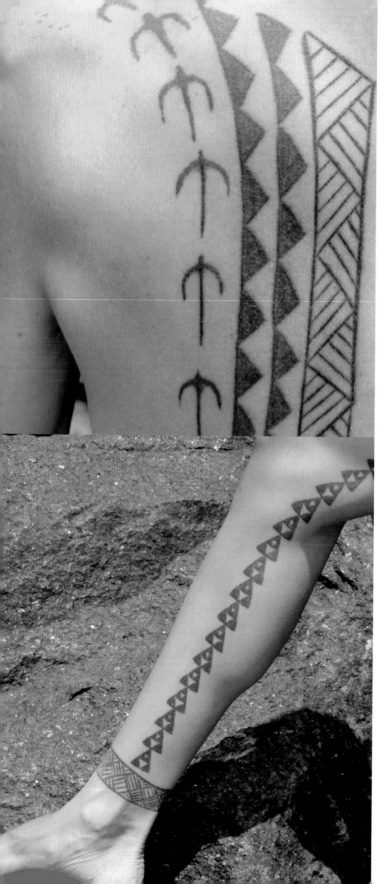

KEONE NUNES

Growing up on the Leeward Coast of Oahu, Keone Nunes acquired invaluable information from family members and revered elders (*kupuna*) about the meaning and iconography of traditional Hawaiian tattoos. Although he never intended to become a tattooist, his deep knowledge of these customs came to the attention of Honolulu-based artist Kandi Everett, who encouraged Nunes to start tattooing in 1990 in order to perpetuate the ancestral practice of Hawaiian tattooing (*kakau*) that was gradually being forgotten.

In the early days Nunes worked by machine, but he also experimented with traditional hand-tapping tools, crafting a home-made tattooing kit that he himself has described as 'horrible'. He lacked the knowledge base to create effective tools, but he sought out others to advise him and later apprenticed under the master Samoan tattooist Su'a Sulu'ape Paulo II. Under Paulo's guidance, Nunes created his first

1 *Pauku* (sectional) design with *pawehe* (weaving pattern)
2 *Ala ma'i* (female design) with *'ulana* (weaving pattern) around ankle 3 *Pahupahu* (half body) tattoos incorporating family and protective designs

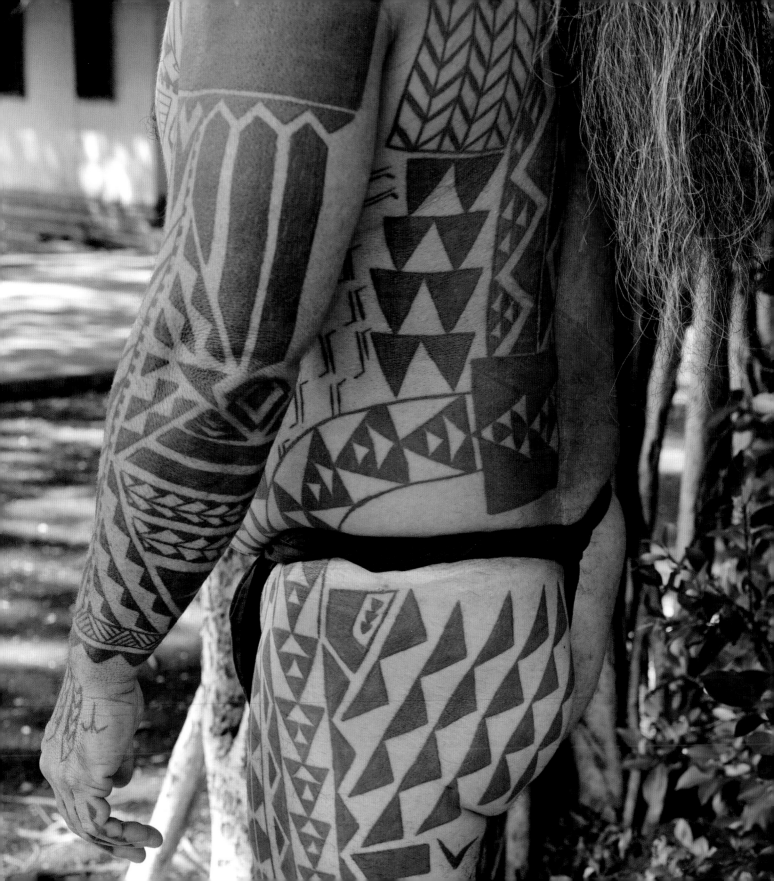

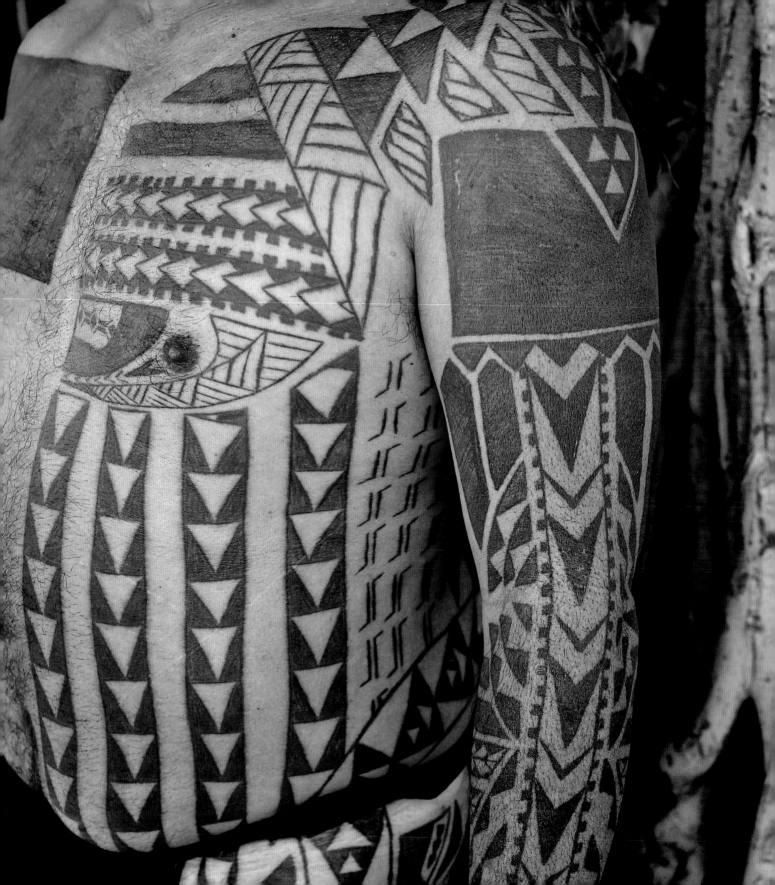

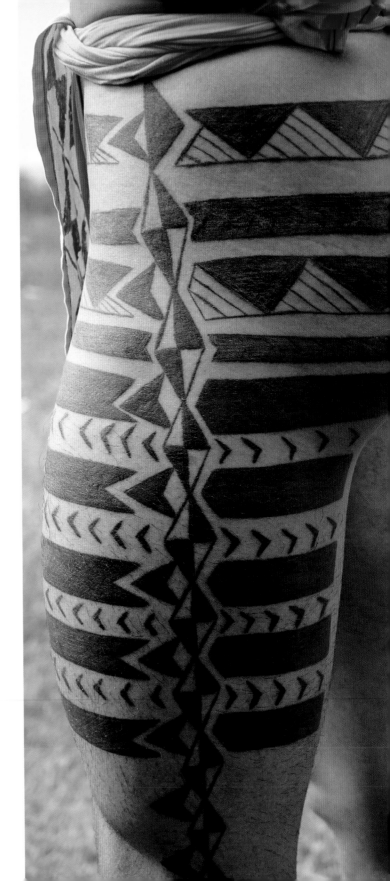

hand-tapped tattoo in 1997. In 1998, his mentor gifted him a set of tools – treasured objects that Nunes continues to use today. Nunes explains: 'My mainstay is the hitting stick (*hauhau*) that Paulo gave me. And I always keep one of his old tools in my rack to teach the other tools how to tattoo. I strongly believe that.'

Nunes' apprenticeship with Paulo was a formal one, but not in the Western sense. It was understood that it would last a lifetime or until Paulo passed. When the Samoan master died in 1999, this event marked a milestone for Nunes. 'His passing really allowed me to rethink what I was doing. For the longest time, I stopped tattooing altogether. But then, Paulo came to me in a dream and said: "Keone, I did not teach you these things for nothing." And since that moment, I made a conscious decision to put away my machines for good and I have been hand-tapping ever since.'

Nunes works out of an old Mormon church. The rhythmic tapping of his comb-like tattooing tool (*moli*) upon the skin is a sacred act. 'That song of the tattoo is the song of our ancestors coming through the wind. When you undergo the process, you experience the same feelings that our ancestors felt 100, 200 or 500 years ago. And when you lay down on the mat and the tapping starts, you are transformed into someone else. You are transported back through time and you meet your ancestors.'

However, the bold blackwork patterns Nunes expertly etches onto living skin cannot be given to just anybody. Traditionally, *kakau* was bestowed for a specific reason. In the repertoire of Hawaiian tattoo designs, certain motifs were restricted to particular families or individuals, especially crest designs or those that embodied ancestral guardian spirits ('*aumakua*), which non-Hawaiians should not wear. Nunes believes if your heart is not in the right place or you are not spiritually ready, you should not be tattooed. 'It's a process, and I interview everyone quite extensively. If a client wants a tattoo for personal growth or to honour their family, I will consider it. But my time is precious and if someone doesn't strike me as a good fit, I will provide alternatives.' LK

4 *Pahupahu* tattoos incorporating family and protective designs 5 Buttock and thigh tattoos integrating the *ala niho* ('path of teeth') design

4 5

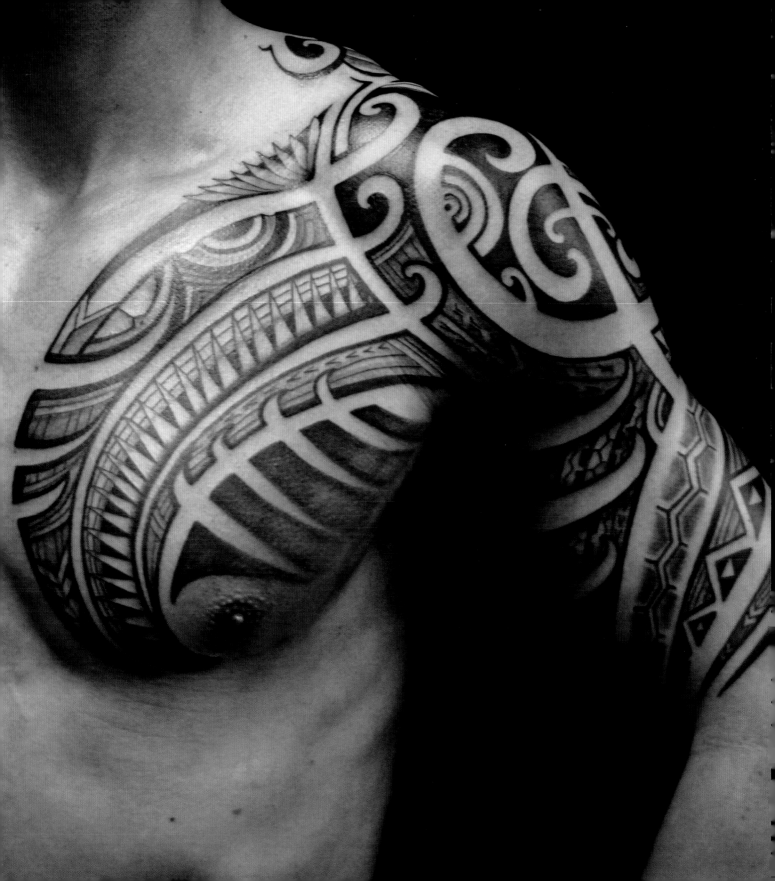

STYLE BLACKWORK, INDIGENOUS
INFLUENCES CARVING, PACIFIC CULTURES, BODY RITUAL
LOCATION HONOLULU, HAWAII

1 Traditional Polynesian patterns with Western shading
2 Pacific Islander motifs blended with contemporary blackwork 3 Mix of traditional Pacific Islander motifs
4 Facial tattoo with traditional Pacific Islander patterns

AISEA TOETU'U

Aisea Toetu'u (also known as Sulu'ape Aisea Toetu'u) specializes in traditional *tatau*: hand-tapped tribal designs from Tonga, Samoa, Rotuma and Micronesia. He also occasionally uses machines when asked to create curly, cartoonesque and figurative works. However, the core of his activity has always been the revival of lost tattoo cultures. Born in Hawaii of Tongan and mixed Hawaiian-Filipino descent, he initiated the Tongan tattoo revival by tattooing on himself the Tonga *peka* (full body tattoo) that had been discontinued in the 1830s.

He has been a full-time tattoo practitioner since his early twenties and belongs to a recent generation of Pacific Islander artists involved in the resurgence of modern Polynesian tattoos. Together with others – including Po'oino Yrondi, Mike Ledger, Orly Locquiao, Joel Albanez and Lucky Olelo – he has enriched the formal lexicon of Polynesian tribal tattoo motifs to create a new mix that incorporates more heterogeneous elements. Previous artists involved with reinventing this type of tattooing relied heavily on Marquesan and Maori influences.

A crucial turning point in his career took place after an encounter with Samoan master Su'a Sulu'ape Alaiva'a Petelo, who helped him acquire his traditional *peka* body marks. They engaged in a master–apprentice relationship that led to Aisea Toetu'u receiving his *suafa matai* (chief) title, followed by his *suafa ta pe'a* (tattoo) title. These events endowed him with the right to use the family tools and to perform the ritual of tattooing in the Samoan fashion.

In 2007 Aisea Toetu'u opened the Soul Signature studio and has helped to reinvigorate several lost categories of Pacific and South East Asian ethnic tattoos, including from Rotuma, Yap and the Kalinga in the Philippines. Along with Rodney 'Ni' Powell (see p.338) from Hilo, he founded the Manulua Tattoo Association. The association travels to island communities and educates people about safe practices in tattooing and avoiding cross-contamination through sanitization and sterilization. **SG**

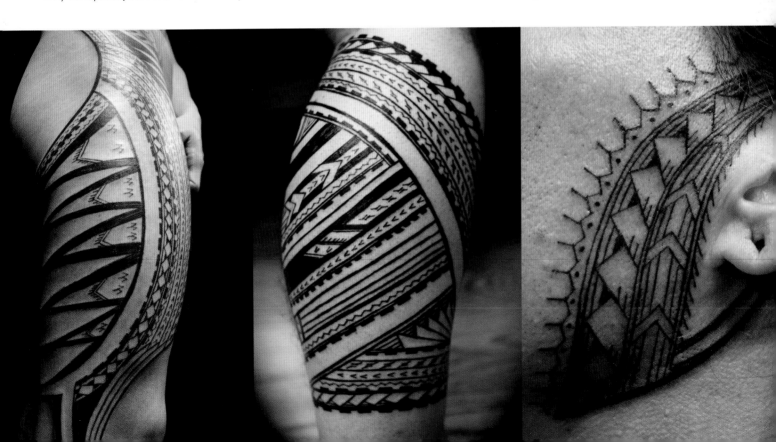

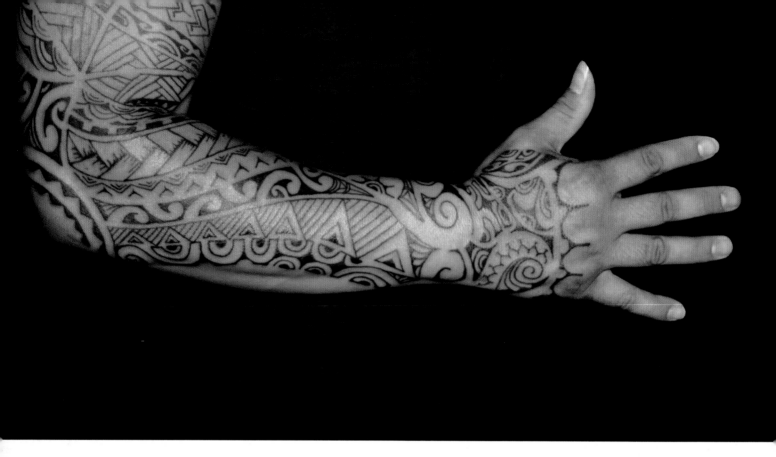

STYLE INDIGENOUS **INFLUENCES** TRADITIONAL PACIFIC ISLANDER ART AND CULTURE **LOCATION** HILO, HAWAII

RODNEY 'NI' POWELL

Rodney 'Ni' Powell was born in Fiji and is of Tongan, Fijian and Samoan descent. He has a master's degree in social work, which has facilitated his full-time employment in behavioural health among Pacific Island immigrant communities. Powell began tattooing in 1998 after being mentored by renowned tattooists Tricia Allen and Sulu'ape Aisea Toetu'u (see p.336). He also credits Su'a Sulu'ape Alaiva'a Petelo for expanding his knowledge of ancient Samoan *tatau* traditions. In 2003 Powell took part in a historical rebirth as one of the Pacific's living treasures; Samoan tattoo master Su'a Sulu'ape Alaiva'a Petelo undertook the task of marking the first traditional Tongan tattoos in more than 150 years in the Hawaii home of *matai* (chief) Tagaloa. Powell's tattoo took thirteen sessions over the course

1 Sleeve commemorating a baby's birth that incorporates various Pacific Islander patterns 2 Tattoos honouring mixed Samoan/Hawaiian heritage

1
2

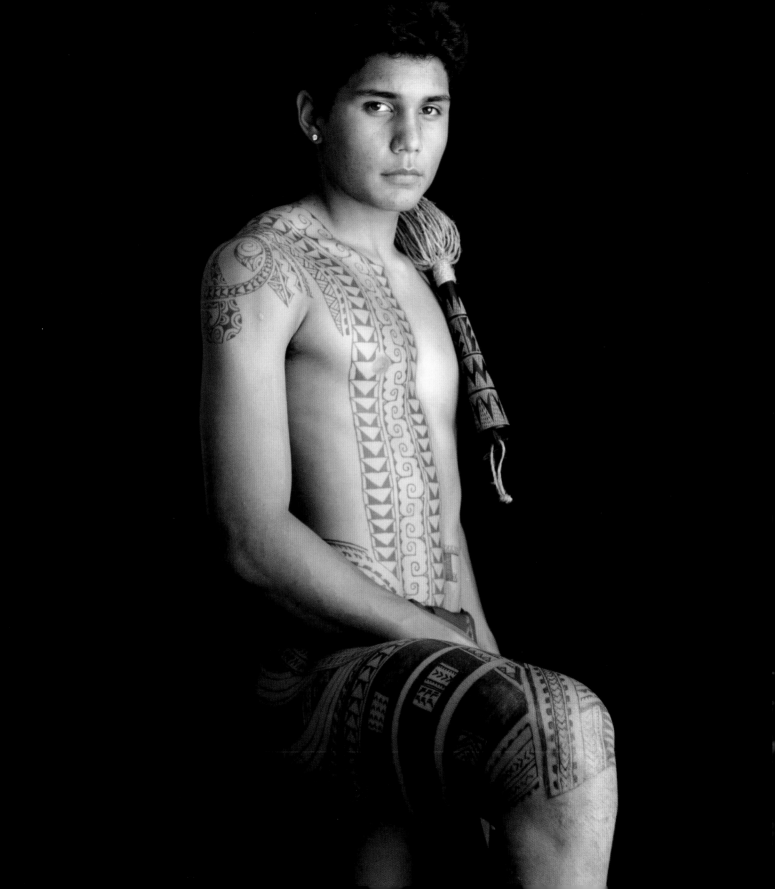

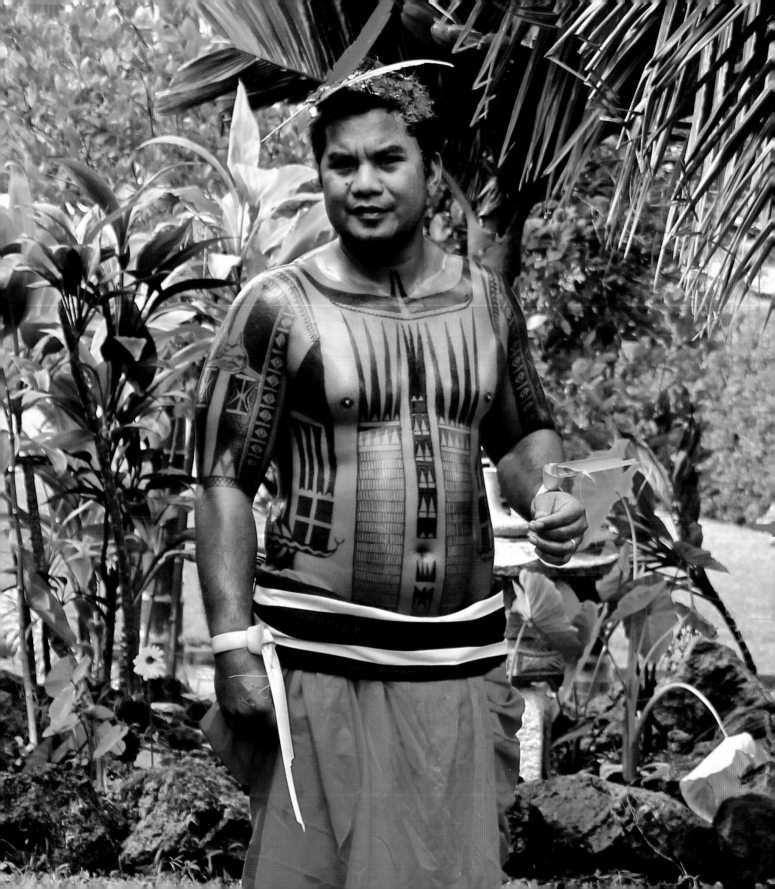

3 Revival of Fais *maak* tattoo on Jermy Uowolo
4 Tribute tattoo to Maui heritage **5** Honouring parents and family with various Pacific Islander motifs

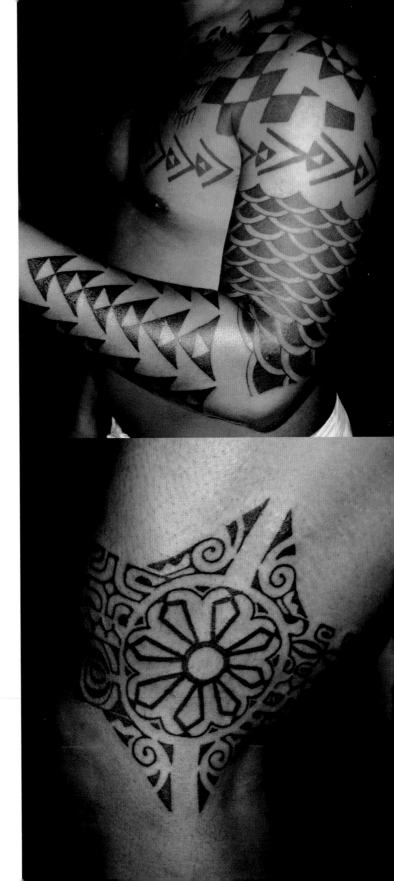

of four weeks to complete and was a challenging experience, yet one that has had a profound effect on Powell's work.

Having participated in the revitalization of the traditional Tongan tattoo, Powell has gone to great lengths to help facilitate revivals in other island cultures. In 2010 he was able to formally apprentice traditional hand methods under Sulu'ape Aisea Toetu'u. Since then Powell has combined hand tools with the tattoo machine in his work and strictly focused on Pacific Island designs. He draws inspiration from historical tattoo illustrations, as well as *tapa* (bark cloth), weaving/lashing and woodcarving from various Pacific Island cultures. Powell's passion for tattooing and Pacific Island art has taken him travelling throughout the region from Samoa, Tahiti and Easter Island to the Marquesas and Palau.

One of Powell's revival projects involved tattoos from the island state of Yap, which is nestled away in the north-west corner of the Pacific in the Caroline Islands and is politically part of the Federated States of Micronesia. Perhaps best known for its huge stone money, the islands have a history of tattooing that continued well into the early decades of the 20th century. By the mid-1970s, however, only a handful of elders remained who wore the *maak* (full-body tattoo) of the outer Yapese Islands. Hawaii transplant Jermy Uowolo, who is originally from the island of Fais – one of the outer atolls located across 240 kilometres (150 miles) of ocean from Yap – wanted to wear traditional tattoos. Despite the distance to his ancestral island, Uowolo has made it a priority to familiarize his children with Yapese traditions and takes an active role in dance and community events in Hilo. In 2009 he made the decision to receive his culture's full-body tattoo. Uowolo sought out another young Micronesian studying in Hilo, Ike Mangi, who had some experience in tattooing. Powell agreed to assist in the endeavour and undertook much of the tattooing. Using a combination of both modern and traditional tools, Uowolo's *maak* was completed in 2012. To commemorate the event, a ceremony was held with the preparation and serving of *kawa*, traditional dancing and feasting. Dr Don Rubinstein of the University of Guam travelled to Hawaii to attend the event and comments: 'I never thought I'd witness a full-body Fais tattoo revived in my lifetime.' Powell's valuable work is helping to bring the Pacific Islands closer together through such visual reminders and celebrations of cultural heritage. **TA**

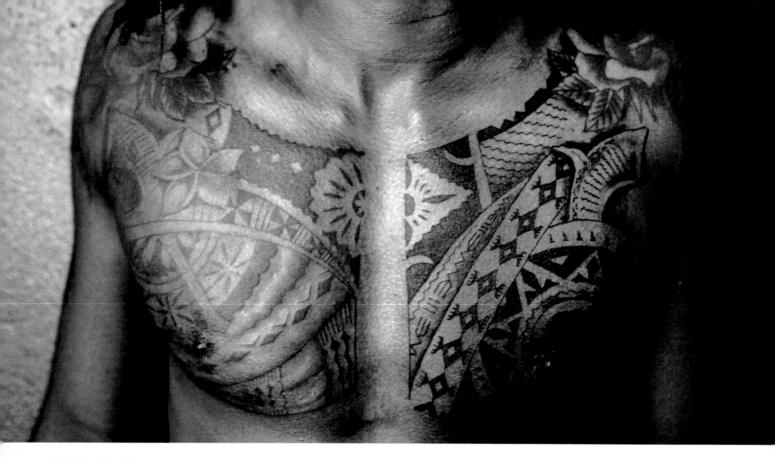

1 Asymmetrical chest piece mixing Oceanic patterns and motifs 2 Dragon 3 Compass rose in Pacific Islander style 4 Melange of Polynesian patterns

WILSON FATIAKI

Wilson Fatiaki is one of many artists reclaiming their cultural heritage and reinventing Pacific Islander tattooing. His mother was part Samoan and his great-grandmother wore the traditional *malu*. Fatiaki proudly states that he had the 'honour to tattoo a part of a *malu* on my mum's leg. I look forward to tattooing a complete *malu* on my mother as a tribute to my great-grandmother'. Although born in Fiji in 1986, he also traces ancestry to Rotuma – a culturally Polynesian island now a Fijian dependency. Although little documentation relating to Rotuman tattooing exists, Fatiaki pays homage to that culture by 'adding specific elements or patterns [such] as the *fui* – the star-looking element with the red diamond-shaped centre that are added to the garlands [worn] around the neck for special functions'.

When Fatiaki was nineteen he met his business partner Chris Samisoni, who was tattooing with a home-made machine. Fatiaki began tattooing as a hobby, but later learned from professional tattooer Joseph Pickering. A chance encounter with a French woman who wanted a tattoo ended in a marriage and a year spent working in Paris. On his return to Fiji, he opened Mahala Tattoo with Samisoni, the name inspired by the charcoal used as tattoo pigment in Rotuma. Fatiaki's blackwork designs evoke classic Oceanic tattoo histories; he explains: 'I am trying to make them unique . . . Technically I like to apply halftone shading and perspective to Polynesian tribals. I think it makes it modern but keeps the essence of it.' AFF

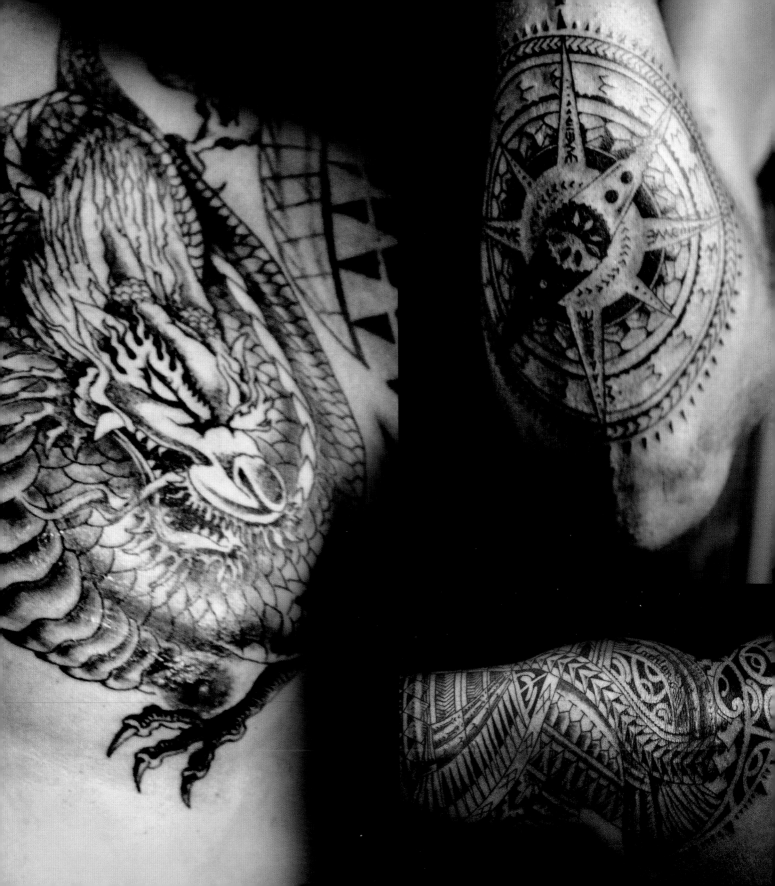

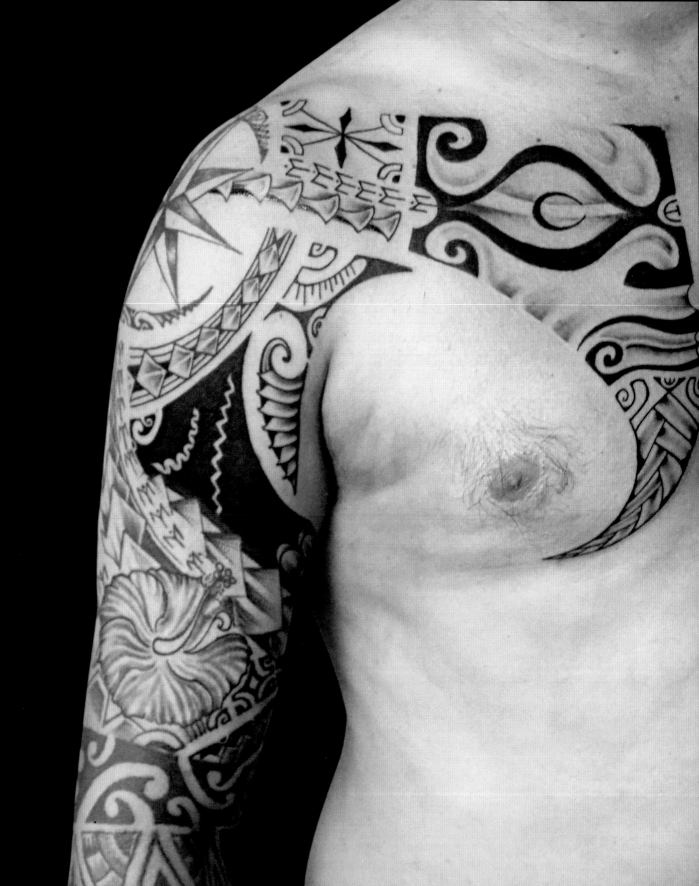

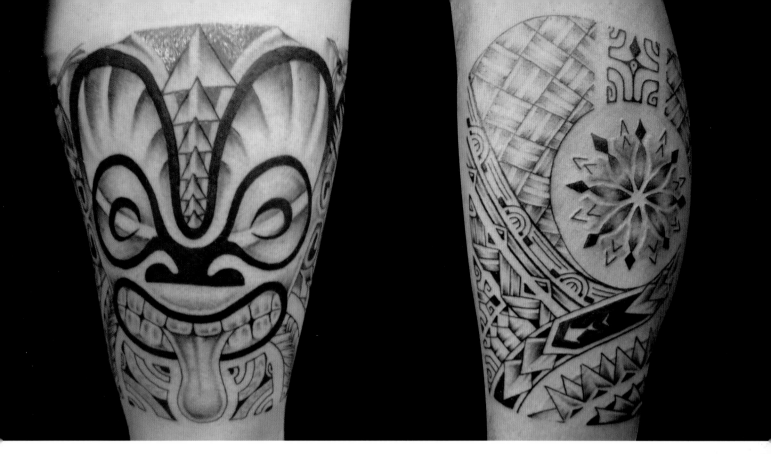

STYLE INDIGENOUS, BLACKWORK **INFLUENCES** POLYNESIAN ART AND CULTURE **LOCATION** MOOREA, FRENCH POLYNESIA

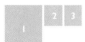

1 Sleeve and shoulder piece mixing traditional and updated motifs, including hibiscus flower and tiki 2 Tiki that blends historic and modern 3 Melange of traditional motifs updated with shading

MATE

Born in Papeete, Tahiti in 1983 to an American mother and a Polynesian father, Mate spent much of his youth around art, thanks to his grandparents who owned Galerie Winkler – the island's premiere venue for traditional and contemporary regional arts. Although he was surrounded by art in many mediums, pyrography caught Mate's attention. He combined this interest in wood-burned designs with the intricate designs that ancient Marquesans etched into bamboo nose flutes (*pu ihu*). Mate learned the art through trial and error, reproducing patterns from the Marquesan tattoo book *Te Patutiki*.

Mate settled on Tahiti's sister island, Moorea, where he met local tattoo artist, Taniera. While tattooing Mate, Taniera saw examples of Mate's pyrography. Recognizing his talent, as well as the fact that contouring Marquesan motifs to bamboo is not unlike contouring designs to fit the human form, Taniera took Mate on as an apprentice in the theoretical and technical side of Marquesan tattooing. Mate opened his own shop nearly a decade ago and has practised comb tattooing for the past five years.

Mate updates traditional designs by adding shading and contemporary elements. Moorea, with its lush, beautiful environment and Polynesian imagery, provides him with great stimulus for his art: 'In my work, I use a lot of patterns from the Marquesas, the Paumotus, the Society and Austral Islands, Hawaii and Samoa, which I respect a lot. I try to mix motifs related to the heritages that customers want to represent, relative to their history and Polynesian genealogy.' Mate also offers traditional (comb) tattoo demonstrations in schools to 'raise awareness of traditional tattooing as it's our children that will keep our culture alive'. TA

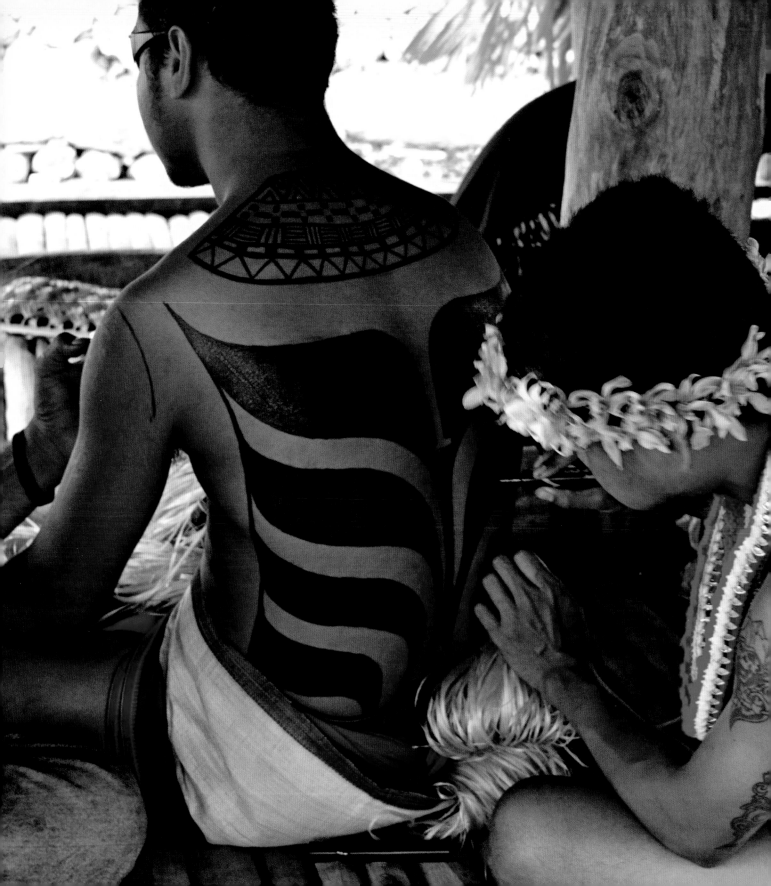

LEO PUGRAM

Today when most people think of Yap Island in Micronesia, they tend to picture its enormous stone money. However, Yap also has a vibrant history of elaborate blackwork tattooing that has virtually died out. Artist Leo Pugram has been at the forefront of a revival to return these designs to the bodies of islanders and visitors.

From childhood Pugram had a talent for art. He drew and sketched, but never envisaged that he would one day be a tattooist. By the end of the 20th century, there were no traditional tattoo teachers left in Yap, and one could only learn about traditional motifs from books. In 2009 Pugram had a breakthrough; a trip to Hawaii introduced him to formal tattooing and he returned to Yap with a tattoo and a machine. News about it quickly spread across the island. He recalls: 'People started requesting tattoos and I would do them for free because it was still new to me. I wanted to be a better artist.'

1 Pugram's traditional Yapese back tattoo is visible as he creates a temporary version of the one he wears

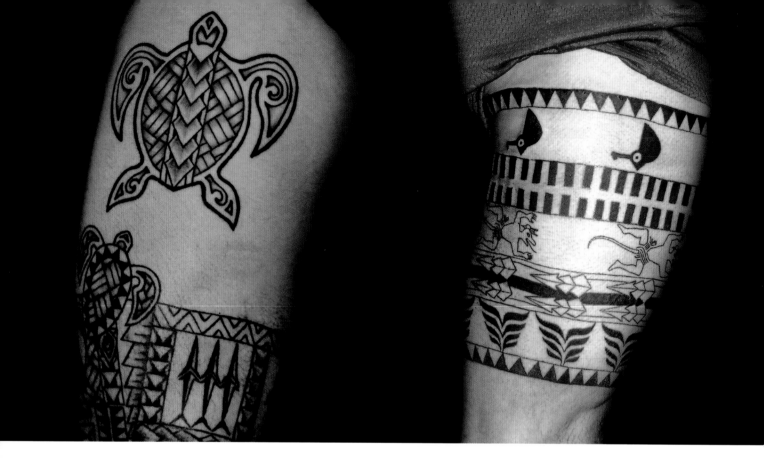

2 Turtle motifs influenced by Pacific Islander art 3 Leg
bands melding traditional designs with other motifs
4 Arm piece inspired by Micronesian patterns 5 Bird
with flowers 6 Design inspired by Pacific Islander art

At the beginning of his tattoo career, Pugram inscribed skulls, scorpions, dragons and similar images. However, he soon became interested in working with traditional Yapese designs: 'I like looking at old photos and reproducing the old Yapese tattoo designs to keep them alive in the culture.' Fascinated by historic designs, he was motivated to get his own body decorated with motifs inspired by his ancestral culture. Acquiring an eye-catching, full back piece derived from a historical design became his near obsession. He recalls: 'I loved that design because I knew it was lost and nobody wears the back piece any more on the Yap Island. I wanted to bring it back.' When tattooist Dean Schubert travelled to Yap for a guest artist spot at Pugram's shop, this dream was realized.

Pugram initially worked non-professionally, but the natural consequence of increased interest in tattooing in Yap allowed him to set up a proper studio. He received help from his friend Don Evans, who originally introduced him to the Micronesian tattoo tradition. Evans told him about this important Yapese art form and showed him books, but more importantly he introduced Pugram to traditional tattoo tools. This confirmed Pugram's belief that the way he had chosen was the right one.

Pugram takes inspiration from almost everything around the island – even from the woven baskets carried daily by most of its inhabitants. Pugram's tattoos on fellow Yap islanders have prompted others to recognize the value of traditional tattooing. Many of Pugram's customers did not know about it before. He admits: 'That is a good thing because they're making a turn for the traditional design instead of skulls, etc.'

In the near future, Pugram plans to start learning the traditional craft of hand-tattooing. 'The method has been lost. No one on the island [does] this tattooing any more so it would be a challenge for me and I hope I would be successful', Pugram says, adding, 'Tattoo for me is a way to express my talent and my art permanently.' TM

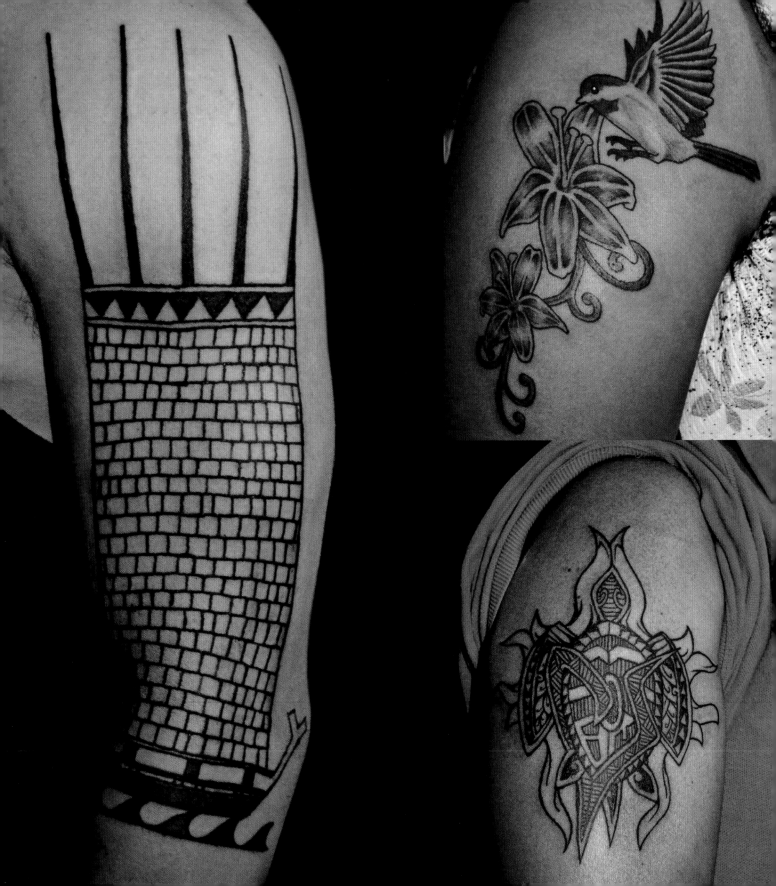

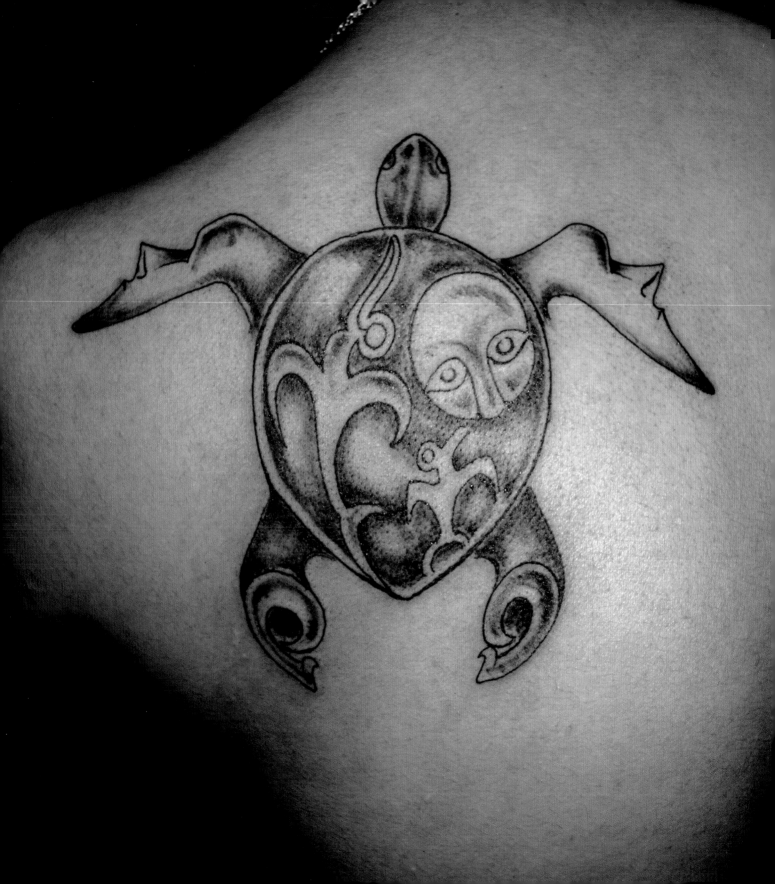

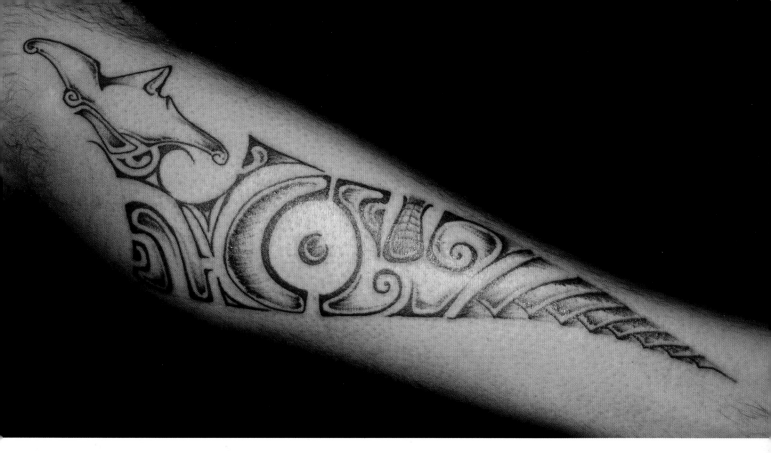

STYLE INDIGENOUS **INFLUENCES** RAPA NUI ART
AND CULTURE **LOCATION** RAPA NUI, CHILE

1 Turtle with Rapa Nui designs on shell 2 Polynesian tiki
updated with shading and realistic face

MOKOMAE ARAKI

Mokomae Araki is one of only two indigenous tattooists on
Rapa Nui (Easter Island). In addition to his talent for inking skin,
Mokomae is renowned locally and internationally for his expertise
in traditional dance and body paint. As a youth, his time was
split between mainland Chile, where his mother taught, and the
island. He became intrigued by tattooing when he met Panda
Pakarati, who honed his skills under the guidance of Tricia Allen,
a Hawaii-based anthropologist and tattooist. Araki learned to
tattoo in mainland Chile and built his first machine with a
rotary motor and a Bic pen when he was seventeen. Shortly
afterwards, he moved to Rapa Nui where he met Allen. She
encouraged Araki to specialize in local designs, whether derived
from woodcarving, *tapa* (barkcloth) or rock art. She also taught
him to use professional machines and proper hygienic practice.

Araki began to study the traditional figures and meanings
of Rapa Nui tattoo and art. Many of his own tattoos are self-
inscribed. When asked about his influences, he replies: 'Tricia
Allen, whose intervention was fundamental for my job and my
life as an artist. And my culture, of course!' Araki's goal is to
differentiate the cultural distinctions between the island groups:
'There are many tattoo artists from other islands in Polynesia,
but not Rapa Nui. I am afraid the system in Chile does not
protect or promote the indigenous culture of our small island.'
Whenever possible, Araki travels to give presentations, dance
performances and, of course, tattoo. **TA**

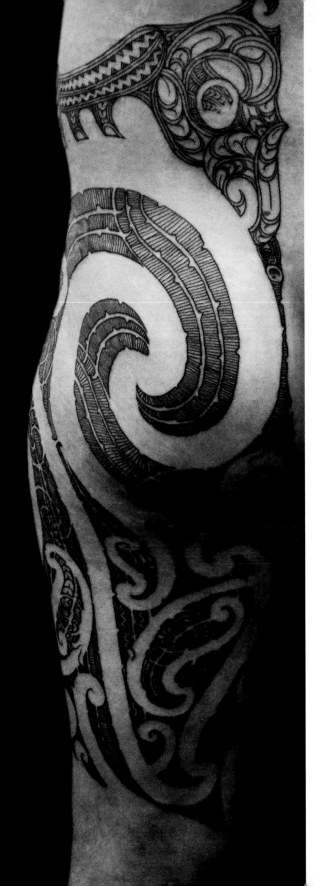

STYLE BLACKWORK, INDIGENOUS **INFLUENCES** CARVING, MAORI ART **LOCATION** PORIRUA, NEW ZEALAND

MARK KOPUA

Mark Kopua is regarded as *tohunga ta moko* – an expert in the art of Maori tattooing. Born and raised in Aotearoa (the Maori name for New Zealand), he is affiliated with three Maori tribes (*iwi*): Te Aitanga-a-Hauiti, Ngati Ira and Ngati Porou, all on the east coast of the North Island. His cultural heritage serves as the source of his remarkable tattoo work, in which ancient and contemporary techniques and designs interact through curvilinear spirals and swirls that inhabit and interplay with the shapes of the body.

Kopua trained as a woodcarver in the mid-1970s and became interested in *ta moko* about ten years later, when he allowed both practices to nourish one another according to Maori custom. He soon became accomplished in both fields. He explains the beginning of his *ta moko* journey: 'I was taught the history and philosophies of *moko* by two sons of Tame Poata, the last of the great *ta moko* masters of my tribal area.' As one of the 'first wave' modern *moko* artists, he has been one of the seminal influences in shaping contemporary Maori tattooing. Kopua is currently exploring the therapeutic dimension of Maori tattooing: 'I am now looking at how the art form and culture of *ta moko* has been utilized in indigenous healing.'

Kopua manages to merge present, past and future in his tattoos – contributing to the reawakening of *ta moko*. As an eminent voice in modern *ta moko* for more than two decades, he has contributed to the survival, spread and reshaping of this practice in New Zealand and abroad. He helps Maori people reconsider the sociocultural potential of *ta moko* as a process. *Ta moko* can be understoood as the living expression of journeys and relationships, not only between a *ta moko* artist and the person willing to wear a *moko* for a lifetime, but more broadly between the living and their ancestors. **SG**

I Classic Maori double spiral buttock tattoo with surrounding motifs derived from traditional patterns
2 Intricate neck piece with motifs influenced by traditional designs

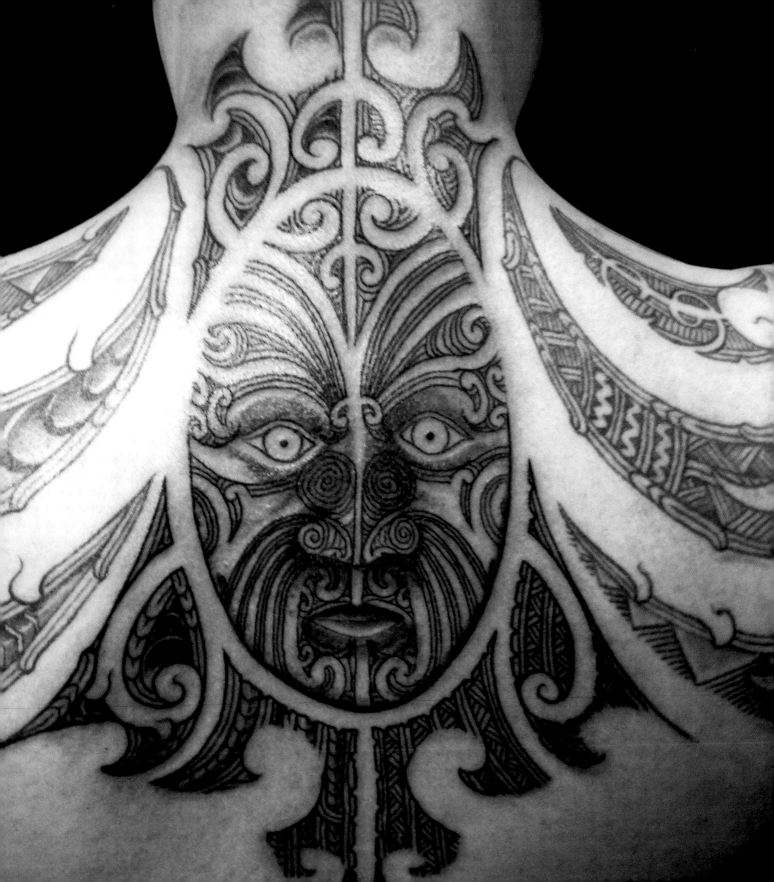

STEVE MA CHING

One of the custodians of traditional Pacific Islander tattooing, Steve Ma Ching's long career has seen the revitalization of the art form. He has expanded the scope of Polynesian designs by modification of traditional motifs. Deeply inspired by motifs from pottery and carvings, Ma Ching transforms these patterns into forms that closely fit the body contours of his customers.

Of Samoan Chinese descent, he was born in New Zealand but was raised in Western Samoa before returning to the country of his birth when he was sixteen. One day he ended up in a tattoo shop: 'While working in the footwear industry, a co-worker of mine asked me to come along while he got a tattoo. Having grown up around Samoan traditional tattoos and also being an avid artist from childhood, I went along and also got tattooed'

1 Neck piece blending contemporary blackwork with elements of Samoan tattooing 2 Lower leg incorporating classic Maori whorls 3 Sleeve combining Samoan and Maori designs

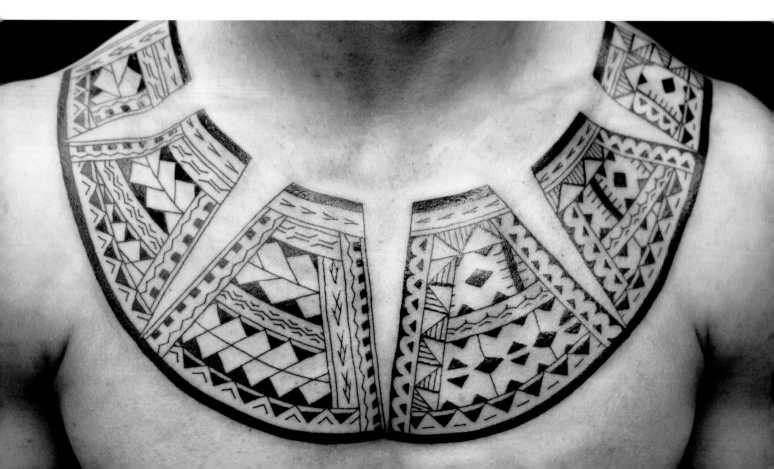

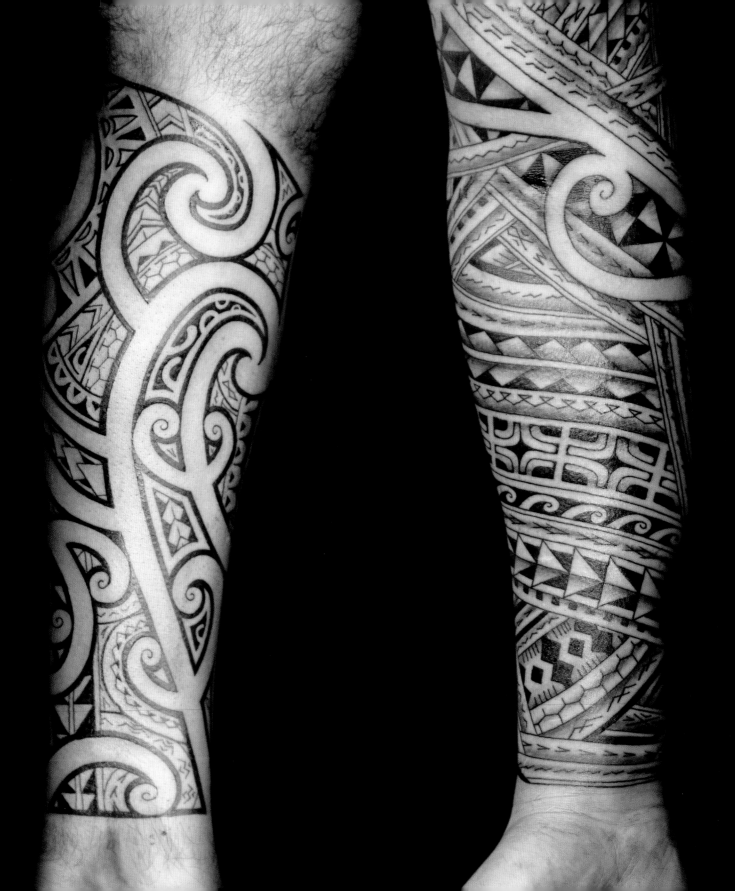

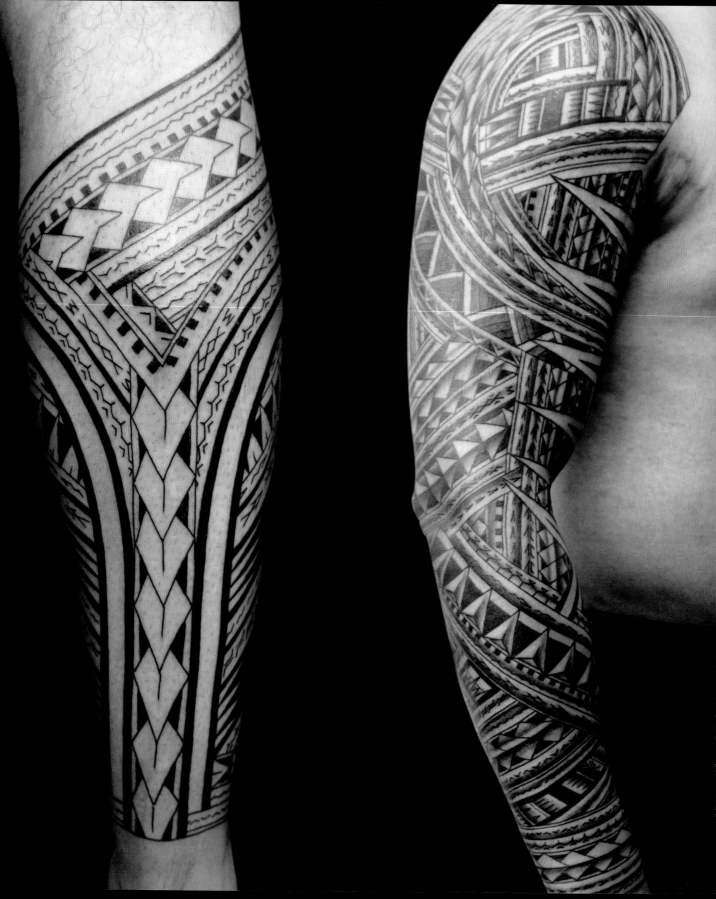

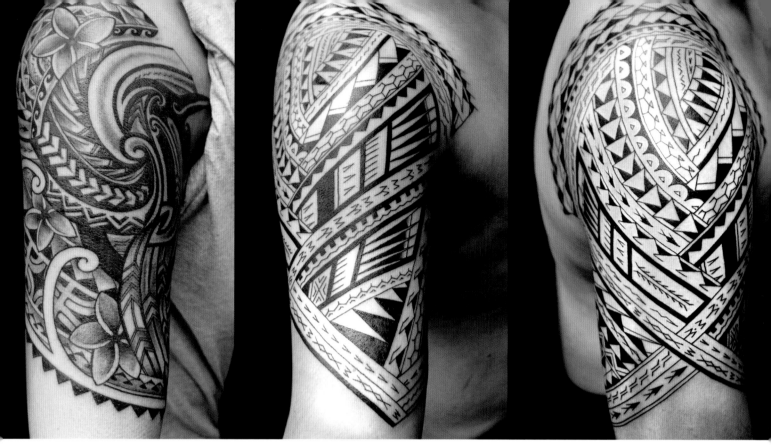

He initially worked under Geoff Kelly of Mount Albert Tattoo Studio, and when he turned twenty-one Ma Ching opened his own studio in the Queen Street Markets. He was forced to close it some years later but began working with legendary tattoo artist Merv O'Connor, who had a wealth of knowledge in the industry and was one of the most respected artists in the country. During the five and a half years he spent with O'Connor in his Auckland studio, Ma Ching improved his skills immeasurably. Ma Ching stresses that O'Connor taught him worldly wisdom, as well as the art and business sides of tattooing. Today, Ma Ching continues to pass on this spirit of mentorship to apprentices at his Western Tattoo Studio in New Lynn, a suburb of Auckland.

Throughout his life, Ma Ching has been fascinated with *pe'a* – the traditional male tattoo of Samoa – as well as other Polynesian motifs, but he decided to keep working by machine. 'In 1990 I was lucky to be handed down traditional tools by master artist Sua Sulu'ape Paulo II, but decided to push my abilities with machine

work with his guidance until his passing. I'm able to educate others in what may be appropriate in one culture and may not be in others and also on how certain designs fit in to others. This is a learning process which is ongoing and sometimes it's pushed into boundaries with intermarriages of different cultures.' He did not understand why Pacific Islanders wanted tattoos with eagles, panthers and other kitsch images, and began to offer customers an alternative by carefully creating band designs inspired by traditional Polynesian tattooing. 'People slowly started to notice that they could get a tattoo connected with their cultural identity and roots. Those bands and designs not only became their cultural signs, but also [their] family bonds because I would create original bands for respective families,' he explains. These bands morphed into pieces that began to cover the entire arms of his clients. One of Ma Ching's groundbreaking works turned out to be an arm-long tattoo for New Zealand rugby player Sonny Bill Williams, which helped expose his art to a far broader audience. **TM**

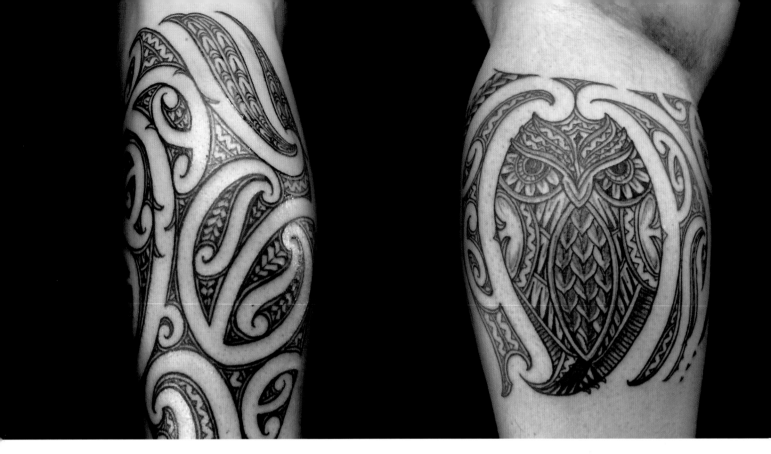

1, 3 Traditional Maori patterns
2 Owl rendered in Maori style

JULIE PAAMA-PENGELLY

Maori *ta moko* practitioner Julie Paama-Pengelly has had an interest in art since her youth. 'It feels like I have been an artist forever and I can't imagine being anything else,' she says. She considers the visual arts a critical aspect of Maori culture and one that is often overlooked: 'Our arts are our *ngakau* (heart) and *aroha* (love) for each other, both living and departed, and possess the energy of our well-being that is being defeated in our modern-day struggles.' Her passion for the arts led Paama-

Pengelly to also work in education, and she balances time between working in various artistic mediums, tattooing and teaching. After a career in academia and museums, she has returned to her ancestral *maunga* (mountain), Mauao, and established the thriving tattoo and body art gallery, Art + Body.

Paama-Pengelly feels privileged to be taking part in the renewed visibility of *ta moko* in Aotearoa (New Zealand): 'I think about how the art was nearly lost to us. I create *ta moko* for our future, not as something that copies the past.' Since *ta moko* originated within a Maori philosophical framework based on genealogy, spirituality and physicality, Paama-Pengelly tries not to mix Maori aesthetics with Western visual systems. She is one of only a few female *ta moko* practitioners: 'I don't dwell on the issues some people might have about women doing *ta moko* . . . I believe that the mandate to [do] *ta moko* comes from my community and I have no shortage of work, so this tells me that I have support in doing it.' TA

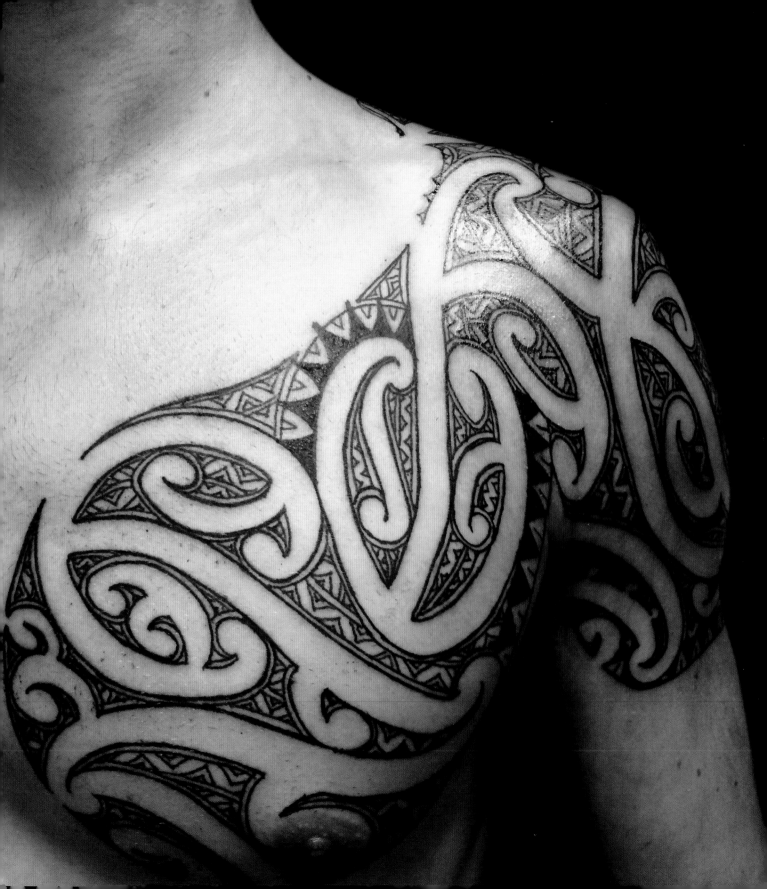

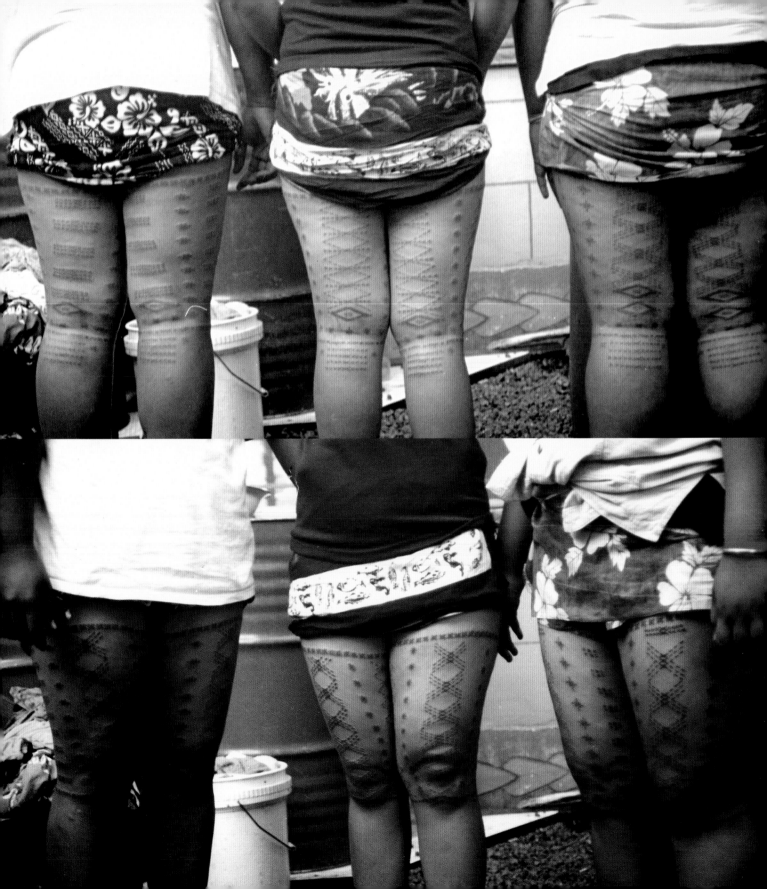

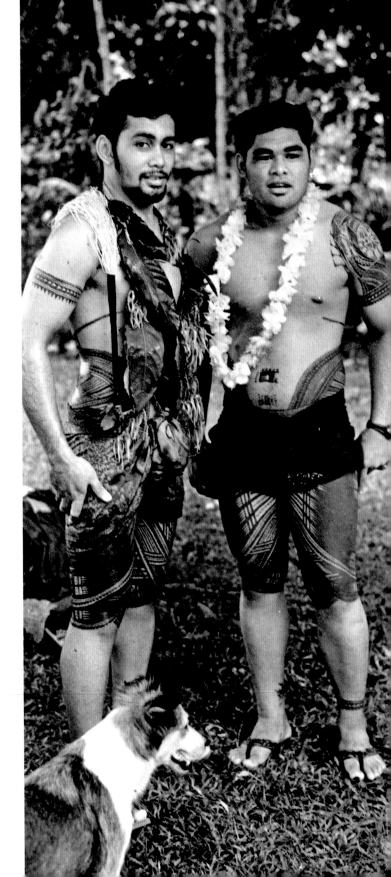

STYLE INDIGENOUS, BLACKWORK
INFLUENCES HAND-TAPPED SAMOAN TATTOOS, SAMOAN
RITUAL PRACTICE **LOCATION** UPOLU, SAMOA

SULU'APE FAMILY

The Sulu'ape Family produce a range of blackwork *tatau* (tattoos) from traditional Samoan male (*pe'a*) and female (*malu*) ritual designs and custom works to more curvilinear, hand-tapped works drawn from the iconographic repertoire of the Samoan archipelago. Raised in a family dedicated to the ritual office of tattooing, both the elder Su'a Sulu'ape Alaiva'a Petelo and his sons Sulu'ape Pita and Paulo III have been deeply dedicated to this traditional craft.

In a cultural context in which tattooing young men and women of the chiefdom is a customary duty, the Sulu'apes have taken *tatau* a step further by deconstructing the original sections of the Samoan bodysuit and reconstructing it into distinctive and fine designs. As important custodians of the ritual tattoo craft since the second half of the 20th century, their influence has filtered through to a multitude of tattooers all over the world. Pita and Paulo III are following in the

| 1 | |
| 2 | 3 |

1–2 Traditional *malu* thigh designs on women
3 Traditional *pe'a* on men with more contemporary arm designs

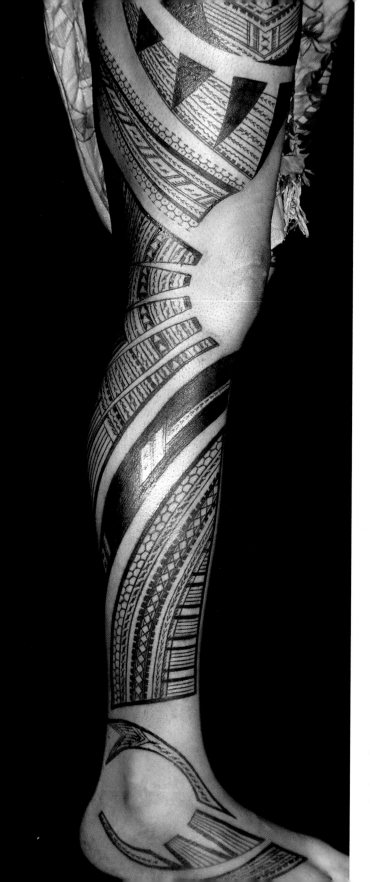

footsteps of their father and their uncle Paulo II through building strong links with Polynesian and Euro-American tattoo professionals.

In Samoa, people attach enormous importance to the maintenance of good relationships – known as *teu le va* – and this cultural value lies at the heart of their tattoo practice. They have always been enriched by encounters with tattoo artists, as well as with customers. New demands have created novel opportunities for the Sulu'apes to experiment with different ways of ornamenting the body that push the limits of their traditional utensils, which tend to restrict the types of lines that can be drawn on the body. They rarely use tattoo guns and their creativity is strongly defined by the use of handmade tattoo combs (*au ta tatau*) that permit little innovation in terms of motifs.

The visual power of the family's practice resides in the arrangement of the traditional repertoire, which alternates solid black, intricate ornamental designs with the use of blank spaces. A recent technical switch from shaped ivory combs made from boar's tusk to steel needles has brought greater sharpness to their tattoo designs. The Sulu'apes are renowned for their skill and precision in the use of tattoo combs; most of their custom tattoos are performed freehand and involve a considerable amount of improvisation.

The tattoos of the Sulu'ape Family are also marked by sobriety – another important cultural quality in Samoa. This sobriety generally differs from the early works of other tattooers in the sense that it signifies maturity and dignity. Apart from the standard male and female bodysuits, the Sulu'apes have developed their own techniques of transforming sections of the original ritual image into custom tattoos. They have also been influenced by iconic Samoan designs in their creation of more symbolic works.

Itinerant by nature, the work of the ritual tattoo expert in Samoa was traditionally performed at the residences of clients or at the tattooer's own settlement. The full tattooing ritual is still occasionally performed at residences, but since 2007 the Sulu'apes have their own studio in the Samoan capital of Apia where they also offer tattooing by machine. In addition to the studio, they have also been allocated a traditional *fale* (hut) in front of the main government building, where they carry out the majority of their hand-tapped works. **SG**

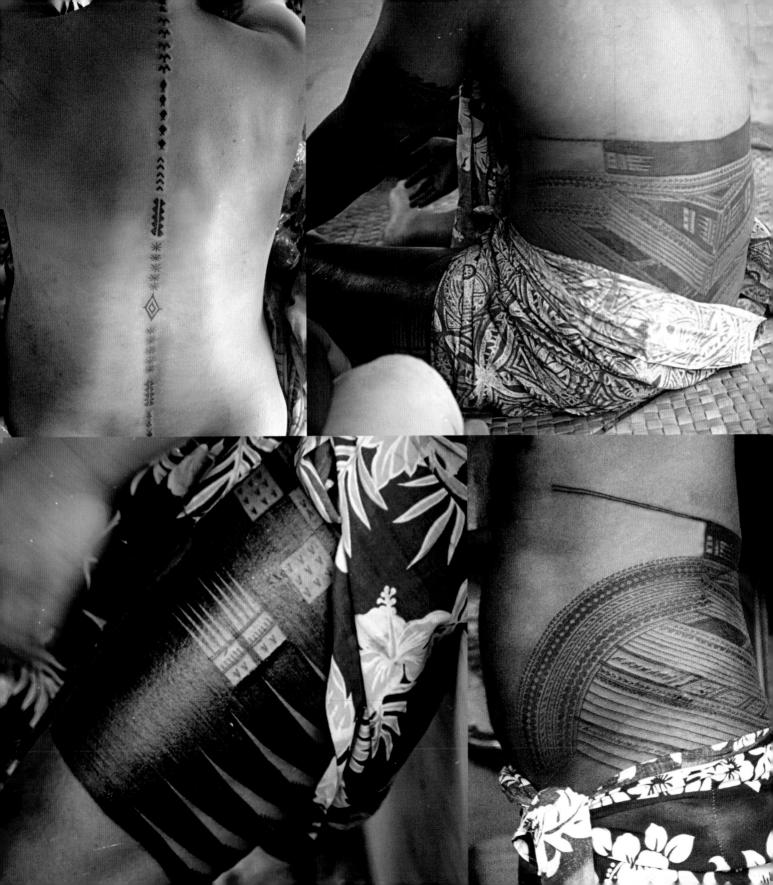

NUKUMOANA GROUP

Among the more remote islands in Oceania are Mu Nggava
and Mu Ngiki, commonly known as Rennell and Bellona.
Although they are culturally and linguistically considered
Polynesian, they are geographically and politically part of the
Solomon Islands. These two small islands escaped the effects
of colonization until 1938, when Seventh-day Adventists arrived
and banned *taukuka* (the traditional full-body tattoo), about
150 years later than most Pacific Islands. The application of modern
imagery continued, as it was not seen as a threat, and knowledge
of practical tattooing endured. Artist and tattooist Kiu Angiki
writes: 'My parents' generation continued with tattooing but with
Western motifs . . . considered more acceptable than traditional
designs since our [traditional] tattooing was tied to our religion.
Our last elder who wore the *taukuka* passed away in 1984.'

Concerned about the loss of an ancient cultural practice,
Angiki and others began revitalizing traditional designs, mainly
in the capital, Honiara, on Guadalcanal as Rennell and Bellona
remain religious and conservative. By the 1990s, the art was
beginning to flourish among the young and others who were
labelled as rebels by the church and the predominant Solomon
Islands population. Many wore only small tattoos, such as the
ghupo or lipo fish, while others revitalized the *taukuka*. The
most visible tattoos are those worn by the Nukumoana Group,
which formed in the 1960s and focuses on the dance and chant
of their home. By the late 1990s, members of the group had
joined the tattoo revivalists. Several of the group now wear
taukuka and practice tattooing. They have also revitalized the
dance, chant and gift-giving that once accompanied tattooing. TA

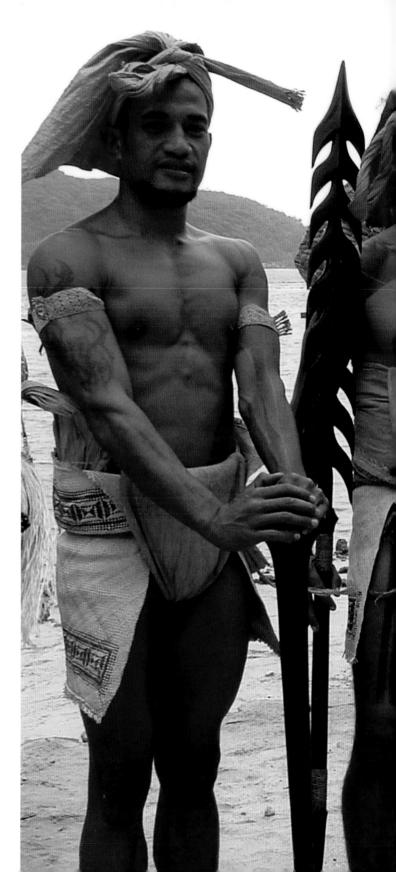

1 Traditional tattoos of Mu Nggava and Mu Ngiki

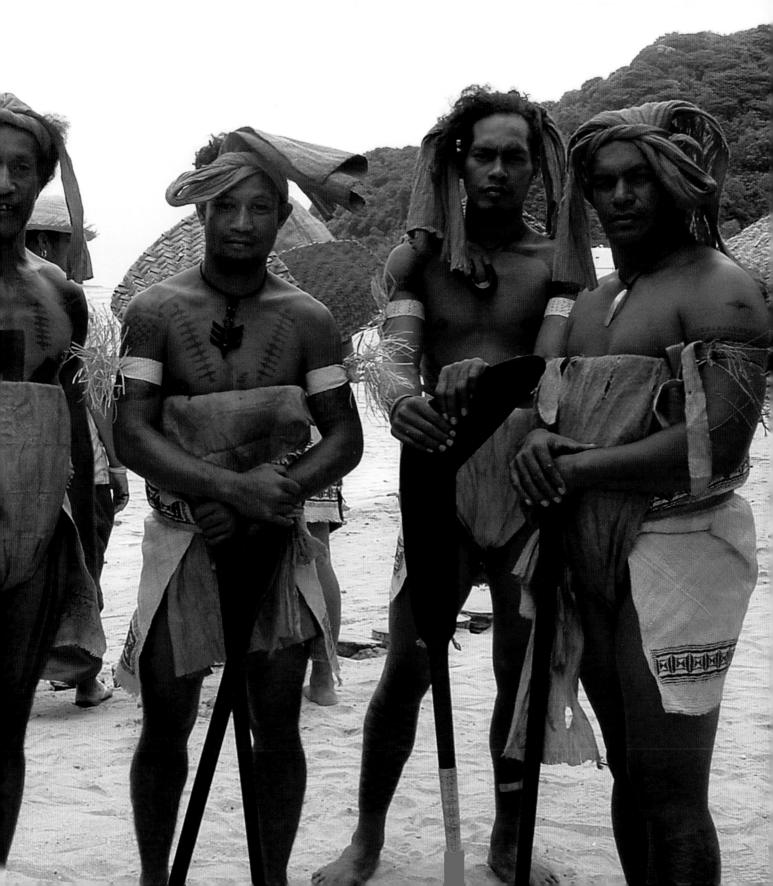

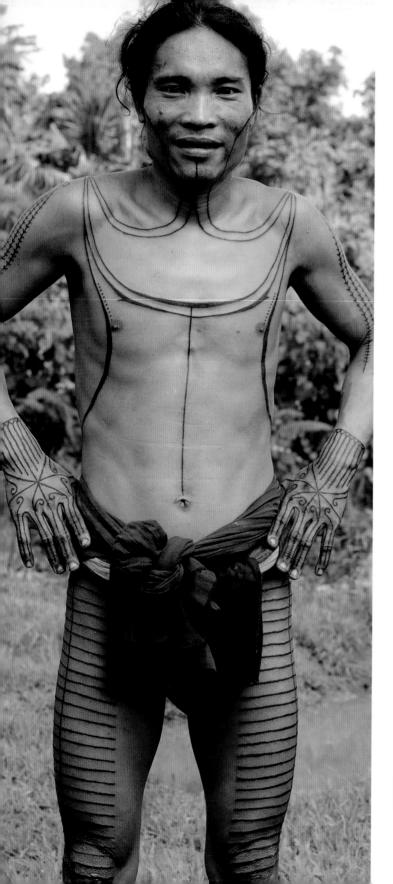

STYLE INDIGENOUS, BLACKWORK **INFLUENCES**
INDONESIAN MATERIAL CULTURE AND ART, SHAMANISM
LOCATION YOGYAKARTA, INDONESIA

DURGA

Riding the new wave of Indonesian tattoo art stretching across the Pacific towards foreign shores, Durga has become one of the leading figures of this tattoo renaissance. Born in Jakarta, he graduated from the Indonesian Institute of the Arts in Yogyakarta with a degree in graphic design. Ever the nomad, he took his skills and talents to Los Angeles where he apprenticed under Su'a Sulu'ape Freewind at Black Wave Tattoo.

Animism and polytheism, the original religions of Indonesia, strongly influence Durga's tattoo art, although his bold graphic designs are also infused with Hindu, Buddhist, Indo-noir and shamanic elements. Initially, Durga worked only by machine but over time he began to feel constrained by modern technology. He says: 'I was plainly tired and I immediately shifted directions. I decided to become a true tattooist – to learn to tattoo totally – and began learning traditional techniques, especially hand-tapping.'

1 Traditional Mentawai patterns 2 Blackwork design inspired by Toraja art

1 2

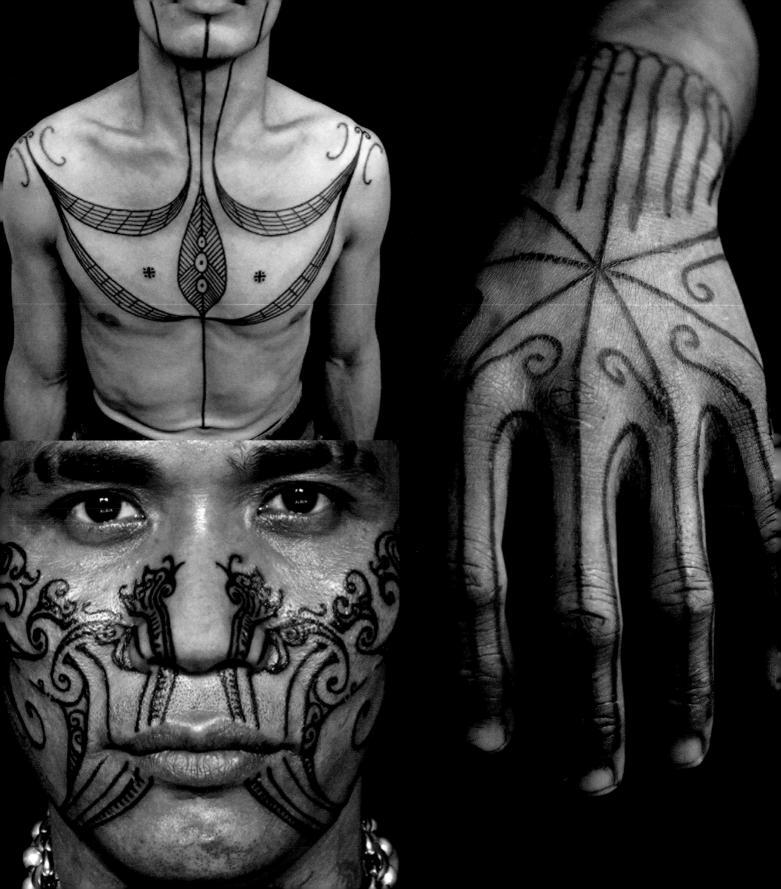

3 Mentawai-inspired torso and facial design 4 Facial tattoo inspired by Indonesian patterns 5 Mentawai hand-tapped design 6 Bejewelled elephant of the Tulang Bawang kingdom executed in Indo-noir style

One of the hallmarks of Durga's professional career has been the Mentawai tattoo revival. Since 2009 he has become a regular visitor to Mentawai tribal villages on remote Siberut Island. From these travel experiences, he has successfully led a revival movement dedicated to preventing the culture and tradition of Mentawaiian tribal tattooing (*titi*) from disappearing. The project features tattoo workshops that take place in the heart of the Siberut jungle, where Durga works together with a number of Mentawai shamans (*sikerei*) who are the tattoo artists among their tribe.

Durga has also become a *sipatiti* (professional Mentawai tattoo artist) and continues to spread awareness of Mentawai tattooing at cultural events, in publications and through carefully crafted and produced video documentaries. Durga is widely sought after on the international tattooing circuit and he can often be found at the most prestigious conventions (London, Amsterdam, Frankfurt), hand-tapping or creating machined tattoos in various Indonesian neo-tribal styles.

Durga's professional mantra is simple: 'Tattoos are the Indonesian culture, and if these tribal designs and everything they are connected to disappeared, we would lose an important part of our country's very unique cultural heritage.' He elaborates: 'For the Mentawai, *titi* symbolizes their identity and their ancestral beliefs, their Arat Sabulungan. This is one system of values that organizes the social and spiritual life of the Mentawai tribe. Each tattoo motif represents something spiritual and meaningful. And from the tattoos found on their bodies we can recognize their original sub-clans, as well as their professions.' Durga further adds: 'Tattooing is a kind of spiritual make-up because it makes the human body beautiful in the eyes of the spirits that control human destiny and the surrounding world. Tattoos also make [people] more recognizable to their ancestors whom they meet in the afterlife.'

In addition, Durga also supports the living tattoo traditions of the Dayak peoples of Kalimantan in Borneo, in collaboration with the Dayak Youth Community in Jakarta, as well as with Herpianto Hendra, an Iban tattooist from the Kapuas region of Kalimantan. Through these dedicated efforts and endeavours, Durga strives to document, preserve and promote the unique artistic heritage of Indonesia's indigenous peoples through his iconography of the skin. LK

STYLE BLACKWORK **INFLUENCES** TRADITIONAL INDONESIAN TATTOOS, BATIK TEXTILES **LOCATION** JAKARTA, INDONESIA / ROTTERDAM, THE NETHERLANDS

I Collar inspired by batik patterns 2–3 Mandala-like designs 4 Traditional floral pattern 5 Torso piece inspired by batik patterns 6 Textile design enlarged into a back piece

ADE ITAMEDA

Ade Itameda belongs to the 'new wave' of Indonesian tattoo artists who are venturing outside the boundaries of traditional Indonesian tattooing. Working between Indonesia and the Netherlands, he respects indigenous traditions while he crafts novel, contemporary blackwork. Itameda's artistic output reflects the clash of two traditions within his family – Chino-Indonesian and Dutch-Indonesian. Respectful of his Indonesian culture, he has taken ancient inscriptions and transformed them into new, modern patterns. His work incorporates Indonesian ornaments, symbols and illustrations, which he identifies with through his upbringing. He describes his style as traditional, but with a contemporary accent.

Itameda's artistic career began in painting, drawing and creating graphics influenced by Indonesian culture, but six years ago 'tattooing became the next way of artistic expression' for him. He finds inspiration for his tattoo work in batik textiles and in the art and architecture in museums and temples.

Itameda enjoys each stage of the design and tattoo process. His projects emerge after an initial consultation with each client. Later, in private, he begins to depict his visions. He draws and searches through books for relevant motifs before drafting the final pattern. Although his bold designs are a creative reinvention of traditional Indonesian tattooing, he is passionate about the heritage of his ancestors: 'It is important to save [traditional Indonesian art] because it contains thousands of beautiful, powerful symbols and meanings. It is good to know what [our ancestors] have to transmit to us, because they knew the world [as] it was before we emerged. We have to benefit because of tradition, and what we get connect [it] with our current life.' TM

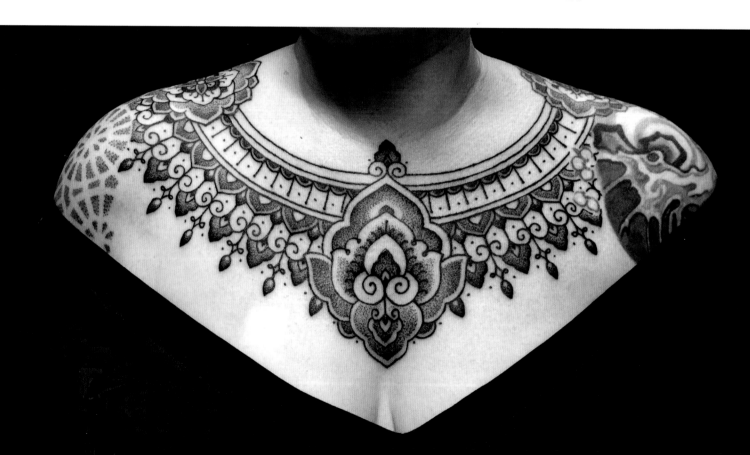

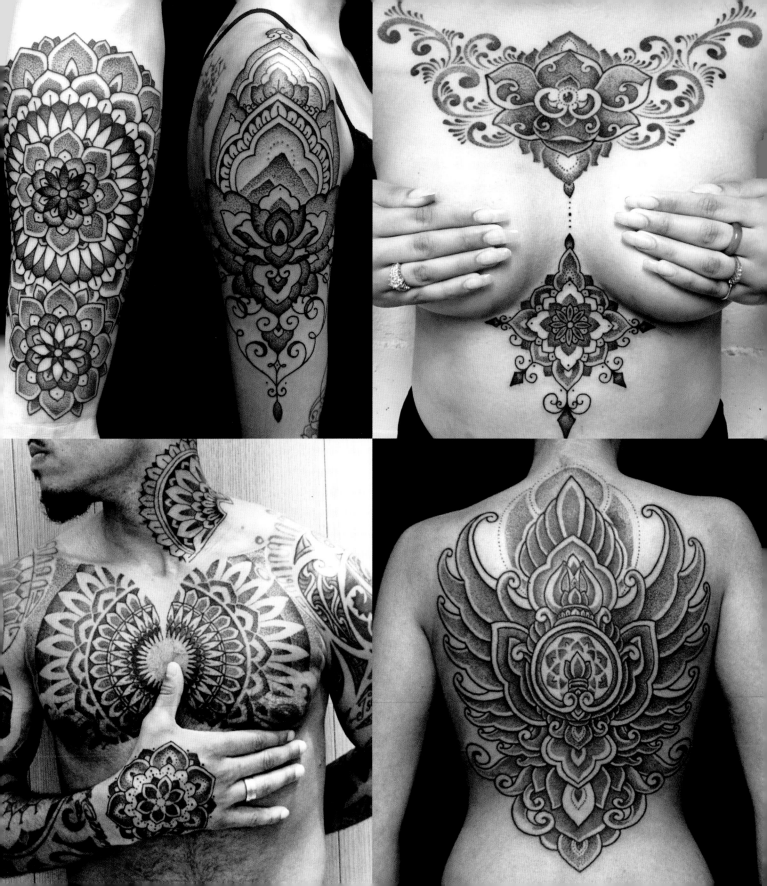

WHANG-OD

Ninety-four-year-old Whang-Od is the last practising Kalinga
tribal tattoo master of the Philippines. Plying human skin with a
citrus thorn embedded in a bamboo stick, she has hand-tapped
traditional Kalinga designs for more than eighty years. Recent
media coverage has sparked worldwide interest in Whang-Od's
tattooing talents. She explains that women's tattoo patterns
in the Kalinga tribe are inspired by everyday objects and are
believed to increase an individual's fertility: 'I tattooed many
of these older women in my village before they reached puberty,
because once their hormones kick in we believe that the
tattooing hurts more then. Women not only receive tattoos
for fertility, but also for beauty, and some women can receive
additional marks if their male relatives were successful in war.
Most of these designs come from nature, like rice bundles, ferns,
steps or snake scales and especially centipedes, which are
powerful spiritual guides.'

I Whang-Od hand-tapping a Kalinga warrior

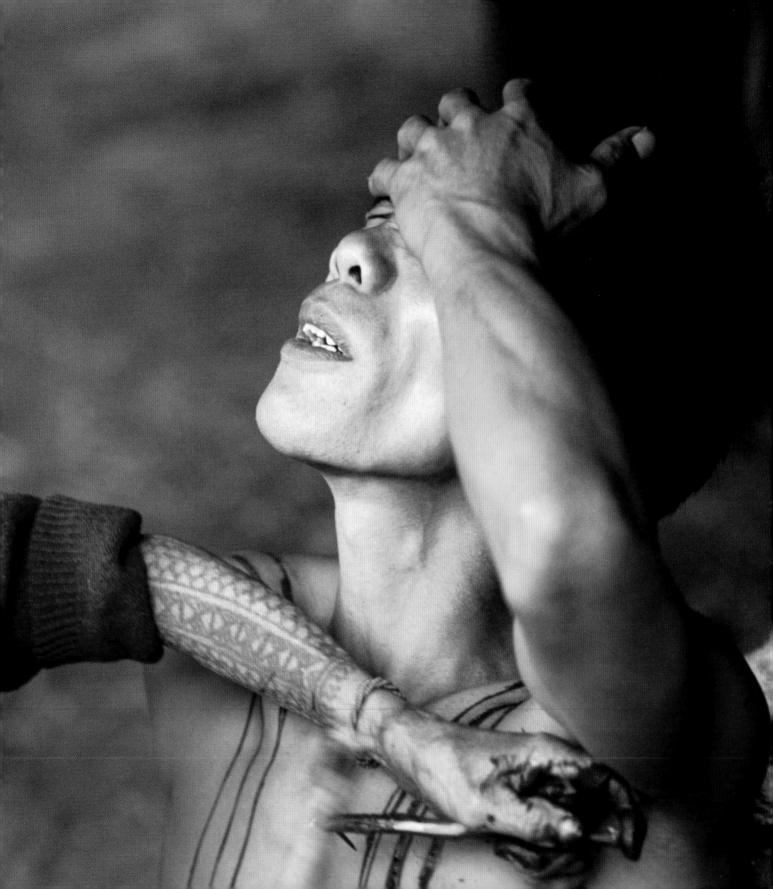

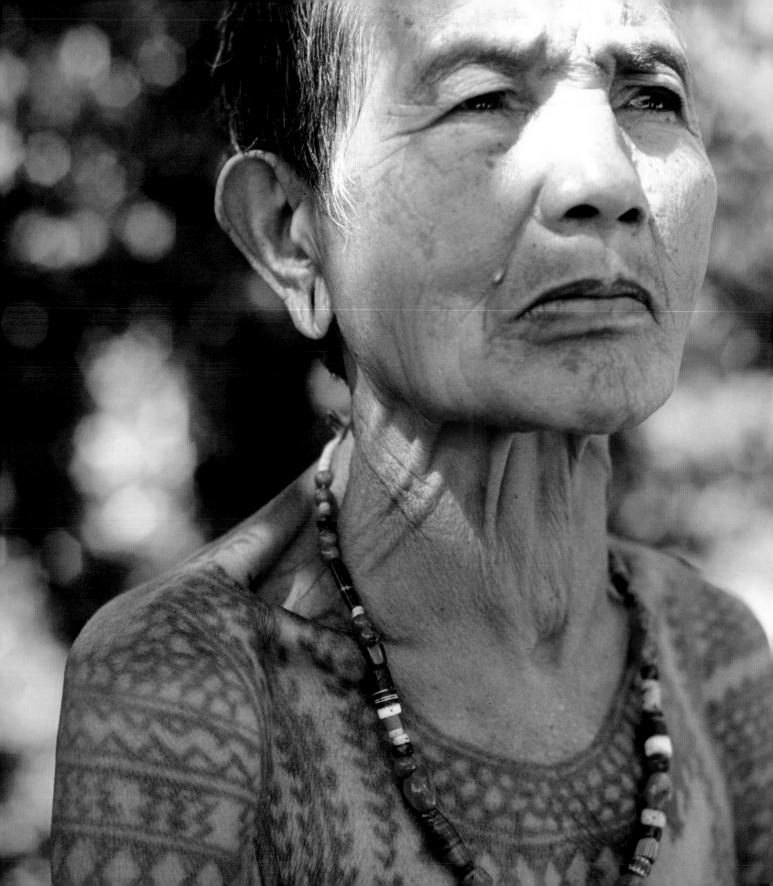

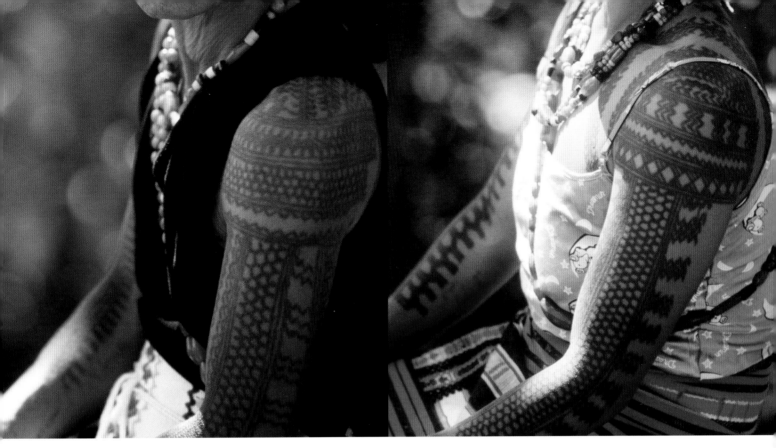

2 Centipede, python scales, rice bundles and step motifs, as well as a tattooed necklace 3–4 Traditional Kalinga arm patterns

Kalinga men's tattoos are closely connected to an individual's social status, and traditionally only warriors who have taken human life on the battlefield earned the right to be marked. Whang-Od notes: 'They were willing to give their lives for our families, villages and people, so successful warriors (mengor) were heavily tattooed with marks of honour.' Men who killed one or more men had elaborate tattoos (batok) applied to their arms and faces, which were composed of centipede or snake scales. Elaborate chest designs (bikking) represented in abstract form the outstretched wings of the predatorial eagle. Kalinga men who performed feats of bravery on the battlefield were also tattooed with linear markings on their backs (dakag), geometric designs on their ribcage and tattoos behind their ears. War captains displayed horn-like motifs (sinaksak'od) that projected outwards above their navels.

Whang-Od follows ceremonial procedures associated with her profession. Historically, the act and practice of Kalinga tattooing was ritualized because flowing blood was believed to attract evil spirits. 'Before I draw first blood, I repeat a chant so that no spiritual harm will come. I also observe a taboo and do not drink any alcohol the night before the tattooing. If I did, the tattoos I create may become infected and [my client] could die. And if [my client] or I sneeze before the tattooing begins, this is a very bad omen and I will have to stop my work.'

The international attention Whang-Od's practice has attracted has preserved a custom that was in danger of disappearing and Kalinga tattoos have become revalued locally. Whang-Od believes that the importance of tattooing lies in its connection to her Kalinga cultural identity. She believes that promoting traditional tattooing will help future generations of Kalinga people to remain in touch with their unique cultural heritage. She explains: 'A lot of Kalinga are now getting tattoos to keep the tradition alive, and it's a wonderful feeling. Tattooing is our ancestors' legacy and it defines who we are as a people.' LK

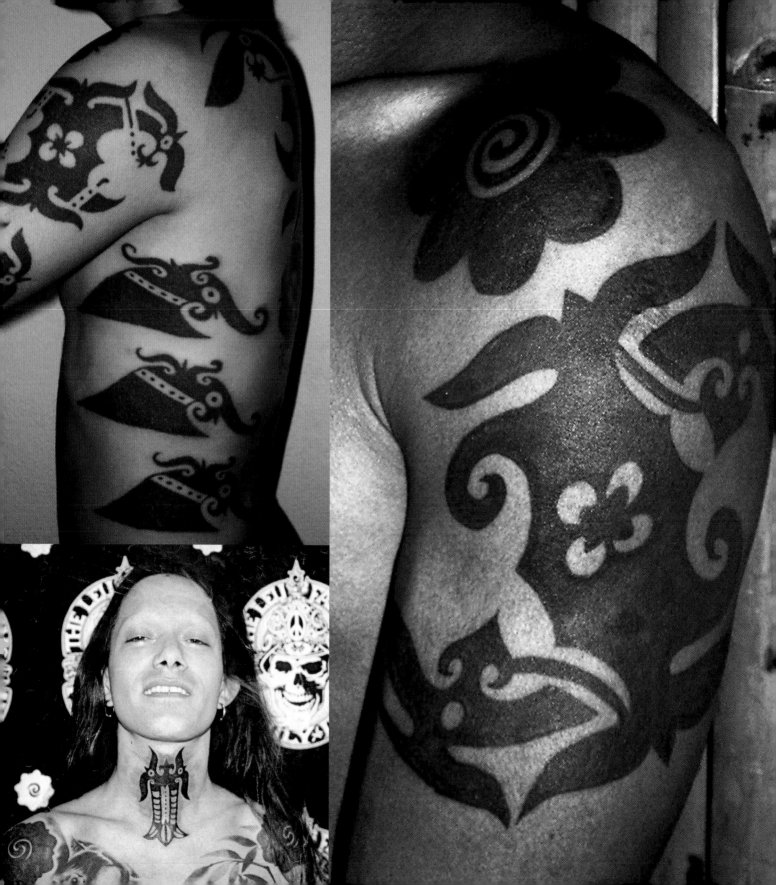

STYLE BLACKWORK, INDIGENOUS **INFLUENCES** RITUAL PRACTICE, HEADHUNTING, IBAN INDIGENOUS ART **LOCATION** KUCHING, SARAWAK, MALAYSIA

1 Traditional motif (*ketam lengan*) symbolizing strength and protection 2 Throat tattoo (*pantang rekung*) 3 Borneo rose (*bunga terung*) – traditionally the first tattoo an Iban acquired – and dog motif 4 Contemporary design based on traditional patterns

ERNESTO KALUM

Ernesto Kalum's blackwork tattoos are dedicated to the Iban and Borneo tattoo cultures. Drawing on a rich tradition of zoomorphic and vegetal designs, his tattoos feature highly stylized dogs, prawns, crabs, aubergine flowers, scorpions, hooks, centipede claws and *Plukenetia* (an indigenous plant), which are central motifs in Iban visual culture. Traditional tattoos range in significance from mere ornamentation to signs of bravery, experience in war or maturity, as well as cures for illness and tools for use in the afterworld.

Initially self-taught and chiefly by tattooing himself, Kalum started using a machine in 1993. He worked in Europe, where Spike from Wolverhampton in the United Kingdom gave him an eight-month residency. In 1998 he established his own tattoo studio, Borneoheadhunters, in Sarawak. Other formative encounters in the tattoo industry led him to realize the importance of his ethnic origins in his practice. Lausanne's Bit Schoenenberger introduced him to the Swiss tattoo scene and the late Felix Leu encouraged him to forgo his machine gun and learn hand-tapping techniques. Kalum recalls: '[Leu] triggered me to revert to the art of traditional tattooing: "You should dump that thing [tattoo machine] into the garbage, you don't need that to tattoo, it's in the blood of your people".' Leu's advice proved compelling. Kalum returned to Sarawak and carried out valuable field research into traditional tattooing in Borneo while many of the elders were still alive. This exposure gives Kalum a direct link to the tattooing practice of the past. SG

JAPANESE

BOTAN/PEONY

The peony generally symbolizes beauty. This flower is an incredibly popular motif especially for use in backgrounds and as a filler. The traditional colour for the peony – red – is associated with Japanese royal power. However, these flowers are rendered in many other colours as well.

KINTARO

The unmistakable red skin of Kintaro, one of many figures from Japanese folklore and mythology, makes him easy to identify. His name translates to something akin to 'strong boy,' and his tiny stature makes his strength all the more impressive.

HO-OO/PHOENIX

Of Chinese origin, the phoenix is typically depicted with five-coloured feathers, and each hue represents essential virtues: decency, fidelity, gentleness, humanity and wisdom. The phoenix's capacity to be regularly reborn from ashes has led to its association with longevity and luck.

KOI/CARP

The carp, a traditionally male symbol from Chinese lore, represents strength and courage. It also reflects endurance, as a legend relates that carp were the only fish to pass through the 'Dragon Gate' and become dragons. It is one of the two most popular Japanese tattoo motifs.

SAKURA/CHERRY BLOSSOM

The cherry blossom is a popular motif in Japanese tattooing and is a beloved symbol in wider Japanese culture. Cherry blossoms represent ephemerality; they bloom for a short time in spring, soon fall off trees and blow away. They are usually rendered in red or white with yellow centres.

SHISHI/LION-DOG

A motif borrowed from Chinese culture, the lion–dog represents strength and courage while offering protection and defence. The fierceness of expression on these creatures belies their gentle and kind nature. *Shishi* are usually paired with peonies in large-scale tattoos.

RYU/DRAGON

Dragons in Japanese lore have considerable power and varied meaning according to the specific type of dragon chosen as a tattoo motif. Generally protective, they often act in a talismanic fashion. Dragons are considered to be one of the two most popular Japanese tattoo motifs.

ONI/DEMON

Supernatural demons are depicted in Japanese tattoos for their symbolic power. Specific characters from Japanese lore, such as Fujin, god of wind, and Raijin, god of thunder, are sometimes depicted as demons. *Oni* images vary considerably, but usually sport horns, fangs and brightly coloured flesh.

INDIGENOUS

Berber tattoo motifs render elements of the surrounding world into reduced geometrical forms and layer meaning on top of them. The scorpion design at times represents evil and death, at others endurance and courage; it also protects against the evil eye.

JERUSALEM CROSS

The Jerusalem cross (Crusaders' cross) has been the most popular pilgrim tattoo in the Holy Land for centuries. The five crosses are thought to represent either the four evangelists with Christ in the centre or the five wounds of Christ (crucified hands and feet and spear wound in his side).

NAGA HEADHUNTER

Naga headhunters wore designs to signify their societal role, including this motif that is interpreted as a lizard or tiger.

KALINGA CENTIPEDE

Centipedes are one of the most common tattoo designs for the Kalinga and are cherished for their symbolic fierceness.

BORNEO ROSE

The 'Borneo rose' (*bunga terung*) is the first tattoo that a man traditionally receives at coming of age. The Iban see it as an aubergine flower, other groups as a cross-section of a durian fruit. In some regions, the central spiral represents the design on the underside of a tadpole native to the region.

KAYAN DOG

Indonesian tattoo motifs often derive from animals and other elements of the natural world. Many variations on the 'dog' (*udo aso*') design exist. They all feature a large, central eye (the dog in profile). Sometimes crossed with a dragon, the appendages can represent fangs or elaborate tails.

MARQUESAN *ENATA*

The Marquesan *enata* motif represents the human figure and can be used to depict both men and gods. It takes a variety of forms, all of which resemble stick figure-like anthropomorphs.

THAI *SAK YANT* TIGER

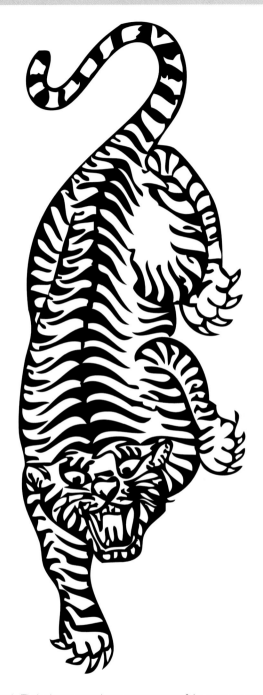

The tiger in Thai *sak yant* tattooing represents one of the more common motifs. Symbolizing strength and power, it imbues its wearer with ferocity and helps to drive away evil spirits.

OLD SCHOOL

A traditional maritime tattoo that marks nautical service and identity, the anchor has been inscribed for many centuries.

DAGGER

The dagger represents a range of emotions related to pain, from physical pain caused by injury to death caused by heartbreak, as shown here, when depicted piercing a heart.

DRAGON

Dragon designs appear to have been imported into old school, Western tattooing from Japanese tattooing. Their appeal is in representing strength and power, as well as exotic flair.

PIN-UP

Part titillation and part appreciation of the women in men's lives, pin-up girls have been a standard motif since at least the late 19th century.

ROSE

Of all the floral designs, the rose has clearly been the most persistently popular over time. Symbolizing a range of meanings from love to beauty, it is worn by both men and women.

PANTHER

The panther represents one of the more modern traditional Western designs, which gained popularity in the mid-20th century. Like the related tiger motif, it represents strength, toughness, speed and ferocity.

EAGLE

A common military symbol historically, the eagle has come to be an iconic representation of American patriotic identity. More broadly, eagles represent characteristics of freedom, power and speed.

CLASPED HANDS

Clasped hands commonly represent a last goodbye or 'farewell to earthly existence'; the design can also represent a range of meaning, from friendship to Masonic affiliation.

MODERN INNOVATIONS

Celtic knot tattoos originated during the tattoo renaissance when people, inspired by indigenous traditions, sought symbols to represent European heritage.

MANDALA

Among the newest popular tattoo motifs, mandalas evoke sacred geometry and appeal to tattoo clients who want bold, abstract patterns that do not evoke specific representational imagery.

BIOMECHANICAL

Beginning in the 1990s, imagery inspired by H. R. Giger and other biomechanical artists found a strong niche in tattooing. These designs represent interest in science fiction and horror while symbolizing strength and masculinity.

3-D EFFECT

Twenty-first-century advances in realism enabled recent interest in three-dimensional, *trompe l'oeil* tattoos that fool the eye into thinking designs are either emerging from or excavated into the skin.

WOMAN WITH CALAVERA MAKE-UP

One of the most popular black and grey designs, female portraits wearing Day of the Dead-inspired *calavera* make-up evoke a blend of beauty and the macabre.

TRIBAL

'Tribal' designs were the first blackwork designs to gain widespread popularity, particularly in the 1980s and 1990s. These curvilinear forms evoke generalized aesthetics of indigenous Amerindian and Oceanic cultures.

DREAMCATCHER

Originally Ojibwe, dreamcatchers became a symbol of Native American unity in the 1960s and 1970s. As a tattoo motif, they became popular in the 1990s to pay homage to Native American cultures, often by outsiders, or to reflect a generalized 'New Age' symbolism.

ARTIST DIRECTORY

Ade Itameda
25 to Life Tattoos
Pannekoekstraat 33a
Rotterdam, The Netherlands
http://www.25tolifetattoos.com
thisis369@gmail.com

Aisea Toetu'u
Soul Signature Tattoo & Art Gallery
1667 Kapiolani Boulevard
Honolulu, Hawaii, United States
http://soulsignaturetattoo.com
soulsignaturetattoo@yahoo.com

Ajarn Thoy
Sukhumvit 77 or Soi On Nut 25
(Wat Tong Nai Temple)
Bangkok, Thailand
https://www.facebook.com/arjahn.thoy

Alison Manners
Feline Lucky
Brisbane, Australia
http://www.mannerstattoo.com

Amanda Wachob
By appointment only
New York, United States
http://www.amandawachob.com/
info@amandawachob.com

Andy Shou
Fright Tattoo
No. 539, Sinjhuang Road
Sinjhuang City, Taipei County, Taiwan
http://www.andyshou.com/
jason@andyshou.com

Benjamin Laukis
The Black Mark
Melbourne, Australia
http://www.theblackmark.com.au/
blaukis.tattoo@gmail.com

BJ Betts
Trademark Tattoo Gallery
2914 Lancaster Avenue
Wilmington, Delaware, United States
http://bjbetts.com/

Caro Wilson
By appointment only
Berlin, Germany
http://cy-n-caro.tumblr.com/
carowilsontattoo@gmail.com

Chris Lambert
By appointment only
Leeds and London, United Kingdom
http://chrislamberttattoo.com/
chris@chrislamberttattoo.com

Claudia de Sabe
Seven Doors
55 Fashion Street
London, United Kingdom
http://www.sevendoorstattoo.com/
sevendoorstattoo@gmail.com

Colin Dale
Skin & Bone Tattoo
Jægersborggade 49 kld
Copenhagen, Denmark
http://www.skinandbone.dk/
colindale@skinandbone.dk

Dan Sinnes
Luxembourg Electric Avenue
15, rue des Jardiniers
Luxembourg City
Luxembourg
https://www.facebook.com/
LuxembourgElectricAvenue

Dana Melissa Dixon
Old World Tattoo
445 SW Coast Hwy # 101
Newport, Oregon
United States
https://www.facebook.com/
oldworldtattooparlour

Daniel Campos
13Agujas Tatuajes & Gabinete
 de Arte
Concepción, Chile
https://www.facebook.com/13agujas
13agujas@gmail.com

Danis Nguyen
Saigon Ink
26 Tran Hung Dao, Pham Ngu Lao
Ward, District 1
Saigon, Vietnam
http://tattoovietnam.com/
info@saigonink.net

Deno
Seven Doors
55 Fashion Street
London, United Kingdom
http://www.sevendoorstattoo.com/
sevendoorstattoo@gmail.com

Dion Kaszas
Vertigo Tattoos & Body Piercing
Suite 2–190 Hudson Avenue, NE
Salmon Arm, British Columbia, Canada
http://www.indigenoustattooing.com/
dion@indigenoustattooing.com

Dmitry Babakhin
Bang Bang Custom Tattoo Shop
Fontanka 38
St Petersburg, Russia
https://www.facebook.com/pages/
Bang-Bang-Custom-Tattoo-
Shop/180124065343053
babakhin@gmail.com

Duke Riley
East River Tattoo
1047 Manhattan Avenue
Brooklyn, New York
United States
http://www.dukeriley.info/
duke@dukeriley.info

Durga
Durga Tattoo
Dusun Jenengan No. 68 RT02/RW07
Maguwoharjo, Sleman
Yogyakarta, Indonesia
http://www.durgatattoo.com/
info@durgatattoo.com

Elle Festin
Spiritual Journey Tattoo
7159 Katella Avenue
Stanton, California, United States
http://spiritualjourneytattoo.com/

Elson Yeo
thINK Tattoo
14 Scotts Road, Far East Plaza #02–65
Singapore
www.thinktattoo.org
thinkelson@gmail.com

Ernesto Kalum
Borneo Headhunters Tattoo
 and Piercing Studio
1st Floor, 47 Wayang Street
Kuching, Sarawak, Malaysia
http://www.borneoheadhunter.com/
info@borneoheadhunter.com

Genko
2–3–7 Osu Naka-ku
Nagoya, Japan
http://genko-tattoo.com/

Henrique Mattos
By appointment only
Rio de Janeiro, Brazil
https://circomarimbondo.wordpress.com/
hm.tattoos@gmail.com

Horimitsu
Nishiyama Building #102 1–16–36
Ikebukuro Toshima, Tokyo, Japan
http://honey-tattoo.blogspot.com/
honeytattoo@gmail.com

Huzz
Huzz Ink, Amman, Jordan
http://huzzink.com/
and Tattoo Dubai, Dubai, UAE
http://tattoodubai.com/

James Kern
No Hope No Fear Tattoo Art Studio
2923 SE Division Street
Portland, Oregon
United States
http://www.nohopenofeartattoo.com
info@nohopenofeartattoo.com

Jessica Weichers
Seed of Life Tattoos
101 East Main Street, Suite 2600
Festus, Missouri, United States
http://www.seedoflifetattoos.com/

Jill 'Horiyuki' Bonny
By appointment only
San Francisco, California
United States
jillbonnytattoo@gmail.com

Jose Lopez
Lowrider Tattoo Studio
16104 Harbor Blvd
Fountain Valley, California, United States
http://www.lowridertattoostudio.com/

Joey Pang
Tattoo Temple
1602, 1 Wyndham Street Central
Hong Kong, China
http://tattootemple.hk
concierge@tattootemple.hk

Julia Mage'au Gray
By appointment only
Darwin, Australia
www.teptok.com

Julie Paama-Pengelly
Art + Body Gallery &
 Creative Studio
229a Maunganui Road
Mount Maunganui
New Zealand
www.facebook.com/artbodycreative
artmaori@gmail.com

Karolina Czaja
Primitive Tattoo
Warsaw, Poland
https://www.facebook.com/
primitivetattoo.studio
primitivetattoo.pl@gmail.com

Keone Nunes
Hale Ola Ho'opakolea
89–137 Nanakuli Avenue
Wai'anae, Hawaii
United States
keonenunes@gmail.com

Kil Jun
Seoul Ink Tattoo
Seoul, South Korea
http://www.seoulinktattoo.com/
seoul_ink@hotmail.com

Kore Flatmo
Plurabella Tattoo
 Studio
3937 Spring Grove Avenue
Cincinnati, Ohio
United States
http://plurabella.com/
contact@plurabella.com

Leo Pugram
Yap Tribal Tattoo
Colonia, Yap, Federated States
of Micronesia
https://www.facebook.com/
YapTribalTattoo
yinug_leo@yahoo.com

Leon Lam
Alchemink Tattoo Studio
2/F, 370 Shanghai Street
Yau Ma Tei, Hong Kong, China
http://alchemink.com/
info@alchemink.com

Lionel Fahy
By appointment only
France
http://lioneloutofstep.blogspot.com/
lionel.fahy@gmail.com

Little Swastika
By appointment only
Tengen, Germany
www.little-swastika.com

Manjeet Singh
Manjeet Tattooz
E–11 1st Floor, Main Jail Road
New Delhi, India
http://manjeettattooz.com/

Marina Inoue
Absolute Art
917 W Grace Street
Richmond, Virginia, United States
http://www.ourtrespasses.com/

Mark Kopua
11 Jillett Street, Titahi Bay, Porirua
Wellington
New Zealand
https://tamokoake.wordpress.com/
mokoake@gmail.com

Massimiliano 'Crez' Freguja
Adrenalink Tattooing Marghera
Via C. Beccaria 4
Venice, Italy
http://www.adrenalinktattoo.com/
crez@adrenalinktattoo.com

Mate
Mate Tatau
PK 24 (across from the Hotel
Intercontinental)
Haapiti, Moorea
French Polynesia
https://www.facebook.com/
matetattoomoorea

Megan Hoogland
Mecca Tattoo
418 S Front Street
Mankato, Minnesota
United States
http://meganhoogland.com/
meganhoogland@gmail.com

Miguel Dark
Acid Ink Tattoo Art
Calle 55 # 10–72
Bogotá, Colombia
http://acidinktattooart.com/
darktatt2@yahoo.com

Mikael de Poissy
Mikael de Poissy Tatouage
25 Rue du Général de Gaulle
Poissy, France
http://www.tattoo.fr/
boulot@tattoo.fr

Mikel
Strong Heart Studios
#107–1405 St Paul Street
Kelowna, British Columbia, Canada
http://mikel.ca/
info@mikel.ca

Miya Bailey
City of Ink
323 Walker Street
Castleberry Hill District
Atlanta, Georgia
United States
http://miyabailey.com/
MiyasArt@gmail.com

Mo Naga
Headhunters' Ink
3rd floor, S Koutsu Complex
Circular Road, Dimapur
India
https://www.facebook.com/
Headhuntersink
headhuntersink@gmail.com

Mohan Gurung
Mohan's Tattoo Inn
Thamel, Kathmandu, Nepal
http://www.mohanstattooinn.com/
mohantattooinn@gmail.com

Mokomae Araki
Mokomae Tattoo
Hanga Roa, Rapa Nui
Chile
https://www.facebook.com/mokomae.
tatoo
Mokomae@gmail.com

Nazareno Tubaro
By appointment only
Buenos Aires, Argentina
consultas@nazareno-tubaro.com

Nick Baxter
By appointment only
Austin, Texas, United States
http://www.nickbaxter.com/

Nick Colella
Great Lakes Tattoo
1148 W Grand Avenue
Chicago, Illinois
United States
http://greatlakestattoo.com/
info@greatlakestattoo.com

Nukumoana Group
Inquire locally for whereabouts
Honiara, Solomon Islands

Nuno Costah
Ideal Tattoo Shop
Rua dos Benguiados 221
Vila do Conde
Portugal
http://www.costah.net/
costahtattoo@gmail.com

Obi
By appointment only
Kolkata and Mumbai, India
abhinandan.basu9999@gmail.com

Orne Gil
Nowhereland Tattoo
Cairo, Egypt
http://www.nowherelandtattoo.com/

Pedro Alvarez
Orion Tattoo
Mexico City
Mexico
neoazteca@yahoo.com.mx

Peter Aurisch
Nevada Johnny
Berlin, Germany
http://peteraurisch.com/
ilike@peteraurisch.com

Pierre Bong
B. S. van Leeuwenstraat 50
Paramaribo
Suriname
https://www.facebook.com/pierre.bong
bongsuriname@yahoo.com

Pius
Inquire locally for whereabouts
Muidumbe, Cabo Delgado Province
Mozambique

Poli Somalomo
Inquire locally for whereabouts
Congo

Rasty Knayles
1933 Classic Tattoos
33 De Korte Street
Johannesburg
South Africa
http://www.1933.co.za/
1933classictattoos@gmail.com

Razzouk Family
Razzouk Ink
Old City Jerusalem, near the Jaffa Gate
Jerusalem
Israel
http://www.razzouktattoo.com/

Rico Schinkel
Crossover Tattoo & Art Gallery
Ollebukta 4
Tønsberg
Norway
https://www.facebook.com/
CrossoverTattooArtGallery

Riki-Kay Middleton
Royal City Tattoo Co.
275 Woolwich Street
Guelph, Ontario
Canada
http://riki-kaytattoos.tumblr.com/
rikikaytattoo@gmail.com

Róbert Borbás
Dark Art Tattoo
Budapest
Hungary
http://www.theartofgrindesign.com/
robart.borbas@gmail.com

Rodney 'Ni' Powell
By appointment only
Hilo, Hawaii, United States
http://tongan_tattoo.tripod.com/
TonganTattoo/
tongan_tattoo@yahoo.com

Roxx
2Spirit Tattoo
11 Pearl Street
San Francisco, California, United States
http://2spirittattoo.com/
info@2spirittattoo.com

Safwan
Imago Tattoo Studio
4059 Boulevard Saint-Laurent
Montreal, Quebec, Canada
http://www.imagotattoo.com/
info@imagotattoo.com

Sake
Sake Tattoo
Kolokotroni 9 & Gkini 6, Halandri
Athens, Greece
http://www.saketattoo.com/
saketattoo@gmail.com

Sam Ije
Inquire locally for whereabouts
Benin

Sanya Youalli
Youalli – Ancient Tattoo Revival
Palenque, Chiapas, Mexico
http://sanyayoualli.com/
sanyatattoo@yahoo.com

Sarah Johnson
The Village Ink/Independent Tattoo
 & Design
101 Yorkville Avenue
Toronto, Ontario
Canada
http://www.thevillageink.com/

Sebastian Winter
By appointment only
http://sebwinter.tumblr.com/
seb@seb-winter.com

Shannon Purvis Barron
Indigo Rose Tattoo
2009 Greene Street #112
Columbia, South Carolina
United States
indigorosetattoostudio@gmail.com
http://www.indigorosetattoostudio.com/

Shaun Dean
Emerald Fox Tattoo Studio
69 Main Road, Muizenberg
Cape Town, Western Cape
South Africa
http://emeraldfoxtattoo.tumblr.com/
shaun@emeraldfoxtattoo.co.za

Simone Pfaff
and
Volker Merschky
Buena Vista Tattoo Club
Peterstrasse 1, Würzburg
Germany
http://www.buenavistatattooclub.de/
info@buenavistatattooclub.com

Stephanie Tamez
Saved Tattoo
426 Union Avenue
Brooklyn, New York, United States
http://www.stephanietameznyc.com/
stephanietamez@gmail.com

Steve Ma Ching
Western Tattoo Studio
3100a Great North Road
New Lynn, Auckland
New Zealand
https://www.facebook.com/pages/
Samoan-Tattoos/83261331600

Stomper
Stomper Tattoo
Av Vallarta #3995–B
Zapopan, Jalisco
Mexico
https://www.facebook.com/
StomperTattoo

Sulu'ape Family
Faleasi'u Village
Upolu, Samoa
https://www.facebook.com/petelo.
suluape
https://www.facebook.com/paul.
suluape.7

Susanne 'Susa' König
Salon Serpent Tattoo Parlour
Jacob van Lennepstraat 58
Amsterdam, The Netherlands
http://www.salonserpent.com/
susanne@salonserpent.com

Taku Oshima
Apocaript
Shinjuku, Tokyo
Japan
http://www.apocaript.com/

Tang Ping
Ziyou Tattoo
FuLi City A–A3
Chaoyang District, Beijing
China
https://www.facebook.com/ziyoutattoo
ziyoutattoos@gmail.com

Tatu Lu
5/18 Burringbar Street
Mullumbimby, New South Wales
Australia
http://www.tatulus.com.au/
tatulu@westnet.com.au

Tirga Poli
Inquire locally for whereabouts
North Cameroon

Victor Portugal
Sławkowska 16/2
Kraków
Poland
http://www.victorportugal.com/
artbyvictorportugal@gmail.com

Whang-Od
Inquire locally for whereabouts
Buscalan, Tinglayan Municipality
Kalinga Province
Philippines

Wilson Fatiaki
Mahala Tattoo Studio
Challenge Plaza (formerly Colonial Plaza)
Namaka, Nadi, Fiji
https://www.facebook.com/
mahalatattoos

Yang 'YZ' Zhuo
YZ Tattoo
No. 30 Building of Sanlitun North
Chaoyang District, Beijing
China
theyzstudio.com
theyzstudio@gmail.com

Yasmine Bergner
By appointment only
Tel Aviv, Israel
http://yasminebergner.com/
yasminebergner@gmail.com

Zele
Zagreb Tattoo
Tratinska 28
Zagreb, Croatia
http://www.tetoviranje.com/
info@tetoviranje.com

Zulu
Zulu Tattoo
165 S Crescent Heights Blvd
Los Angeles, California, United States
and
200 E Live Oak Street #2B
Austin, Texas, United States
http://zulutattoo.com/
appointments@zulutattoo.com

INDEX

Page numbers in **bold** indicate featured artists and their work.

CONTRIBUTORS

Tricia Allen (TA) is a faculty member of the University of Hawaii and Windward Community College, as well as a long-time tattooist. She has travelled throughout the Pacific documenting the revival of tattoo arts and practising Polynesian tattooing. She is the author of *The Polynesian Tattoo Today* (2010) and *Tattoo Traditions of Hawai'i* (2006), which won awards at the Hawaii Book Publishers Association. Allen has curated many exhibitions in the United States and abroad. See www.ThePolynesianTattoo.com

Kimberly Baltzer-Jaray (KBJ) is an independent scholar whose area of expertise is early phenomenology and existentialism. She is a lecturer at King's University College at Western, Canada, president of the North American Society for Early Phenomenology, associate editor of the *Journal of Camus Studies* and a writer for *Things & Ink* magazine.

Dr Anna Felicity Friedman (AFF) runs the popular website tattoohistorian.com and photoblog Tattoo History Daily. She spent many years as a college professor (University of Chicago and the School of the Art Institute of Chicago). Her numerous articles, lectures and media appearances have helped to expand public knowledge of cutting-edge research about tattoo history and culture. She consults on exhibitions and is curatorial director for the forthcoming travelling exhibition, 'TATTOO: Ancient Myths, Modern Meanings', which launches in 2016.

Dr Sébastien Galliot (SG) is a professor in the anthropology department of Aix-Marseille University and a research associate at CREDO (Centre for Research and Documentation on Oceania). His doctoral thesis was dedicated to the history and ethnography of tattooing in Samoa. He is the author of *Tatouages d'Océanie: Rites, techniques et images* (2014) and was an adviser for the Musée du quai Branly exhibition 'Tattoo, Tattooed' in 2015.

Amelia Klem Osterud (AKO) is a tattooed librarian from Milwaukee, Wisconsin, who writes and speaks about tattoo and circus history. She is the author of *The Tattooed Lady: A History* (2009) and a regular contributor to *Things & Ink* and *Z Tattoo* magazines. She holds master's degrees from the University of Wisconsin–Milwaukee in history and library science. When she is not writing, knitting or playing ice hockey, Amelia can be found planning her next tattoo.

Dr Lars Krutak (LK) is an anthropologist, photographer and writer who has travelled the indigenous world for more than fifteen years, documenting the traditions of tribal body modification. His

books include *The Tattooing Arts of Tribal Women* (2007), *Kalinga Tattoo: Ancient and Modern Expressions of the Tribal* (2010), *Spiritual Skin: Magical Tattoos and Scarification* (2012) and *Tattoo Traditions of Native North America: Ancient and Contemporary Expressions of Identity* (2014).

Dr Matt Lodder (ML) is an academic art historian at the University of Essex in the United Kingdom. His research centres on the history of Western tattooing in the 19th and 20th centuries, with a particular focus on the connections between tattooing and the broader visual cultures from which it emerges. He has been obsessed with tattooing since childhood, when stories of his great-grandmother's tattoo and how his grandfather narrowly avoided getting a fly tattooed on his nose while drunk were the stuff of family legend.

Tomasz Madej (TM) is an anthropologist who works at the Asia and Pacific Museum in Warsaw, Poland. His scientific work focuses on the phenomenon of the 'tattoo unplugged' and the contemporary meaning of ethnic tattoos. He has conducted fieldwork among the Mentawai in Indonesia and in Thailand in South East Asia. He was a curator for the exhibition 'Sak Yant – the Magic of Thai Tattoo'. He also writes for Polish tattoo magazines.

Joan Riera (JR) was born in Barcelona, but lived his early years in Cameroon and Benin, where he became interested in African traditional culture and tribal tattooing. After studying anthropology and sociology in London, in 2005 he opened a travel agency called Middle-Africa that offers an alternative view of the continent and its peoples. He also organizes tattoo trips to meet Africa's last surviving tattoo masters.

Nicholas Schonberger (NS) is a New York City-based tattoo historian and graduate of the Winterthur Program in Early American Culture at the University of Delaware. He is a contributing author of *Forever: The New Tattoo* (2012) and served as curatorial consultant on the exhibition 'Skin & Bones: Tattoos in the Life of the American Sailor' at the Independence Seaport Museum in 2010.

Dr Ole Wittmann (OW) studied art history at the University of Hamburg in Germany and has worked for various museums and foundations. He was involved in organizing the exhibition 'Tattoo' at the Museum für Kunst und Gewerbe Hamburg in 2015. His ongoing research focuses on Christian Warlich.

PICTURE CREDITS

Unless indicated, all images featured in the book are courtesy of the artists. Every effort has been made to credit the copyright holders of the images. We apologize in advance for any unintentional omission or errors and will insert the appropriate acknowledgment in subsequent editions of the work.

2 Peter Aurisch **6** Susanne König **8** Tang Ping **10** Sanya Youalli **11** image 3: Aisea Toetu'u **11** image 4: Tirga Poli, photo Joan Riera **12** Little Swastika **13** James Kern **14** © Michael Johnson (Mikel) **16** Yale University Art Gallery, Trumbull Collection **17** Sagayenkwaraton (baptized Brant). Named Sa Ga Yeath Qua Pieth Tow, King of the Maquas (Mohawk), 1710; Source: Library and Archives Canada/John Petre collection/c092418 **18** Franz R. and Kathryn M. Stenzel Collection of Western American Art. Yale Collection of Western Americana, Beinecke Rare Book and Manuscript Library **19** The Mariners' Museum, Newport News, VA **20** image 6: TCS 8, Harvard Theatre Collection, Houghton Library, Harvard University **20** image 7: courtesy National Park Service; Longfellow House-Washington's Headquarters National Historic Site; Archives no. 1008-2-2-2-144 **21** image 8: SailorJerry.com **21** image 9: 'The Zeis Studio' – Milton Zeis Estate **22** image 11: Collection of Dale Grande of the Chicago Tattooing Co. **23** photo by John Olsen/The LIFE Picture Collection/Getty Images **24** Richard Todd Photography **25** Vyvyn Lazonga **26** Damian Shaw/ Newspix/ Rex **27** © Angela Gzowski **28–31** Amanda Wachob **32–5** Duke Riley **34–7** Stephanie Tamez **38–41** Nick Colella **42–3** BJ Betts **44–5** Dana Melissa Dixon **46–7** Megan Hoogland **48–9** Jessica Weichers **50–3** James Kern **54–5** Kore Flatmo **56–7** Marina Inoue **58–61** Miya Bailey **62–3** Nick Baxter **64–7** Shannon Purvis Barron **68–71** Elle Festin **72–5** Jose Lopez **76–9** Zulu **80–3** Jill 'Horiyuki' Bonny, photos by John Agcaoili **84–7** Roxx **88–9** Dion Kaszas **90–1** Riki-Kay Middleton **92–5** Safwan **96–7** Mikel **98–9** Sarah Johnson **100** © Pedro Alvarez **102** image 2: IRA BLOCK/National Geographic Creative **102** image 3: Art Institute of Chicago, photo Anna Felicity Friedman **103** Museo Larco; Lima – Perú, photo Anna Felicity Friedman **104** photo Anna Felicity Friedman **105** images 6–7: Dan James Pantone **106** photo Lars Krutak **107** image 9: photo Anna Felicity Friedman **107** image 10: © Jan Sochor / Alamy **108–11** Pedro Alvarez **112–15** Sanya Youalli **116–17** Stomper **118–19** Daniel Campos **120–1** Henrique Mattos **122–3** Nazareno Tubaro, image 3: photo © Juan Salvarredy **124–5** Miguel Dark **126–7** Pierre Bong **128** © Simone Pfaff and Volker Merschky **130** © The Art Archive / Alamy **131** image 3: © Erich Lessing **131** image 4: akg-images / Erich Lessing **132** image 5: akg-images / Album / Oronoz **132** image 6: akg-images **133** Tea Mihaljevic **135** photo Anna Felicity Friedman **136** General Photographic Agency / Stringer/ Getty **137** image 10: © David Turnley/Corbis **137** image 11: Collection William Robinson **138** photo Anna Felicity Friedman **139** Stichting Circusarchief Jaap Best/ www.circusmuseum.nl **140** Tattoo Alex Binnie, Richard Todd Photography **141** Tattoo Filip Leu 1995, photo 2012, Bobby C. Alkabes **142–5** Dan Sinnes **146–7** Lionel Fahy **148–51** Mikael de Poissy **152–3** Nuno Costah **154–7** Massimiliano 'Crez' Freguja **158–9** Sake **160–1** Deno **162–5** Chris Lambert **166–9** Claudia de Sabe **170–3** Little Swastika **174–7** Peter Aurisch **178–81** Caro Wilson **178** image 1: photo Jens Junge **180** image 2: photo Jibégé Fotograf **182–3** Sebastian Winter **184–7** Simone Pfaff and Volker Merschky **188–9** Susanne 'Susa' König **190–1** Rico Schinkel **192–5** Colin Dale **196–7** Róbert Borbás **198–201** Dmitry Babakhin **202–3** Karolina Czaja **204–7** Victor Portugal **208–11** Zele **212** © Yasmine Bergner **214** The Art Archive / Alamy **215** image 4: Razzouk Family **216** JAMES L. STANFIELD, National Geographic Creative **217** Murat Yazar **218** image 7: Yasmin Bendaas, Algeria, 2012 **218** image 8: Eliot Elisofon Photographic Archives, National Museum of Africa Art, Washington D.C. **219** Chris Greenwood **220–1** Tattoos Orne Gil, photos © Ines Della Valle **222–5** Poli Somalomo, photos Joan Riera **226–9** Tirga Poli, photos Joan Riera **230–1** Sam Ije, photos Joan Riera **230** image 1: photo Joan Riera **231** images 2–3: Esteban Tapella **232–3** Shaun Dean **234–7** Rasty Knayles **238–9** Pius; images 1–4: photos Lars Krutak **240–3** Yasmine Bergner **244–7** Razzouk Family **248–51** Huzz **252** © Joey Pang, Tattoo Temple Hong Kong **254** The Art Archive / Alamy **255** © dpa picture alliance archive / Alamy **256** photo Anna Felicity Friedman **257** © Danita Delimont / Alamy **258** image 6: photo Lars Krutak **258** image 7: Maellyn Macintosh **259** Jon Derksen **260** photo Lars Krutak **261** © John Warburton-Lee Photography / Alamy **262–5** Joey Pang, Tattoo Temple Hong Kong **266–9** Leon Lam **270–1** Tang Ping **272–3** Yang 'YZ' Zhou **274–7** Andy Shou **278–9** Kil Jun **280–3** Ajarn Thoy **282–3** images 5–6: photos Piotr Szot **284–5** Elson Yeo **286–7** Taku Oshima **288–9** Horimitsu **290–3** Genko **294–7** Danis Nguyen, photos SonMeo Nguyen **298–9** Obi **300–3** Mo Naga **304–5** Manjeet Singh **306–9** Mohan Gurung **310** © Durga Tattoo **312** image 2: photo Lars Krutak; image 3: photo Anna Felicity Friedman **313** photo Anna Felicity Friedman **314** photo Anna Felicity Friedman **315** PP0206293© 2015. musee du quai Branly, photo Claude Germain/Scala, Florence **316** image 7: photo Anna Felicity Friedman **316** image 8: Nationaal Museum van Wereldculturen. Coll. no. RV-10775-45 **317** photo: Gunther Deichmann **318** J. Sutcliffe, National Library of Australia, an10345322 **319** Roonui Anania, photo Tricia Allen **320–1** Alison Manners **322–5** Benjamin Laukis **326–7** Tatu Lu **328–31** Julia Mage'au Gray **332–5** Keone Nunes, images 1–2: photos Lars Krutak **336–7** Aisea Toetu'u **338–41** Rodney 'Ni' Powell: images 1–3, 5 photos Tricia Allen **342–3** Wilson Fatiaki **344–5** Mate **346–9** Leo Pugram **350–1** Mokomae Araki **352–3** Mark Kopua **354–7** Steve Ma Ching **358–9** Julie Paama-Pengelly **360–3** Sulu'ape Family, images 1–8: photos Sébastien Galliot **364–5** Nukumoana Group, photo Tricia Allen **366–9** Durga **366** image 1: photo Tomasz Madej **369** image 9: photo Tomasz Madej **370–1** Ade Itameda **372–5** Whang-Od, images 1–4: photos Lars Krutak **376–7** Ernesto Kalum

ACKNOWLEDGMENTS

An enormous number of people around the world have contributed to making *The World Atlas of Tattoo* the rich, global tour through tattoo culture and history that it encapsulates. Particular thanks are in order for a few of these myriad individuals: Lars Krutak, Benoît Robitaille, Aaron Deter-Wolf, Ole Wittmann, and Matt Lodder for proofing various of the chapter openers to ensure that all the information in them represents the most cutting-edge scholarly research; Kimberly Baltzer-Jaray, Amelia Klem Osterud and Tricia Allen for coming through in the eleventh hour with taking on additional writing; Joanne Friedman for supplying financial assistance; Odessa Cozzolino for being patient while this project kept taking precedence over hers; David Huettner for months of psychological and logistical support (including many cups of carefully prepared coffee and tea); and lastly, and most importantly, Eleanor Herlihy for being incredibly forgiving of an overtired mom who had to prioritize work over play far too often. Sébastien Galliot acknowledges Lisa Renard's valuable assistance with text and images for Mark Kopua. Quintessence also thank Theresa Bebbington, Sarah Hoggett and Helen Snaith.

Front cover: Tattoo by Simone Pfaff and Volker Merschky
Photograph © Juan Salvarredy

Back cover: Tattoo by Durga
Photograph © Juan Salvarredy

Anna Felicity Friedman is an interdisciplinary scholar and tattoo historian. Formany years she taught at the University of Chicago and the School of the ArtInstitute of Chicago. She has recently curated a travelling exhibition about tattoo history and culture, which put her in touch with a wide range of contemporary global artists.

James Elkins is E. C. Chadbourne Chair of art history, theory and criticism at the School of the Art Institute of Chicago.

First published in the United Kingdom in 2015 by
Thames & Hudson Ltd
181A High Holborn
London WC1V 7QX

This paperback edition first published in 2019

This book was designed and produced by
Quintessence
The Old Brewery
6 Blundell Street
London N7 9BH

Project Editor	Fiona Plowman
Editorial Assistant	Kate Symondson
Designer	Dean Martin
Production Manager	Anna Pauletti
Editorial Director	Ruth Patrick
Publisher	Mark Fletcher

British Library Cataloguing-in-Publication Data
A catalogue record for this book is available from the British Library

ISBN 978-0-500-29497-0

Printed in China

To find out about all our publications, please visit
www.thamesandhudson.com
There you can subscribe to our e-newsletter, browse or download our current catalogue, and buy and titles that are in print.